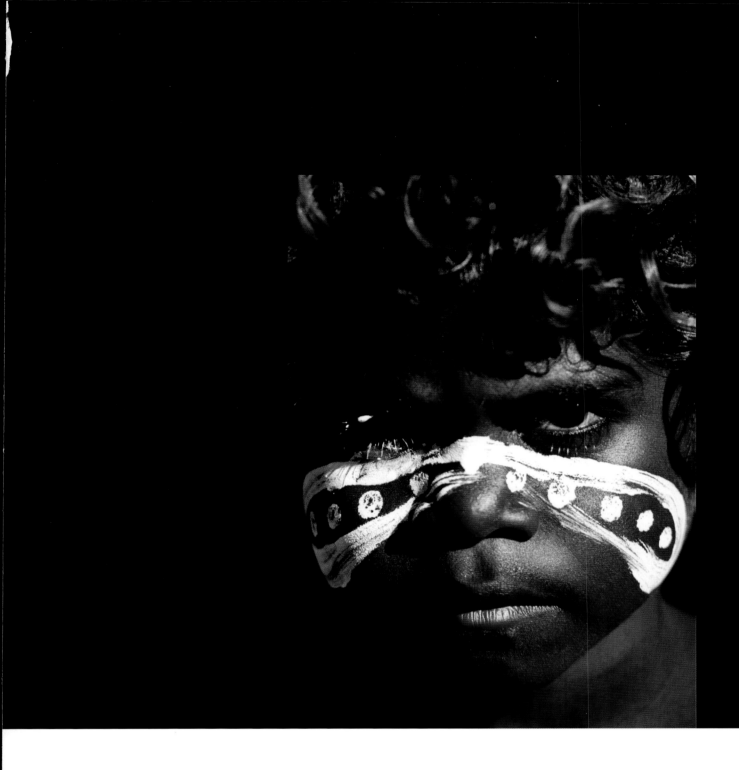

AUSTRALIA

THE NEW FRONTIER

WHITE STAR PUBLISHERS

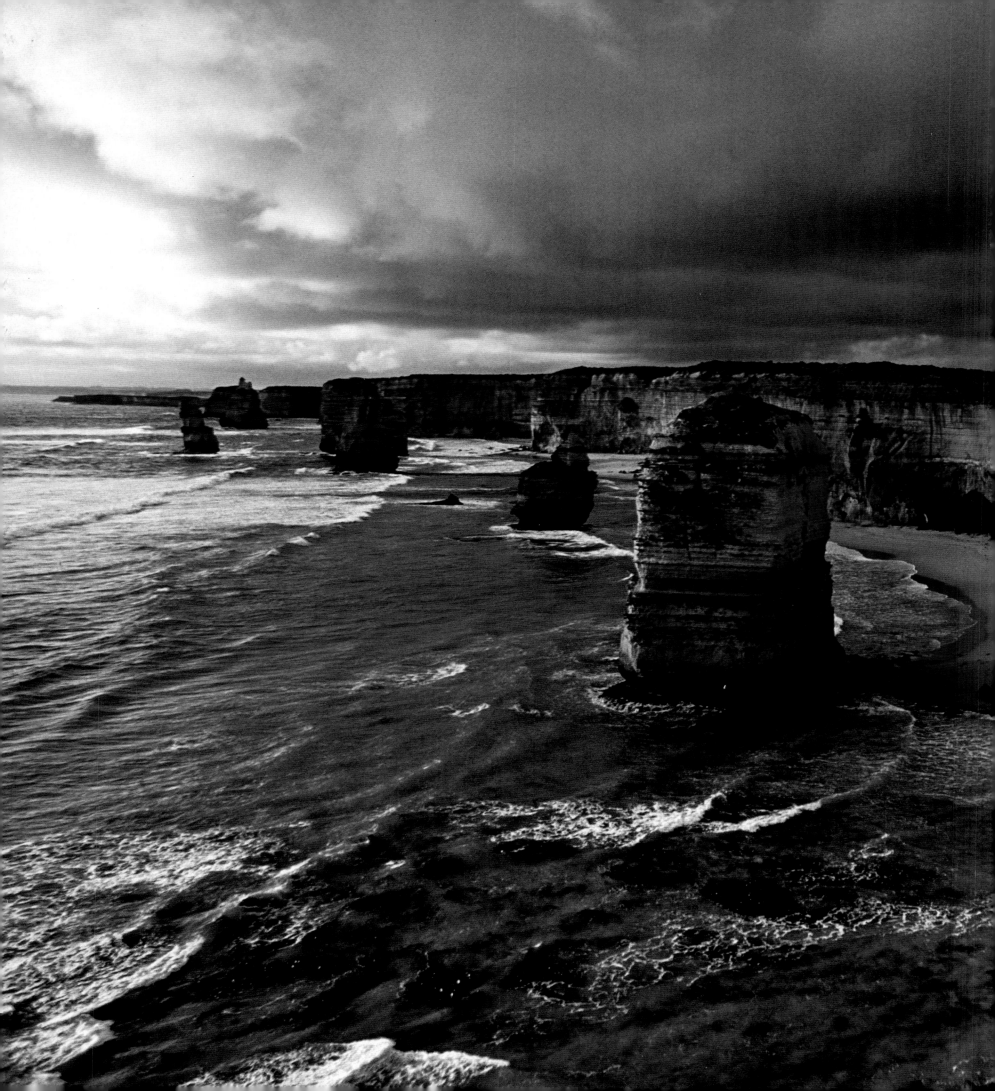

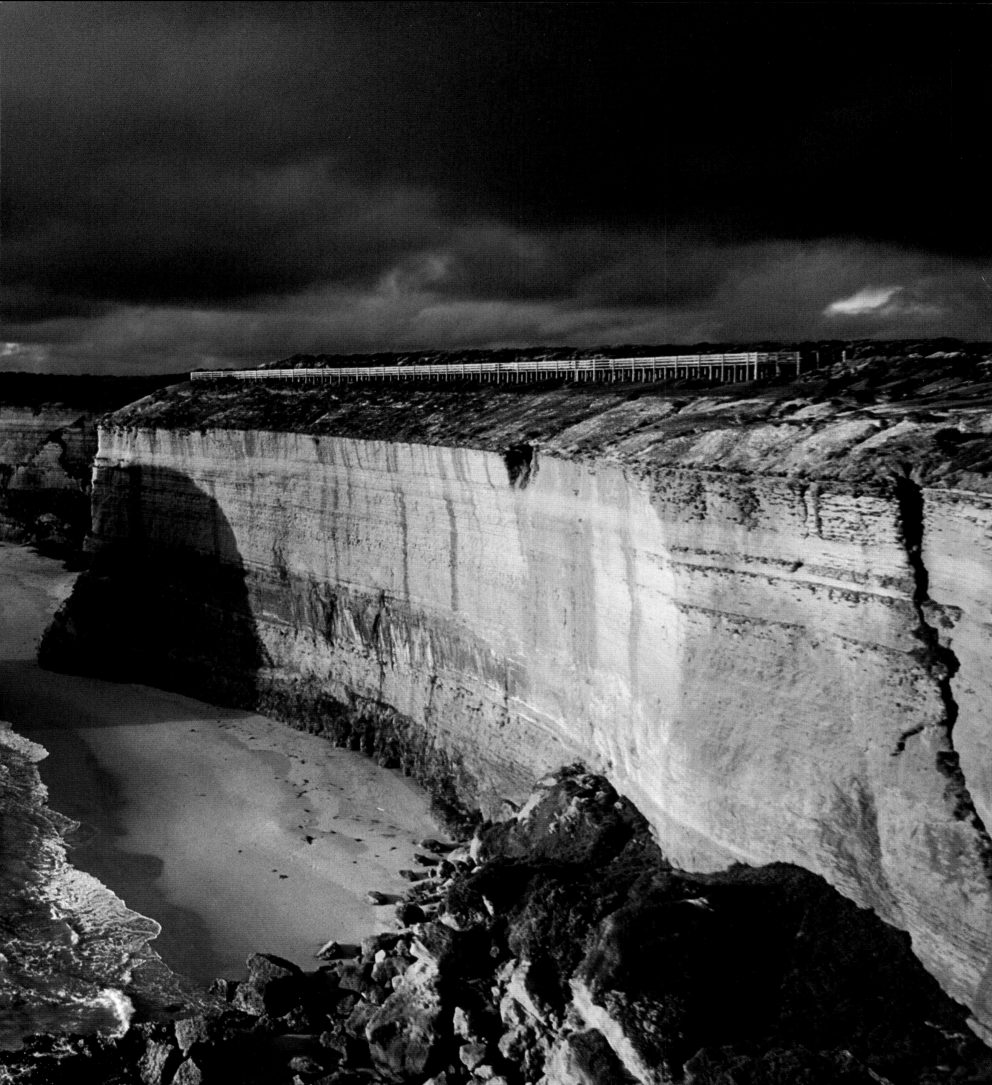

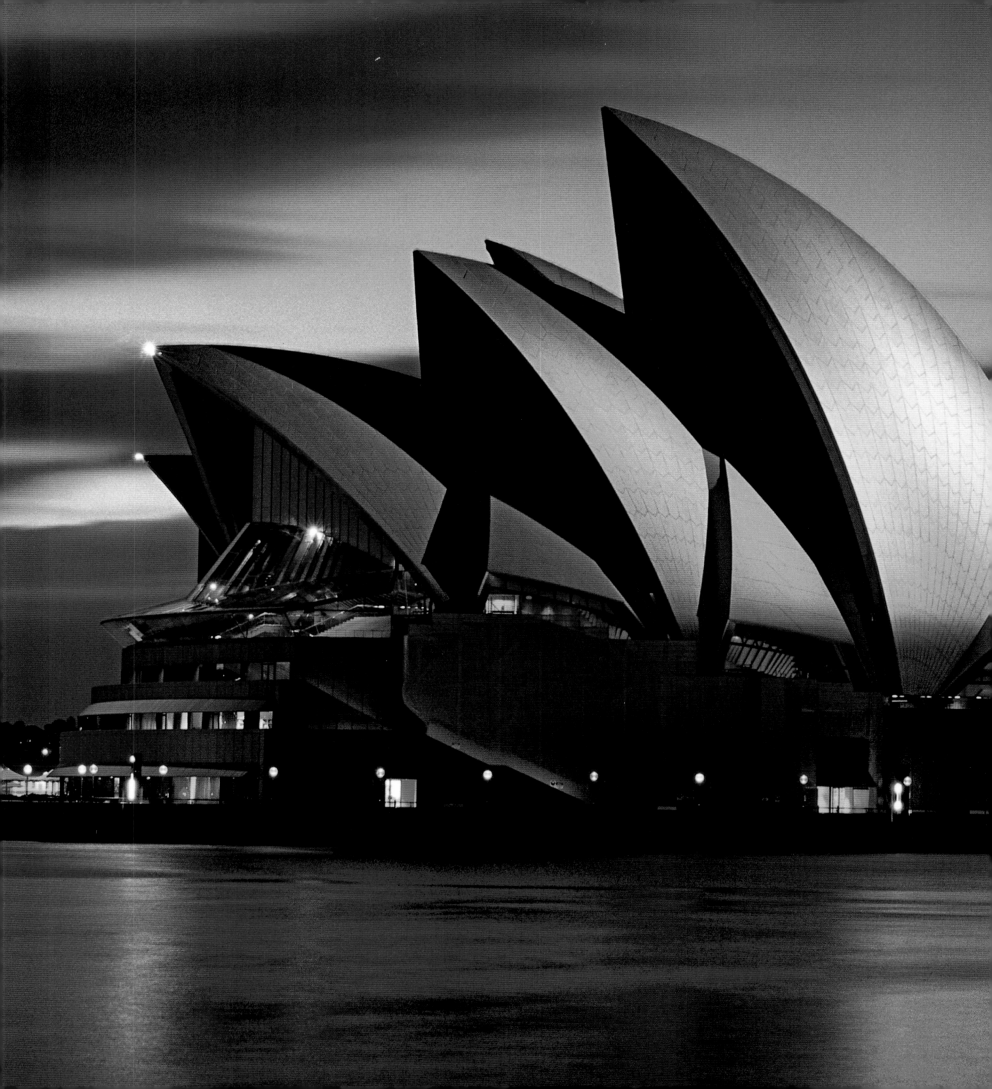

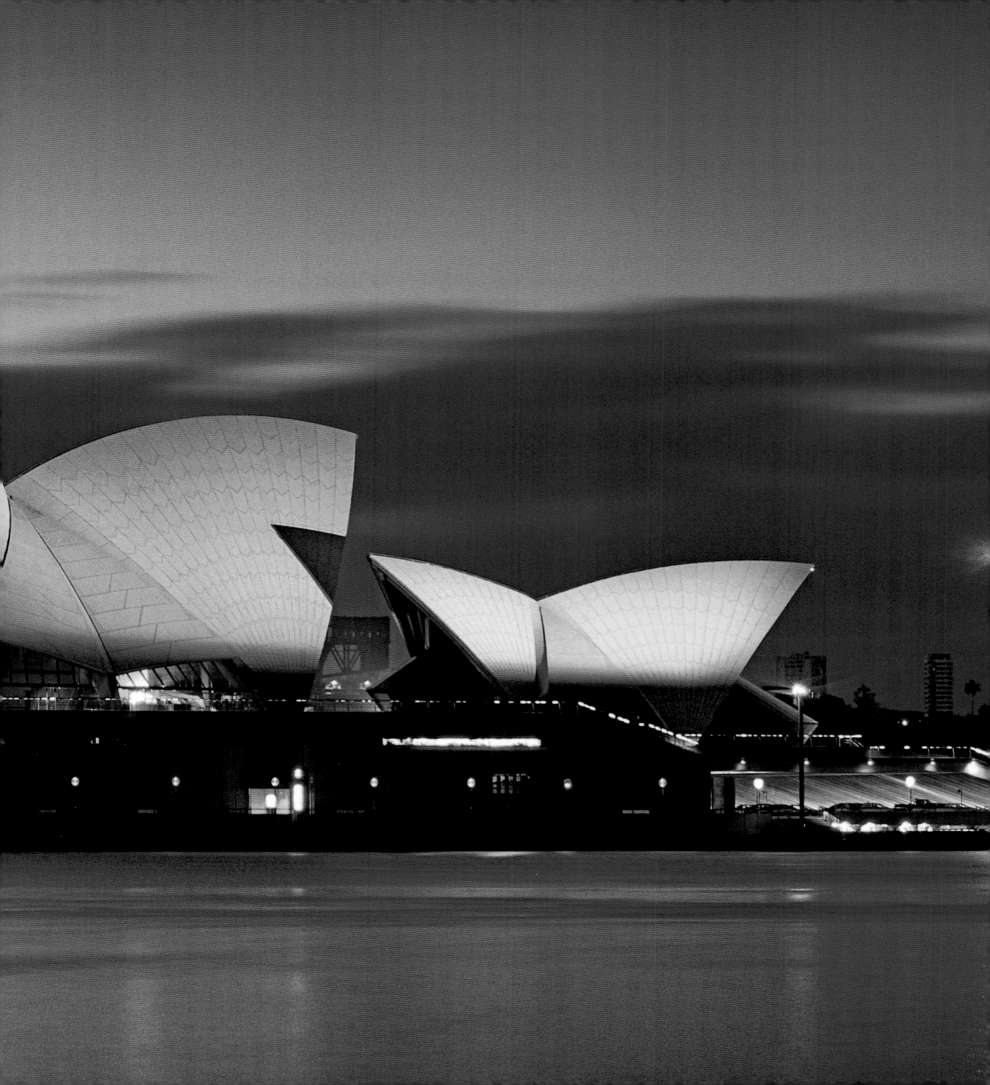

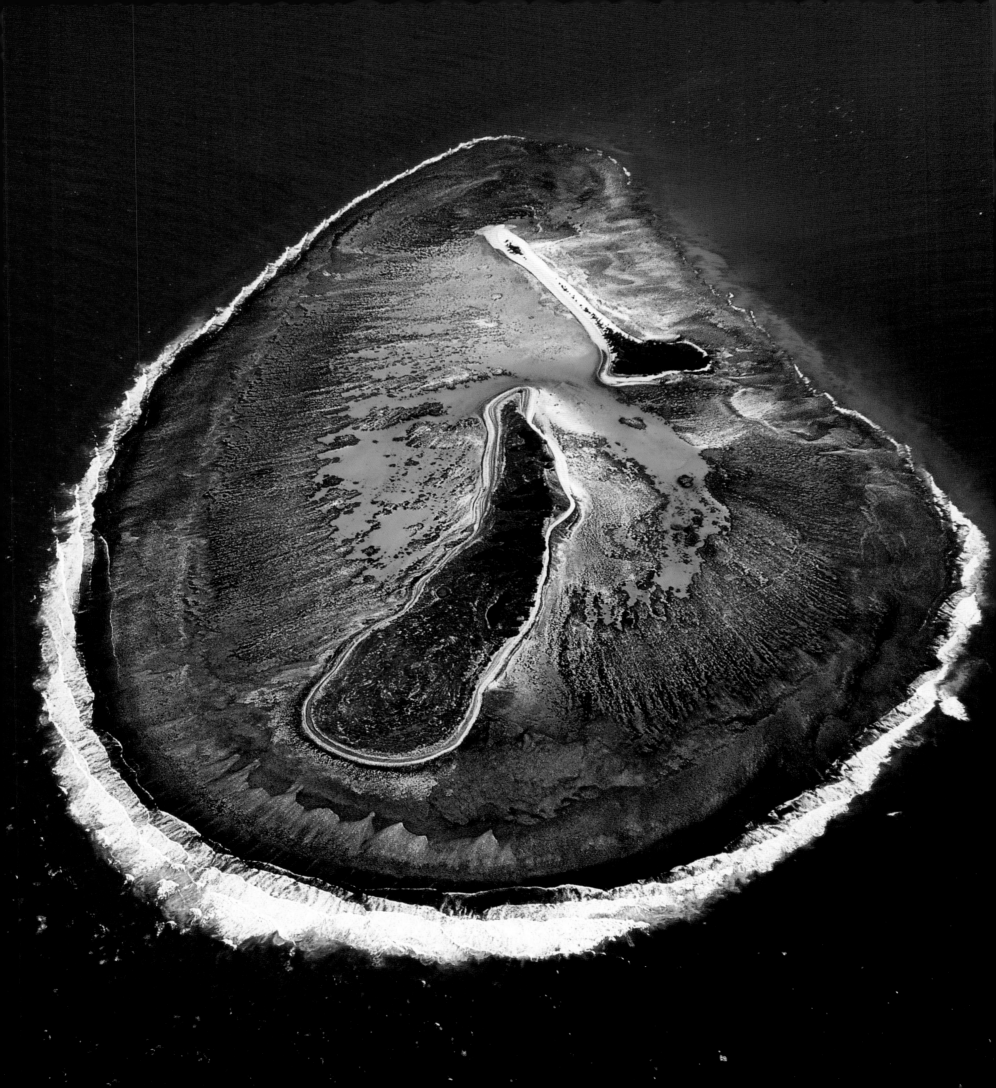

1 The typical painted face of this Aboriginal child in Arnhem Land, in the Northern Territory, heightens his intense and proud gaze.

2-3 The "Twelve Apostles," imposing rock stacks that emerge in the Port Campbell National Park, are one of the attractions of the Great Ocean Road.

4-5 Uluru, for millennia the heart of Aboriginal spiritual life, takes on a deep red hue at sunset, heightening its almost sacred atmosphere.

6-7 The unmistakable profile of Sydney's Opera House, the symbol of a country racing toward the future, stands out against the purple sky.

8 A coral atoll in the Capricorn Group, one of the many divers' paradises of the southern part of the Great Barrier Reef.

9 FROM LEFT TO RIGHT Koalas spend most of their time clinging to the branches of trees; the red rocks of Gantheaume Point, near Broome, stand out against the pure blue sky; motorists risk close encounters with the most unusual animals on the road.

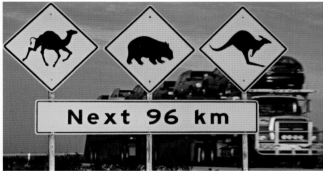

TEXT BY
ALESSANDRA MATTANZA

HISTORICAL INTRODUCTION
GIANNI GUADALUPI

EDITORIAL DIRECTOR
VALERIA MANFERTO DE FABIANIS

GRAPHIC DESIGN
CLARA ZANOTTI

EDITORIAL COORDINATION
FEDERICA ROMAGNOLI
GIADA FRANCIA

© 2006 White Star S.p.a.
Via Candido Sassone, 22/24
13100 Vercelli, Italy
www.whitestar.it

TRANSLATION: Sarah Ponting

ISBN 88-544-0126-9

Reprints: 1 2 3 4 5 6 10 09 08 07 06

Printed in China
Color separation by Fotomec, Turin

CONTENTS

INTRODUCTION

AN ISLAND, A CONTINENT

Australia is a magical place: an incredible and unique rainbow of colors set, like a precious stone, between land, sea and sky, which is capable of enchanting with its intense and unique light that evolves and changes from one moment to the next, running backward in time. This land is an expert hypnotist, which enchants with the mysterious forms of its magnificent monoliths – labyrinths of pure magnetic rock, between whose walls it is easy to lose sight of the boundary between past and present. It manages to bewitch with the magic of the clouds that race above the expanses of the ocean, lightly furrowing the Barrier Reef with turquoise shades and playing lightheartedly amid the thick tropical vegetation. The clouds chase each other, as soft as cotton balls caressed by the wind, between the naked shapes of the mountains, gorges and canyons. Other clouds are tinged with pink behind the outline of the Opera House, with its architectural sails, still sleeping in the torpor of the first light of morning, which wakes beautiful Sydney from her slumber.

Australia is the smallest continent and the largest island in the world; a many-sided kaleidoscope of emotions and sensations, dominated by a wild and powerful nature. It is as though Mother Nature had amused herself by remixing the colors on her palette in infinite variations to create a magnificent work of art, like a painter armed with brush and canvas and transported by a creative rapture.

The red of the earth becomes even more intense in the grains of dust, shading into the yellow, ocher and orange of the rock, breaking down into warm brown harmonies and merging in the soft fur of the kangaroos. The gorges of Uluru – the huge, supreme and spectral monolith that is the country's symbolic throbbing heart – triumph over all, while the disquieting Kata Tjuta rock domes that sternly stand guard amid the sand of the desert delineate the peaks of the Olgas.

The blue of the sea follows the light of the sun and the shadows of the clouds, shading into a thousand hues among the chain of patterns formed by the reef. It envelops the forms of lush tropical islands, cloaking the coast of the little atolls lost in the vastness of the Pacific; solitary scraps of land among the mosaics of the coral reefs. It laps the beaches of the Indian Ocean, which form crescents of powder-fine white sand. It caresses the seals of Kangaroo Island that dance happily and noisily among the waves, as light and swift as ballerinas. It follows spectacularly beautiful coasts, framed by pretty fishing ports, bushes and wildflowers, sculptures and rock stacks, such as the Twelve Apostles – imposing rock sentinels that magically emerge from the waters near Port Campbell.

The green of the forest wraps the Queensland mountains in an intricate cloak, clothing the gum trees in emerald green leaves that reveal the inquisitive faces of koalas. It winds its way over

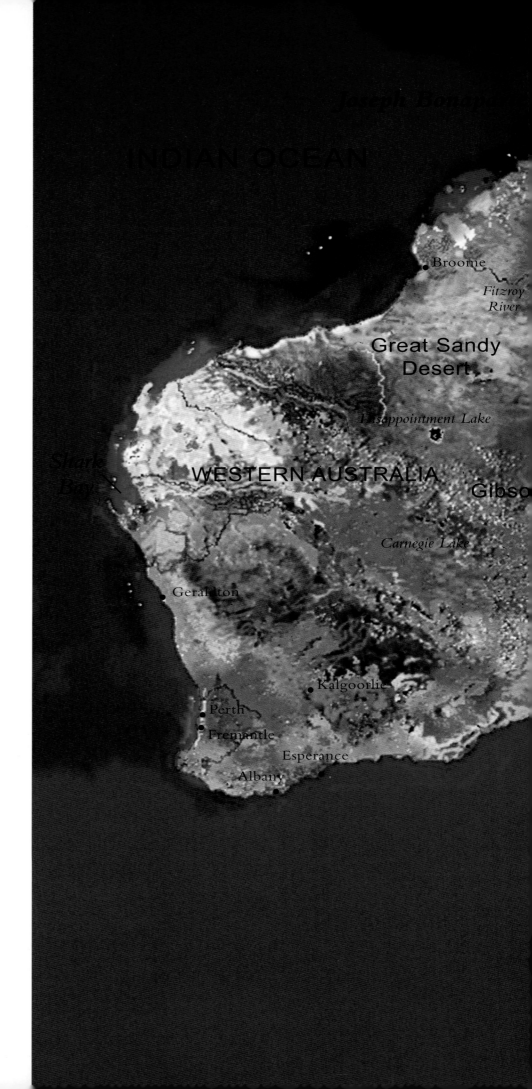

the rock of Kakadu National Park, an enchanted web of marshes, waterfalls and lakes that in the dry season become billabongs – waterholes covered with a blanket of water lilies that are populated by a myriad of birds and terrifying crocodiles.

Australia is a land of contrasts, with which it is easy to fall in love, but that is difficult to conquer. It entices the visitor with its splendid young cities with their outdoor life, brimming over with joie de vivre, edged with heavenly beaches and studded with a wealth of art and futuristic architecture. It charms with the warmth and generosity of its people – multiethnic faces and free spirits with the hearts of pioneers. It disturbs with the vastness of its desolate bush and the desperation of the deserts of the Outback: the last frontier, where the horizon fades into a distant never-ending line.

Australia is an intense place, which penetrates the soul. It is a land that helps answer a thousand questions, but at the same time raises many more. Australia is an extraordinary adventure, which it is impossible to forget. It is a spiritual journey that perhaps only the Aborigines manage to comprehend in full.

14-15 Flocks of birds fly over the Magela Wetlands in Kakadu National Park during the rainy season, offering a truly extraordinary spectacle.

16-17 The Great Barrier Reef, a huge silver swirl in the turquoise Pacific Ocean, snakes along the coast for over 1200 miles.

18-19 The huge, unmistakable form of a great white shark (Carcharodon carcharias), a dangerous inhabitant of the Australian seas, looms menacingly, its wide dorsal fin reflected just beneath the surface of the water.

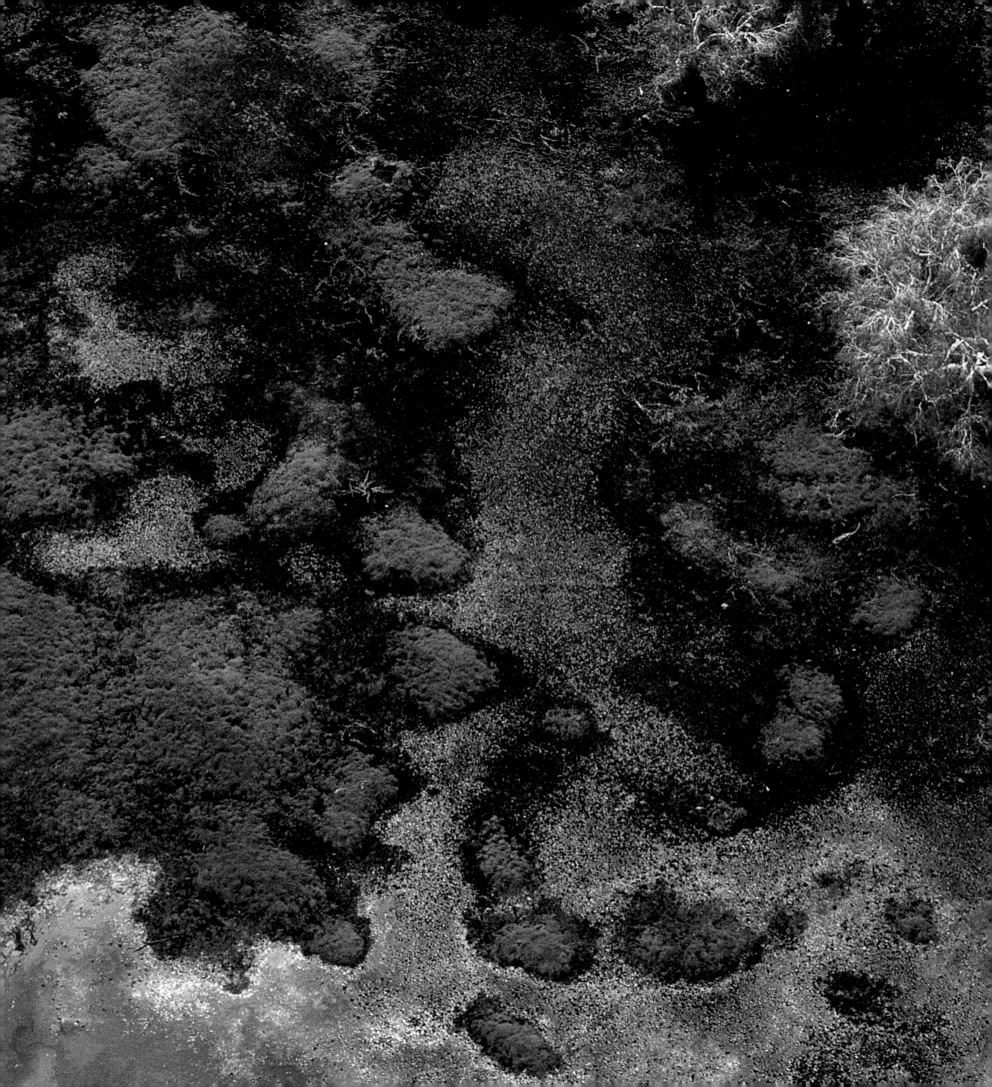

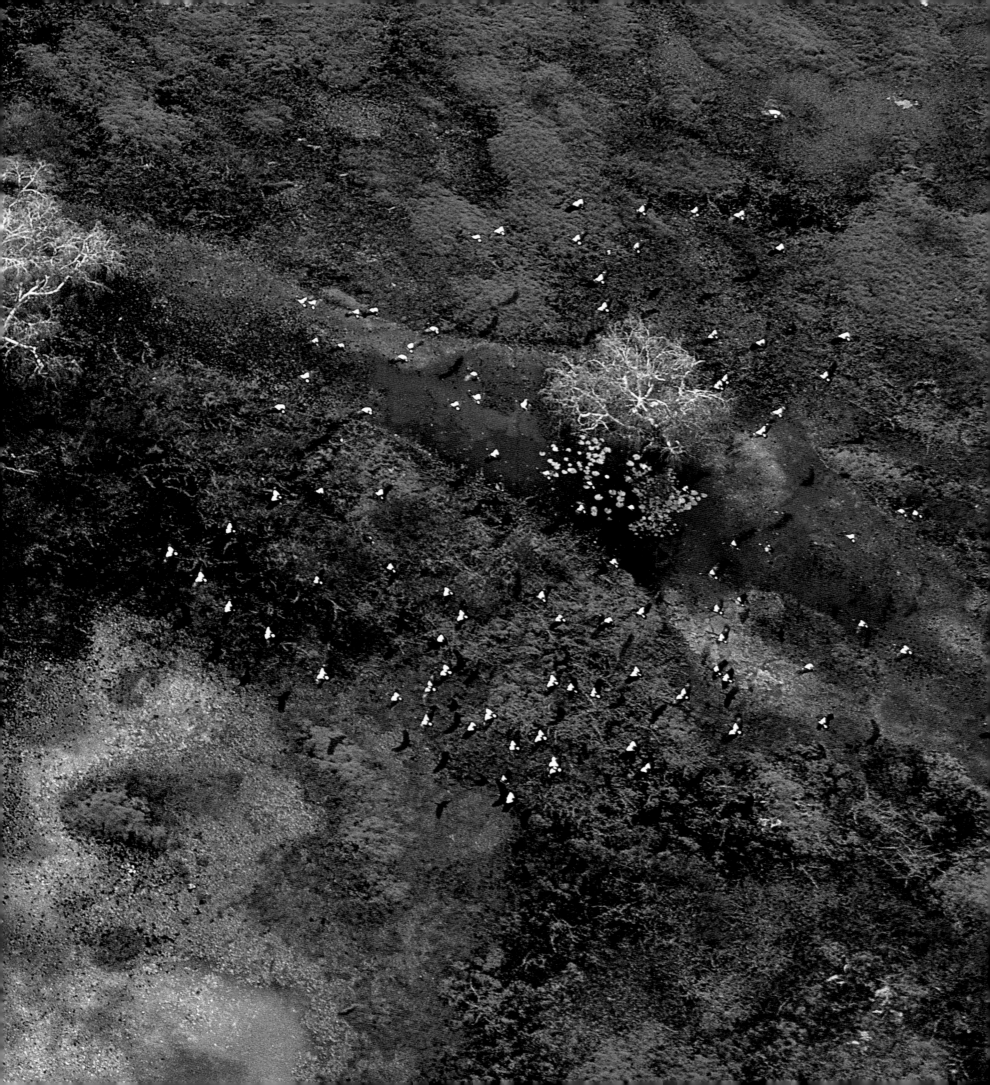

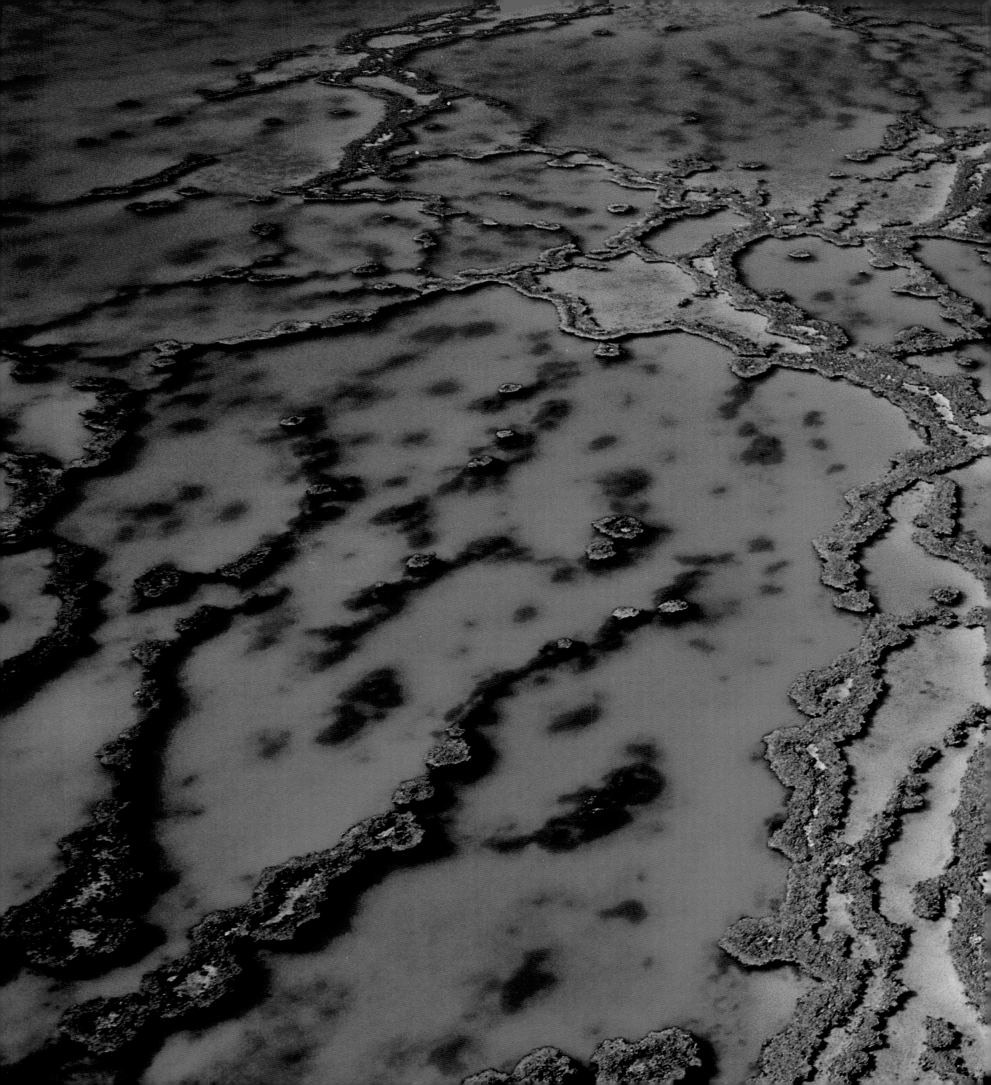

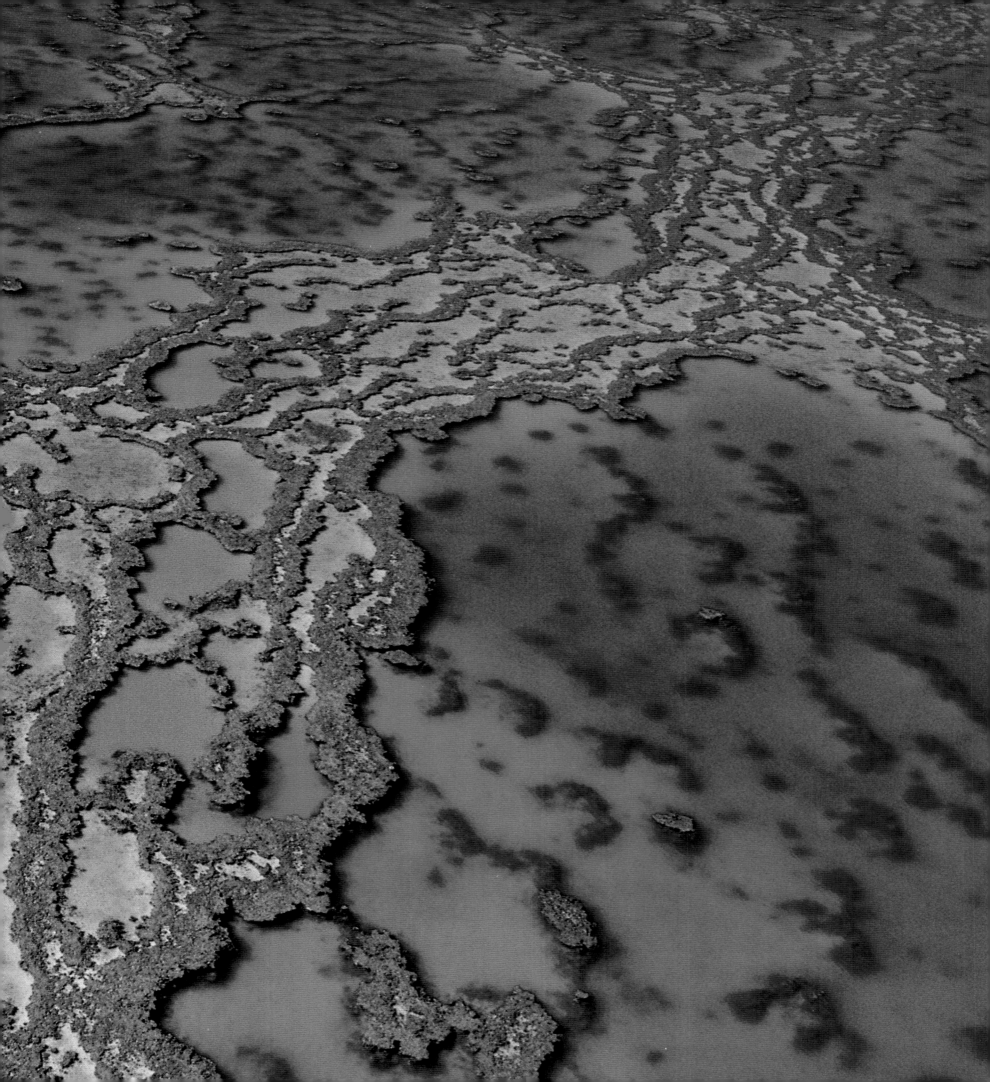

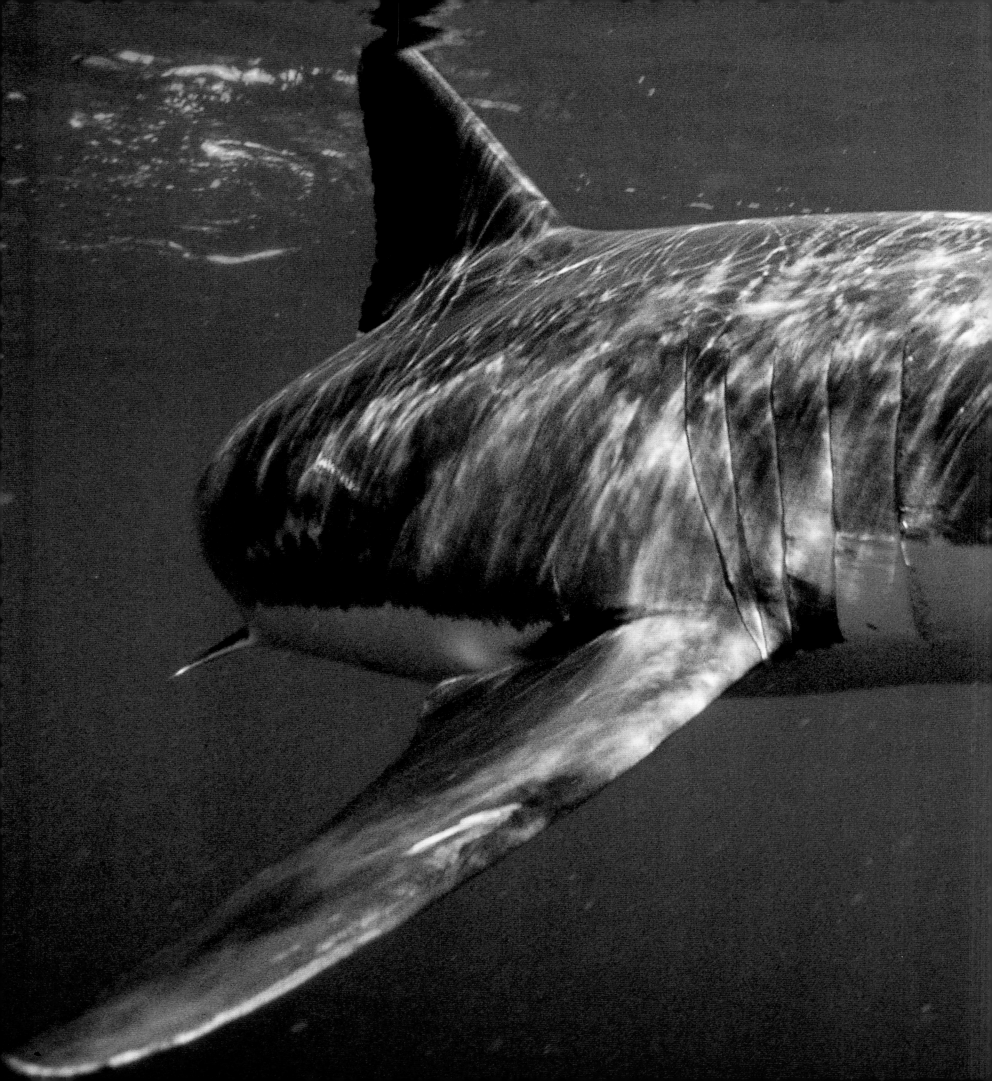

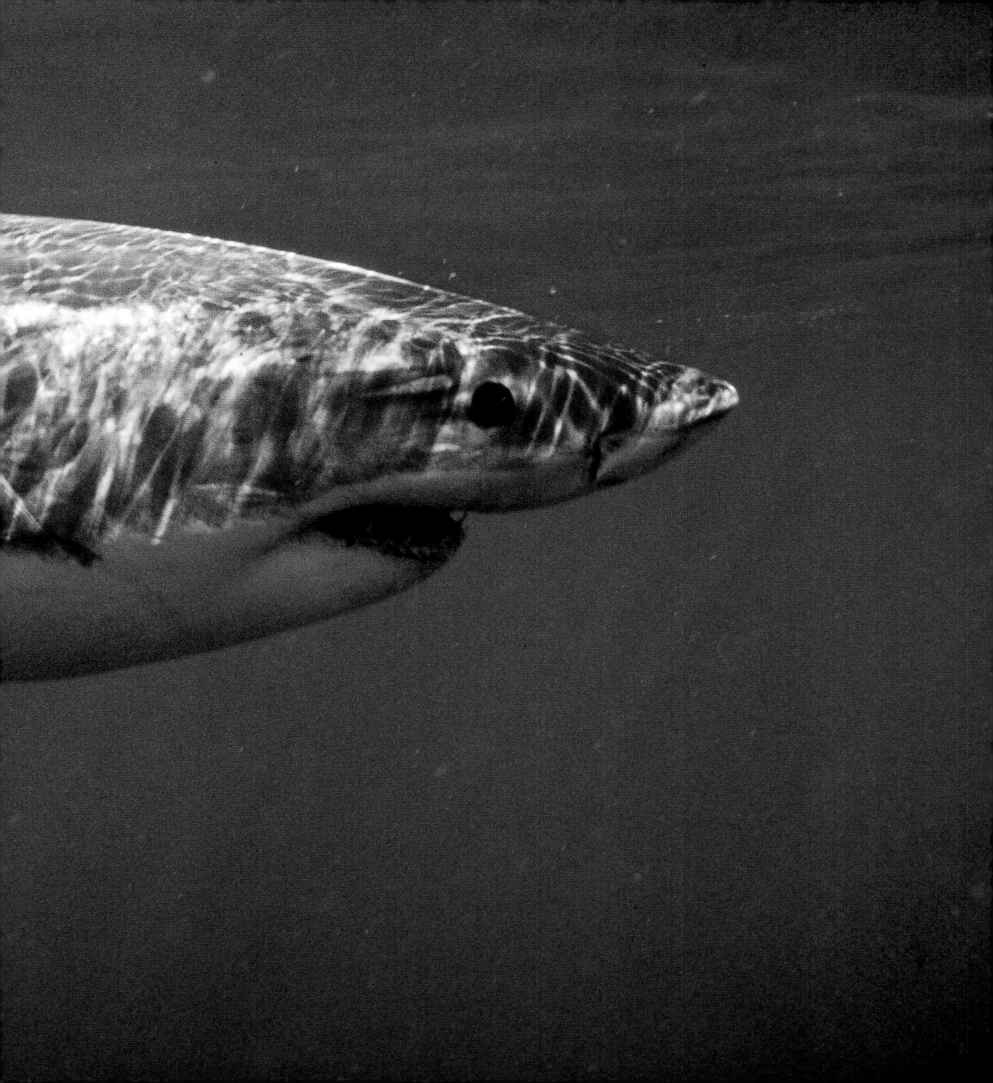

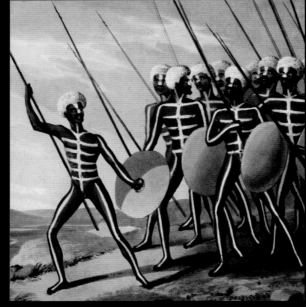

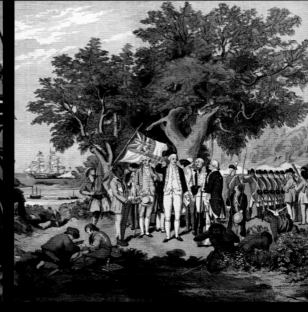

HISTORY IN THE ANTIPODES

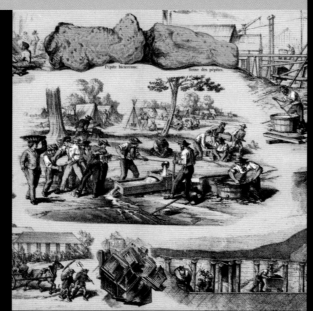

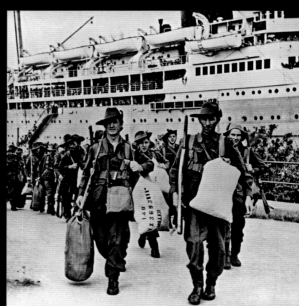

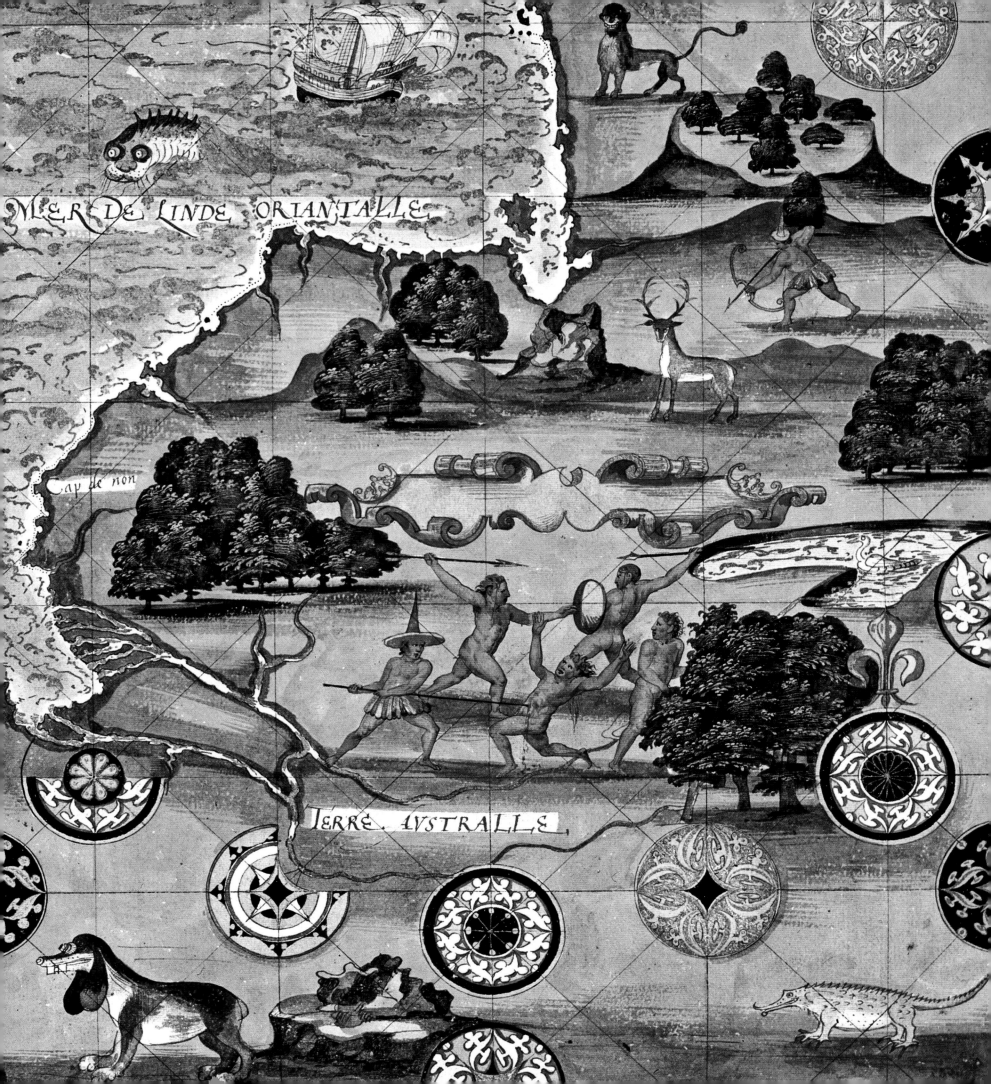

MER DE LINDE ORIANTALLE

Cap de non

TERRE AVSTRALLE

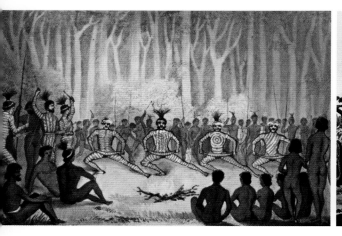

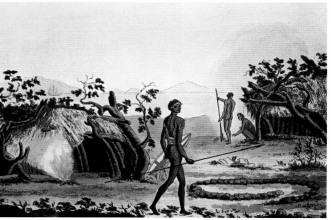

IN THE LAND OF THE DRAGONS

Australia was a fortunate land prior to the arrival of the white man. This island the size of Europe was inhabited by small groups of people who lived such simple lives that only oral traditions – one of the most elementary form of chronicling – existed, while elsewhere in the world empires had been waxing and waning for centuries and millennia. They were hunters and gathers who simply moved on when the fruits of a wood were finished, wild game became scarce or a river yielded few fish, for there was no lack of space. And if two groups happened to end up in the same area, a simple skirmish with sticks and stones would settle which had to leave. The wheel and pottery were unknown to the Aborigines, but they conceived the most genial throwing weapon – the boomerang, whose smooth clean lines and marvelous simplicity are capable of arousing the envy of many a designer. They conversed with deities as modest as themselves: sylvan spirits that had no need for temples, but inhabited a rock, bush or spring; evanescent,

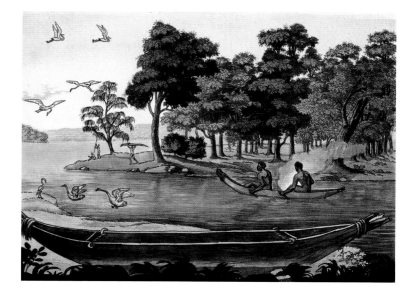

impalpable lesser gods that manifested themselves sparingly, limiting themselves to shining in the moonlight instead of consigning tablets of the Law or dictating revelations; minor deities that were unable to protect them from the arrogant invaders convinced that a greater god had granted the entire legacy of Adam to them alone.

Indeed, that secluded world was inexorably condemned to death on the day, in September 1606, in which a Spanish ship sailing from Peru under the command of Luis de Torres, ventured into the treacherous waters that divide New Guinea from the Cape York Peninsula, discovering "very large islands inhabited by fat and naked dark-skinned men," which were actually the farthest outreaches of the southern continent. The Dutch may have already landed here, in search of water and wood. They called it the Land of Dragons, but were not interested in it, for the desolate country, with its miserable natives, had nothing that could stimulate their commercial curiosity.

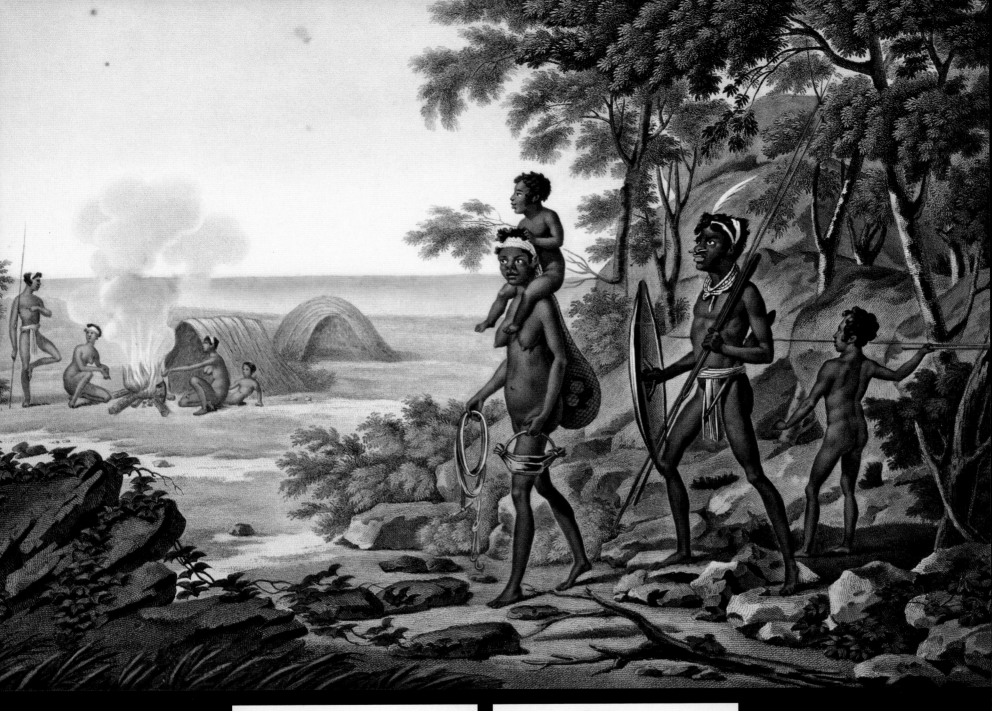
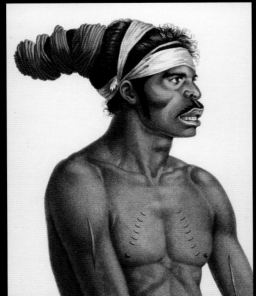
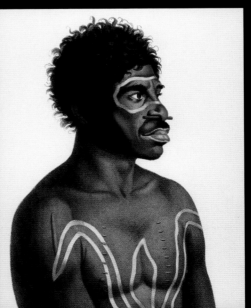

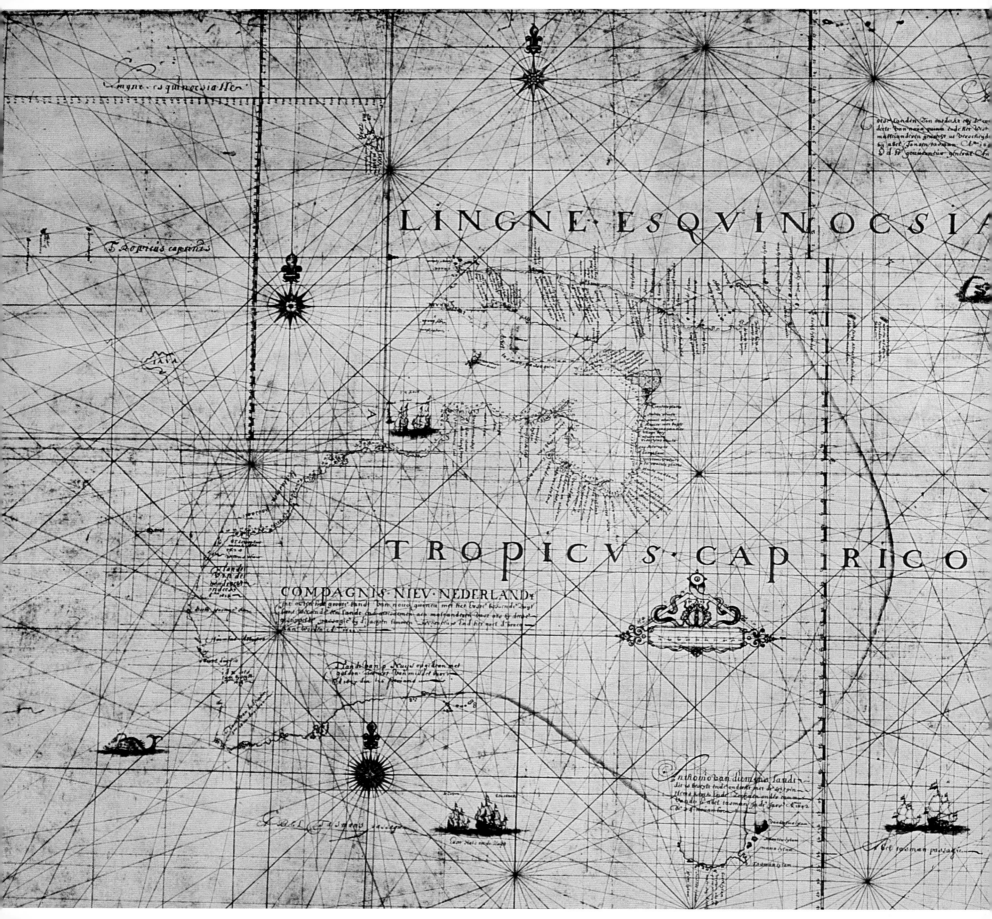

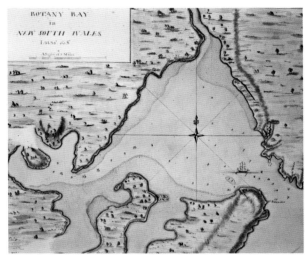

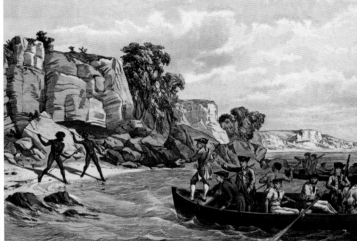

According to the geographic conceptions of the age, a southern land had to exist farther south; perhaps a good market, with rich supplies of cinnamon, musk, pepper and rubies. An expedition organized by the governor of the Dutch East Indies and entrusted to the skillful leadership of the navigator Abel Tasman and the pilot Franz Visscher, departed from the capital Batavia. The two ships sailed too far south, from west to east, but in November 1642 finally sighted a great land: the island that is now known as Tasmania. A year later Tasman navigated along the northern coast of Australia, penetrating the Gulf of Carpentaria, and various Dutch sailors subsequently identified stretches of the continent that, between 1665 and the 19th century, would be known as New Holland.

The first real explorer of the southern land was a British buccaneer, William Dampier, who was abandoned there by his crew with a young cabin boy in 1668. After an eventful voyage, he managed to reach the Dutch East Indies aboard a lifeboat and subsequently published the story of his adventures, which earned him a commission in the British Navy and the command of an expedition to the South Seas, to explore the country that even he had described as inhabited by "the most wretched people in the world." He visited the western coast around Shark Bay for over four months, before sailing back to England.

The mysterious continent subsequently remained undisturbed for almost a century, until a shark-infested shallow inlet of the eastern coast baptized Botany Bay, witnessed the arrival on 29 April 1770 of the *Endeavour,* captained by James Cook, who spent years systematically exploring the coast inside the Great Barrier Reef. Unlike his predecessors, Cook refused to be discouraged by the desolate appearance of the land that he was examining: "We believe that everything that nature has given this land develops beyond measure here," he wrote.

"Almost all types of imported cereals, fruit and tubers will be able to flourish and will be cultivated with due care. And nourishment for far more livestock will never be in short supply, in any season."

In actuality, it was not the prospects of agricultural and pastoral development that attracted the attention of the British government to the land that by that time was known as Australia. It was instead the need after the Revolutionary War to find a new penal colony for the transportation of convicts, whose numbers exceeded the capacity of the British prisons and could no longer be sent to the hitherto traditional deportation destinations of Virginia and Maryland. During the late 18th century, British laws were exceptionally severe: the theft of goods worth just two pounds was punishable by hanging, while deportation was inflicted for far lesser crimes. The jails and prison ships were extremely overcrowded and the government did not know what to do with all those "dregs of society," most of whom were not even criminals, but poverty-stricken individuals guilty of having tried to ease their hunger. Some suggested dumping them on the icy coasts of Greenland, while others proposed islands inhabited by cannibals, in order that they be devoured as just retribution for their crimes. Finally, the more moderate suggestion of sending them as colonists to that land that had so favorably impressed Captain Cook prevailed.

Consequently, in January 1788, Governor Arthur Phillip's First Fleet set ashore the initial contingent of 757 convicts, some of whom were accompanied by their families. After a terrible eight-month voyage on the high seas, the convicts landed at Port Jackson, in the roadstead that was to be named after the 1st Viscount Sydney, then British Home and Colonial Secretary. The expedition had been an extremely expensive venture (one captain wrote that the government would have saved money by keeping the convicts in Britain and "perhaps providing them with fine wines and robes of crimson and gold") and was organized very badly: there were no nails or needles, no women's clothes, no ammunition for the muskets, no carpenters, farmers or builders, and even the convicts' documents had been left behind in Britain, and consequently nobody knew for which crimes they had been condemned. Dressed in the remnants of old sails, they wandered like sleepwalkers in an alien world. Some fled inland, in the conviction that China lay beyond the mountains, and died of hunger or were killed by the Aborigines. Only the iron will of Governor Phillip managed to keep the little colony alive, although many of his officers begged him to relinquish what appeared to be a desperate endeavor. However, the governor did not give in and the situation began to improve – very slowly – with the arrival of the successive fleets and the extension of the cultivated land.

The turning point in the precarious southern colony's destiny was marked by the arrival of a shipload of animals, not men. In 1797 Captain John MacArthur introduced merino sheep and in 1803 the first cargo of wool left Port Jackson bound for London: Australia had finally produced goods to export, precisely at the time at which the homeland, engaged in the Napoleonic Wars, needed them most. The ever-growing demand of British industry stimulated great growth in the population of merino sheep, whose numbers soared from approximately 290,000 in 1821 to 16 million in 1851, and exports of wool to Britain rocketed from 175,000 pounds in 1821 to 39 million pounds in 1850. The first victims of the indiscriminate expansion of the farms were of course the Aborigines, who were driven inland and often exterminated without qualms.

The sheep farmers were not the only members of the colony to prosper. The officers of the New South Wales Corp, trained in Britain to guard the convicts, were granted land, which they farmed with the labor of the prisoners themselves, exploiting them like slaves and monopolizing trade, especially of liquor. This powerful faction managed to thwart all the efforts of the governors to regularize the situation by granting land to the colonists and ex-convicts who had served their sentence and could thus become free farmers. This was the period of the so-called "squattocracy," i.e., the absolute superiority of the "squatters" – owners of huge flocks of sheep, who were in favor of deportation to exploit the forced labor of the convicts and against the granting of land to immigrants.

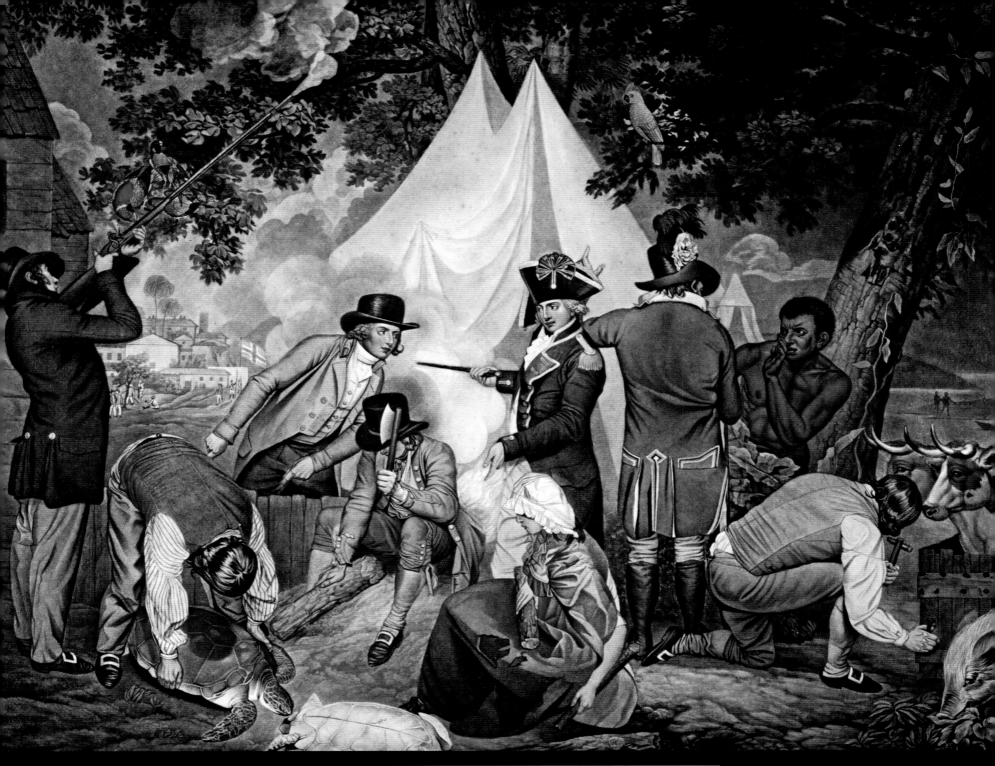

GOVERNOR DAVEY'S
PROCLAMATION
TO THE ABORIGINES
1816.

"Why Massa Gubernor", said Black Jack – "You Proclamation all gammon"
"How Blackfellow read him eh? He no learn him read book."
"Read that then" said the Governor, pointing to a picture

Nonetheless, it became increasingly clear that the southern colony could not prosper on servile labor and that only free immigration could ensure its development. In 1840 the British government finally decided to stop deporting convicts to New South Wales, which was proclaimed an independent colony the following year. A total of 88,250 convicts had been sent to Australia since 1788, including 11,638 women. The years between 1830 and 1850 were those of systematic colonization, with the sale of land and rent of pastures to immigrants. The country seemed destined for constant and regular development until an unexpected event heralded a sensational new economic phase: gold was discovered near Bathurst on 3 April 1851. The resulting gold rush was as overwhelming as its Californian counterpart. Towns and villages were abandoned and fields and herds of cattle deserted, as everyone flocked to the goldfields hoping to make their fortune. In June 1852, 59 ships anchored in the port of Melbourne lost their crews – not one sailor remained aboard, as every single one had left for the camps of the diggers, where a fabulous story circulated about a man known as Kerr, who had displayed a nugget weighing around a hundredweight in the streets of Bathurst. In 1852-1853 alone over 100,000 foreign immigrants arrived and the population of Victoria increased from 70,000 to 540,000 between 1850 and 1860.

The gold rush, with its inevitable accompaniment of unruly adventurers, naturally caused various problems of law and order, which the inefficient and corrupt Border Police were unable to control. It marked the end of the "squattocracy," although sheep farming remained a fundamental economic activity. However, the Australian economy started to diversify and expand. Following the discovery of gold, mineral prospecting was intensified, leading to the exploitation of tin, iron, zinc, coal, lead and silver deposits, while the need to feed a constantly growing population stimulated the development of agriculture and cattle farming. Tropical crops, such as sugar cane, were introduced to North Queensland, due to its suitable climate, and were cultivated by the forced labor of enslaved Melanesians and Polynesians. "Piracy, kidnapping and killing were common methods of recruiting these workers, whose mortality rate was four times higher than that of the white population." In the meantime, the decline of the Aborigines continued inexorably: in 1876 the last true Tasmanian Aborigine died, while a year later the white population reached 2 million (compared to 1.5 million in 1858) and topped 3 million in 1889.

Crossing the Terrick-Terrick Plains Aug. 29 - ʒ Becker 60

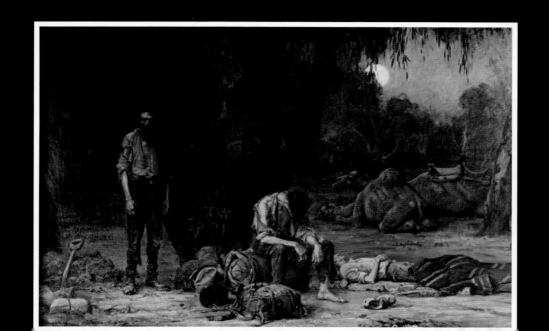

Exploration of the immense, empty interior of the continent commenced in the 1840s and was completed over the subsequent 30 years, accompanied by a high toll of tragedies. While Sturt and Eyre reached Lake Victoria in 1844, three years later Leichardt died in the attempt to cross the continent from east to west, and the same fate befell Kennedy

in the tropical forest of Queensland in 1848. Similarly, Stuart crossed Australia from south to north in 1862, although Burke and Wills died of starvation while attempting the same feat two years earlier. Meanwhile the land that had been founded as a penal colony – a cesspit for the outcasts of the homeland – had become one of the British possessions most open to progress and ideas of social justice.

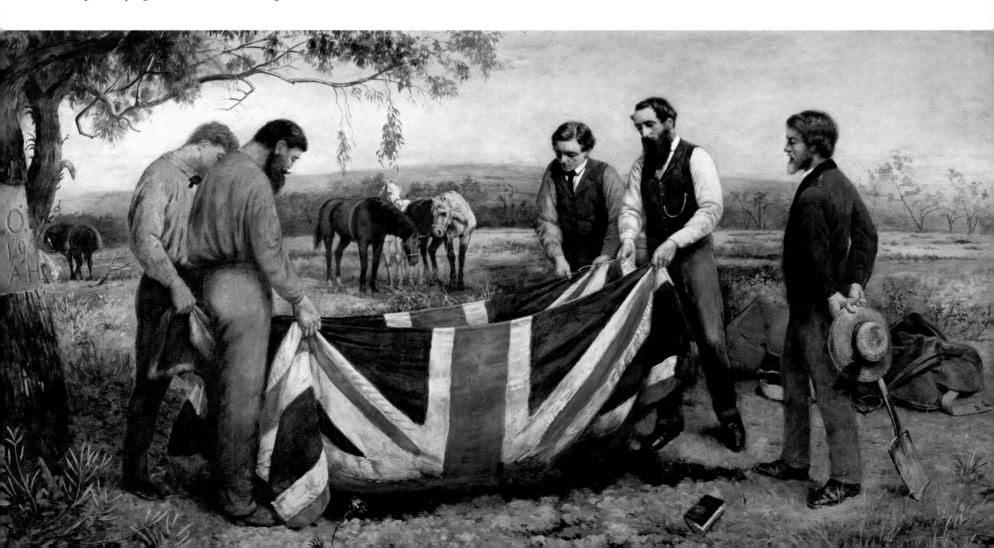

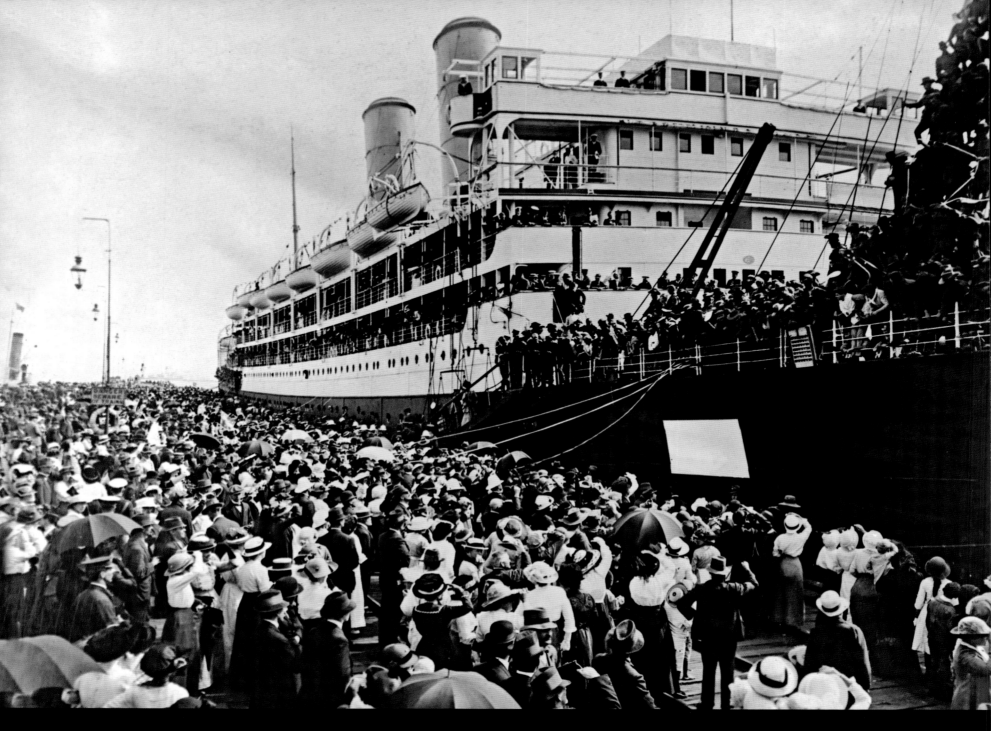
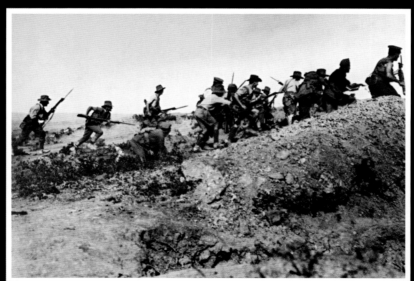

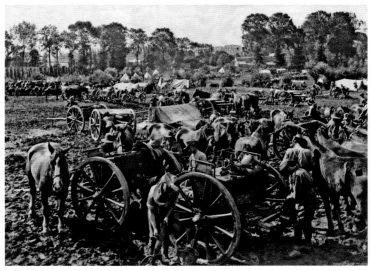

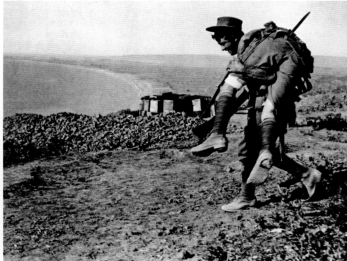

32 TOP AUSTRALIA'S PARTICIPATION IN WORLD WAR I WAS NUMERICALLY IMPORTANT. THE PHOTO SHOWS A CROWD OF FRIENDS AND RELATIVES GATHERED ON A SYDNEY QUAY TO WAVE OFF THE SOLDIERS EMBARKED ON A SHIP ABOUT TO SAIL FOR EUROPE.

32 BOTTOM AUSTRALIANS AND NEW ZEALANDERS FORMED THE CORPS KNOWN AS ANZAC. IT SERVED IN THE 1915 DARDANELLES CAMPAIGN, INTENDED TO CONQUER CONSTANTINOPLE BUT ENDING IN A COSTLY RETREAT.

33 TOP LEFT AND RIGHT THE AUSTRALIANS NOT ONLY FOUGHT AT GALLIPOLI (RIGHT: A SOLDIER ACCOMPANIES A COMRADE-IN-ARMS WOUNDED AT THE FRONT TO A FIELD HOSPITAL), BUT ALSO IN FRANCE, WHERE THEIR FIVE DIVISIONS REINFORCED BRITISH LINES.
PHOTO LEFT: THE CAMP OF A HORSE-DRAWN BATTERY.

33 BOTTOM THE DEFEAT OF GERMANY, ENTHUSIASTICALLY CELEBRATED BY THE SYDNEY CROWD SHOWN IN THIS PHOTO, EARNED AUSTRALIA THE MANDATE TO GOVERN THE FORMER GERMAN COLONY OF NEW GUINEA.

In 1855 Sydney's stonecutters became the first in the world to obtain an eight-hour working day, while universal male suffrage with secret voting was introduced in Victoria and South Australia in 1856-57. The Labour Party was founded in Sydney in 1891 and Australia's first Labour government took office in Queensland nine years later, while in South Australia women achieved the right to vote in 1894. The Federation of Australian States was established in 1901 and the first federal parliament was inaugurated in Melbourne, although the designated capital was Canberra, which was only founded in 1913. The Labour Party's proclaimed aim was to construct a "workers' paradise" in the brand-new continent, improving the living conditions of the workers and introducing social reforms such as free education and health care. However, the increasing affluence of the country also aroused the wish to defend it from "the uninvited guests," i.e., immigrants of Asian or Oceanian origin. This gave

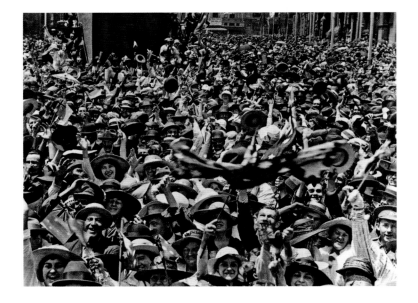

rise to the White Australia policy, aimed at excluding the colored "undesirables" (but also certain whites, such as Italians, who according to one Labour politician could not "be considered civil in the true sense of the word, for they always have a knife in their hand and a razor in their pocket"). The Chinese, who had arrived in great numbers during the Gold Rush, were driven out. In 1855 the government of Victoria had already imposed an entry tax of £10, in 1878 the Queensland shipping union imposed the dismissal of all Chinese sailors, and the Polynesian and Melanesian plantation workers were subsequently repatriated.

After the outbreak of World War I in 1914, Australia made a considerable contribution to the British Empire's war effort, forming the Australian and New Zealand Army Corps (ANZAC) together with New Zealand, which landed in Gallipoli in a vain attempt to take possession of the Turkish capital, but was forced to retreat following eight months of bloody fighting.

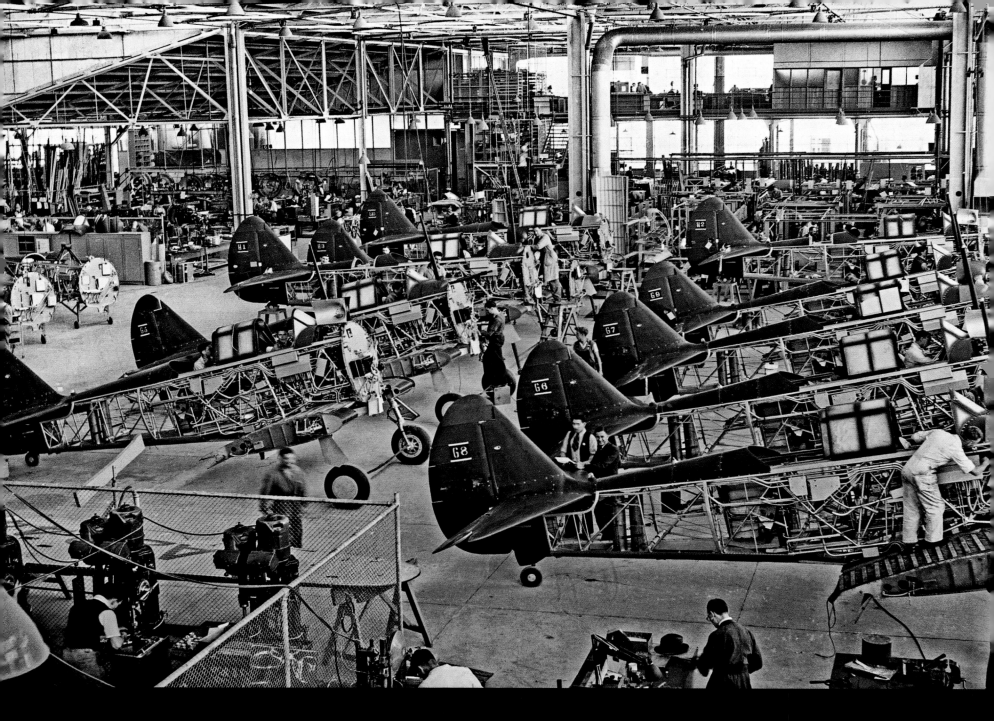

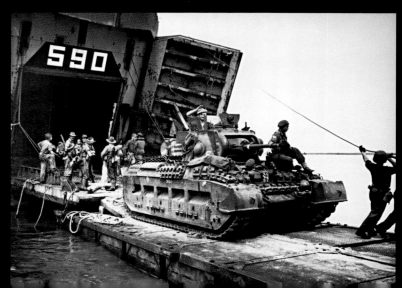

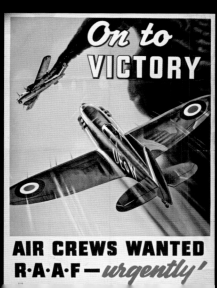

On to VICTORY

AIR CREWS WANTED
R·A·A·F — *urgently'*

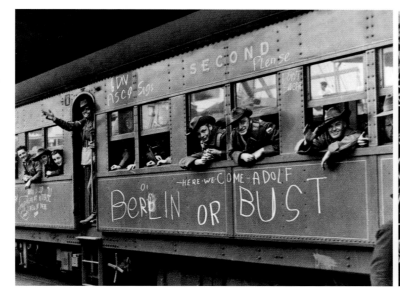

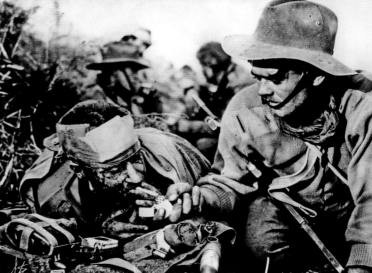

34 TOP WORLD WAR II TRIGGERED RAPID CHANGE IN AUSTRALIAN INDUSTRY. THE PHOTOGRAPH SHOWS A FACTORY THAT BUILT AIRCRAFT DESTINED FOR THE ROYAL AUSTRALIAN AIR FORCE.

34 BOTTOM LEFT AUSTRALIAN TROOPS FOUGHT ALONGSIDE THE AMERICANS IN THE PACIFIC: HERE AN ARMORED UNIT IS SHOWN LANDING ON THE ISLAND OF TARAKAN, OFF THE COAST OF BORNEO, IN 1945.

34 BOTTOM RIGHT THE AUSTRALIANS DID NOT WAIT FOR JAPAN TO ENTER THE WAR TO SIDE WITH BRITAIN, BUT IMMEDIATELY JOINED FORCES WITH THEIR HOMELAND AGAINST NAZI GERMANY. THIS POSTER INVITES AUSTRALIANS TO ENLIST IN THE RAAF TO FIGHT THE GERMANS.

35 LEFT AUSTRALIAN TROOPS WERE DEPLOYED ON THE LIBYAN FRONT AGAINST ROMMEL'S AFRIKA KORPS IN 1941. THIS PHOTO SHOWS A GROUP OF SOLDIERS LEAVING A TRAINING CENTER IN THE INTERIOR, HEADED FOR SYDNEY, WHERE THEY WOULD SET SAIL FOR EGYPT.

35 RIGHT AUSTRALIAN CONTINGENTS PARTICIPATED IN THE 1950 KOREAN WAR AND LATER IN THE VIETNAM WAR. THIS PHOTO SHOWS A WOUNDED SOLDIER FINDING SOLACE IN A CIGARETTE DURING A PAUSE IN THE FIERCE FIGHTING IN THE KOREAN HILLS.

In 1918 five Australian divisions were deployed in the front-line in France. In return for its contribution to Allied victory, Australia – now a member of the League of Nations – was granted the mandate to govern the former German colony of New Guinea in 1921.

The war had brought about the birth and rapid expansion of the engineering industry, which paradoxically was boosted by the serious economic crisis of 1929, because the drop in prices and exports of raw materials stimulated the development of the manufacturing sector in order to replace imported products with domestic ones. However, it was World War II, with the advance of the Japanese and what appeared to be the imminent danger of invasion (although there was never actually any real threat) that created an "industrial mentality" in Australia. The country was required to provide large quantities of supplies to the American, New Zealand and Australian troops and to manufacture ammunition, aircraft, machine tools and

weapons. In the meantime, the soldiers of the Dominion not only fought the Japanese in the Pacific islands, but also the Italian and German forces in Africa (at El Alamein) and later in Europe.

Following the war, the Labour Party continued its policy of social improvement, introducing the 40-hour working week in New South Wales in 1947, which was extended to the rest of the country in 1948, while the Aborigines were finally granted the right to vote in 1949. However, during the same year, the long period of Labour rule came to an end with a resounding electoral defeat. A year later Australia participated in the Korean War alongside the United States and also sided with America in the successive Vietnam War, always with the aim of asserting and consolidating "western" and "white civilization" against the much-feared "Asian" expansion, which had become tinged with red following the victory of the Communist Revolution in China.

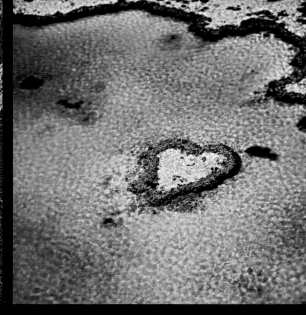

MAGICALNATURE

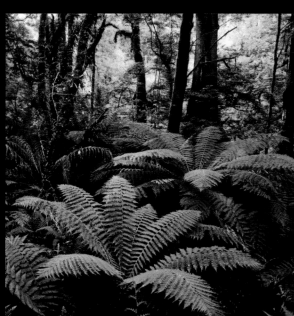

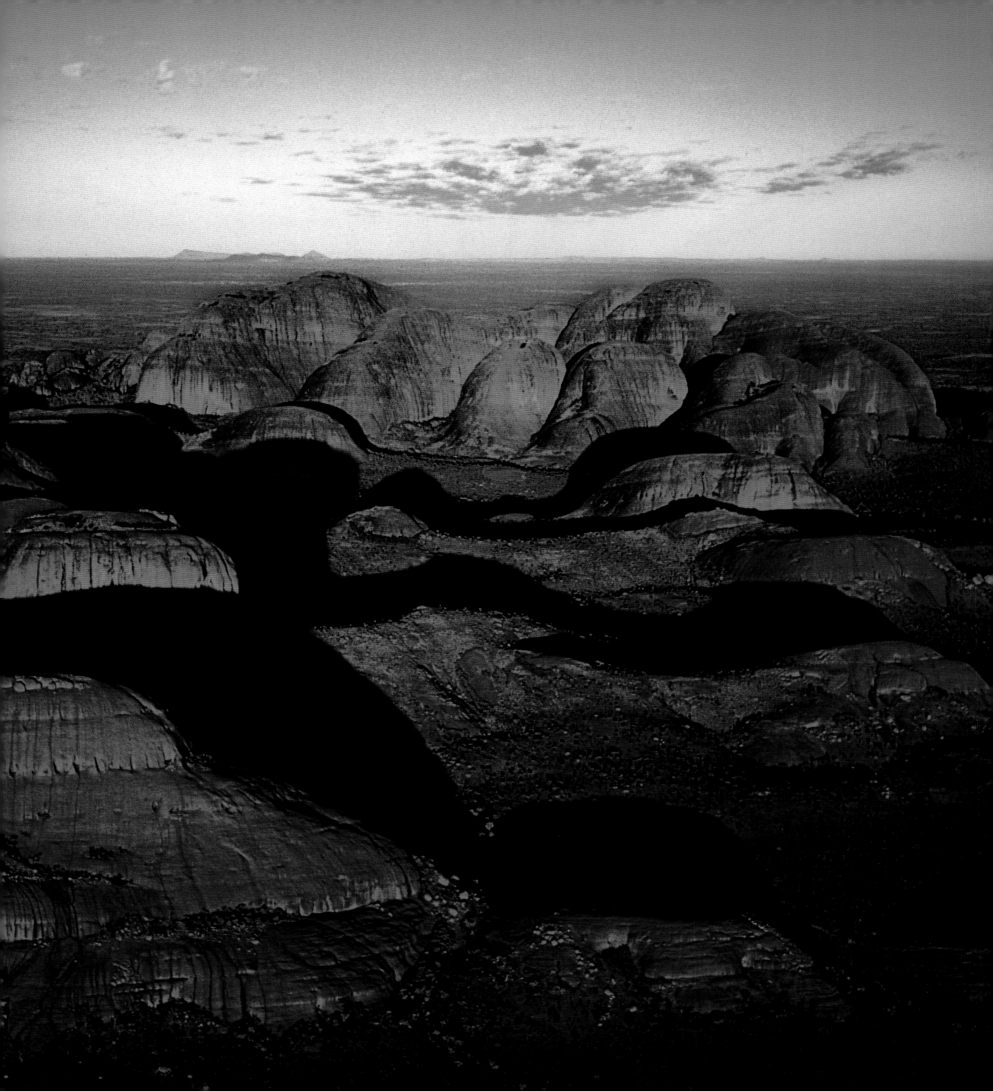

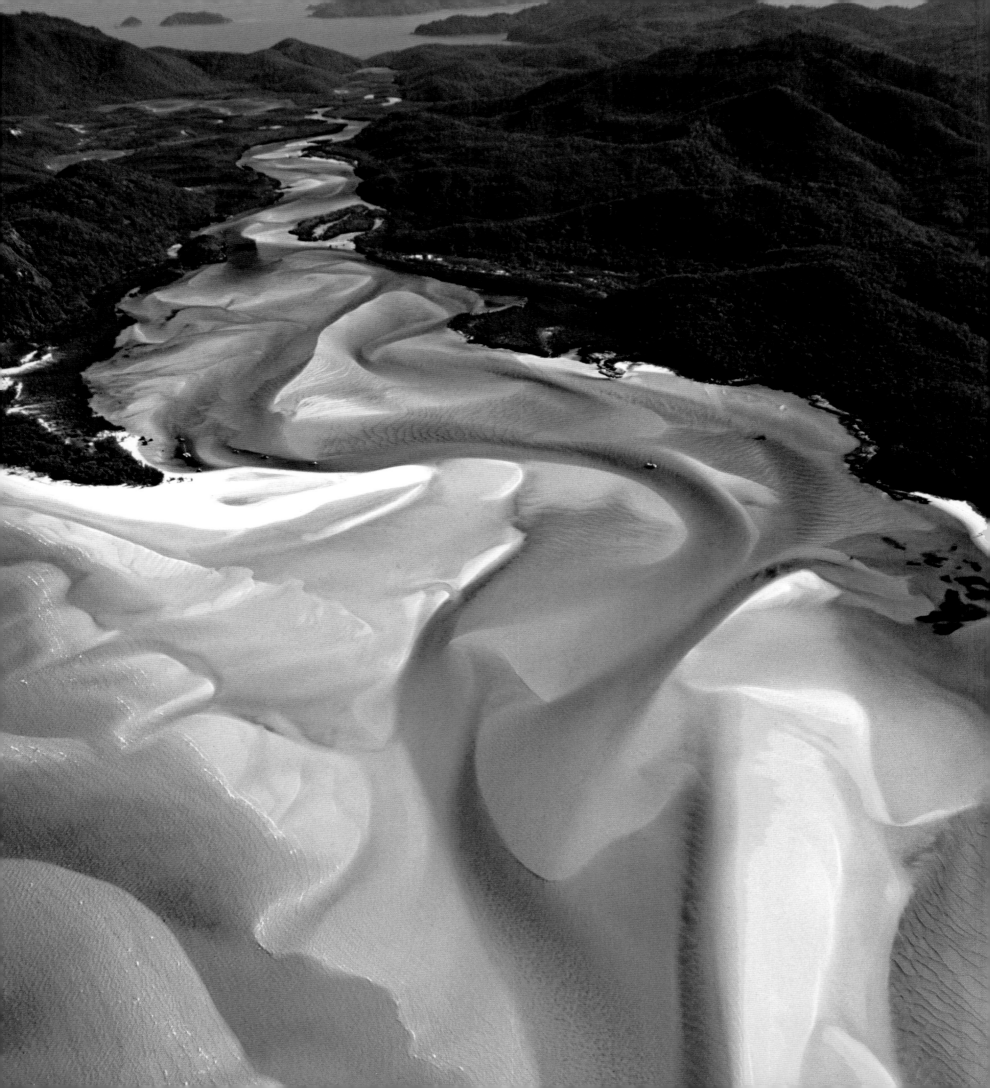

36 CLOCKWISE FROM LEFT Huge branches of horny coral reach out toward the abyss of Flinders Reef in the Coral Sea; the heart-shaped Heart Reef atoll in the Great Barrier Reef; luxuriant ferns in the Melba Gully State Park in Victoria; a wetland crossed by a river in Kakadu National Park.

37 The Olgas are a group of imposing red sandstone formations, possibly the remains of an enormous monolith that the elements have eroded until dramatically changing its form, dividing it into 36 distinct outcrops.

38 The high tide creates spectacular effects at Whitehaven Beach, one of the most magnificent beaches of the Whitsunday Islands.

39 LEFT AND RIGHT Dense vegetation surrounds the Daintree River, while the Flinders Ranges National Park is dominated by a rugged landscape.

MAGICAL NATURE, MOTHER NATURE

Mother Nature must have been sleeping when she created Australia, awakening to find that everything that she had dreamed about had miraculously become reality. It is a beautiful, free and wild country, which is ruthless and cruel. However, it is also simply stunning. Nature conquers the visitor in the spectacular national parks (and there are at least 540 of them!), which are perfect collages of ancient rainforests, deep rocky gorges, prehistoric deserts where time stands still, heavenly islands and long, impressive stretches of coastal dunes. It is the same Nature that the Aborigines, who reached these coasts aboard rafts and small boats from the Asian islands over 50,000 years ago, learned to respect, know and love, It was also the Nature that the first explorers, who adventured into her deserts and amid her salt lakes without precautions, learned to fear. It is the Nature that still frightens and disturbs the average Australian, who prefers to take refuge between the offices, beaches and Victorian townhouses on the edge of the cities and leave the Outback to the cowboys, farmers, adventurers and pioneers – tough men who are not daunted by distance and do not fear the heat, desert, solitude, snakes and poisonous creatures. However, it is always magical Nature. Nature is simply breathtaking in Australia. It may be due to the country's dimensions and vastness, an ancestral return to our roots or the anxiety that grips the eye when it scans the horizon in all directions without ever glimpsing the end. Indeed, Australia is a "lady" in all respects, with a land mass covering an area of almost 3 million square miles – a little larger than Europe and slightly smaller than the United States – that 65 million years ago decided to make a long journey, detaching herself from the enormous protocontinent of Gondwanaland to isolate herself in the Pacific Ocean. Today her appearance is simply stunning, considering her ripe old age: some of the most beautiful of her breathtaking panoramas date back to 3.5 million years ago!

Australian Nature is astonishingly beautiful, rich and variegat-

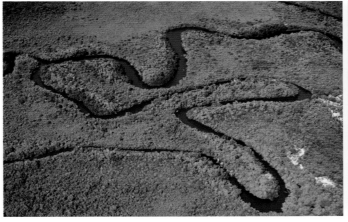

ed, with plants and animals that do not occur anywhere else in the world. It is also incredibly ancient and conserves the legacy of the Aborigines and the fossil sites of Riversleigh in Queensland and Naracoorte in South Australia – that rank among the largest in the world – or those discovered among the spectacular dry lakes of Willandra in New South Wales, which date back to at least 40,000 years ago. This Nature is so precious as to have captured the attention of UNESCO, which has inscribed 14 Australian areas on its World Heritage List: an acknowledgement that helps us understand how, in the end, this magical land belongs to all of us.

40 Sand dunes stretch as far as the eye can see in the majestic setting of the Strzelecki Desert in South Australia.

41 FROM LEFT TO RIGHT A jeep travels along a red sandy track in Karijini National Park; sturdy spinifex bushes thrust their roots into the arid earth of the Little Sandy Desert along the Canning Stock Route in Western Australia; low hills rise among the sparse vegetation in the Outback, the vast uninhabited inland area of Australia.

RED
EARTH

Red like the color of the earth, red like the heart of Australia. The red earth is part of the country's deep roots. It can be seen on the dirt tracks and the desert sand. It can be admired in the form of mighty stone, in the mystic and evocative capacity of massive monoliths. It can be found in the crevices in the rock and Aborigine paintings, on the walls of caves that conceal magical legends. It can be breathed along the trail left by the stockman rounding up his sheep on horseback at sunset, lost in a cloud of dust. It can be encountered cutting the entire continent in two, for miles and miles, on the Stuart Highway Drive, which stretches undaunted for 1700 miles, following the course of the legendary Ghan – the railroad "inspired" by the caravans of the Afghan camel drivers – for part of the way, before continuing to Darwin, amid dazzling white desert saltpans and isolated settlements, always accompanied by the spirit of the kangaroos. These lands are home to many of these animals, which jump wild and free among the bush. At night, dazzled by the headlights, they hurl themselves unwittingly beneath vehicles, representing a severe test of endurance even for jeeps.

The red earth is the mistress of the Outback: the Outback is itself a myth. Almost every Australian state has its own Outback and everyone knows it, at least by hearsay. Everybody agrees that it is majestic, infinite, immense and that nothing else like it exists in the world. However, nobody knows exactly where it starts and where it ends. It is like a land without frontiers. "Get away from the coast, continue driving and driving, without worrying about distance… and, when you are in the middle of nowhere, when you really start hoping that you will see the shape of another car appear on the horizon, then you will

understand that you are there…." This is the advice offered by Australians, who also add that you should never to venture too far without adequate supplies of gas and water.

However, the Outback is more than a mere tourist adventure. It is necessary to forget the present to understand it fully, returning to the past and to your roots, entrusting yourself to instinct, like animals. You must learn anew how to listen to your sensory perceptions in order to understand that you are there, to try to orient yourself and to discover the meaning of things. When you suddenly feel tiny in the face of the infinite advance of nothingness, when the monotony of the landscape that continues for miles and miles dulls your senses until exerting an almost hypnotic effect on your mind, then you know that you have reached the Outback.

The Red Centre in the Northern Territory is a triumph of red earth and a sea of sand dunes. It is one of the least inhabited places in the world, which nonetheless boasts the largest population of Aborigines – the only people who feel truly at home in the Outback. The sun accompanies your every step. The road runs between the land and sky, pursued by a desert that never gives it a moment's respite. It is a desert of rock and dust, which mingles with tongues of green and yellow sun-scorched grass, shrubs, spinifex and thorny bushes Towering gum trees line the paths or stand out solitary in the immense nothingness. The huge ghost trees, with their white trunks and thousand-armed skeletons, have a spectral air, like tormented souls awaiting judgment.

Uluru, the world's largest monolithic rock (2.2 miles long, 1.5 miles wide and 1142 feet high), emerges from the dusty earth as if in

43 TOP Uluru is a unique spectacle. Australians now tend to use the traditional Aboriginal name to refer to this great monolith once known as Ayers Rock. The Aborigines consider it taboo to climb this great monolith, which is their sacred mountain.

43 BOTTOM The Olgas, or Kata Tjuta, emerge from the earth in their full disquieting beauty, framed by the majestic clouds.

a dream, constituting an indescribable natural spectacle. The first European explorer to sight it was Ernest Giles, in 1872, but the name by which it was known until recently was given to it by another pioneer, William Gosse, who was perhaps the first white man to conquer its summit. He called it Ayers Rock, after the South Australian premier, Henry Ayers. Only in 1985 was it returned to the Aborigines, who restored its old name and leased it to the government for the creation of a national park. Mystic and supreme, Uluru continues to fuel the stories and legends of the Aborigines, who consider it sacred. Climbing it is taboo, for it is tantamount to following the traces of the Mala, the hare-wallaby people of the sacred rock. Nonetheless, crowds of tourists swarm all over it, unperturbed, like tiny ants on the immensity of the steep rock. However, the mysticism of the spot remains intact, despite the pressing onslaught of modernity.

Uluru, with its caves, crevices and ravines seems to have eyes, ears and mouth. Like a beautiful woman playing hard to get, it teasingly shows only a small portion of itself (10 per cent), hiding the rest in the bowels of the earth. As if by magic, each day at sunrise and sunset it turns into a chameleon, an expert at changing color in the brief span of a second, assuming a deep orange hue. However, when the rain falls it can be discerned sinister, against the background of the desert, framed by a gray and menacing sky lit by a battle of magnificent lightning bolts. It can also be seen in the dark night, the shadow of distant ghosts, covered with little roaring waterfalls. There are those who believe that this is the only moment in which it shows its true face.

The same mystic and rarefied atmosphere pervades the air around the Olgas, which were named in honor of Queen Olga of Württemberg during the 19th century. Isolated in even deeper solitude, in the pure splendor of nature and the vastness of the desert, they are a mysterious labyrinth composed of 36 red sandstone monoliths shaped like giant domes, some of which have a monstrous appearance. The Aborigines believe that they are the bodies of the ancestral heroes celebrated in the Tjukurpa, the Dreamtime – the period of the creation – and call them Kata Tjuta, meaning "Many Heads." Their eastern face is the realm of men alone and is taboo even for the women of the tribe, not just for foreigners. Words flow like a river in flood, becoming leg-

ends in Aboriginal stories that tell of giant cannibals with stone bodies, kangaroo-men, lizard-women with miraculous powers and venomous snake-men. The "heads" culminate in Mount Olga (1805 feet), the home of the snake Wanambi, who lurks in the gorge below during the dry season and curls up in a hole on the summit during the rains. His breath is the wind that whistles lightly in the gorge and accompanies the steps – and the soul – in the Valley of the Winds.

However, this is not the only place where the heart of the Outback beats. It can be reencountered in the deep, ancient gorge of the Watarrka National Park, formerly known as Kings Canyon, between steep and very tall walls and on the edge of precipices where the breathing of the spirits can be heard. From here the gaze sweeps over endless landscapes, where the red rock protrudes above the soil in honeycomb formations between oases of sand and palms, waterholes and waterfalls, enveloped by little islands of rainforest. The heart of the Outback also throbs between the rocky walls of the Western MacDonnell ranges, another frontier land, where the men of Alice Springs used to bring their wives on their honeymoons. "In the past, when the only links were via caravan and camel, it was truly difficult to find a woman willing to come and live here! Not that things have changed much today….," joke the sunburned rangers. Indeed, the wild and rugged natural environment speaks for itself. Ghost towns, such as Arltunga, once swept up in the gold rush, are now sad testimony to a past that no longer exists. Rivers of sand are dotted with tiny pools of water, where wallabies hurry to drink, and stones occupied by basking perenties – the largest Australian lizards, with long and lightning-fast claws.

The roots of the earth are exposed between the reddish quartzite walls of Simpson's Gap, a deep crevice cut out of Roe Creek, and the very close faces of the Standley Chasm, just a palm apart in some spots, which become a blaze of red when the sun manages to illuminate them completely, towards midday. The magical evocative capacity of the red earth in the Devil's Marbles Conservation Reserve bewitches visitors with unique rock formations: giant and mysterious stones that are transformed into a kaleidoscope of iridescent shades at dawn and sunset, which the Aborigines believe to be the eggs of the rainbow-serpent.

The Outback also reigns supreme in Western Australia, where most

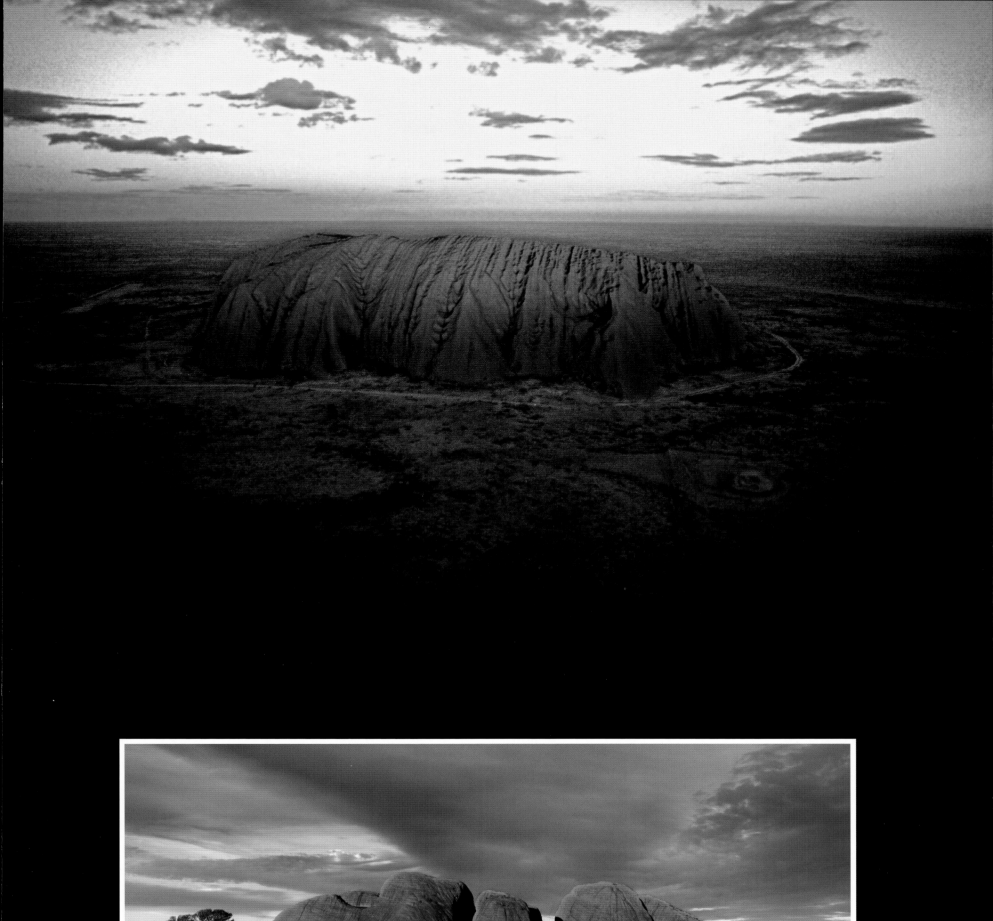

of the immense region (almost 1 million square miles, with a population that hardly exceeds 1.5 million people) is a variation on the theme of the red earth and ocher rock desert. It is overbearing and menacing, but also an inexhaustible source of extraordinary emotions, such as the scorching expanses of the Great Sandy Desert, or the Gibson Desert. Or the vastness of the Karijini National Park — one of the wildest and most beautiful in Australia — which extends over the continent for 1.5 million acres on a rough plateau around the Hamersley Range, dotted with ocher sandstone canyons, gaping gorges and dizzy rocky balconies descended by waterfalls that dissolve in rivers, bights and pools. Or like Wave Rock, an unusual geological formation that caused a great sensa-

of the sky, in the heart of Nambung National Park. Gray kangaroos, wallabies, opossums, large lizards and emus hide among the rocks and shrubs, camouflaged in the vegetation, in a truly surreal landscape. Although they are mainly hidden from sight, Australians will tell you that a storm is all that it takes to flush them out, triggering a unique spectacle, as thousands of fleeing kangaroos bound among the pinnacles. The first Dutch explorers thought that these pinnacles were the ruins of an ancient city, but they were mistaken. Some believe that they are instead a petrified forest, others an army of men transformed into stone and others still merely a geological phenomenon, nonetheless their origins remain shrouded in mystery. The red earth once again assumes legendary tones in the Kimberley, Australia's wildest soul — a plateau where the red rock is sculpted in deep gorges and rises in the jagged peaks of the Durack and King Leopold Ranges, or in the unusual sandstone formations of Purnululu, known as the Bungle Bungles. These rocks take the form of countless summits that emerge from nowhere, dotted with spots and tongues of grass that vaguely resemble green icing

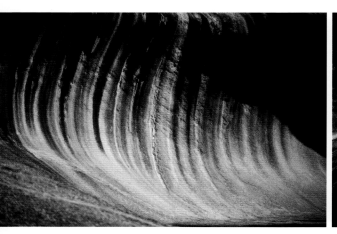
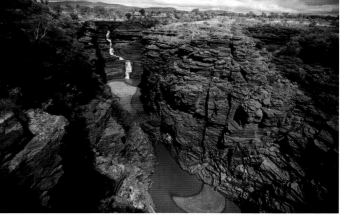

tion when it was discovered, even ending up on the cover of *National Geographic*. Although now invaded by Japanese tourists and worshipped by surfers, it remains an impressive sight — a gigantic wave (33 feet long and 50 feet high) — of a thousand different hues that changes color in the late afternoon, when the smooth rock assumes warm shades of brown, carmine and orange. The red of the earth meets the yellow of the rock in the Pinnacle Desert, a maze-like forest of thousands of sandstone pillars — jagged and sharp, simple and linear, of all shapes and sizes — larger than a man or as small as your fingers — which stand out against an expanse of red desert that contrasts sharply with the blue backdrop

sugar sprinkled on giant cakes when viewed from above. They are actually an expanse of honeycomb rock formations, with alternating stripes of orange silica and thin layers of black lichen.

The Gibb River Road — the "Beef Road" — is a perfect example of an Outback road. It runs between Kununurra and Derby, small towns isolated in a desolate landscape, and crosses the heart of the Kimberley, following the traces of red earth of an old drovers' trail. It covers miles and miles of sand and mire, furrowed by rivers and marshes notorious for their fierce crocodiles. Stopping at the stations for fresh supplies of water, food and fuel, you may come across the legendary swagmen —

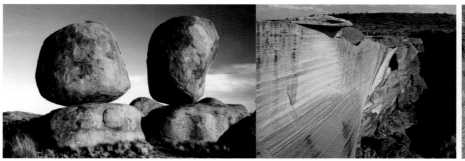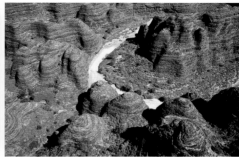

vagabonds who live beneath the stars in the company of their swag, a blanket rolled around a mess tin and a few personal belongings. You may also happen to meet the eyes of an Aborigine, run into a kangaroo grazing furtively at the roadside or follow the light of the sun day after day, without any precise destination. All of these sensations will stay with you forever, like the red earth that envelops the misshapen baobabs, laps the trunks of tiny prehistoric palms and disappears beneath the crystal-clear waters of rivers and lakes, studded with the inquisitive yellow eyes of saltwater crocodiles. Is the Kimberley perhaps the true last frontier? After all, it is only inhabited by isolated communities of Aborigines and – like the Far West – adventurers, such as the workers of the Argyle Diamond Mine (a huge opencast mine that is the largest diamond "factory" in the world) or farmers with properties as large as a European country, willing to fight tooth and nail to defend their land from fires and violent storms.

The Outback is even more ruthless – "tough and rough," as the Australians say, or worse still, "bloody" – on the Eyre Highway, which runs along the edge of the Nullarbor Plain. Here water really is a mirage, the air becomes clear, the light dazzling and the temperature can exceed 122° F, making it difficult for vehicles to proceed, even at low speeds. The traveler comes face to face with Australia's empty vastness, amid sand and red rock deserts, meteorite craters and salt lakes. In the middle of nowhere the only signs of civilization are the roadhouses – service and gas stations scattered here and there like grains of dust, sometimes hundreds of miles from each other. An example is Cocklebiddy, which is home to splendid limestone caves, or the evocative former telegraph station of Eucla, invaded by sand after having succumbed to the devastating blows of nature. The Nullarbor Plain is an immense lunar landscape that ends suddenly in the Bunda Cliffs, 240-foot sheer rock walls that stand imposingly over the Great Australian Bight, a stretch of sea much frequented by migrating southern right whales. Here everything seems possible, even the sighting of a UFO, as proclaimed by the signs around Border Village.

The red earth is the faithful companion of the roads, as testified by Queensland's sunbaked, narrow, dusty and sinister Tropic of Capricorn Drive, which is plied by the huge and aptly named three-trailer road trains. This road is another Outback legend and the sole sign of life in a desolate expanse in the middle of nowhere, dotted only with isolated farms (the paradises of sheepshearers), a few mines, wrecked cars and abandoned hangars.

Green once again mingles with the red earth in the Gulf of Carpentaria in the Outback – a torrid and endless savanna, crossed by snake-like winding rivers and lakes teeming with huge and dangerous crocodiles. During the monsoons the mining cities can remain isolated for weeks on end even today. Then there are the river ports, with their battered pubs and bars, relics of a world that would appear to have stopped at the times of the pioneers, if it were not for television. The only spot where it is possible to encounter a little life is Mount Isa, a sprawling mining town, where muscular cowboys challenge each other to ride bulls and cows in Australia's most important rodeo, held in August. Here too the heart of the Outback beats strongly.

However, it is in the Flinders Ranges National Park, one of the most beautiful in the country, situated in the Outback of South Australia, that the red earth achieves its highest chromatic expression. Shades of ocher and purple triumph in these boundless landscapes, amid clefts and rocky gorges, while wildflowers bloom in the meadows beneath the caress of the spring rains and the warm desert light. The evocative power of the scenery is so intense as to have inspired the hearts of painters, Aboriginal artists and nature photographers. The sensations aroused by the spectacle become a burning passion in the solitary spirit of adventurers seeking themselves, free spirits who believe in dreams and let their thoughts soar in the immensity of the sky, swept away in the moonlight by a violet cloak studded with stars. This is the instant in which Mother Nature makes peace with the earth, bestowing moments of unforgettable beauty – moments that are worth a lifetime.

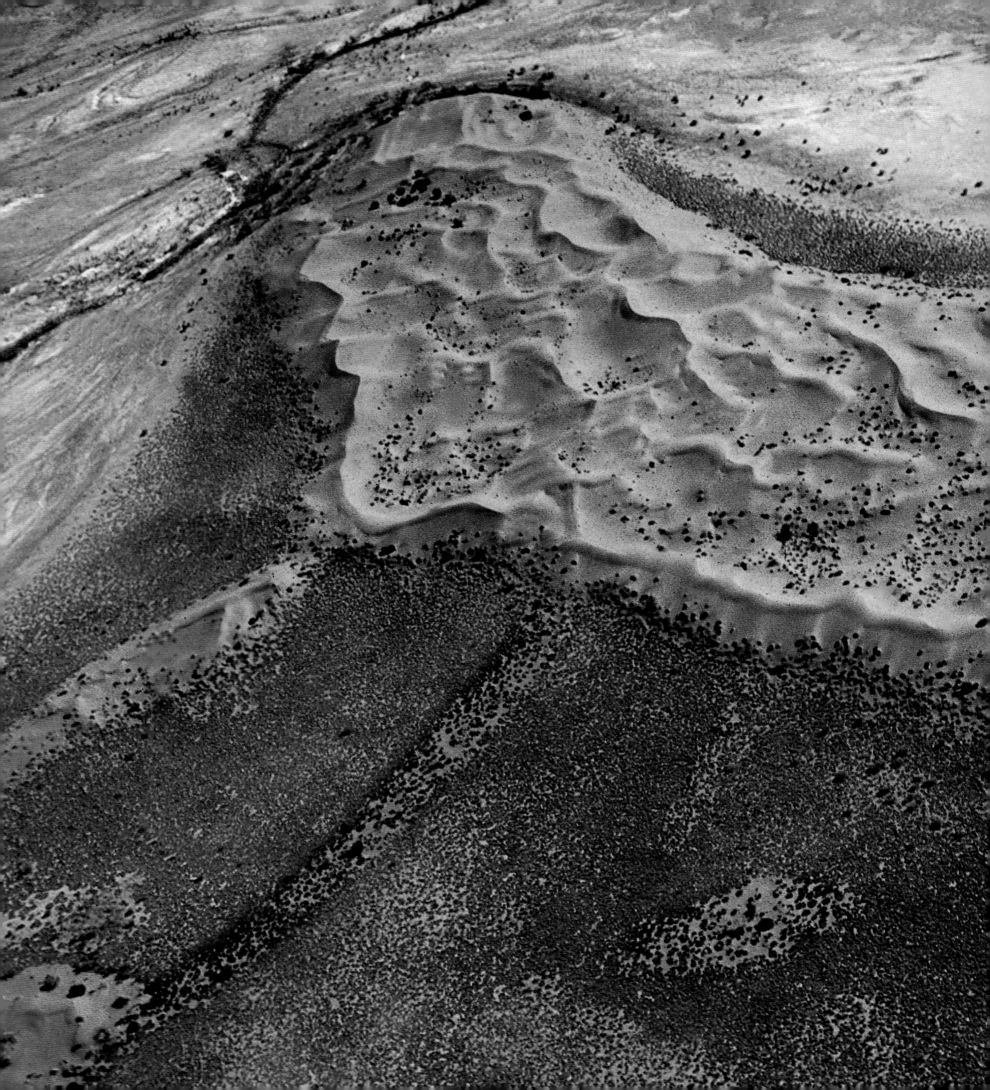

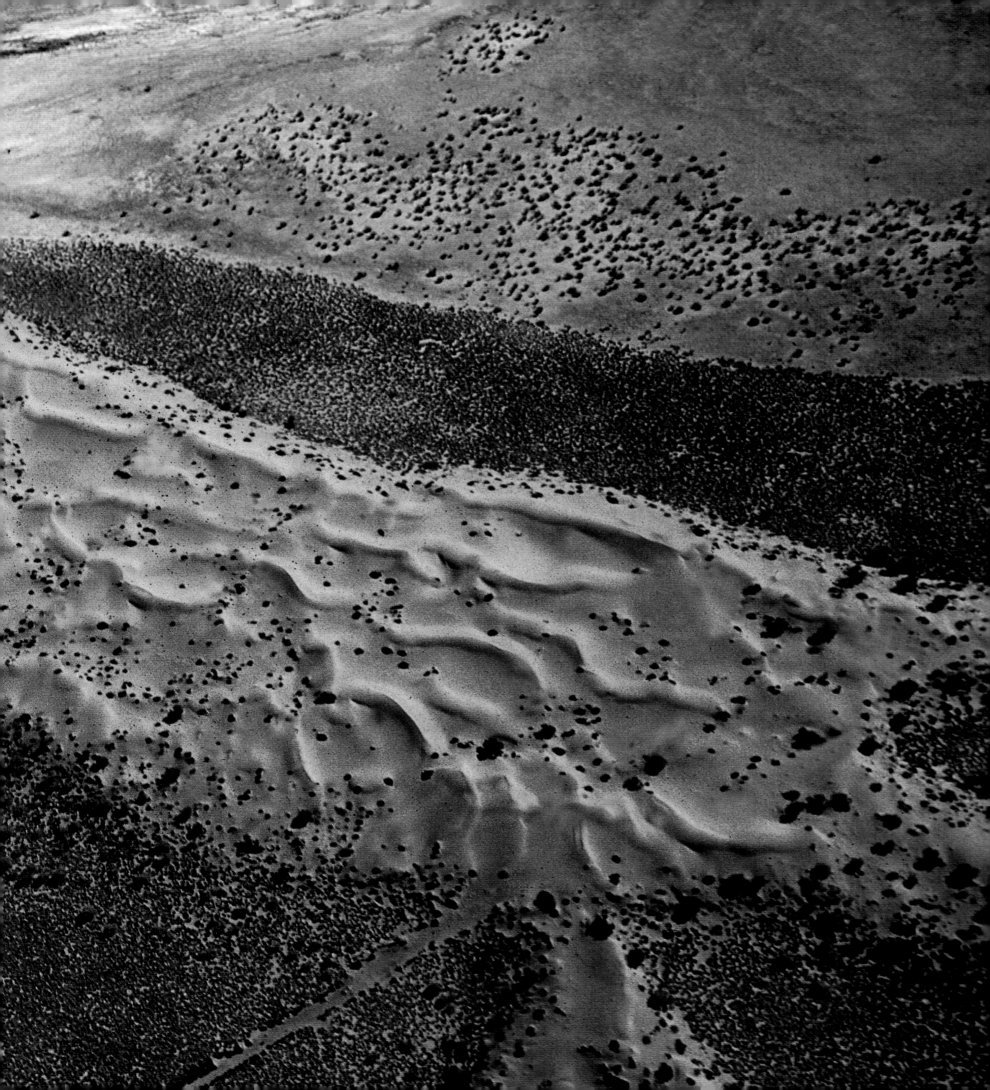

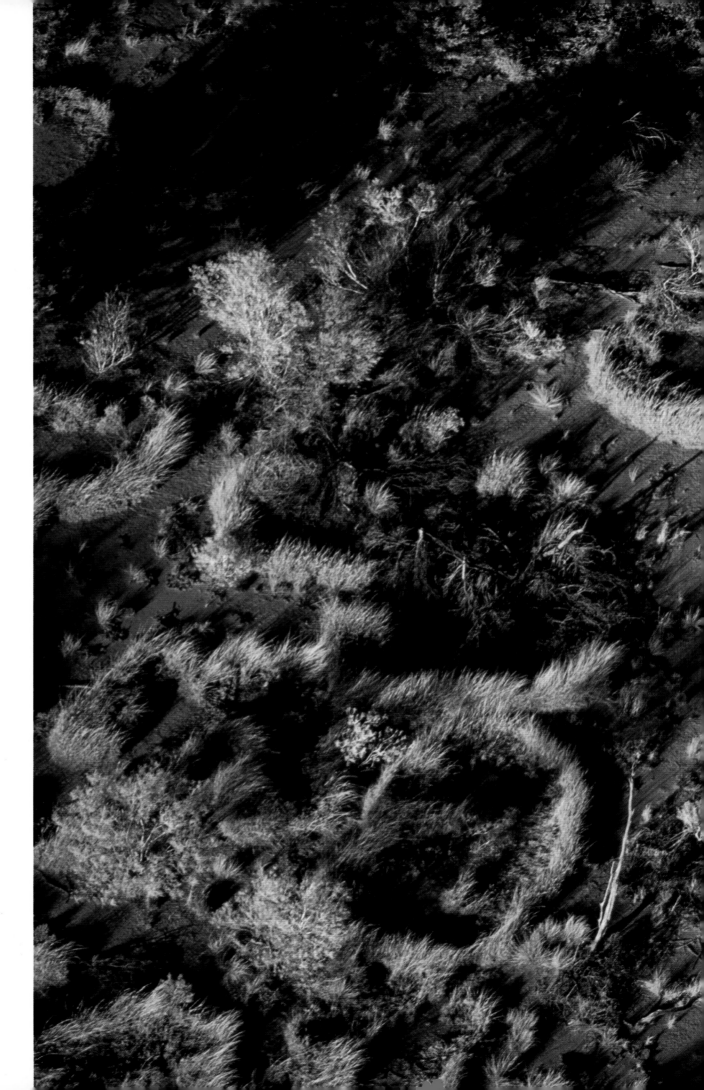

48-49 Viewed from above, the arid vegetation of a desert area near Uluru National Park seems to trace strange shapes.

50-51 This evocative photograph shows the wave-like rock formations of the MacDonnell Ranges National Park.

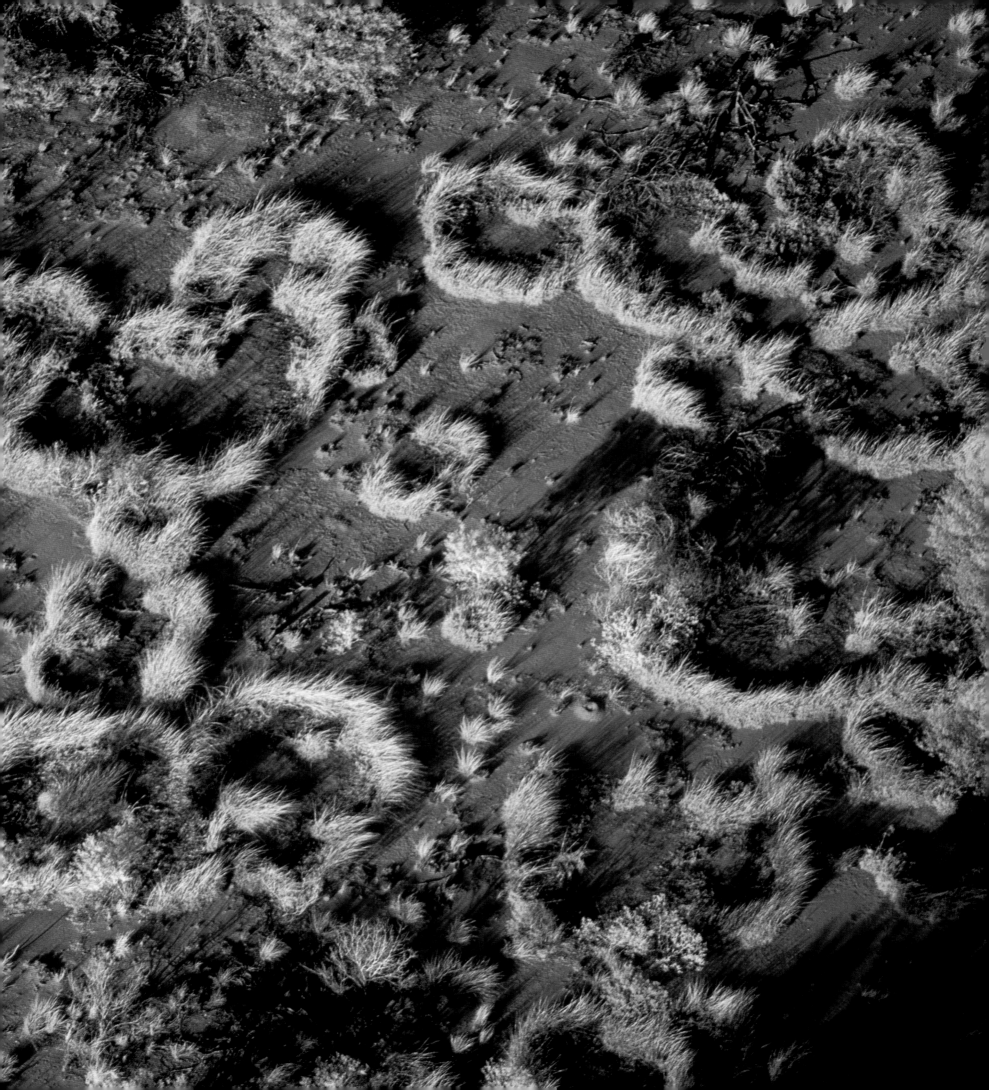

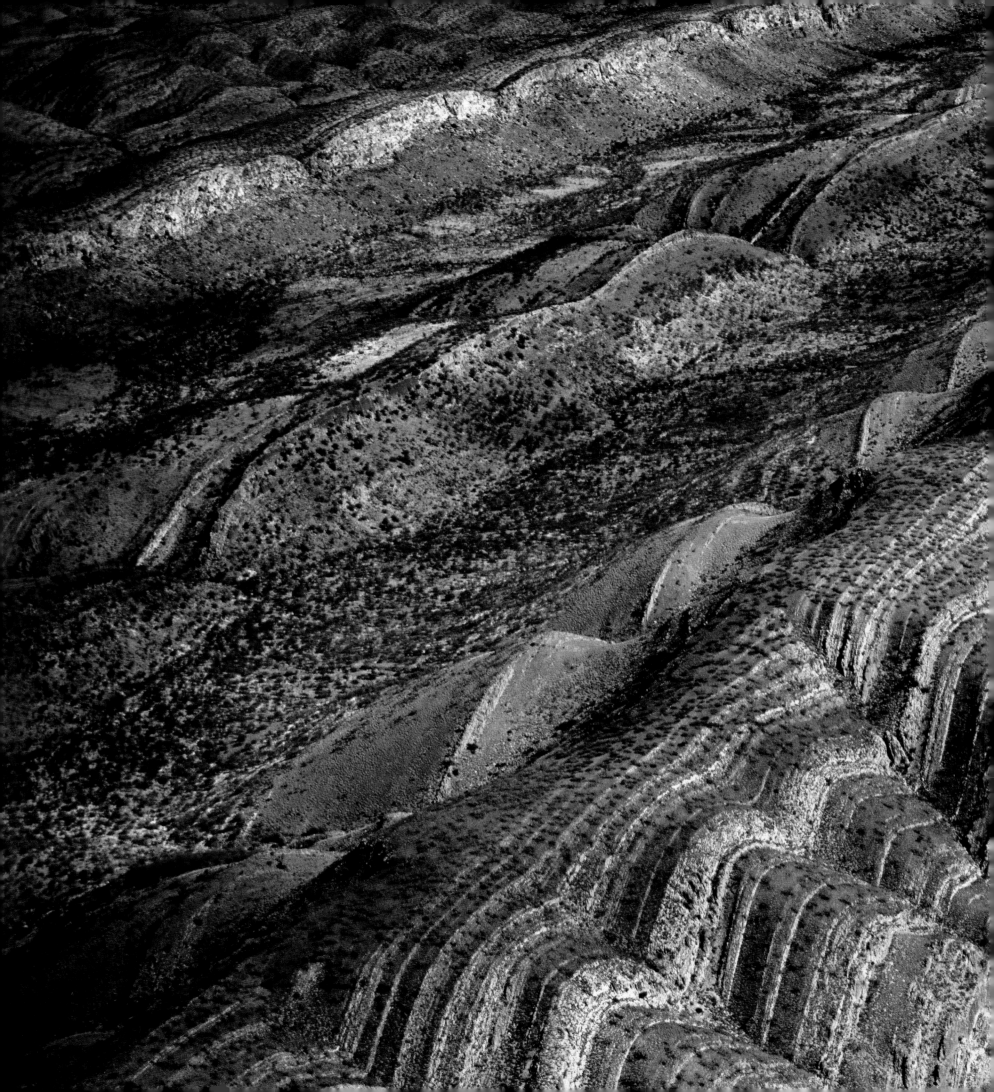

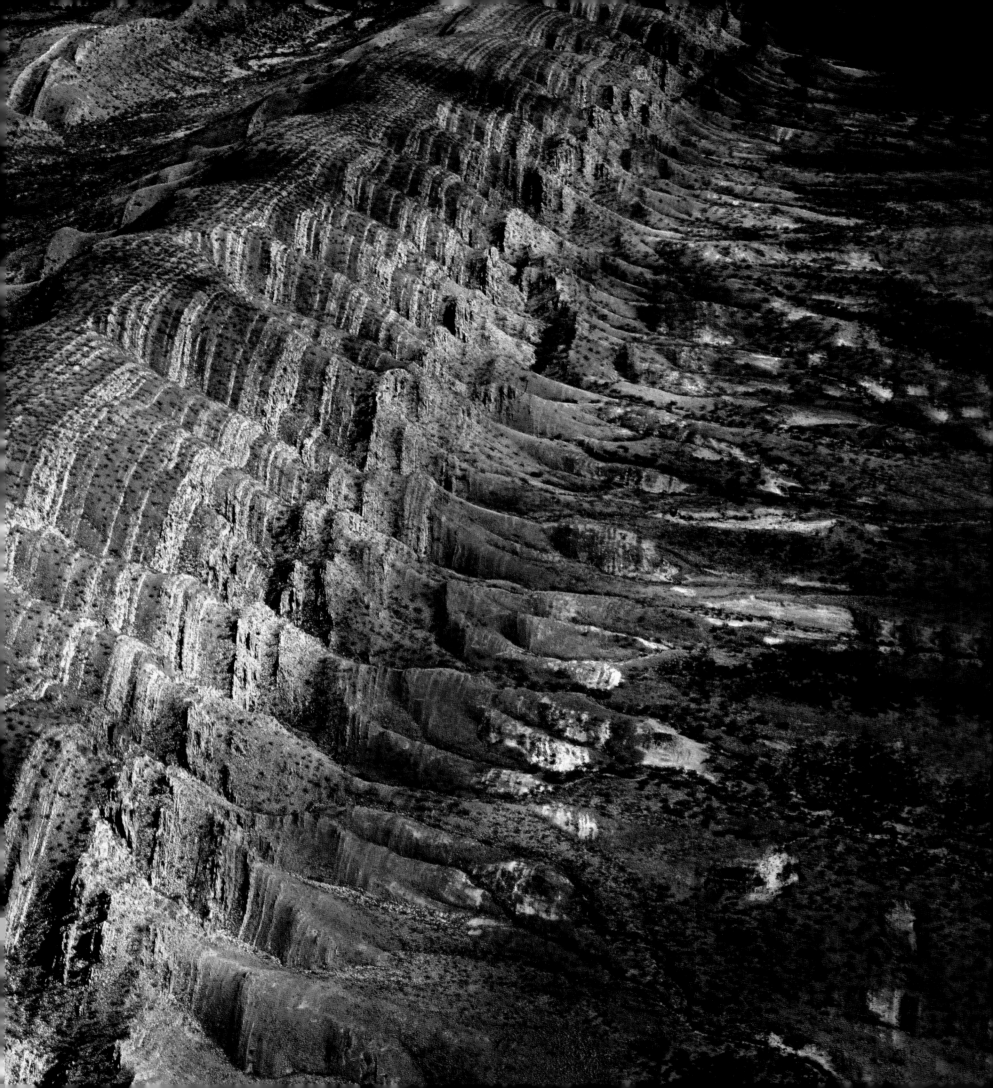

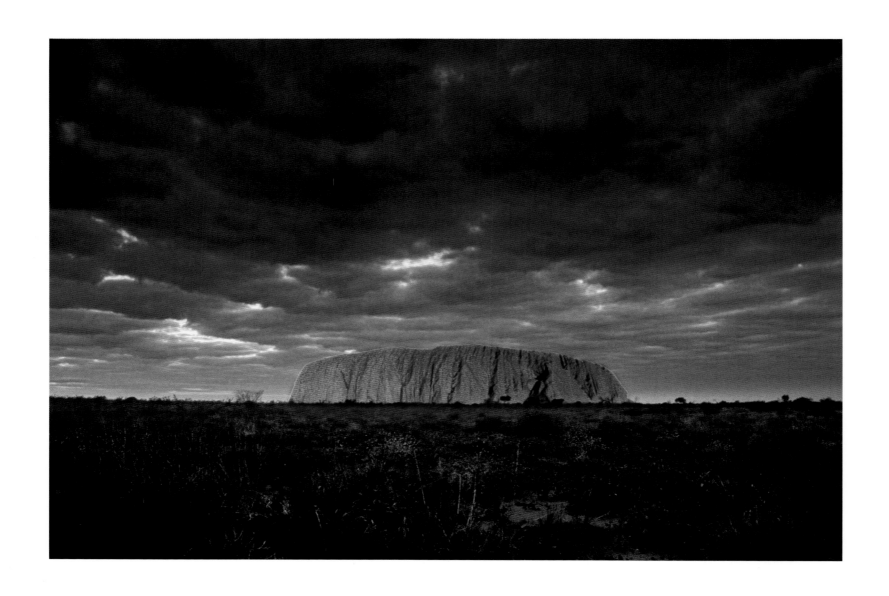

52 ULURU ABLAZE WITH ORANGE AGAINST THE DRAMATIC DARK SKY.

53 VIEWED FROM ABOVE AND FROM A CERTAIN ANGLE, THE MONOLITH LOOKS LIKE A
HUGE SLEEPING ANIMAL, LYING IN THE IMMENSE AND SILENT VASTNESS OF THE OUTBACK.

54–55 THE PRIMORDIAL ENERGY OF NATURE APPEARS IN ALL ITS POWER AROUND THE
IMPOSING SHAPE OF ULURU.

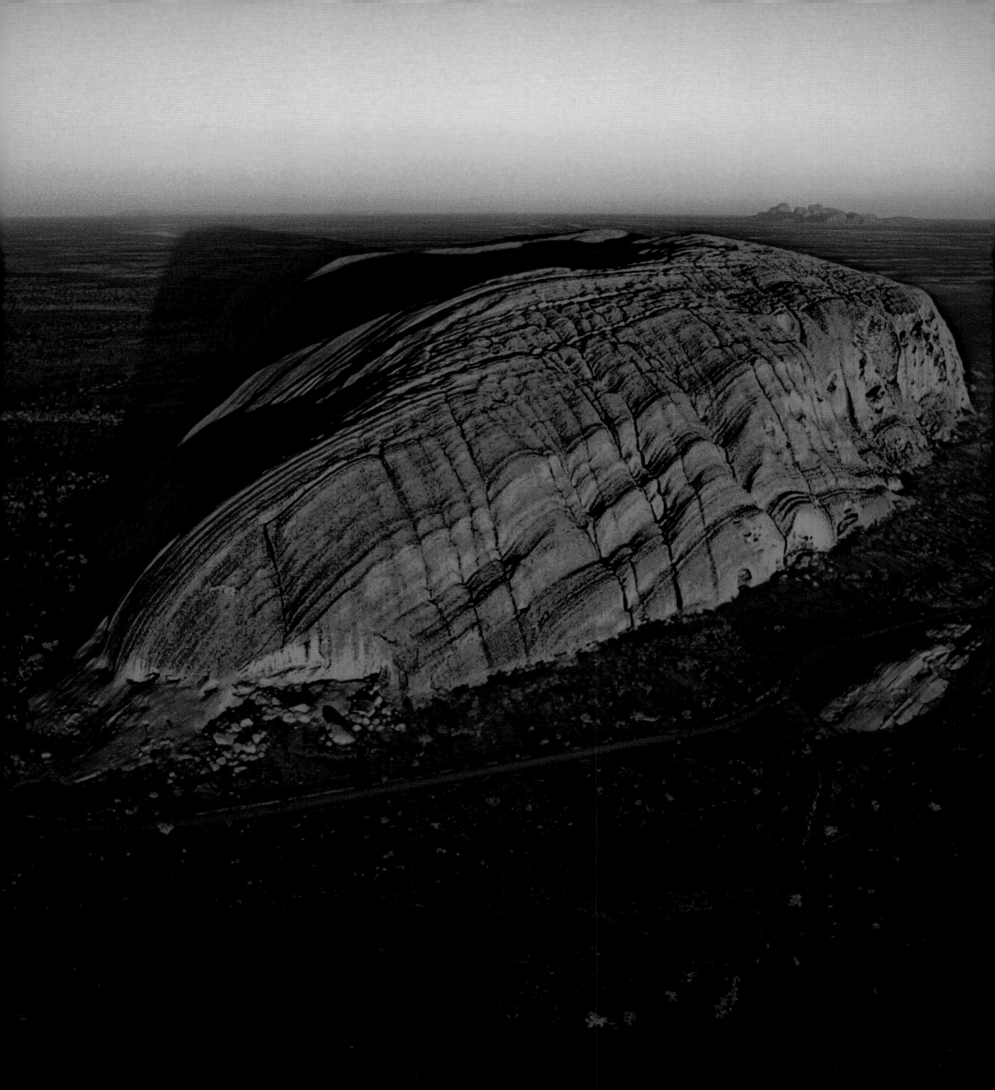

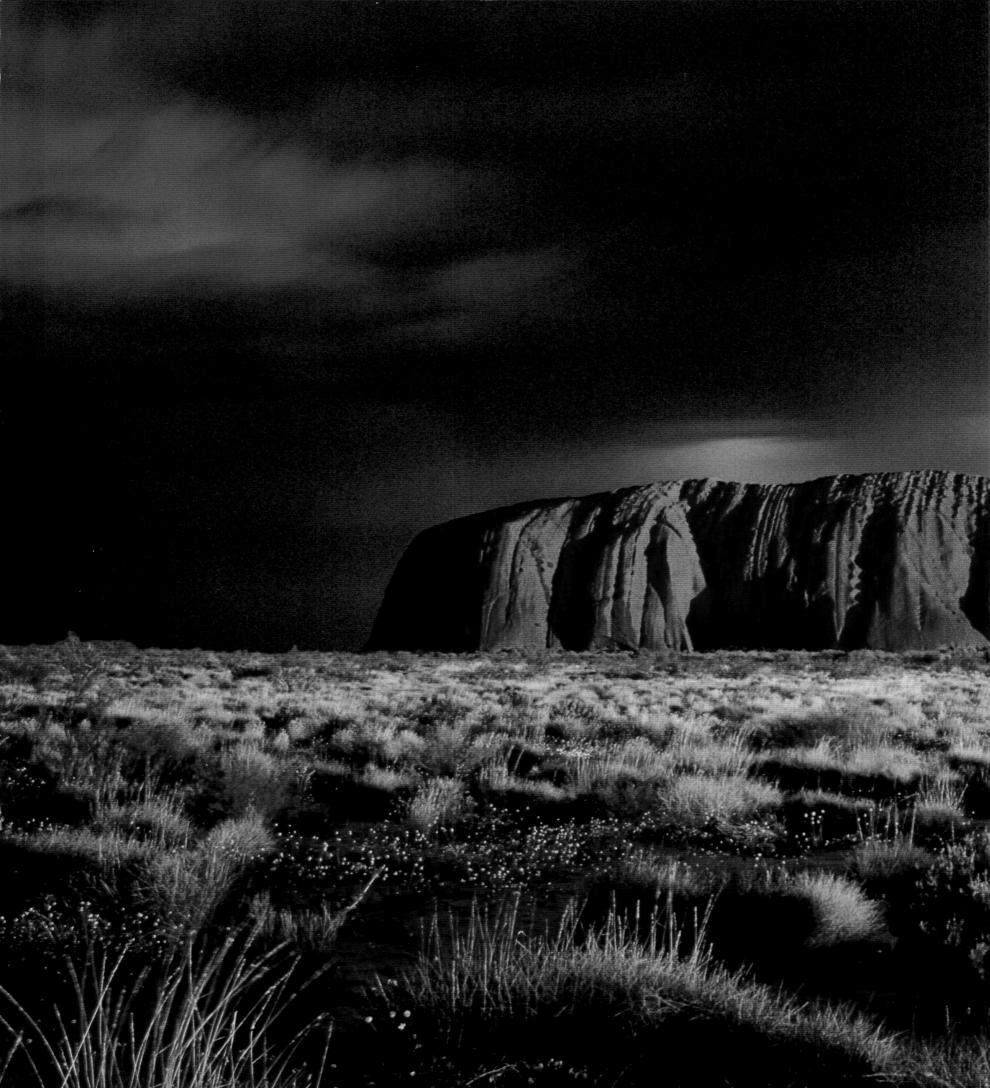

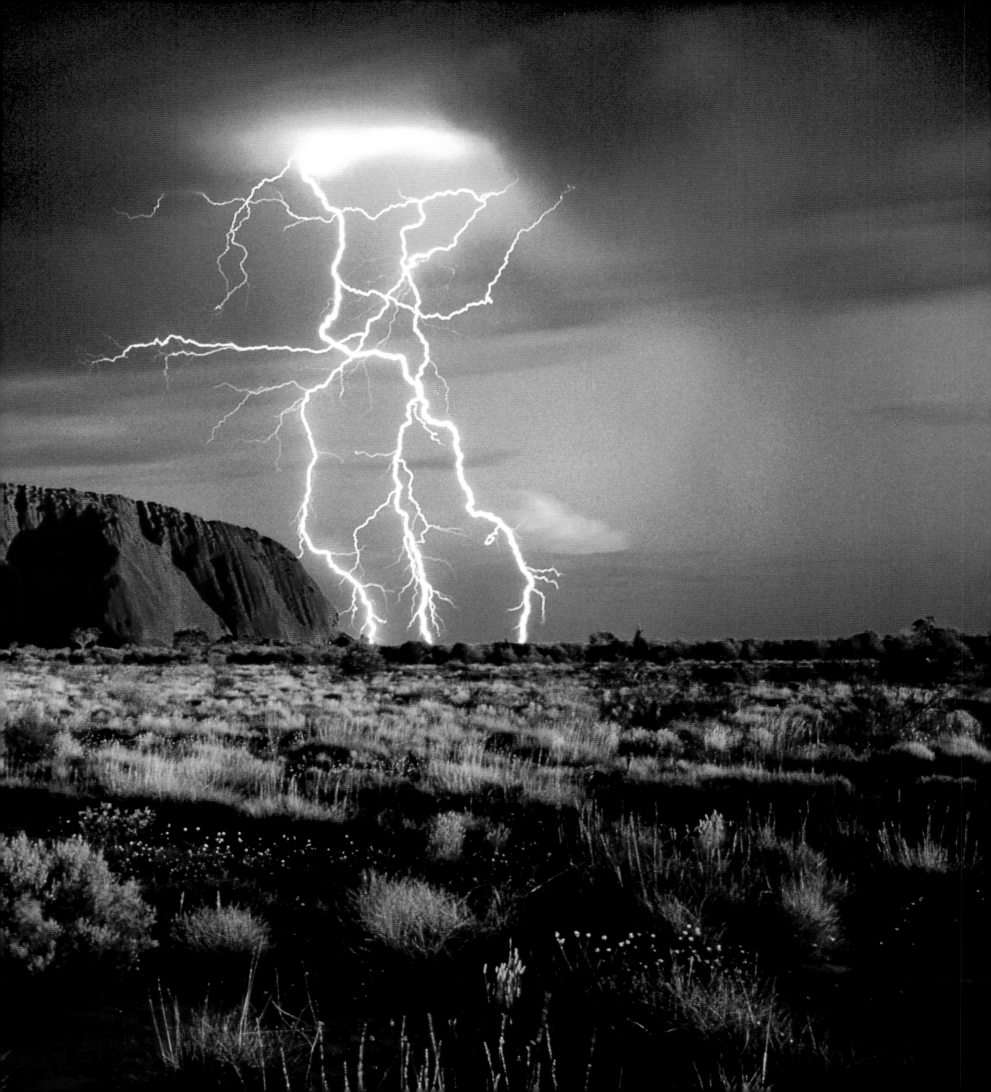

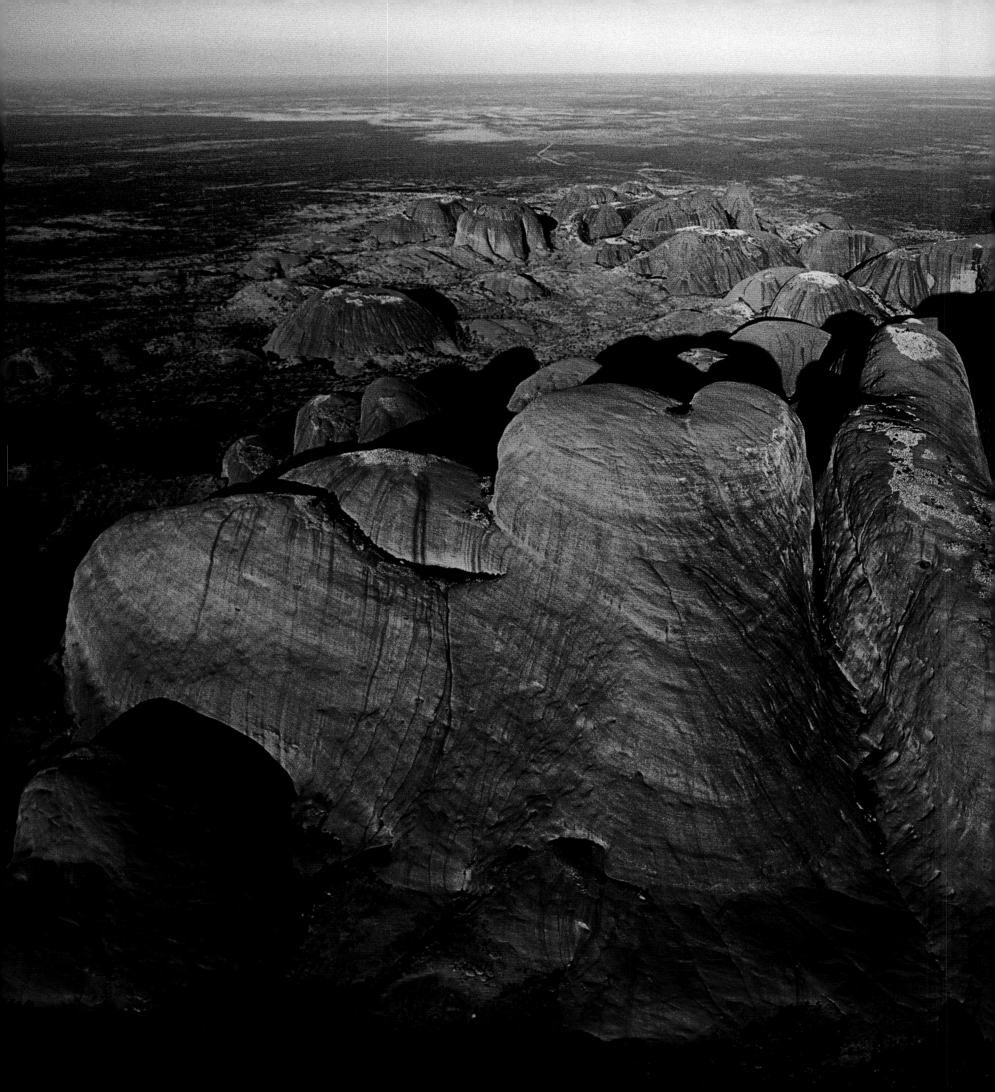

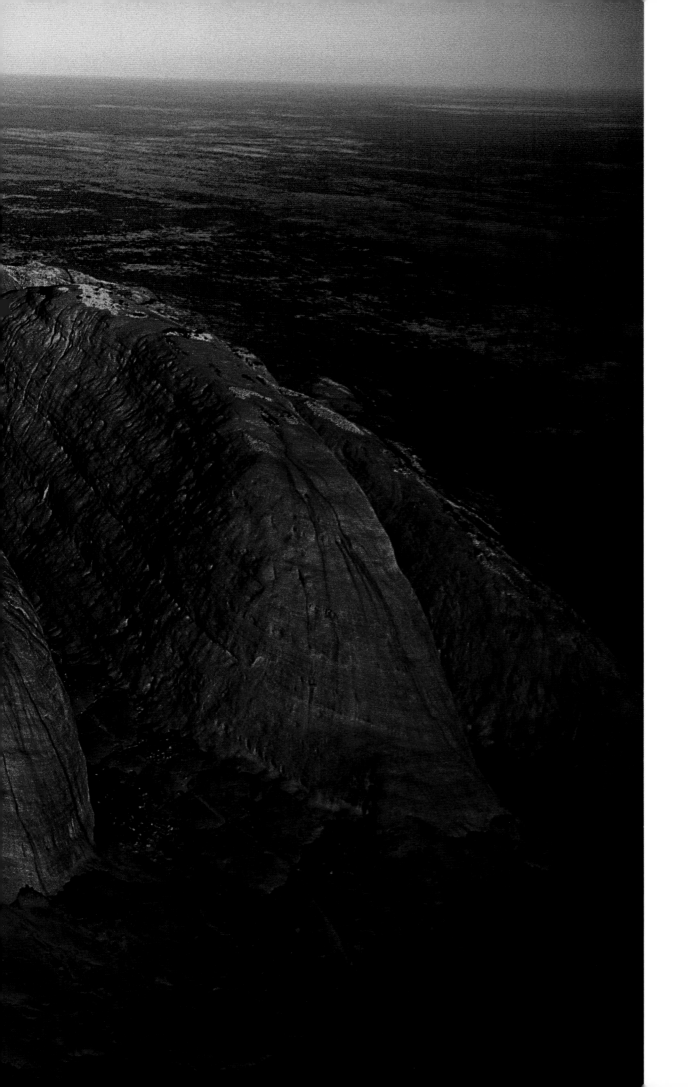

56-57 FROM THE AIR, THE OLGAS LOOK LIKE A THOUSAND-HEADED MONSTER FROM THE AIR. THE ABORIGINES HAVE ALWAYS CONSIDERED THIS PLACE SACRED.

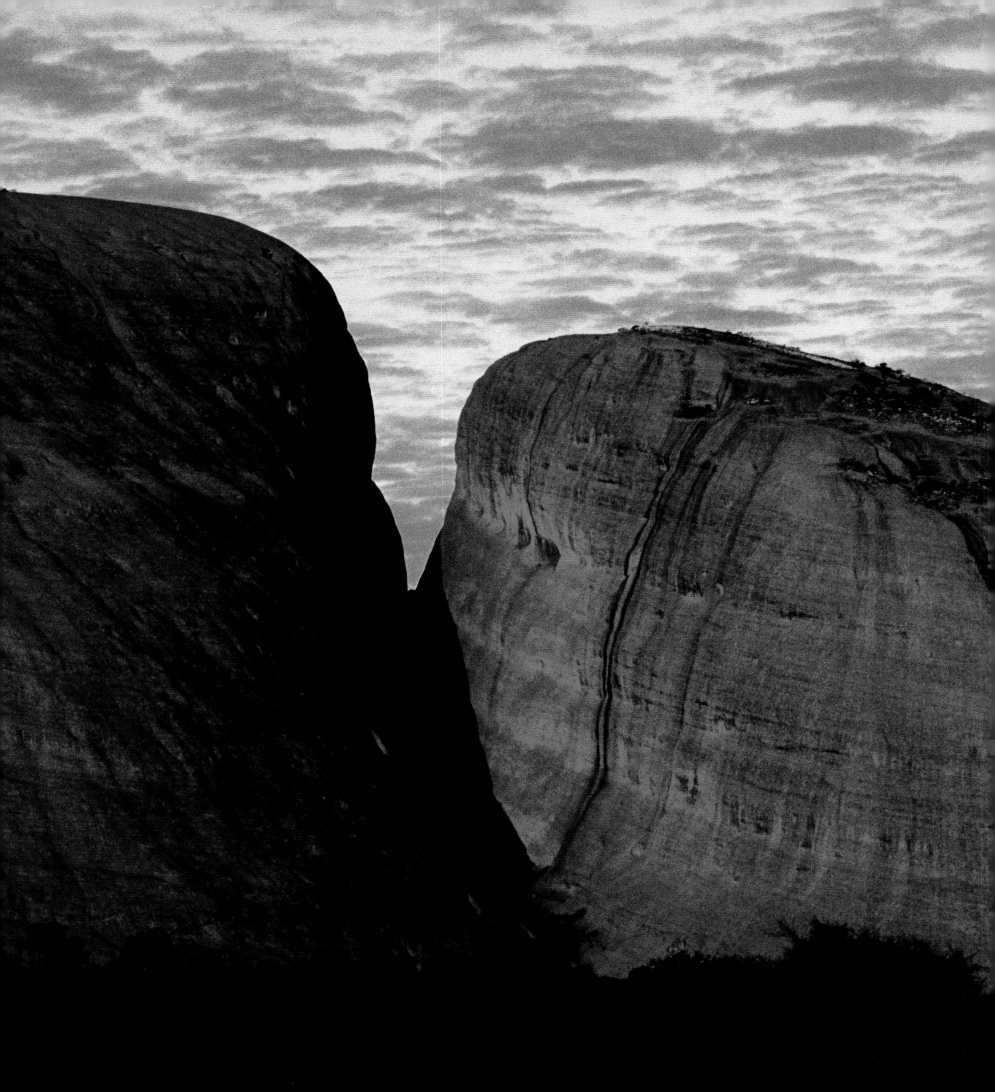

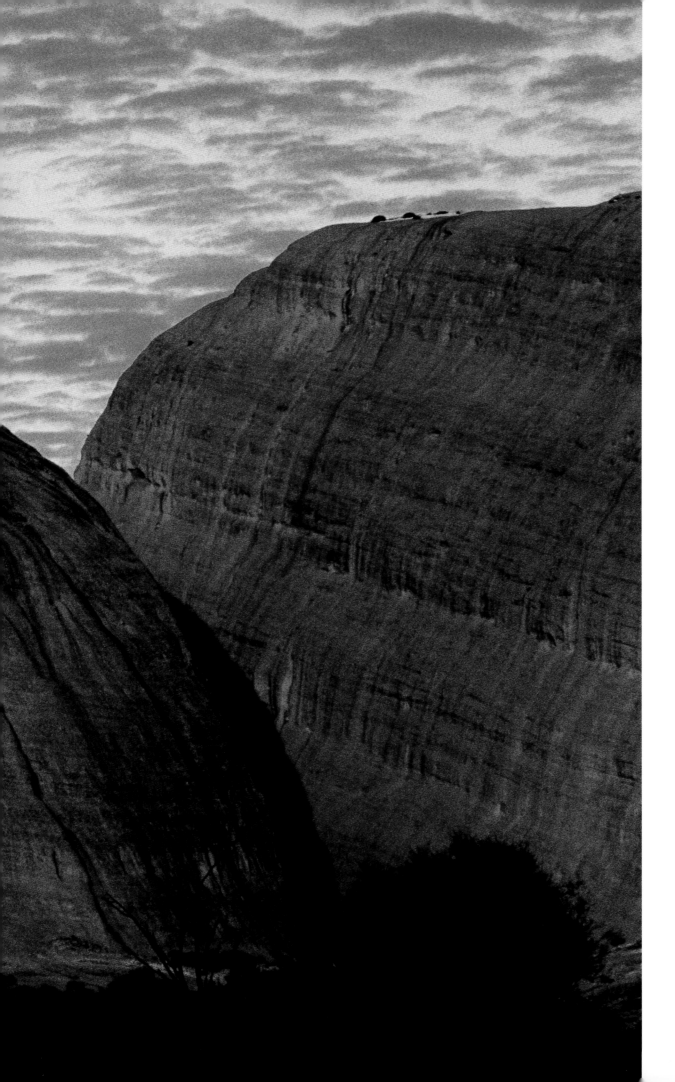

58-59 "Rounded minarets, giant and sometimes monstrous domes," was how the Olgas (named after Queen Olga of Württemberg) were described for the first time. However, for the Aborigines the rock formations remain Kata Tjuta, "Many Heads."

60-61 A forest of sandstone pillars stands out against the turquoise sky in Nambung National Park: this is the Pinnacle Desert, where it is possible to glimpse kangaroos and other animals, jumping here and there.

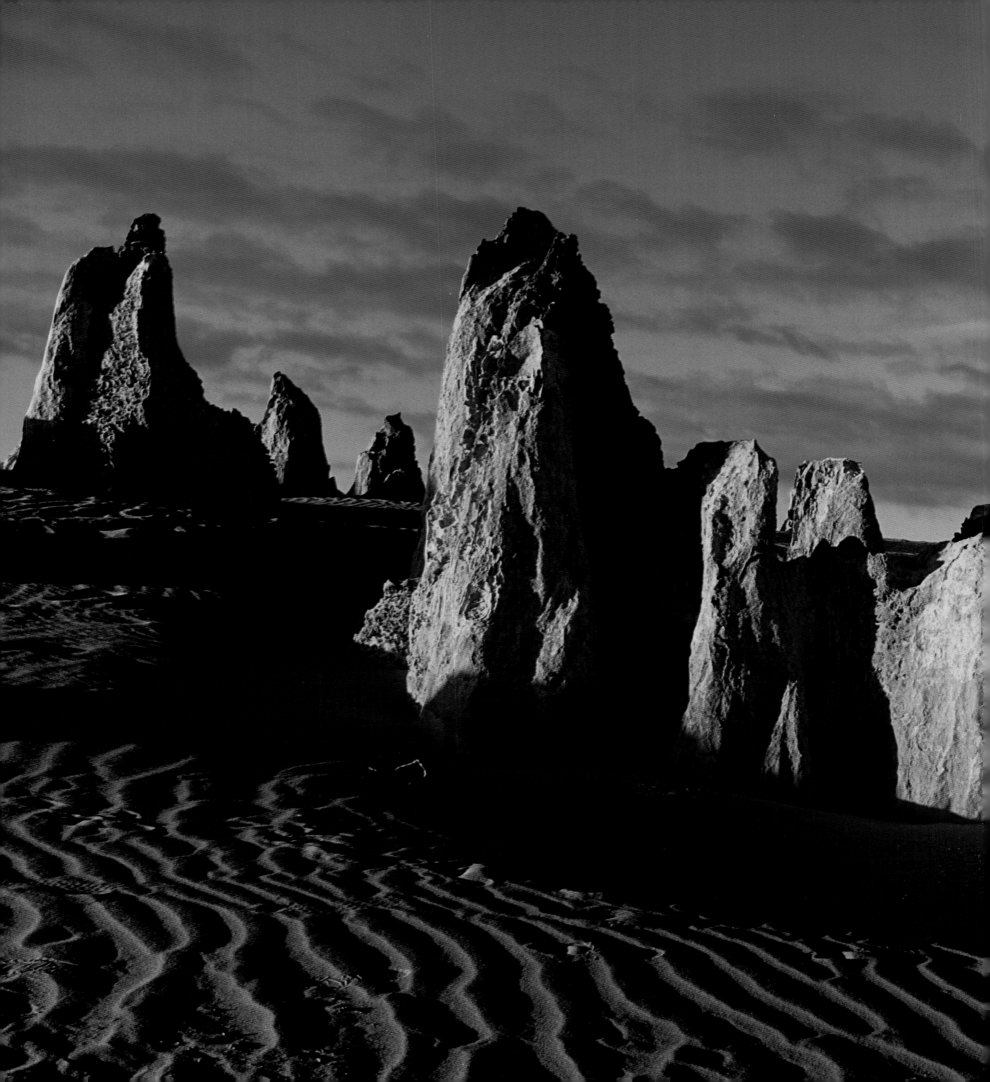

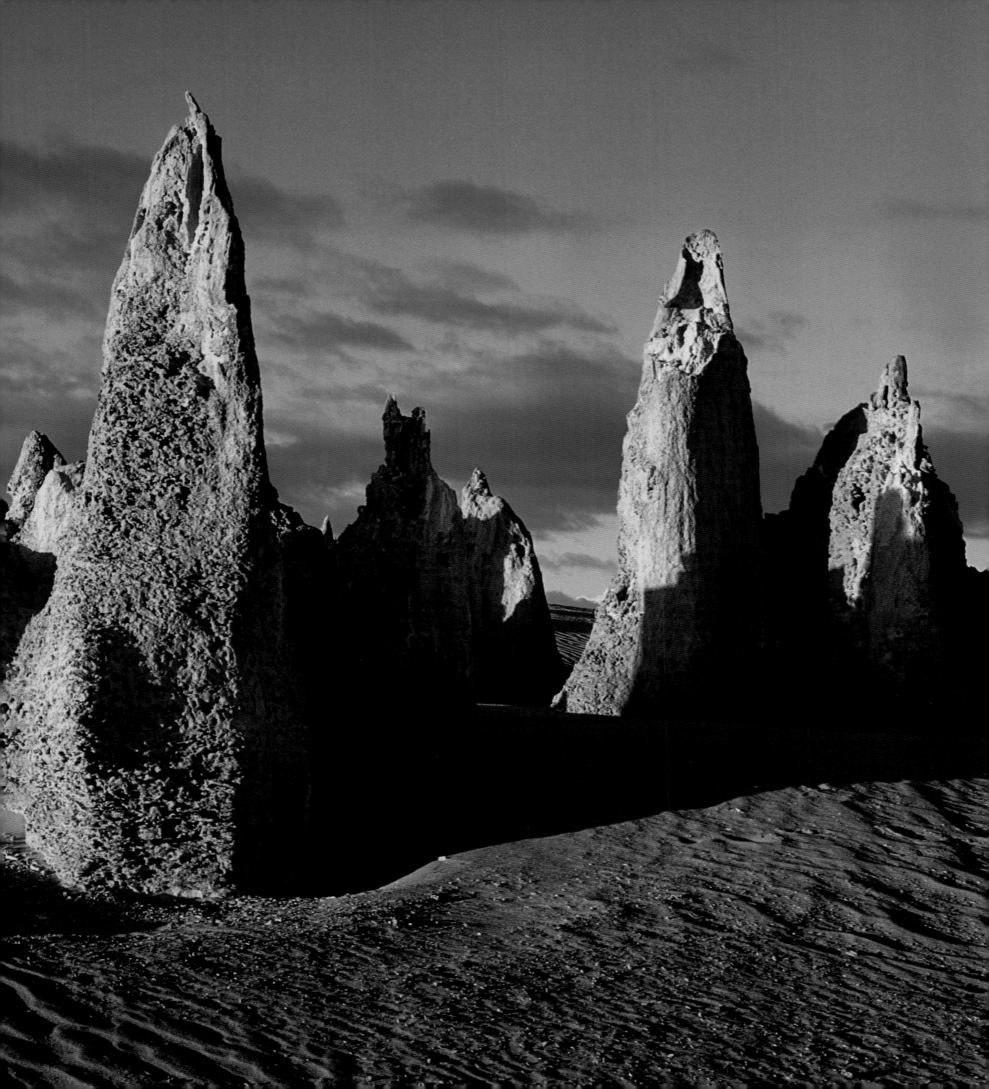

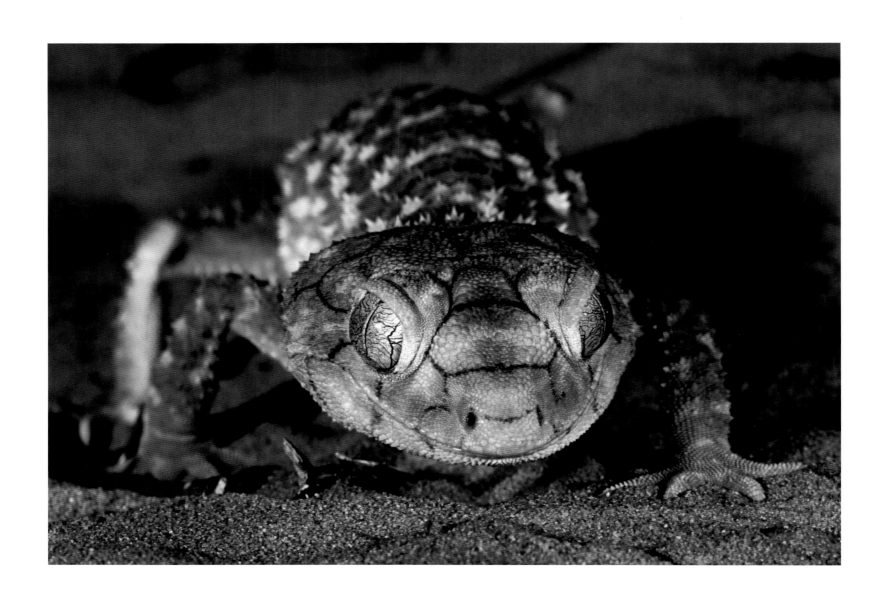

62 GECKOS ARE A FREQUENT SIGHT IN AUSTRALIA: THIS KNOB-TAILED GECKO
(*NEPHRURUS SP.*) SEEMS TO BE WATCHING THE PHOTOGRAPHER, PERPLEXED.

63 THE WIND TRACES SINUOUS SHAPES ON THE SAND IN ONE OF THE OUTBACK'S
MANY DESERT AREAS.

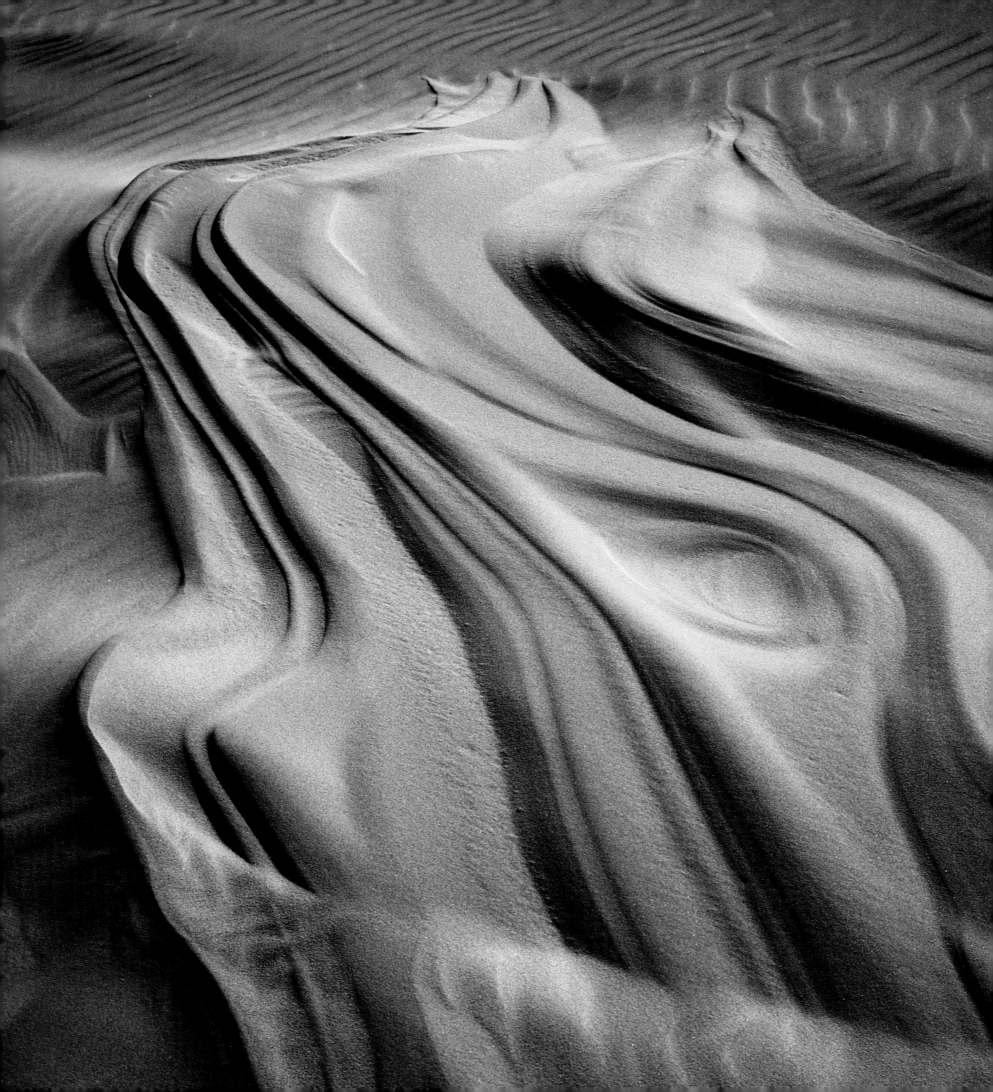

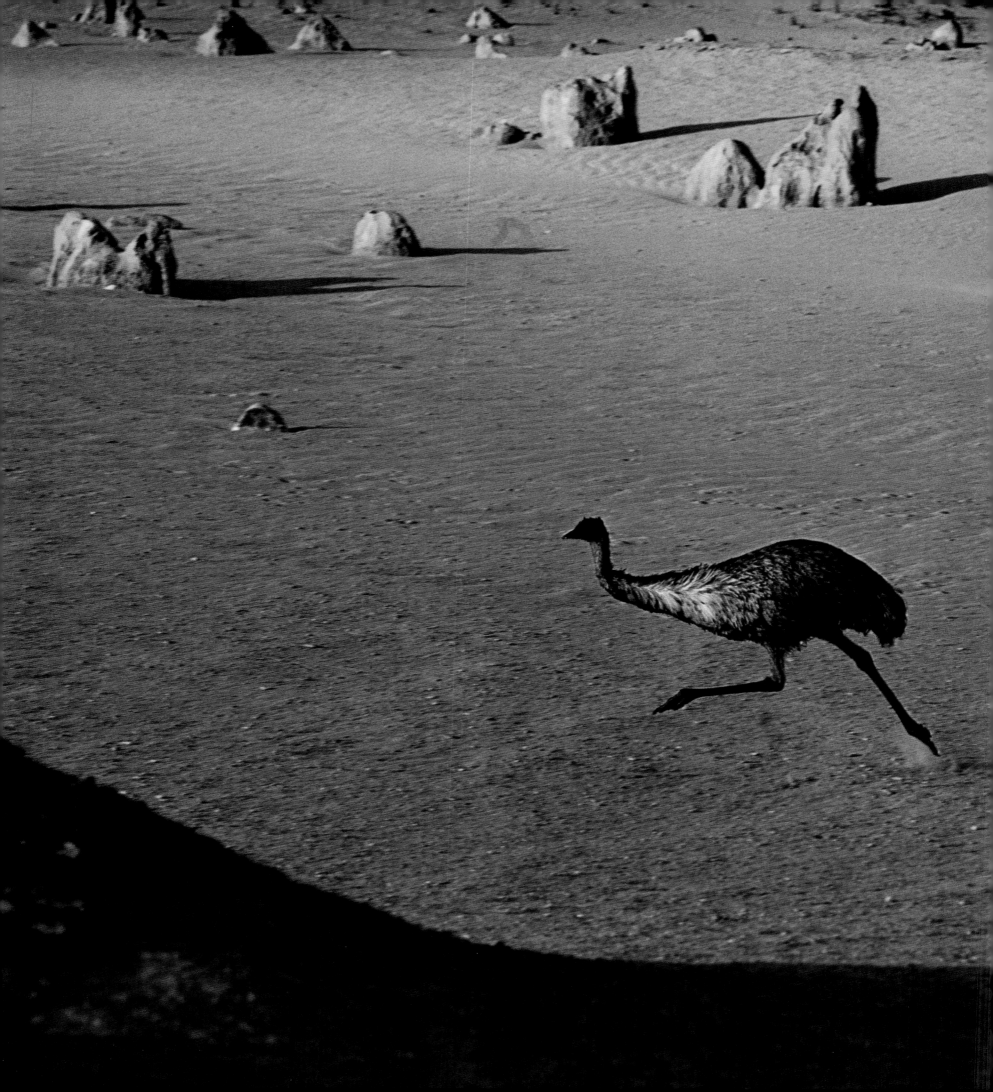

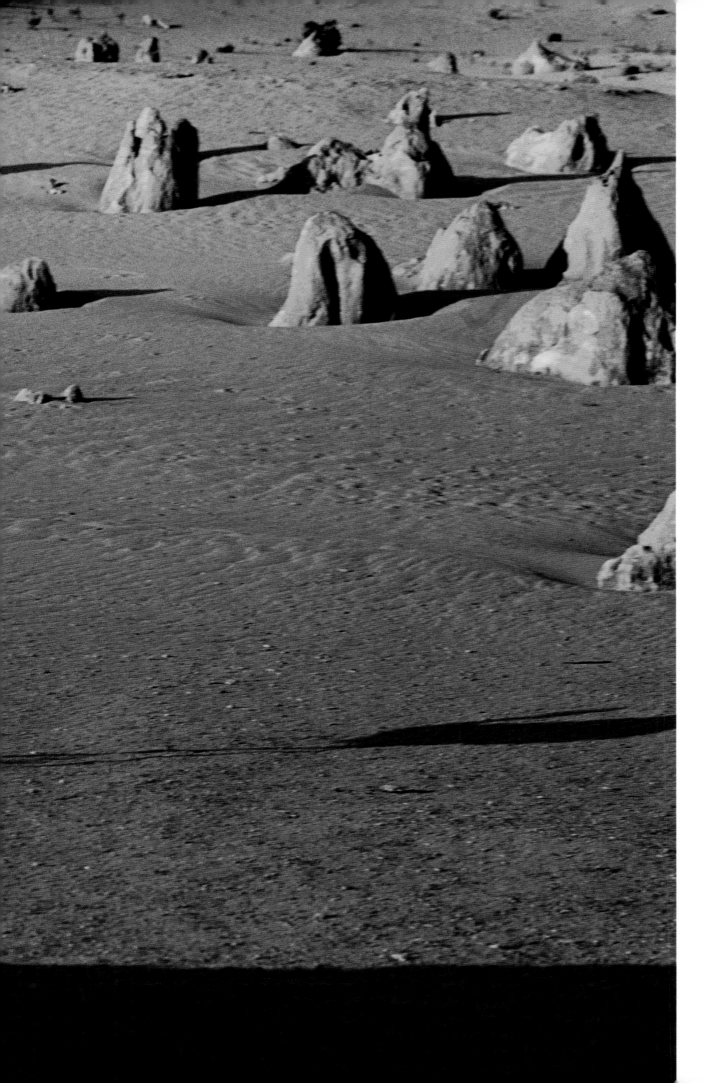

64-65 EMUS ARE JUST ONE OF
THE SURPRISING INHABITANTS
OF THE PINNACLE DESERT,
WHICH RESERVES UNEXPECTED
SURPRISES FOR THOSE WHO
HAVE THE PATIENCE TO STOP
AND WATCH THE LOCAL FAUNA.

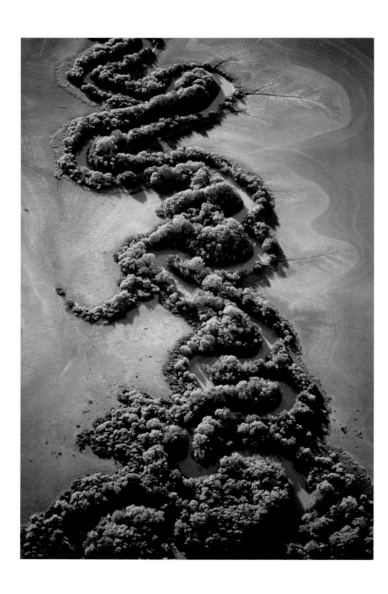

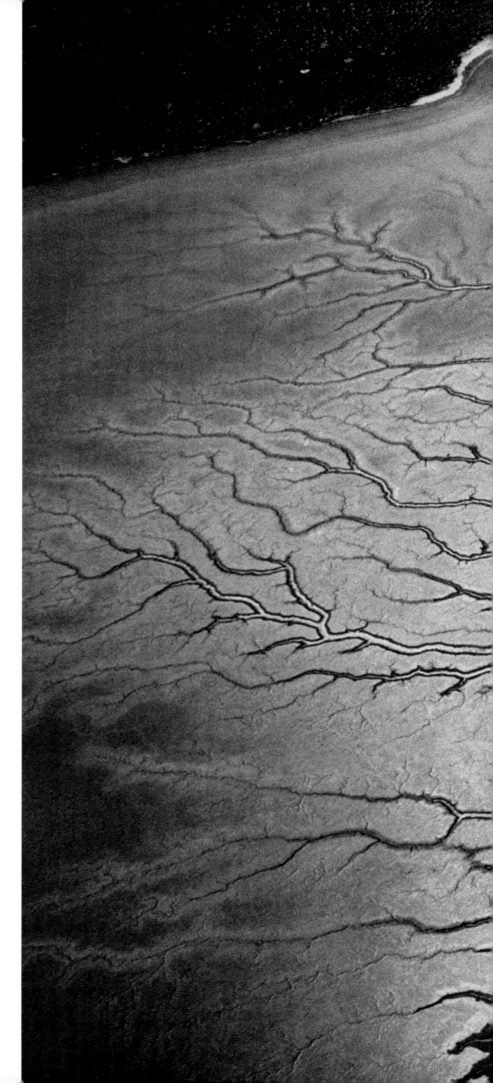

66 A SWIRL OF FOREST MARKS THE PRESENCE OF THE TREE-LINED RIVER, WHICH CUTS THROUGH THE UNBROKEN BLANKET OF THE SURROUNDING LAND.

66-67 THE RIVER, WHICH FORMS MANY NARROW BRANCHES RESEMBLING THIN CRACKS IN ICE, APPEARS LIKE A FRAGMENT OF WATER AND FOREST LOST IN THE BARENESS OF THE MUD THAT SURROUNDS IT ON EVERY SIDE.

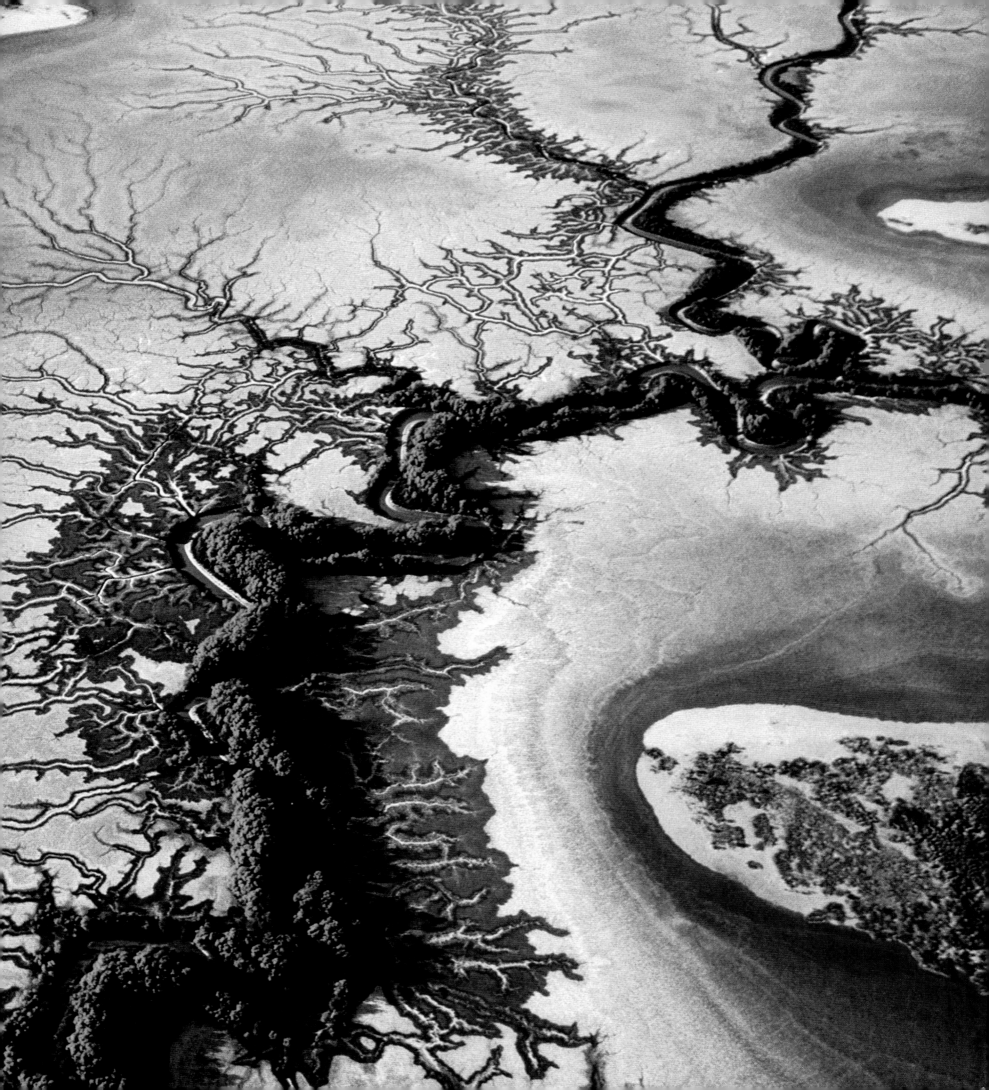

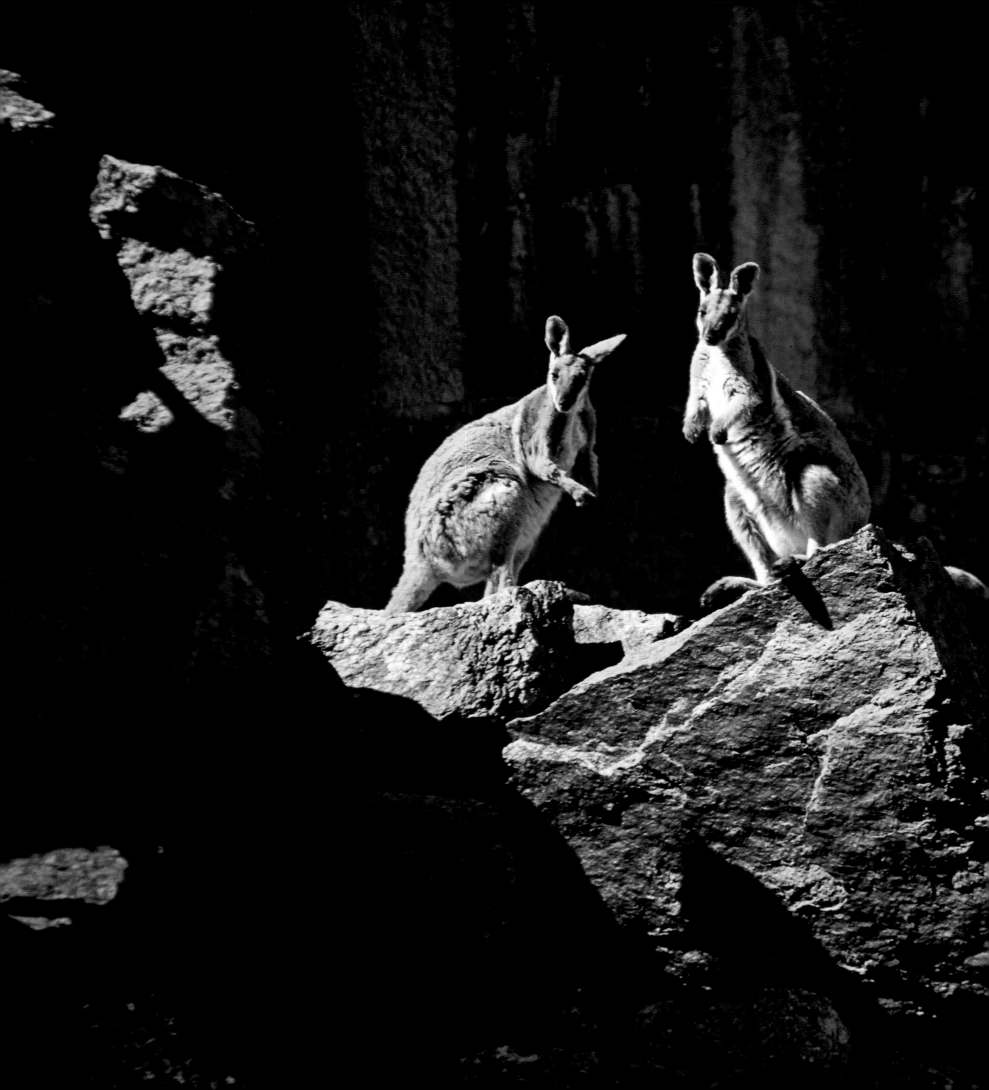

68-69 A couple of wallabies peep curiously from between the rocks in Flinders Ranges National Park in South Australia.

70-71 A helicopter flies over the Bungle Bungles in the Purnululu National Park. These rounded rock formations are striped with alternating layers of silica and black lichens. The lichens cover the darker areas, creating an evocative contrast with the orange silica.

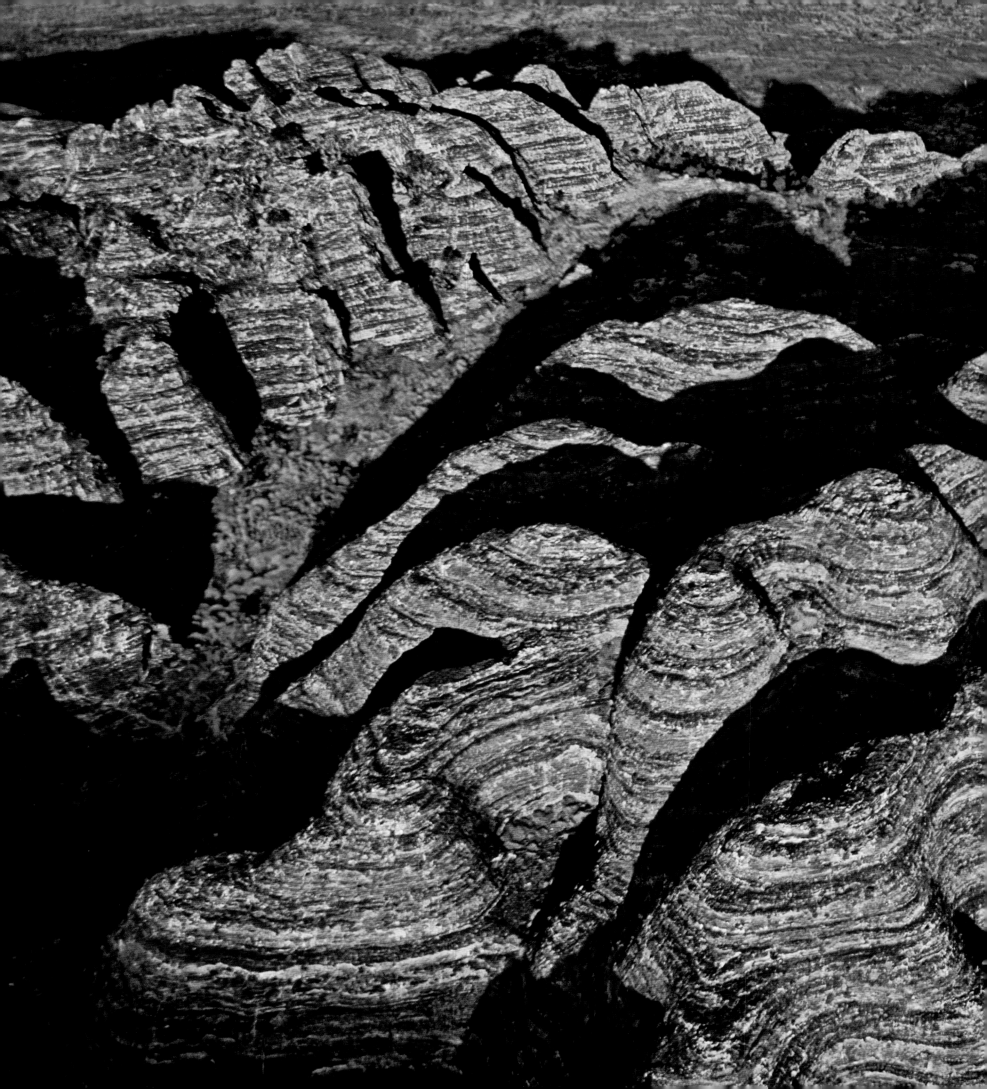

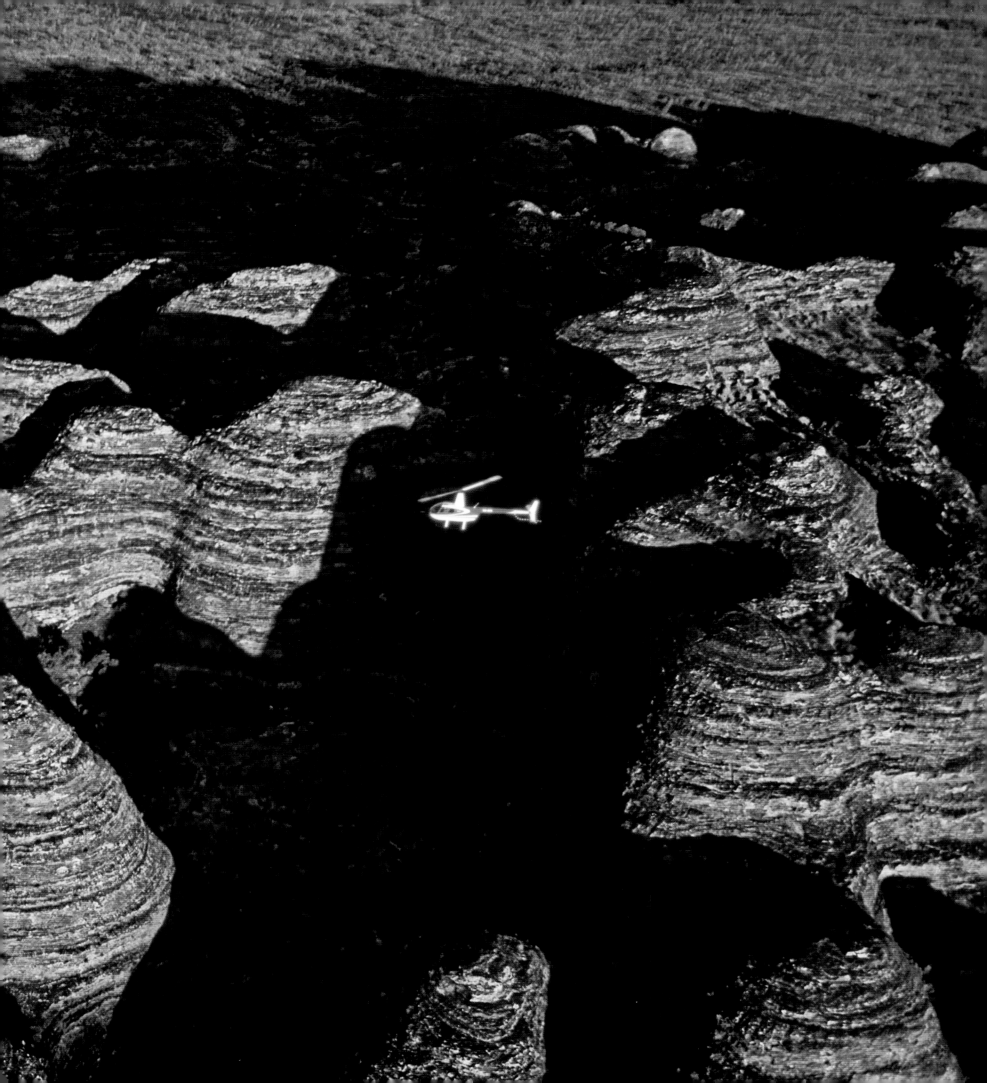

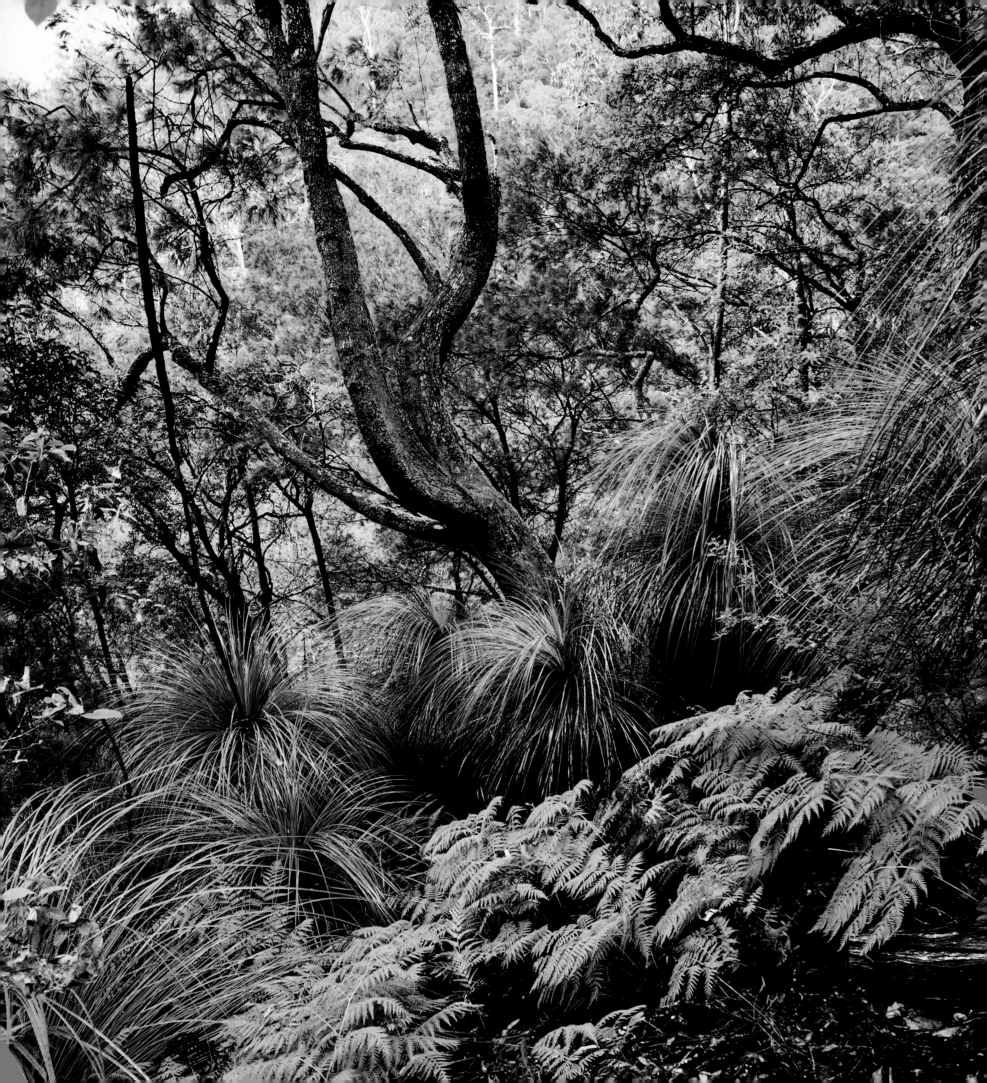

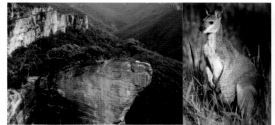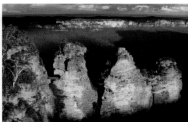

72 Lush vegetation grows along the sides of a path in the Kondalilla Falls National Park, on Queensland's Sunshine Coast.

73 FROM LEFT TO RIGHT Mountains covered with green gum trees at Hanging Rock, in the Blue Mountains National Park; a kangaroo, the symbol of Australia; the Three Sisters (Meehni, Wimlah and Gunnedo), seen from the panoramic viewing spot of Echo Point, at Katoomba, in the Blue Mountains National Park.

GREEN
FOREST

Green like the forest, green like the spirit of Australia, the country that dreams of greenery, even when it knows – in the vastness of the desert – that it cannot have it.

Perhaps this is the reason why the forests of the land down under have a bewitching charm. They are accompanied by a prehistoric memory and enchant according to an ancient Aboriginal rite, blending present and future in a single magical past. The forests are tropical gardens: talkative and brightly colored parrots nest in the trees, kangaroos and wallabies graze in the grass, great emus hide among the ferns, and countless microscopic insects, sinuous snakes and poisonous spiders creep between the leaves. The forests cloak the mountains with iridescent waves, work their way between the rocky balconies and dissolve in marshes, covered with a blanket of water lilies and mangroves. They are set with crystal-clear lakes that are inhabited by "freshies" (freshwater crocodiles), and crossed by slow-flowing rivers resembling giant snakes, which are populated by "salties," the terrifying saltwater crocodiles.

The green of the forest overwhelms the senses. A truly unique emotion strikes you the first time that you look down on the Australian forest from high ground. Your nostrils throb with pure oxygen, heavy with exotic perfumes; your ears are filled with the voice of the wind and singing of the birds, and your eyes take in the endless expanse of hills, covered with a thick and intricate green cloak that fades to shades of emerald green with bluish shadows towards the horizon. The end cannot be seen and you feel a part of something greater. You are tempted to close your eyes and fix a snapshot in your mind so that you can remember the sight forever. Your heart releases an incredible sense of freedom. How many shades of green exist? Ten, twenty, a million? It seems as though Australia knows them all.

The thickly-wooded Blue Mountains in New South Wales are swathed in a rarefied blue mist produced by eucalyptus oils, which has given them their name. They have an almost surreal appearance, crossed by winding trekking trails that run alongside ravines and precipices, climb up the rocks and linger over breathtaking panoramas, like at Hanging Rock. Kattoomba, Wentworth Falls, Mount Victoria and Mendlow Bath are no ordinary mountain towns: they have become luxurious resorts and the favorite retreats of many Sydney residents, with their wooden houses, Victorian hotels, spas and wellness centers, cafés frequented by artists, antique and confectionary shops and sophisticated art galleries. Artists and eccentric figures haunt pretty Leura, where sorcery shops line the road that leads into the forest. However, once again Nature is the star of the show, displaying her works of art, such as the magnificent Veil Falls and Gordon Falls.

Another natural masterpiece is the Three Sisters, vigil ladies of the forest. The name of these three sandstone rocks is derived from an Aboriginal Dreamtime legend that tells of a chief of a tribe who transformed his three daughters into stone to protect them during an enemy invasion, but unfortunately died before he had the chance to break the spell. Today the three rock formations are part of the mystery of this land, like the caves carved out of its bowels in an ornate pattern of limestone formations, stalactites and stalagmites. The Jenolan Caves are another evocative spot, where adventurous young Australians bring their girlfriends for a romantic boat trip on the underground lakes. There is even a ramshackle hotel that displays faded black-and-white photographs of its guests.

74 FROM LEFT TO RIGHT THE TROPICAL FOREST OF CAPE TRIBULATION NATIONAL PARK, IN QUEENSLAND, REACHES OUT WITH ALL ITS WILD AND IRREPRESSIBLE POWER TO LAP THE SEA, REVEALING ONLY A STRETCH OF BARE GRAY ROCK AND A TONGUE OF WHITE SAND; A KOALA PEEPS CURIOUSLY THROUGH THE BRANCHES OF A GUM TREE ON KANGAROO ISLAND; THE GREAT OCEAN ROAD, ON THE SOUTHERNMOST COAST OF THE STATE OF VICTORIA, CROSSES OTWAY NATIONAL PARK, HOME TO A RAINFOREST WITH EUCALYPTUS WOODS AND SPECTACULAR WATERFALLS, INCLUDING THE BEAUCHAMP FALLS.

The green of the forest also transforms the walls of the Dandenongs – Melbourne's version of the Blue Mountains – into a dense web of gum trees and enormous umbrella-shaped ferns, whose fissures are home to at least 300 species of orchid and multicolored birds, including the lyrebird, which is a skilled mimic capable of reproducing all sorts of noises. Rocky peaks, ravines with Aboriginal rock drawings and waterfalls that cascade onto amazing rock formations are the attractions of another range of mountains: the Gariwerds, in the huge Grampians National Park in Victoria. The area is a mosaic of varied landscapes, with eucalyptus forests inhabited by amiable koalas, arid expanses, lush ferns, watercourses, whose banks are frequented by shy platypuses, and stretches of subalpine vegetation around Mount William.

The green of the forest turns to white in the Snowy Mountains, between New South Wales and Victoria. The presence of snow makes

 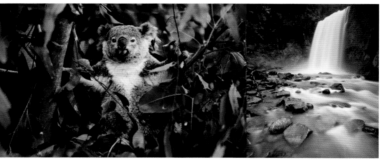

them special for Australians, as the only other place in the country where it can be found is in the Victorian Alps. Although the Snowy Mountains are not particularly high in comparison to the world's other ranges, their ski slopes that cut through eucalyptus forests, very low temperatures (which can fall to –20° C) and little towns that imitate the Swiss ski resorts make them an attractive destination. They are dominated by Mount Kosciusko, the highest point in Australia, at 7316 feet. Kosciusko National Park is an expanse of thick forests, mountain peaks, meadows of colorful wildflowers, splendid morainal lakes set in the greenery and crystal-clear mountain streams in which anglers fish for trout.

In Queensland the green is lit with endless colors in the most magnificent of all the Australian forests. This tall, rich and incredibly

beautiful woodland is what remains of the primordial tropical forest that enveloped the entire continent millions of years ago. It is a green universe, which reawakens the senses and takes the spirit back to its roots. The air is hot and heavy, overwhelmed by precious essences, and the sun peeps through the branches, threatening the broad leaves of the ferns and caressing the tropical flowers that sprout from the intricate vegetation. The forests follow on from each other in a long series, the symbols of the generating power of creation. The stern Atherton Tablelands dominate Cairns in a triumph of iridescent shades of green. The magnificent woods of Barron Gorge National Park, with its untamed nature, are counterbalanced by two volcanic lakes – Lake Eacham and Lake Barrine, heavenly expanses of crystal-clear water – and the forest of Mount Hypipamee National Park, which boasts 300 species of birds, pools and pure white waterfalls. The green of the forest reaches far away, snaking around the Captain Cook Highway as far as Cape Tribulation, another of nature's frontiers. It forms a rainbow of shades ranging from green to blue, composed up of tropical hills furrowed with rivers and mountain streams, isolated and solitary white sandy beaches, set in the deep blue sea, fishing villages, and waterfalls that tumble into deep gorges, such as Mossman Gorge, the home of the Kuku Yulanji Aborigines. The forest and the Daintree River merge in a wild triumph of emerald green in the Daintree National Park. You can dive off giant rocks into the crystal-clear mountain streams, travel on steel-bottomed boats (necessary to protect craft from crocodiles) that slowly follow the current, or cross rivers on wooden barges. You can listen to the tales of Crocodile Dundee-like figures that describe enormous snakes capable of swallowing a sheep and "salties" that devour poor rangers, but are also raised – and sometimes eaten – on the local farms. Cape Tribulation, thus called by Captain Cook after his ship ran into its coral reef, forms the extreme tip of this paradise. It is frequented by hippies and artists seeking a new life and is lapped by the turquoise waters of the Coral Sea and edged by lacy patterns formed by white tongues of sand. The Cape Tribulation

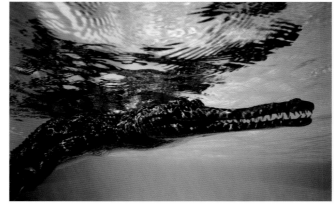 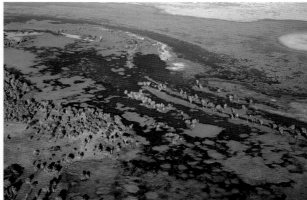

National Park is home to species of plants and flowers that grow in no other place in the world, as well as a huge variety of ferns. It is like being in an enormous greenhouse populated by over 120 types of birds, sentinels of the forest, which are often none too silent. The huge branching estuaries, where enormous brightly colored butterflies flutter among the mangroves, are also home to crocodiles.

The green of the forest triumphs in its full force in another distant Australian frontier: the Tip, or the Cape York peninsula, which is one of the most untamed corners of the country and last scraps of Aboriginal land. The area is difficult to reach, requiring a journey of at least 500 miles by jeep. During this great adventure among muddy roads, fords and rivers teeming with crocodiles that are impracticable and flooded during the monsoon period, you will come across small mining towns – relics of a world that is no more – such as the desolate ghost town of Weipa, a memento of the gold rush. These areas are haunted by the sad tale of Edmund Kennedy's 1848 expedition, of which only 3 of the 14 participants survived. Kennedy himself died, wounded by an Aboriginal spear. Today it is possible to approach the world of the natives in a more peaceful manner, visiting the Quinkan Reserve Aboriginal Art Galleries, which house some of the world's richest collections of rock paintings. Quinkan is the name of the characteristic and somewhat sinister figures with wide-open eyes that the Aborigines believe to hide in the cracks in the rock. Laura, a former gold mining town hosts the Aboriginal Dance Festival in June, during which the Aborigines perform spectacular dances to the rhythm of music with a truly hypnotic power, in another moving event that is impossible to forget.

The green of the forest encounters the deepest spirit of Australia in another magical spot: Kakadu National Park – the largest in Australia – in the heart of the Top End of the Northern Territory. Here wetlands extend for over 7,700 square miles of pure, wild and irrepressible tropical nature; mountain ranges stretch as far as the eye can see, racing towards infinity; rocky terraces struggle to emerge from the thick blanket of vegetation, while red sandstone formations, cloaked in woodland, fall away in sheer walls with mysterious ravines at their feet. The wide green South Alligator River dissolves in a maze of waterways and pools, which becomes an enormous basin with layers of water lilies and green tongues of grass and shrubs in the rainy season, when it becomes home to thousands of birds that are attentively eyed by the large saltwater crocodiles. Just as the rock changes color with the light of the day, Kakadu also changes, develops and mutates with the passage of the year; indeed, the Aborigines identify six distinct seasons. The marshes are an infinite microcosm of water in all shades of green and dry up with the arrival of the dry season, creating a series of billabongs: pools that are covered with water lilies and frequented by birds (280 species!). They attract elegant Jabiru storks, menacing crocodiles, wallabies, large and small kangaroos and wild creatures that return to hide in the bush as soon as they can. Only the parrots maintain a lively presence in all seasons. Mother Nature, the ruthless ruler of this land, indulges her whims in an explosion of colors toward the sea, with a flourish of rainforests, eucalyptus woods, swamps and mangroves. The land is dotted with tall, sculpture-like termite mounds that resemble jagged rocks. During the monsoon period, the waters of the rivers pour over the sandstone escarpments, culminating in lakes, cataracts and waterfalls, such as the Jim Jim Falls, which cascade over a 500-foot cliff, or the Twin Falls, where the river empties into a pool of water fringed by a sandy beach. In Kakadu the earth speaks with the voice of the Aborigines and shows itself in the twists and turns, ravines and fissures of the stone: the cradles of rock painting and guardians of secrets dating

77 The evocative Russell Falls cascade between the luxuriant vegetation of Mount Field National Park in Tasmania.

78-79 Tarra Bulga National Park, in the heart of the Strzelecki Ranges, is dominated by splendid eucalyptus forests (*Eucalyptus regnans*), which create a unique habitat.

back 20,000 years. A mystic atmosphere pervades the Ubirr caves, whose walls are decorated with figures of animals, the Mimi trickster spirits and the legendary rainbow snake. The shadow of mystery and uneasiness also hovers over the figures and symbols of Nourlangie Rock, another spiritual legacy of the Gagadju. Admiring Aboriginal art remains a sensory experience that draws the viewer into the deepest, blackest soul of these people. When you enter a sacred cave, you have the sensation that you are not alone and feel your skin crawl: this is the breath of the spirits.

The magic of lights and colors is repeated at Yellow Water, a lagoon that looks as though it has been painted on canvas with bright oil colors, set among lush vegetation that intermittently culminates in the yellow triumph of the water lilies that dot its surface around the trees. These trees shade into hues of pink at violet at dawn and sunset, while they are enchanted by the moonlight at night and lit by the sun during the day.

The green of the forest also merges with the water in Litchfield National Park, another corner of the Northern Territory that is home to a marvelous collection of waterfalls and imposing sandstone structures. It is dominated by the Tabletop Range, enveloped by a eucalyptus forest, where billabongs alternate with lush green areas dotted with termite mounds and pure white waterfalls that plunge off red stone cliffs into wonderful little lakes. Here the water is so light and pure that it almost seems to perfume and caress the skin. The forest is reflected in a marvelous tropical pool at the Wangi Falls, while the Florence Falls, Tolmer Falls and Sandy Creek Falls are also a triumph of water and rock. Mystery — that sense of the unknown and disturbing — is rediscovered at Lost City, in a complex of sandstone pillars of uncertain origin, which recall an ancient abandoned city.

Green nature becomes an idyllic oasis in Lawn Hill National Park, another magnificent area of Queensland constituting a tropical paradise in a vast, torrid and deserted land. It is a perfect blend of limestone hills, fringed with palms, ferns, gum and fig trees; deep gorges formed by 200-foot red sandstone walls, bathed by cool springs; rocks

decorated with the paintings of the Waayani, and waters plied by adventurers aboard canoes, all immersed in dense vegetation populated by an entire universe of animals, including crocodiles, freshwater monitors and rare green pythons. History encounters nature at the Riversleigh Fossil Site, an immense site containing limestone fossil deposits that recount tales of carnivorous kangaroos, giant wombats and the extinct Tasmanian wolf: animals that lived in the jungle that covered these lands at least 20 million years ago.

The green of the forest rediscovers the frontier in the distant land of Tasmania, in its unspoiled virgin forests, which have not yet been entirely explored. Or in the natural amphitheater of the Walls of Jerusalem and the area of the thousand lakes, among the dark and intricate woods of the Franklin-Gordon Wild Rivers National Park, crossed by impetuous rivers and dotted with rugged plateaus dominated by the majestic quartz monolith known as "Frenchman's Cap." The heart of the frontier beats amid the fronds of the Cradle Mountain National Park, where abundant rainfall enables luxuriant forests to prosper, full of waterfalls, springs, buttongrass marshes, picturesque lakes, such as Lake St. Clair, silver acacias and gigantic blue-leaved gum trees. The caves of the impenetrable forest are inhabited by the almost-extinct Tasmanian devil that resembles a badger with the expression of a vampire, which is the only carnivorous marsupial in the world and the star of a fortunate cartoon series. The rainforest prospers in the Southwest National Park and Southwest Conservation Area, and has remained almost intact since the discovery of the island by Abel Tasman in 1642. It is populated by enormous gum trees, which can reach a height of 300 feet, fast-moving rivers that plunge into deep gorges, prehistoric ferns and rare lichens. The forest, where it rains 200 days a year, is permanently veiled in a light mist. Here the senses are seriously challenged and the spirit rediscovers its freedom: absolute freedom, the infinite freedom of a land on the edge of the world, a primordial world that is so intact as to touch the very roots of creation. A remote world on the border between existence and life. . . .

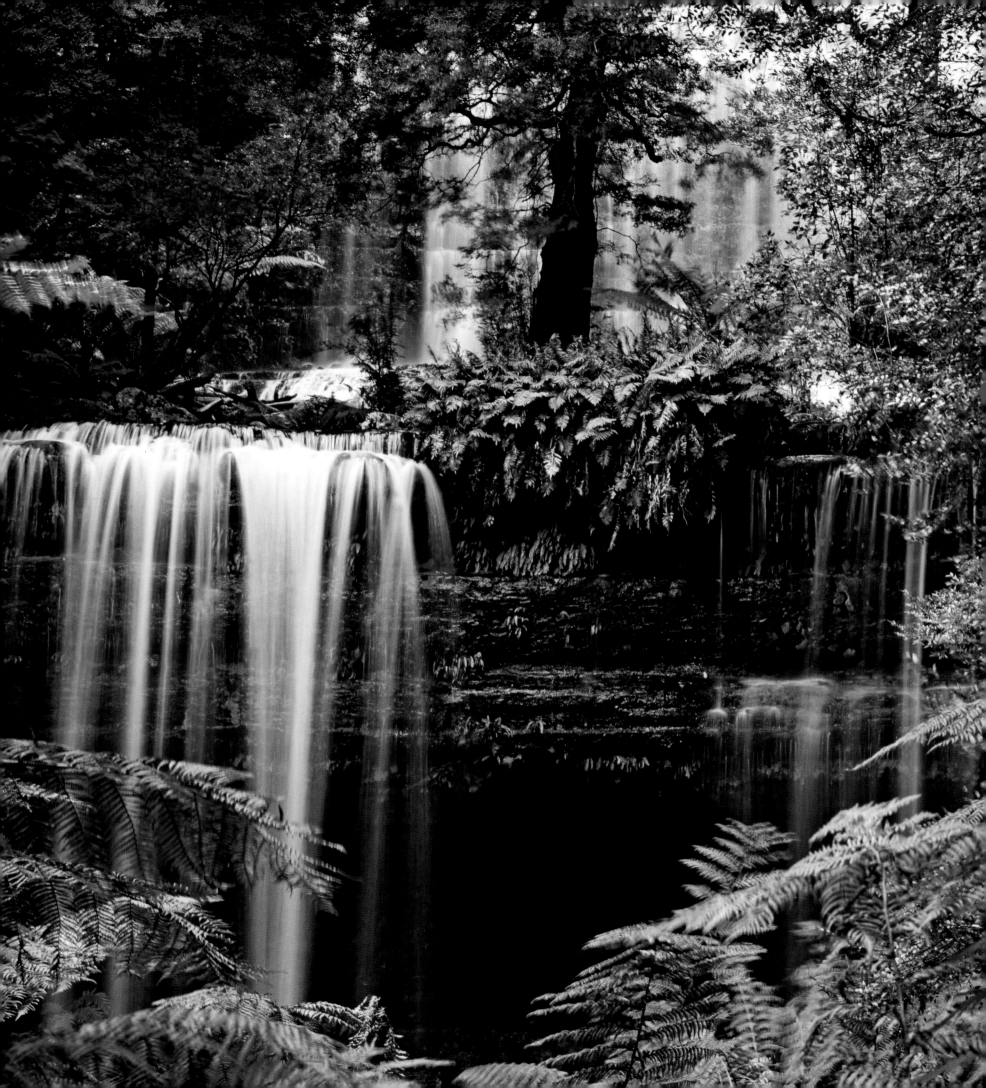

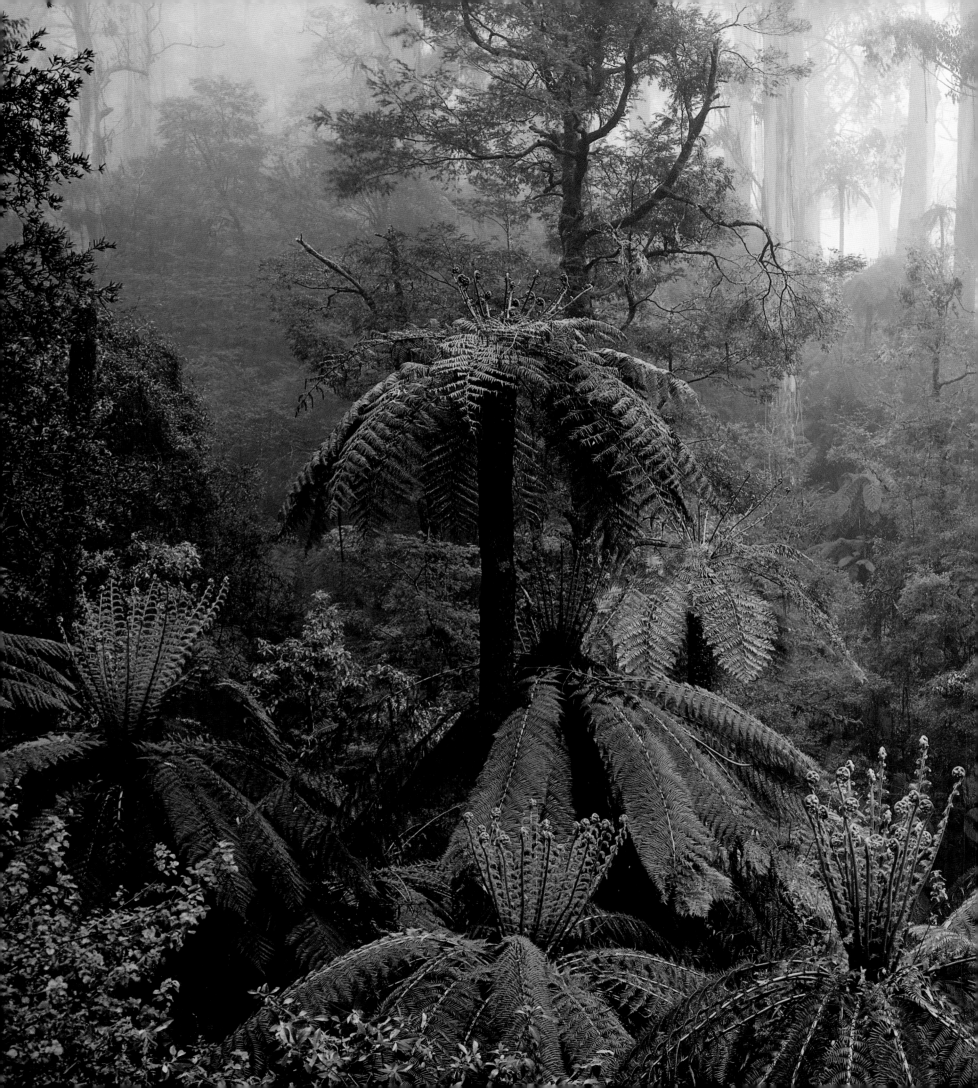

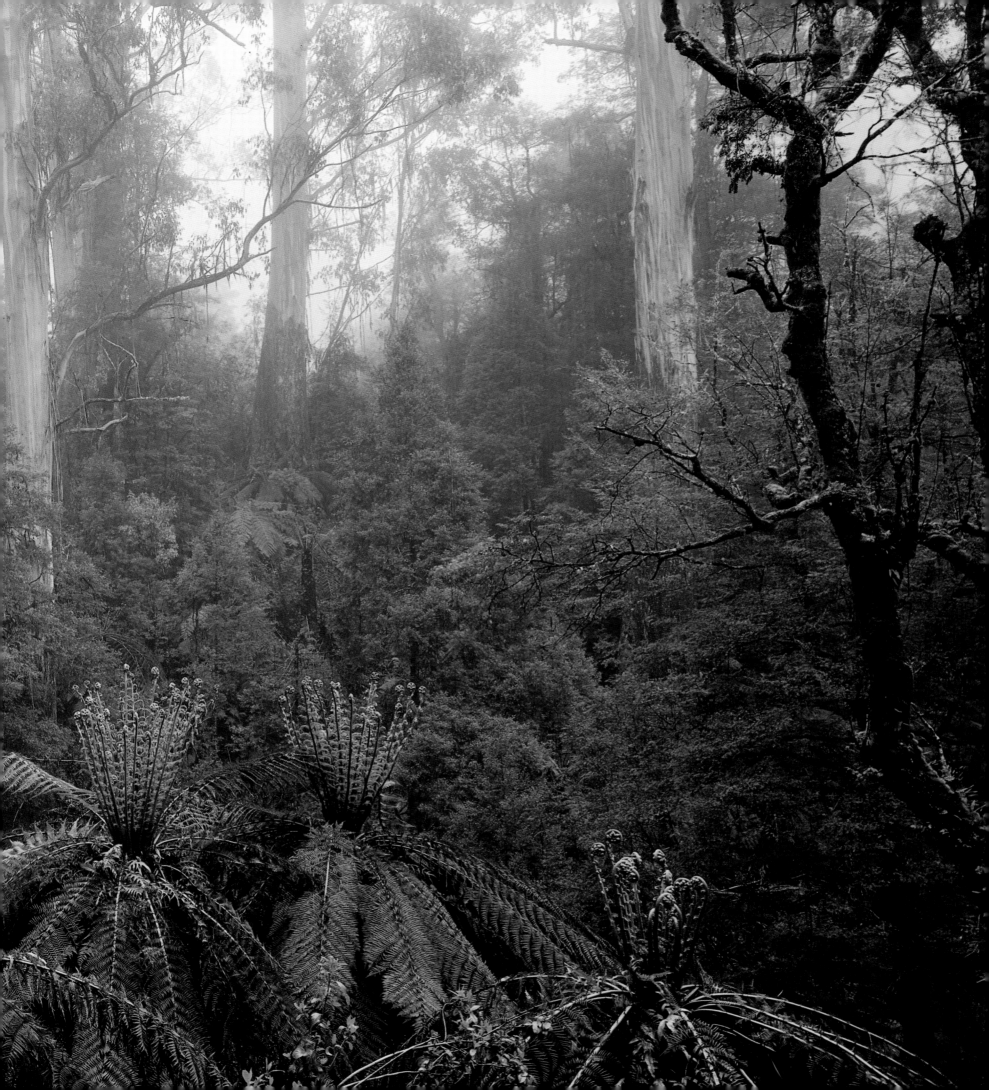

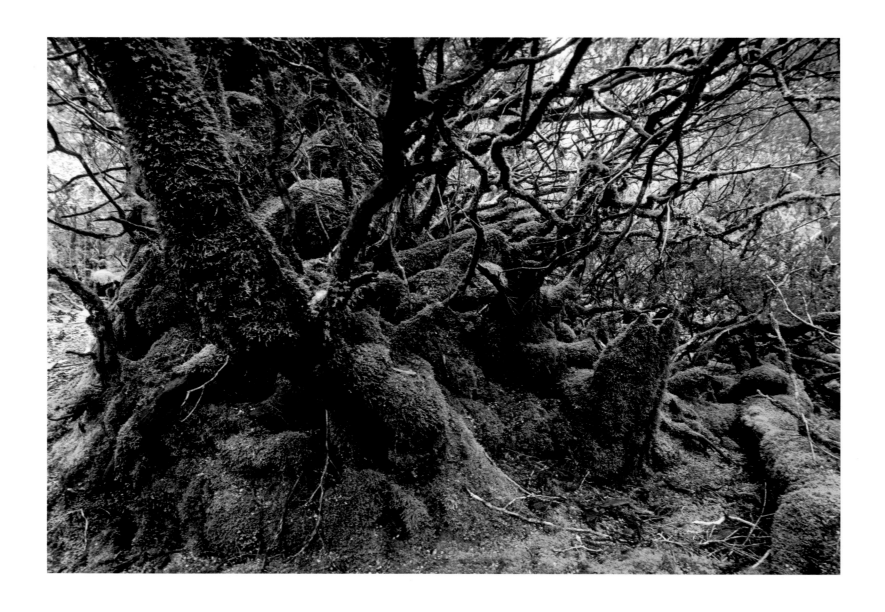

80 TASMANIAN MAGIC. SEGMENTS OF TREES COVERED IN DEEP GREEN MOSS IN THE
MYRTLE FOREST IN CRADLE MOUNTAIN-LAKE ST. CLAIR NATIONAL PARK.

81 WATERFALL VALLEY IN CRADLE MOUNTAIN-LAKE ST. CLAIR NATIONAL PARK
IS HOME TO A THICK FOREST WHOSE GLADES AND CLEARINGS
OFFER MANY EVOCATIVE VIEWS.

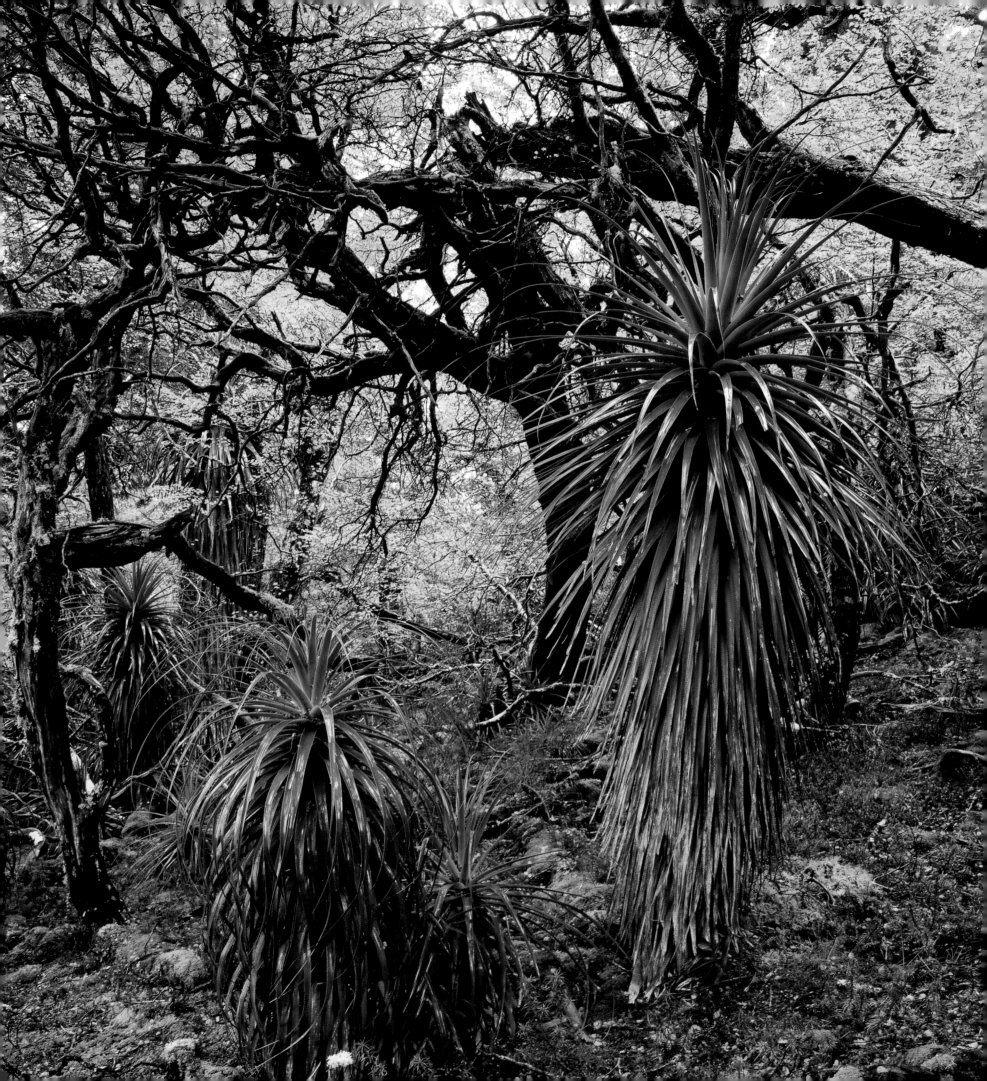

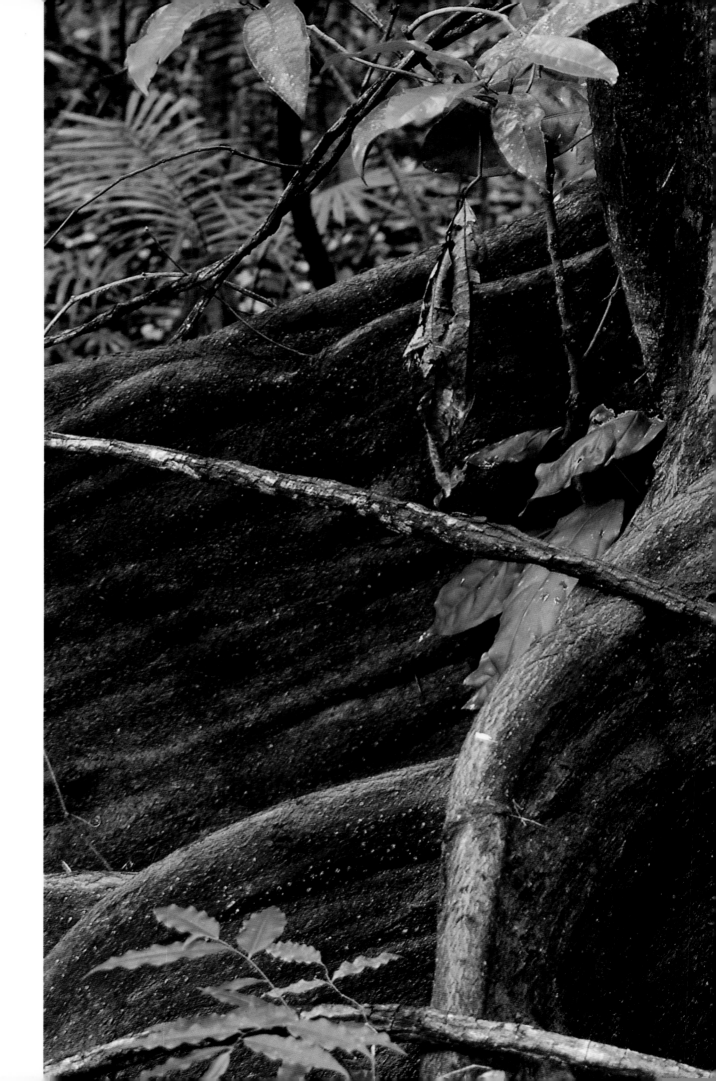

82-83 The mighty roots of a tree intertwine to form curious shapes in the rainforest of Daintree National Park in Queensland.

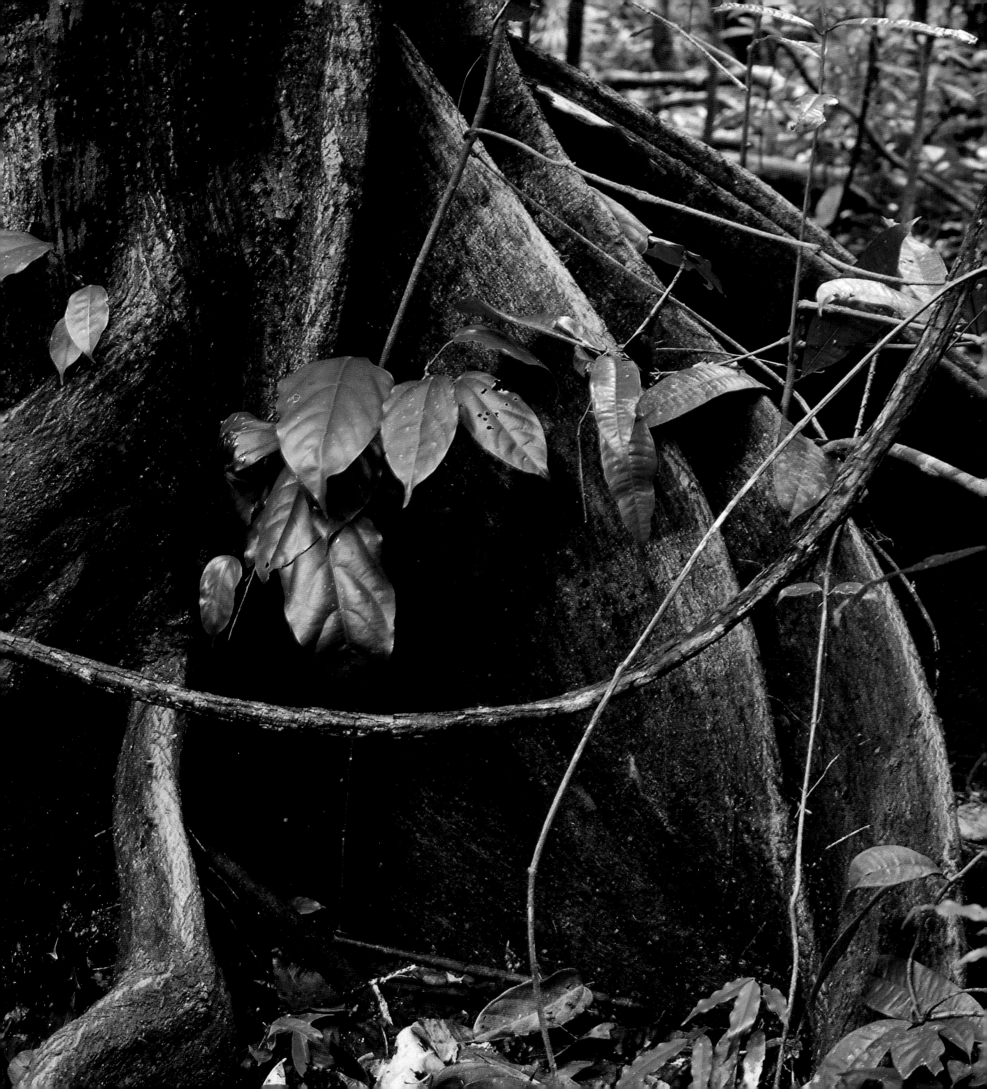

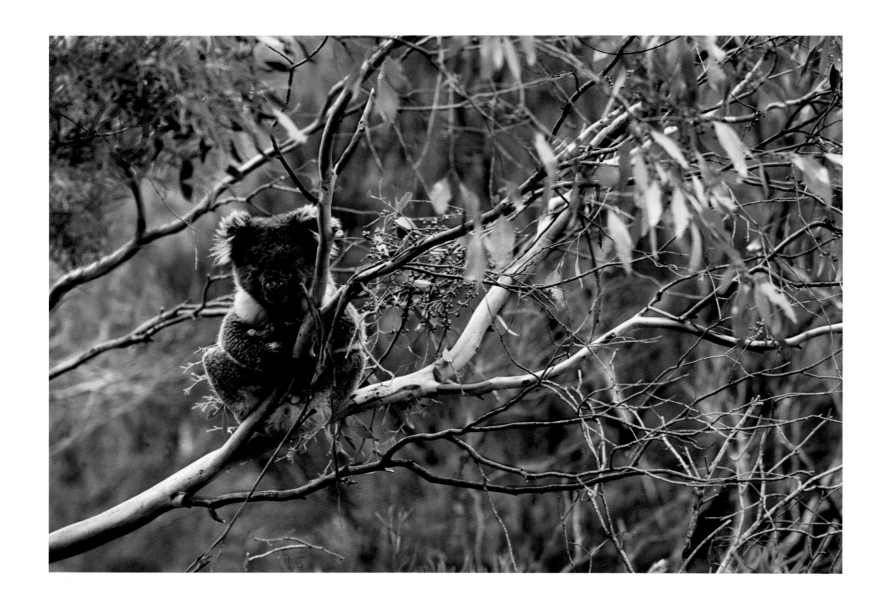

84 A MOTHER KOALA CLIMBING A EUCALYPTUS TREE WITH HER BABY ON HER BACK IN THE
CURRUMBIN WILDLIFE SANCTUARY. KOALAS ARE GENERALLY SHY AND RESERVED ANIMALS.
HOWEVER, SOMETIMES THEY CAN BE SEEN PEERING CURIOUSLY THROUGH THE LEAVES OF TREES
TO SEE WHAT IS GOING ON BELOW.

85 A YOUNG KOALA DOZING ON THE BRANCH OF A EUCALYPTUS TREE.

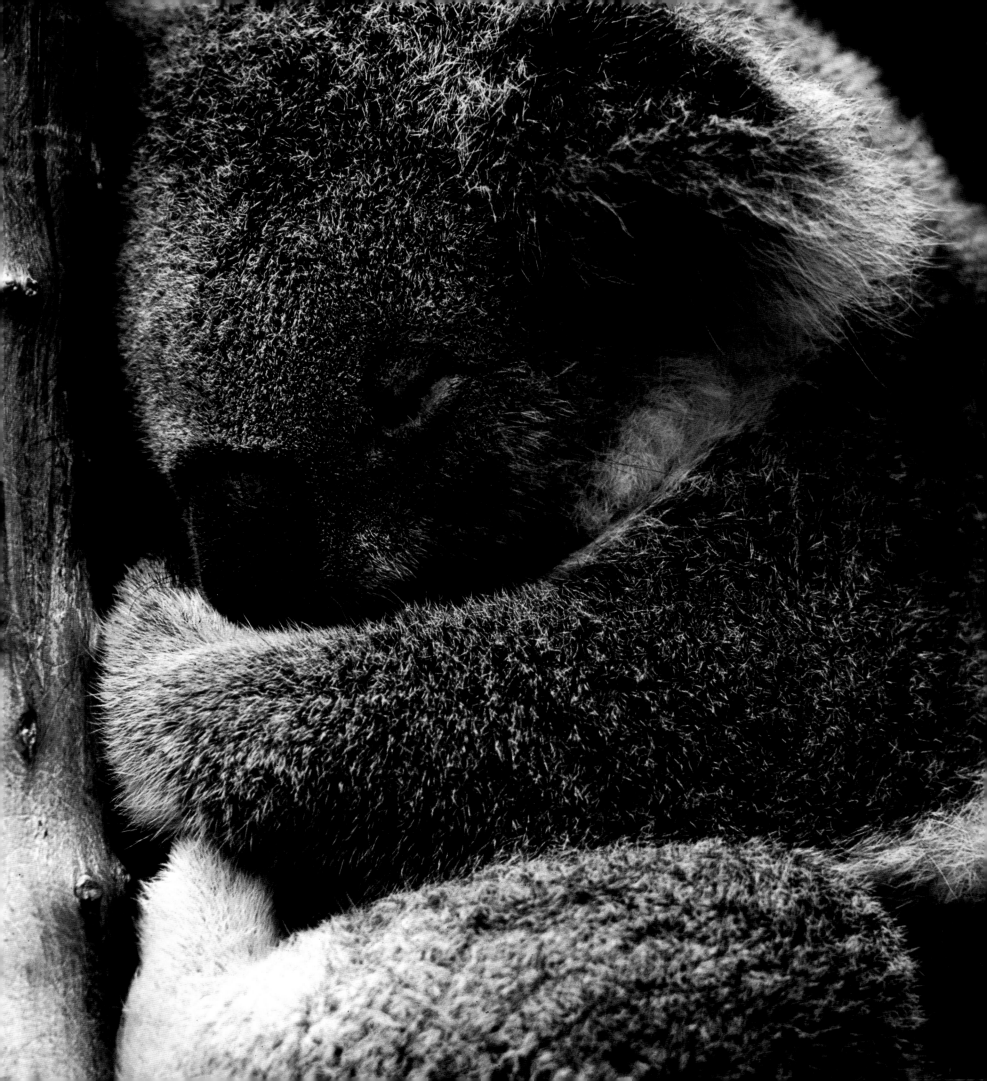

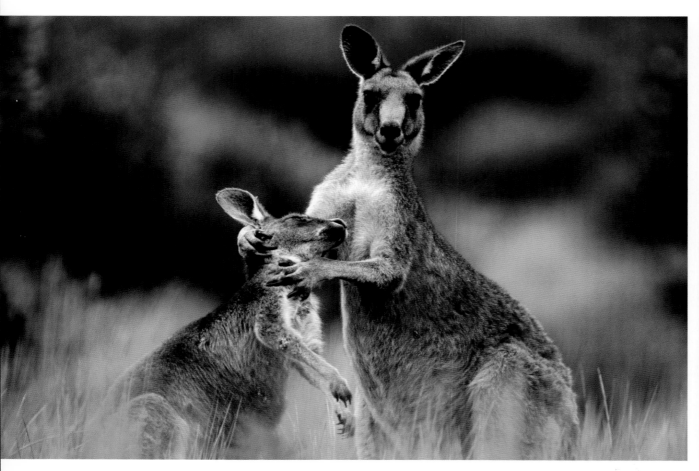

86 WILSONS PROMONTORY NATIONAL PARK IN VICTORIA IS HOME TO A VERY RICH FAUNA, INCLUDING OVER 30 MAMMAL SPECIES. KANGAROOS ARE PARTICULARLY NUMEROUS: HERE AN ATTENTIVE MOTHER AFFECTIONATELY SCRATCHES THE NECK OF HER JOEY.

86-87 A GRAY KANGAROO *(MACROPUS GIGANTEUS)* BOUNDS THROUGH THE BRIGHTLY COLORED VEGETATION IN THE SAME PARK.

88-89 THE GREEN AUSTRALIAN FORESTS, WHICH UNFOLD BOTH IN THE INTERIOR AND ALONG THE COAST — AS IN THIS CASE — ARE ONE OF THE ELEMENTS UNDERLYING THE GREAT APPEAL OF THIS FABULOUS COUNTRY.

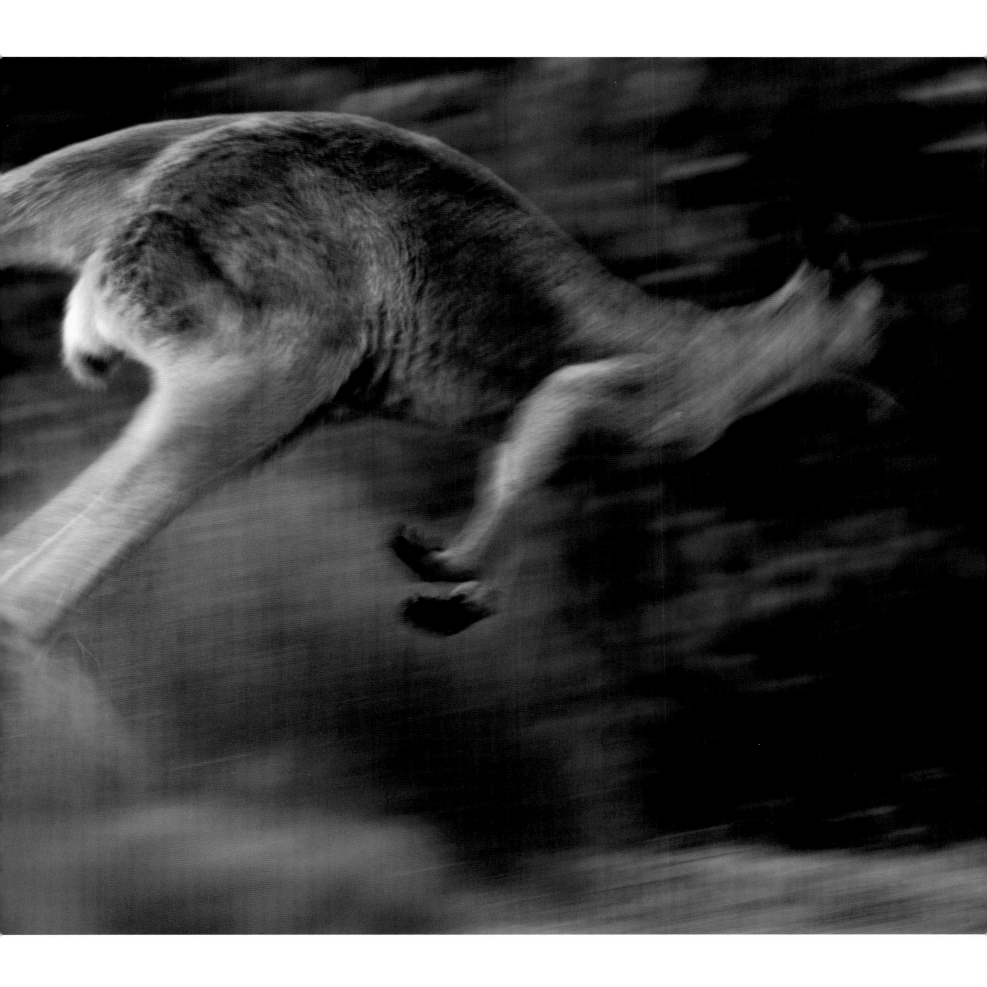

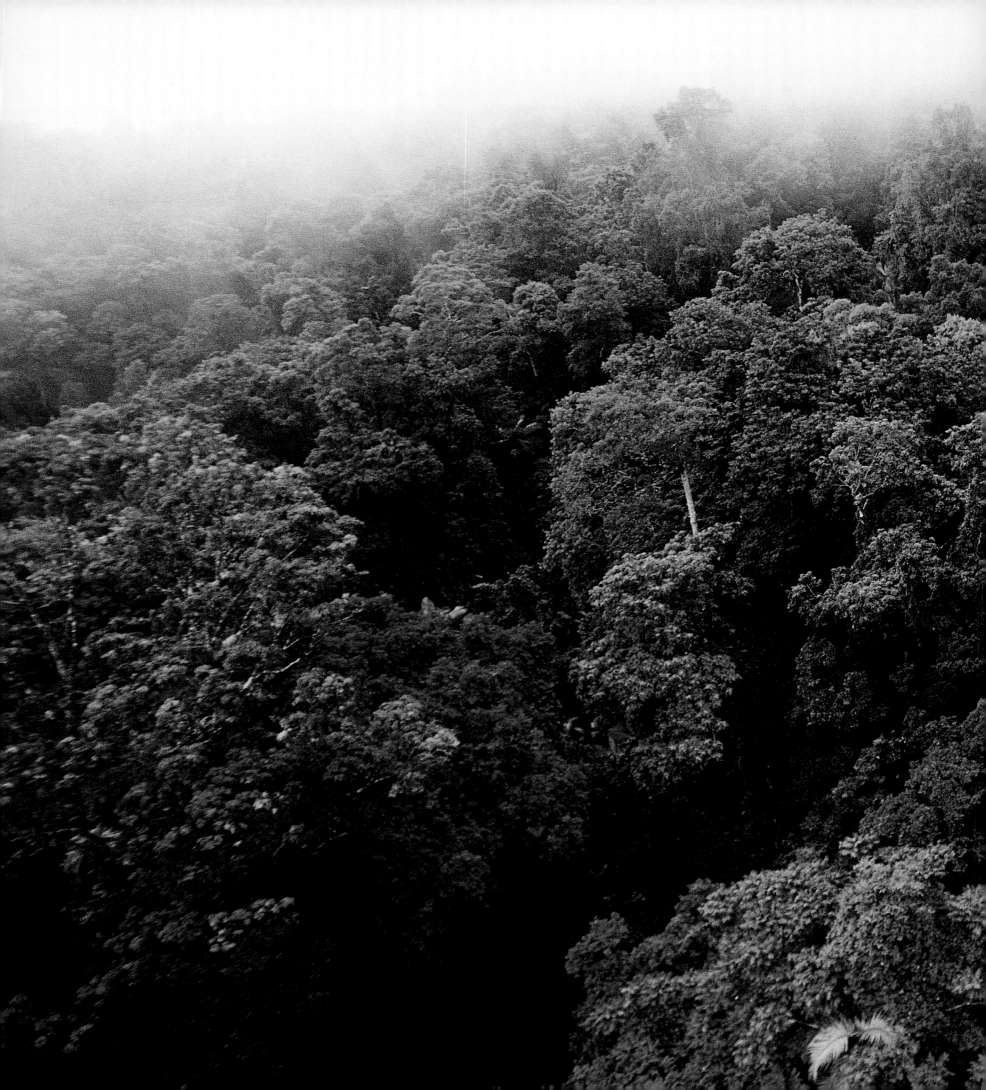

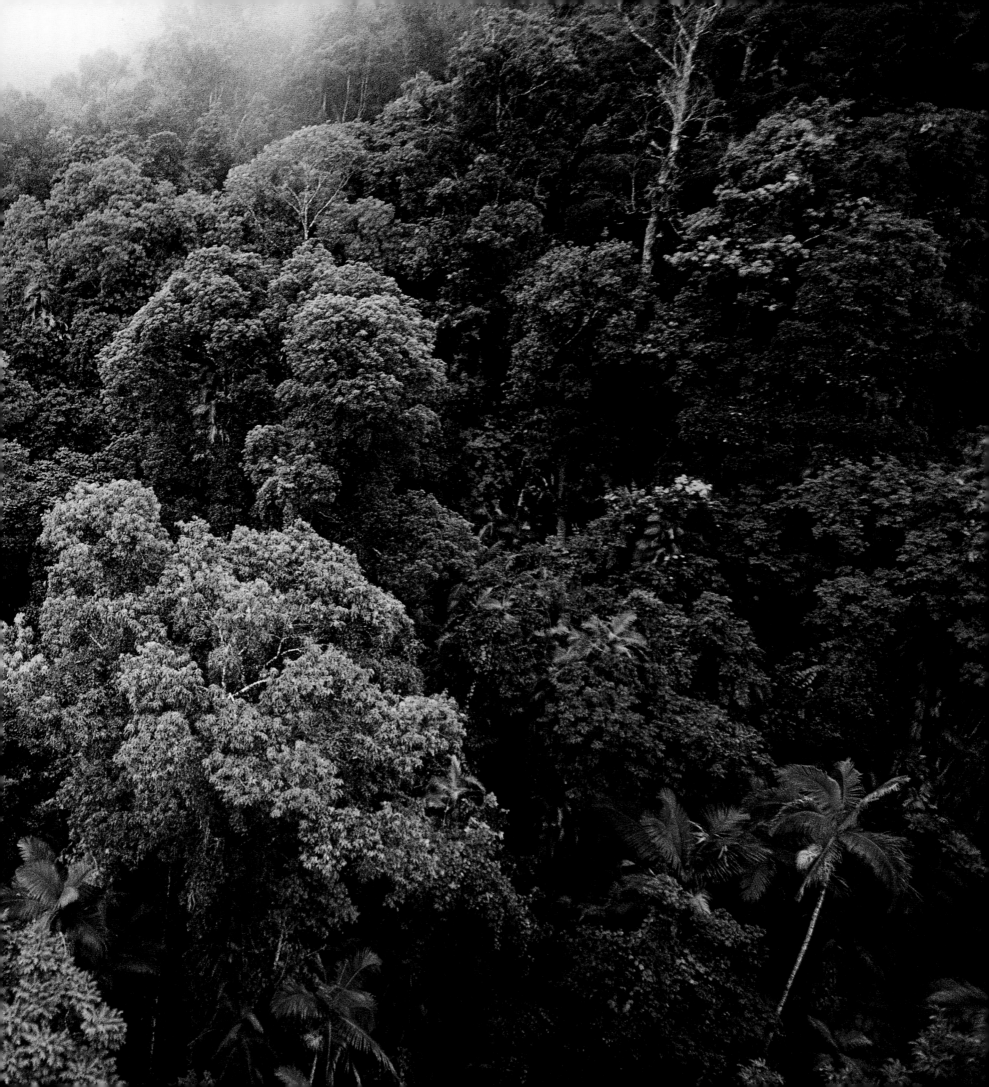

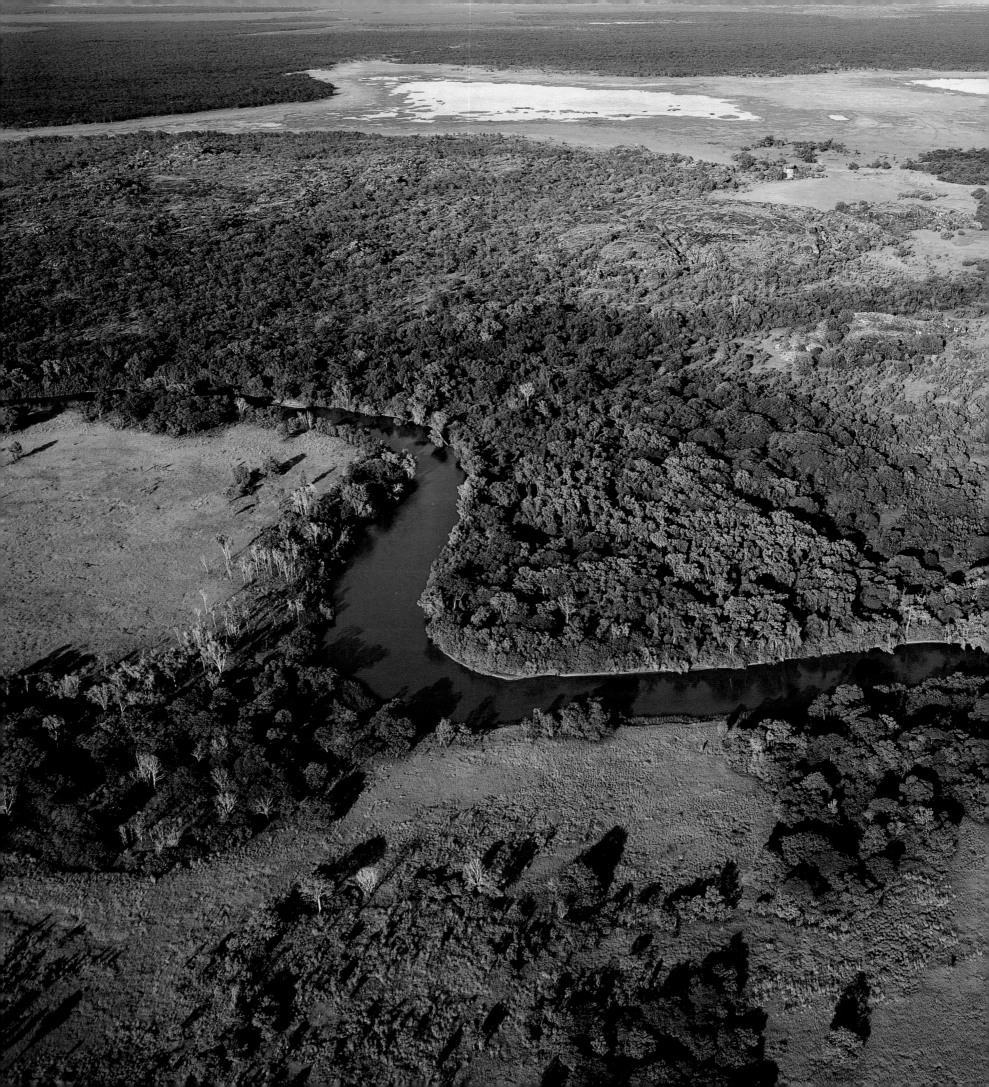

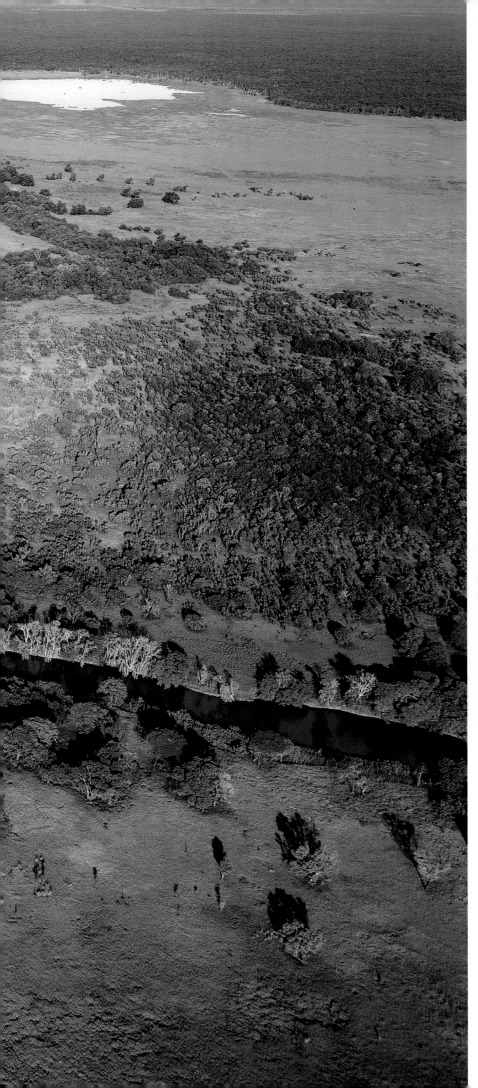

90-91 A WATER WONDERLAND. AN AERIAL VIEW OF THE EAST ALLIGATOR
RIVER, AS IT SNAKES ITS WAY TREACHEROUSLY THROUGH THE UNBROKEN
EMERALD-GREEN BLANKET OF EUCALYPTUS WOODS, FERNS, TREES AND BUSHES.

91 THE EAST ALLIGATOR RIVER ALMOST SEEMS TO "SMILE" AT THE ROCK,
LINED BY THE LUXURIANT GREEN FOREST IN THE CANNON HILL AREA.

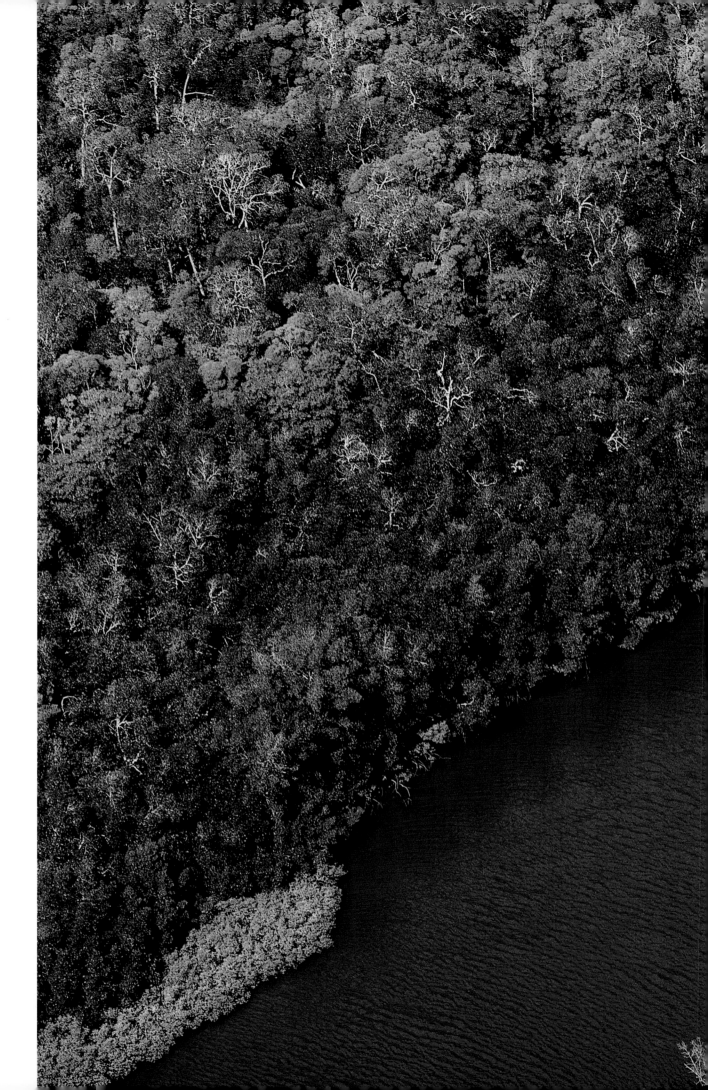

92-93 A boat plows through the waters of Newcastle Bay, on Cape York Peninsula, home to Australia's largest mangrove forest, which covers an area of 77 square miles.

94-95 A Johnston's crocodile glides through the water, legs spread as though ready to pounce. The locals have nicknamed these animals "freshies" since they live in fresh water.

96-97 Immediately following the rainy season, Kakadu National Park is transformed into an immense microcosm of greenery and water.

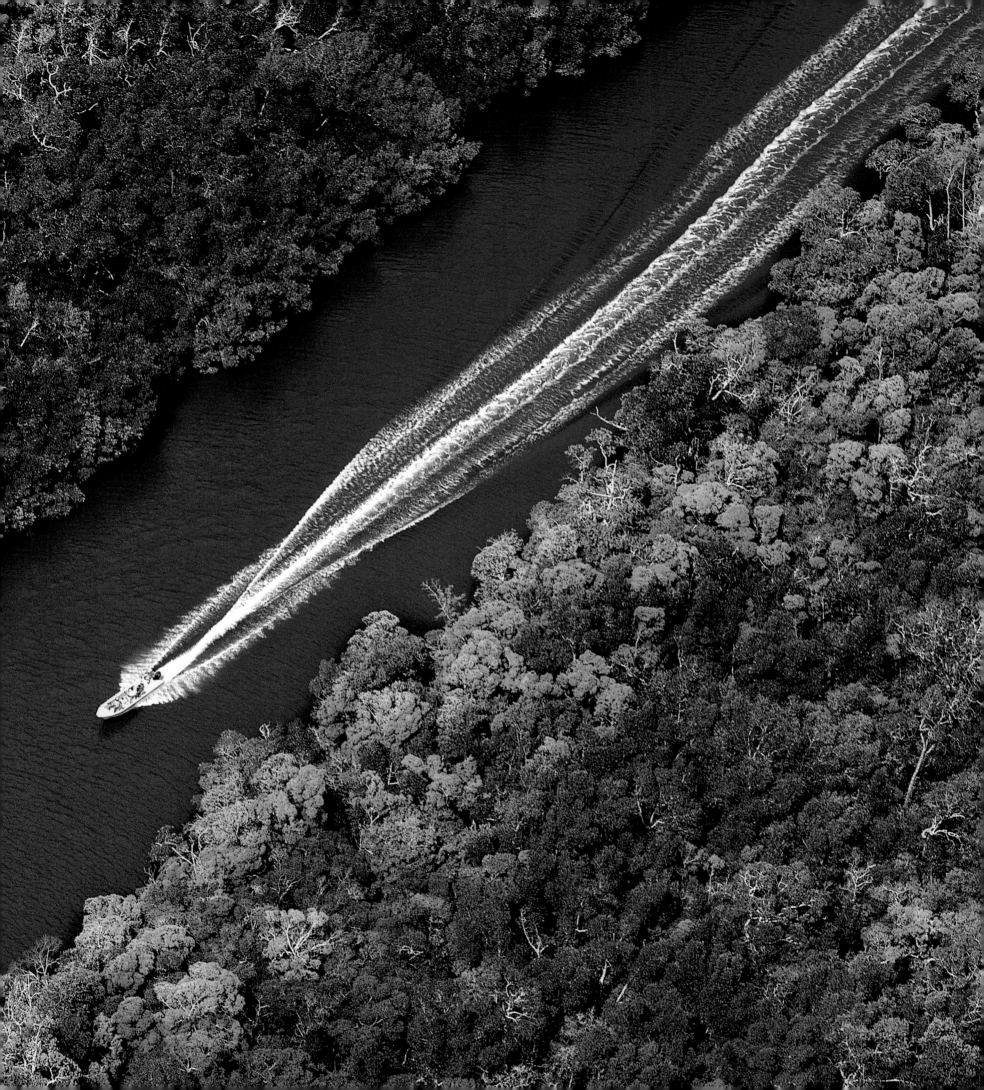

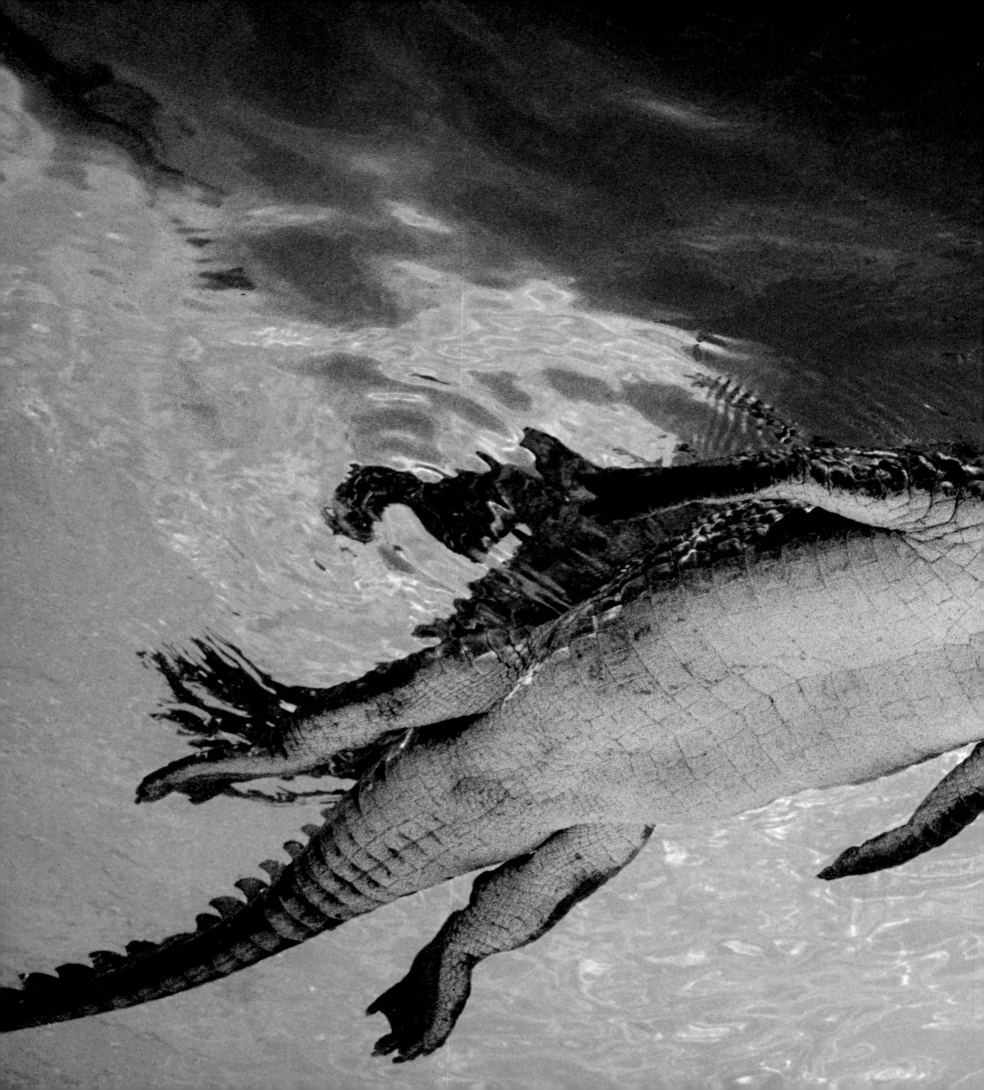

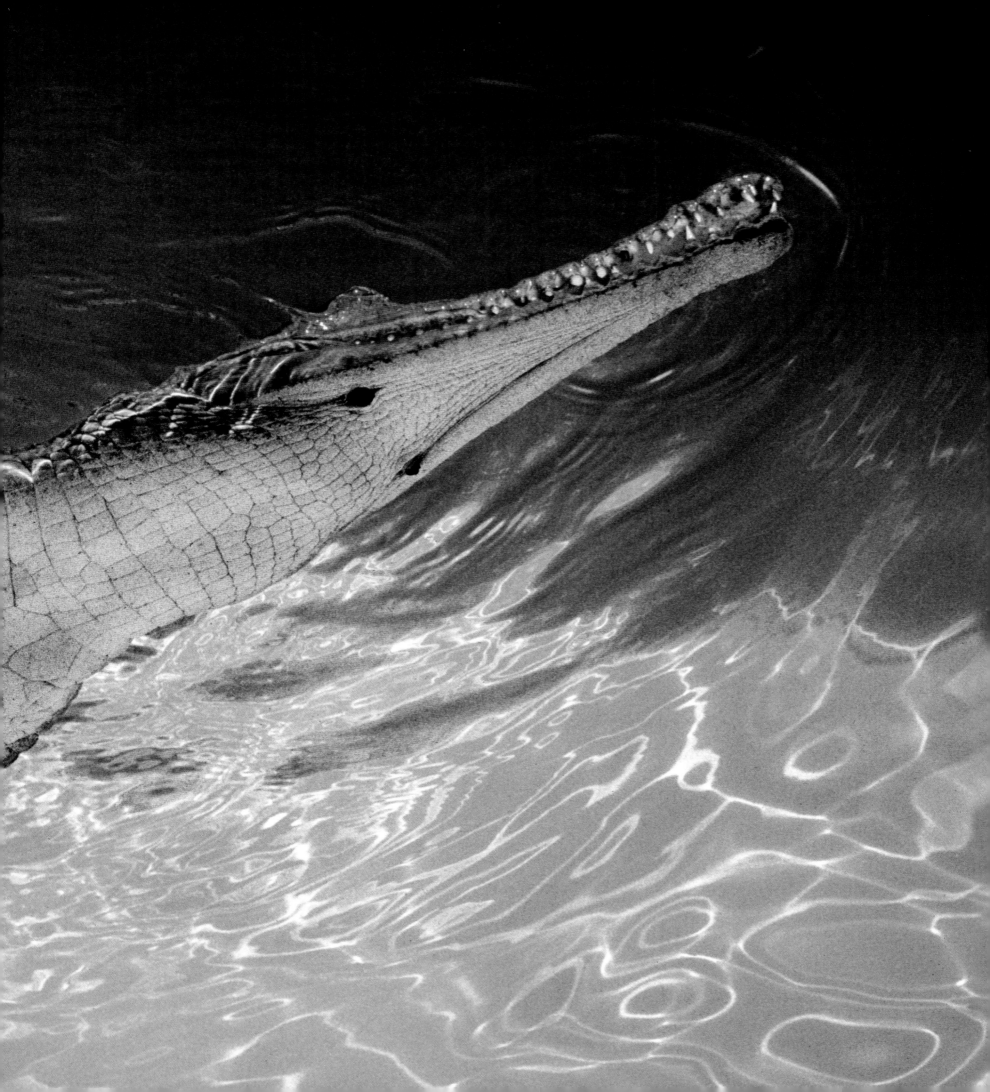

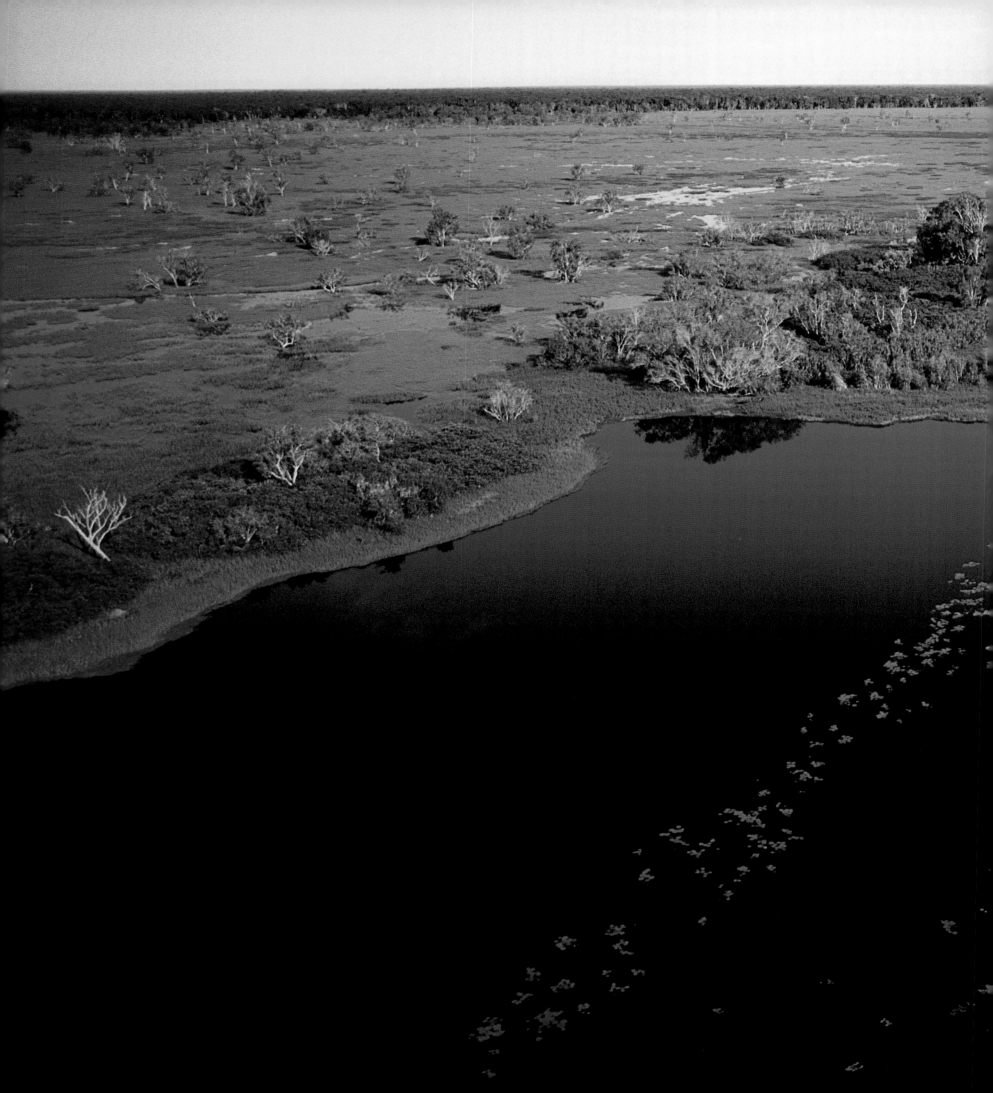

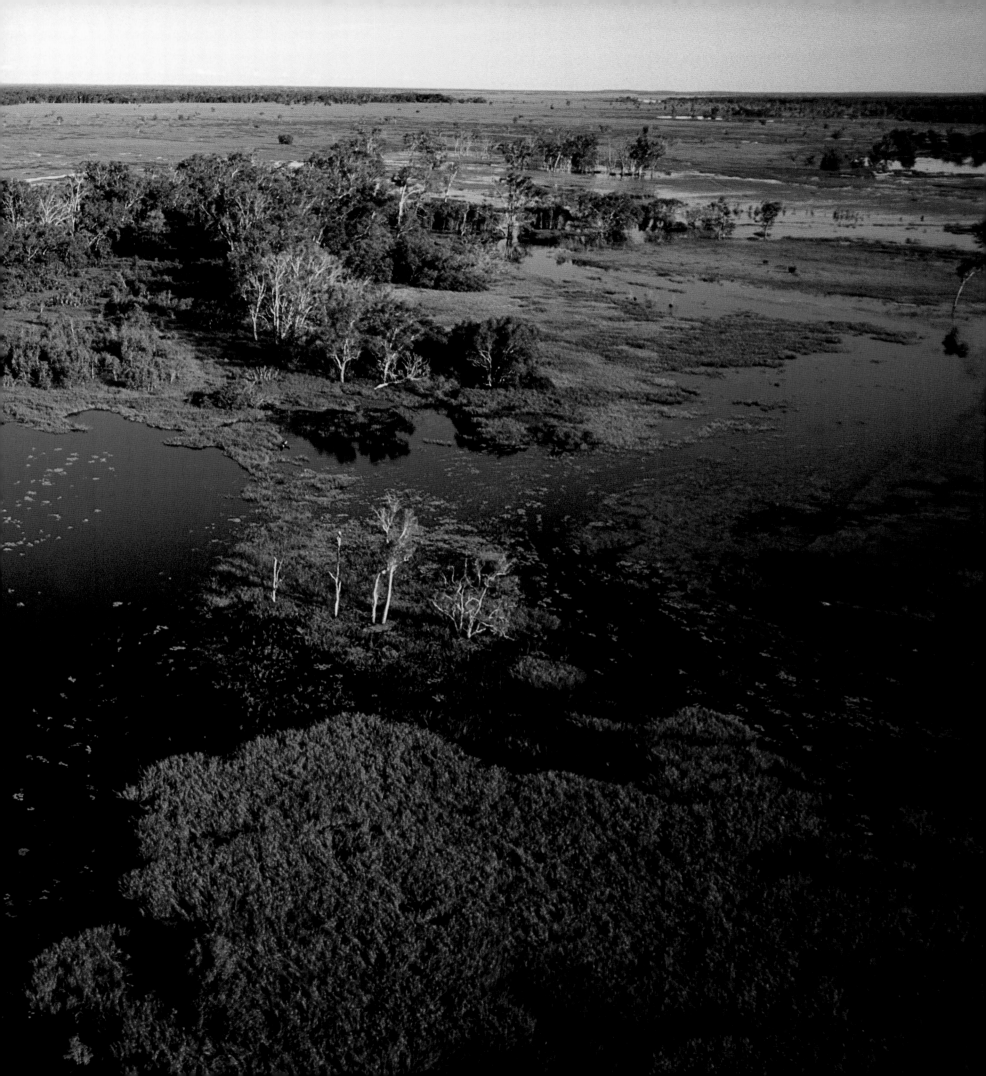

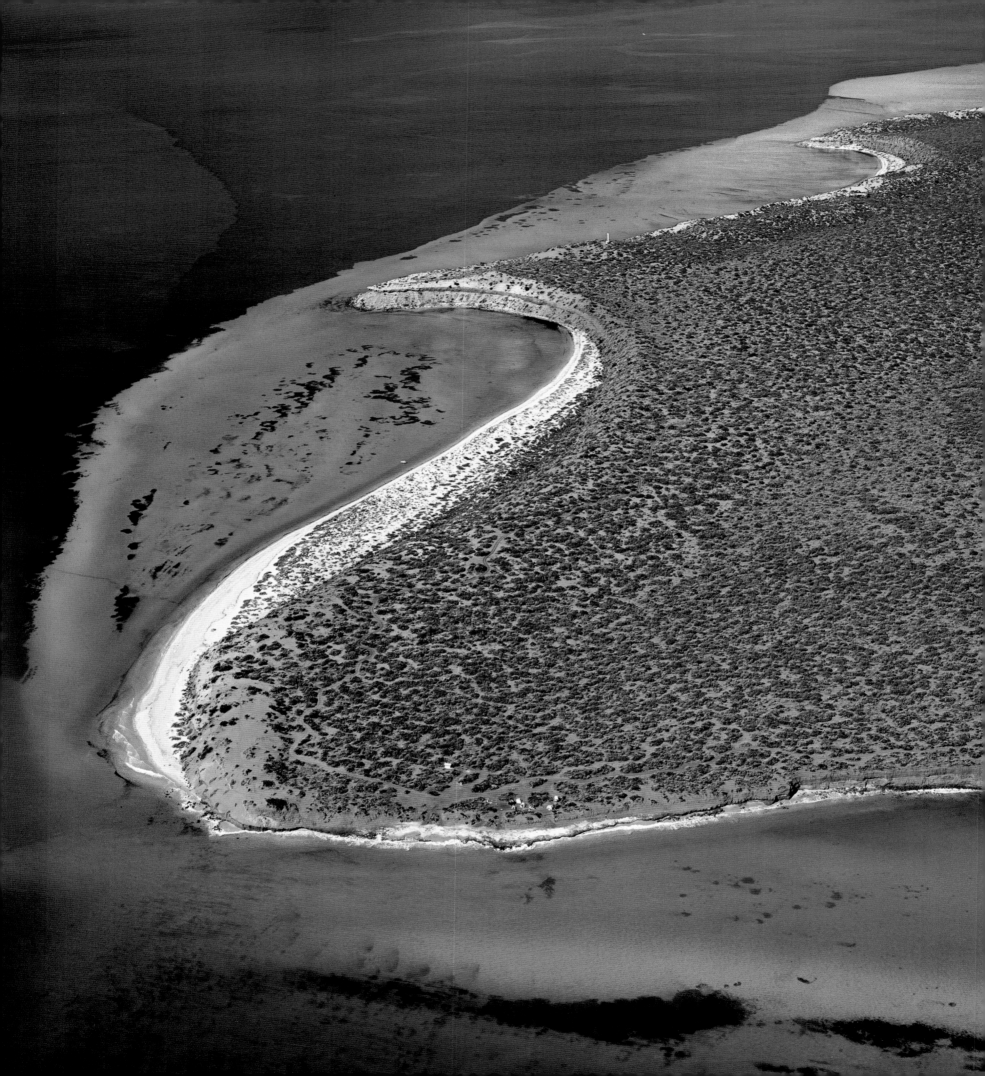

BLUE
SEAS

Blue like the sea, blue like the infinite Australia sky. In Australia sea and sky meet in an unparalleled battle for the horizon, which is placated by the loving encounter of the warm light of sunset, when the fleeting sun hesitates before falling slowly into the water and tingeing the sky with fiery hues, charged with passion.

The blue sea is the Australian dream. It doesn't matter how many oceans you have crossed, no other sea is as majestic and powerful, or so immensely vast.

The blue sea is the Great Barrier Reef, the most magnificent thing in the world and the most beautiful of Mother Nature's creations, which stuns the eyes. In order to appreciate its beauty to the full, it is necessary to take to the sky like a bird, take deep breaths of air and unleash your imagination. . . . It is an arabesque of grey veins that contrast with the blue of the Pacific Ocean, dotted with banks of coral, studded with islands and atolls – heavenly oases lost in the dream of celestial lagoons. It is an enchanting world of shades that burn with a blue fire, from the crystal-clear waters that envelop endless coral reefs, to the white waves that break in the open sea and the deepest, most intense blue. It is a world unto itself, of undefined dimensions, which runs alongside the lush green coast of Queensland. The Barrier Reef stretches northward from Lady Elliott Island, off Bundaberg, for about 1,250 miles to Bramble Cay, near the coast of Papua New Guinea. This extraordinarily vast world covers an area of tens of thousands of square miles – the size of a European country. It is a mosaic of over 2,900 different reefs that formed during the last Ice Age (15,000 years ago), although in some stretches its "construction" dates to over 18 million years ago.

Like the Outback, it is not sufficient to view the reef from above to understand it to the full; it has to be experienced personally, beneath the water in order for it to penetrate your soul. A universe of blue will unfold before your eyes, reawakening the primordial instincts of the spirit and firing the senses. Noises are muffled and distant, breathing is short and quick, movements become slow and careful. Water caresses your skin, ruffles your hair like a light breeze, and overwhelms your sight with a phantasmagoria of colors, like the inside of a fantastic kaleidoscope. A magical scene appears before your eyes: expanses of breathtaking red, white, blue, yellow and orange forests of coral, with branches resembling the skeletons of trees, meadows of splendid underwater "flowers," sponges and starfish, sea fans and sea lilies covering the rock, inhabiting every nook and cranny. Busy shoals of brightly colored fish, huge or tiny, solitary or in groups, of every shape and color, move back and forth in fluffy clouds of teeming life and swim enticingly alongside divers. It is an incredible aquarium in which you seem to fly amid enormous turtles, leerfish, surgeonfish, butterfly fish, curious parrotfish, giant groupers, seahorses that gather around playful, elegant mantas dancing weightlessly in the blue, dappled cobra fish that levitate, graceful dugongs (the sirenians that inspired the mythical figure of the mermaid!) that cast mischievous glances among the coral. . . . And then there is the terror of the seas: sharks, so terrifying and so different. The smaller reef shark, the hammerhead shark with its

100 LEFT THIS CORAL FORMATION IS PART OF THE CAPRICORN-BUNKER GROUP IN THE GREAT BARRIER REEF MARINE PARK. SOMETIMES EVEN THE CORAL PLAYS GAMES WITH NATURE, ASSUMING TRULY FANTASTIC FORMS.

100 RIGHT SCRAPS OF GREEN LAND FRAMED BY A FAINT RING OF WHITE SAND REACH OUT INTO THE BLUE SEA IN THE WHITSUNDAY ISLANDS, GREEN DOTS IN THE BLUE VASTNESS OF THE GREAT BARRIER REEF.

101 FROM LEFT TO RIGHT INDIA HEAD, A ROCKY GREEN PROMONTORY, THRUSTS OUT INTO THE TURQUOISE SEA OFF GREAT SANDY NATIONAL PARK, FRASER ISLAND; THE NATURAL PARADISES OF THE FREYCINET PENINSULA AND SCHOUTEN ISLAND IN THE BACKGROUND OF COLES BAY, TASMANIA; THE EXTRAORDINARY FLOORS OF THE GREEN TASMANIAN SEA ARE HOME TO A MYRIAD OF MULTICOLORED CREATURES.

curiously shaped head, the strange carpet shark, and the aggressive and much-feared white shark, which only the most adventurous dare to approach, from the safety of large steel cages. The last frontier is here too: in this underwater world, where nature triumphs and man once again feels infinitely small.

The blue of the Great Barrier Reef also conceals disturbing aspects. This maze of razor-sharp coral that branches out in the shallow waters was the nightmare of the first explorers to appear on this coast, who called the noise of the waves against the reef "the voice of God." They were well aware that if their boats ended up on it, then it would be the end, as testified by the outlines of the wrecks that

some of which have peculiar shapes, such as hearts and stars, while others are simple tongues of sand engulfed by the immensity of color. The choice is overwhelming.

There are the Southern Islands, which embellish the reef with verdant sandbanks. Lady Elliot Island, once isolated from the rest of the world for long periods due to the infrequent connections to the mainland, lies around the elegant outline of its lighthouse. Lady Musgrave Island, a tiny grain with a pretty coral-ringed bay, displays its charms among green meadows, whose silence is threatened by the incessant voices of flocks of terns and seabirds. Heron Island has a sunny personality, with waters teeming with colored fish, coral for-

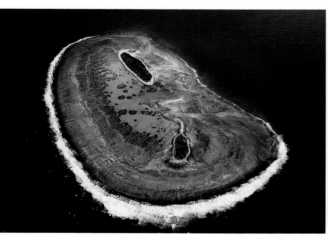 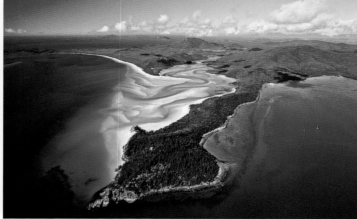

mations and a bountiful land that is home to seabirds and turtles. The islands of the Keppel Group National Park, with their tropical rainforest-covered hills, rise from the sea like a chain of emeralds mounted in a blue setting. Then there are the Central Islands: the Whitsunday Islands, which Cook named after the day of their discovery, that dramatically outline the Great Barrier Reef.

stand out sinisterly against the coast.

The blue of the sea envelops another great spectacle of nature: the islands of the reef – over 700 "grains of sand" dispersed in an infinite succession of turquoise and sky-blue shades, covered with rock and lush greenery, scraps of blinding white sand. They are splendid tropical paradises, pieces of a perfect mosaic of sky, earth, sea and coral. Some are uninhabited, while others are dotted with luxury hotels and resorts, yachts and little boats. It is necessary to climb back into the sky to observe the kaleidoscope of countless shades of blue, free your imagination and lose yourself in this endless sea of little dots,

However, the great explorer was unable to enjoy this enchanted vision from above, featuring a hundred or so high-cliffed, lush green little islands thickly covered with pine woods and edged with fjords and blue saltwater lagoons, populated by chattering parrots and brightly colored butterflies. These tropical gardens are enclosed by coral and brilliant turquoise and fringed by idyllic beaches of soft white sand, such as the much-photographed Whitehaven Beach. Finally, there are the Northern Islands, where the coral approaches the coast, almost wrapping it in a series of long ribbons, forming a fantastic lacy thread. The reef is bursting with blue, in the quest for per-

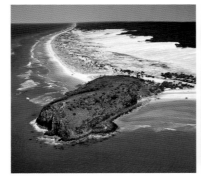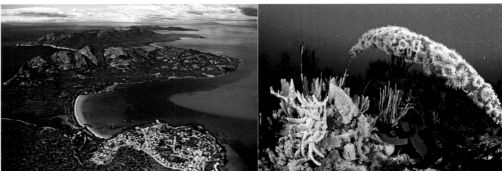

fect harmony. The white beaches of Magnetic Island, whose trees are home to sleepy koalas, is followed by the strongly evocative sea around Orpheus Island, whose sand is studded with colored shells. The green mangroves and wooded mountains of Hinchinbrook Island contrast with its dazzling white beaches. The untamed nature of Lizard Island, inhabited by huge monitor lizards, is simply bewitching, with lush meadows, heaths and rugged granite headlands.

The blue sea transforms many Australian islands into legends. Fraser Island, off the coast of Queensland, for example, is more than an island: it is a separate universe and unspoiled paradise with luxuriant tropical vegetation, where time seems to stand still. Rainforests cover the island with a carpet of wild plants and ancient trees, such as ferns, palms and satiny trees, interrupted only by freshwater lakes, crystal-clear watercourses and multicolored cliffs outlined against the sea and sky. The bays nestling among the vegetation, such as Hervey Bay, are a refuge for the humpback whales that winter in the area. Time seems also to stand still on Kangaroo Island, a splendid paradise off the coast of South Australia. The island is home to 21 natural parks, with gloriously healthy and varied populations of kangaroos, wallabies, duck-billed platypuses, seals, dolphins, sea lions, sharks and whales. The sea shimmers in the sunlight with a thousand different shades of opal as the clouds race across the sky. The land is fragmented between balconies of rugged coast, stretches of sandy dunes, almost blue-leaved eucalyptus woods, limestone caves and lagoons that are the nesting site of thousands of birds.

Rottnest Island, off the coast of Perth in Western Australia, is another piece of Australia in which blue plays with the colors of the water to form a phantasmagoric display. A former prison for Aborigines, it blends lush vegetation with a touch of history, although once again the sea plays the starring role. Its Caribbean colors are combined with a lush green coast, fringed with little bays with sand as white as sugar and sculpted stretches of stone and rock, whose openings are sprayed with sea foam. Expanses of heath extend solemnly between salt lakes, thickets and bushes, which provide shade for resting quokkas, sociable little wallabies that vaguely resemble large rats.

However your senses and instinct take you farther still, on to the far frontiers of the ocean, to discover the primordial spirit of this land, among its remote islands, seeking the emotions that lit the eyes of the first explorers. Volcanic Lord Howe Island is a dependency of New South Wales and an enchanted emerald-green land scattered with forests and mountains, with such a unique natural habitat as to have been declared a World Heritage site. A little farther away, immersed even more deeply in the Pacific, is Norfolk Island, a former penal colony with an adventurous past. Isolated from the rest of the world, it is inhabited by the descendents of Fletcher Christian and the other mutineers of the *HMS Bounty*, who follow their own rules of life, just like an ancient tribe. However, the farthest outposts of Australia are perhaps to be found in the blue Indian Ocean: the Cocos Islands – 27 coral islands of which only 2 are inhabited – and Christmas Island (closer to Java than Australia), a tropical paradise where it is easy to encounter dolphins and slow-moving turtles laying their eggs on the beaches. Here too it is nature that rules, unaware of time.

Off the southeastern coast of Australia, south of Melbourne, lies Tasmania, the island of the islands! This heart-shaped, untamed and enchanting microcosm of forest, land and sea lies among the waves of the Indian Ocean. It is a small autonomous state of the Commonwealth of Australia, which is clearly distinguishable from the rest of the country and forms a separate world, almost 200 miles from the mainland. It is a frontier land, which has populated the dreams of adventurers of all times and takes the visitor back to stories of whalers, sailors, pirates and sailing ships. The deep blue stormy sea laps the coasts of the island, fringed with Polynesian-style white sandy beaches, and contrasts with the green Norwegian-like fjords, glimpses of dark, "gothic" Alpine mountains, covered with impenetrable forests, meadows dotted with a profusion of wildflowers, and

quiet little lakes, lost in the magical emerald green landscape. It is an explosion of colors, passions and nature: to the north, the red deserts of Mother Earth and the warm tropical seas, to the south a world of snow, ice, water and rain, which resembles nearby Antarctica.

Tasmania's dual face bewitches visitors with a menacing appearance that contrasts strongly with the tranquil English-style villages with Victorian houses, craft workshops, green pastures dotted with sheep and orchards and Hobart's 19th-century pastel-colored buildings. Tasmania (or Van Diemen's Land, as it was called up until 1856, when the early explorers still mistook it for the mainland) has always exerted an almost disquieting charm. During the second half of the 19th century it was only visited by brave captains and sailors, desperate men fleeing the long arm of the law, providing that they managed to survive the terrible ocean gales without drowning in the treacherous and stormy waters of Bass Strait, which is overlooked by magnificent coasts. Shipwrecks and ancient submerged ghosts continue to fuel fantastic legends and stories. They rest, like threatening omens, on the seafloor beneath the waters of the Hunter Islands and Furneaux Islands, in the infinite blue expanses that surround Tasmania's archipelagos.

The land re-encounters the blue sea along the Australian coast, giving rise to indescribably striking stretches such as Shark Bay, in Western Australia – an untamed scrap of land sheltered by the Peron Peninsula and a string of breathtakingly beautiful islands. The water caresses the sand at Monkey Mia, where happy and playful dolphins swim towards the beach to meet man, and plays with the stromatolites – primitive green and blue algae that are authentic living fossils, 3.5 million years old – that have contributed to making the area a UNESCO World Heritage site. The waters of Ningaloo Marine Park allow visitors to swim freely amid the mantas and whale sharks that inhabit a coral reef that is smaller but no less spectacular than the Great Barrier Reef.

The blue sea merges with the land along some of Australia's most breathtaking roads. The Pacific Highway, in New South Wales,

is a living legend and the road to adventure that leads to the tropical Queensland sun. Almost like a wonderful Australian Route 66, it reflects the many faces of this land as in a mirror: the solitary beaches lapped by the blue of the Pacific, the tropical forests, the slightly shabby charm of certain seaside resorts, the kitsch atmosphere of the gaudy tourist attractions and the freedom of the hippy communities and alternative villages that serve as a refuge for artists and writers seeking inspiration. However, it also reflects the bustle of the industrial cities, the activity of the small farming towns, flanked by banana and sugar cane plantations, and the magnificence of the killer whales that dance off Cape Byron, not far from the lively little town of Byron Bay.

Another miracle of nature is offered by the splendid marriage of land and sea that characterizes the Great Ocean Road Drive in Victoria, which stretches for 150 miles along the evocative winding Shipwreck Coast from Torquay to the whaling port of Warrnambool, whose bays are the refuge of whales with their calves. Giant eucalyptus trees and enormous umbrella ferns line the road, making it difficult to glimpse the clearings dotted with grazing sheep through the lush vegetation. Solitary ruined lighthouses dominate the sea from atop the overhanging cliffs. Sandy beaches frame steep, rugged faces of rock, covered with bushes of wildflowers. Surfers challenge each other with zigzagging races and breathtaking acrobatics, seizing their moment on the crest of the rollers that break in a cascade of white foam. The dazzling blue of the sea is set off by tall, white limestone cliffs, sculpted with arches and pinnacles, at the mercy of impetuous winds and mighty waves, which assume magical hues between the Twelve Apostles that emerge majestically from the sea near Port Campbell. These enormous rock stacks are almost 200 feet tall and witness the magic of the iridescent Australian light each day at dawn and dusk. However, these watchful sentinels of the ocean are perhaps most evocative when wrapped in a light mist, which makes them resemble rarefied ghosts among pale rosy shadows in a fantastic idyll of the encounter between sea and sky.

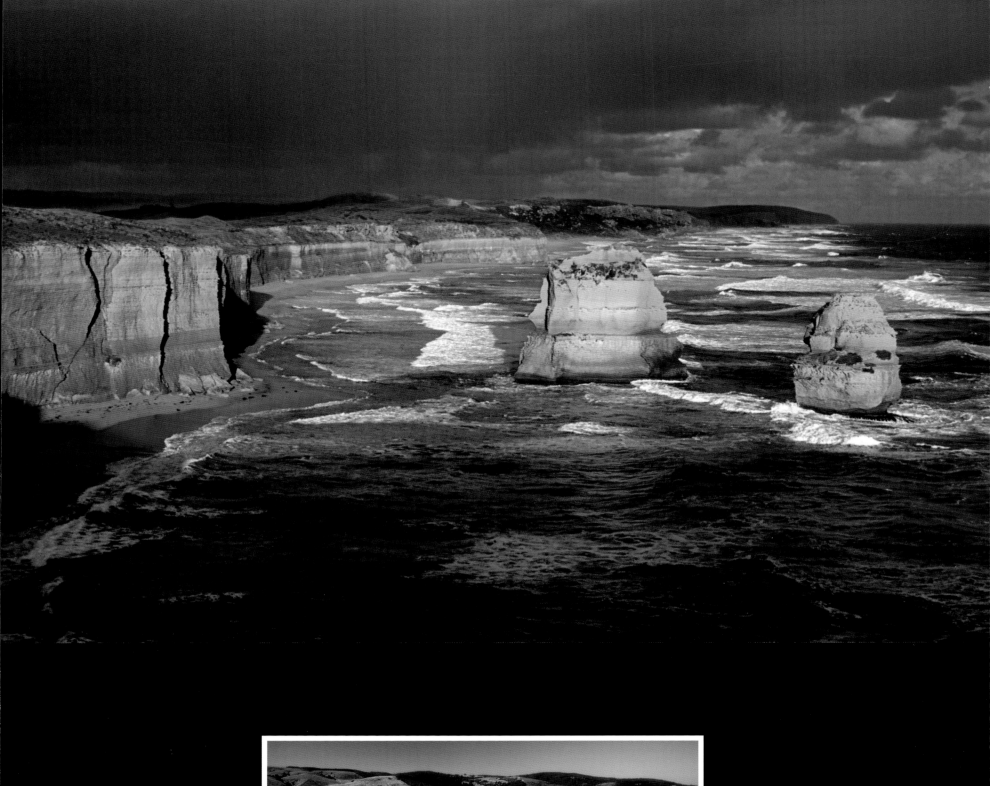
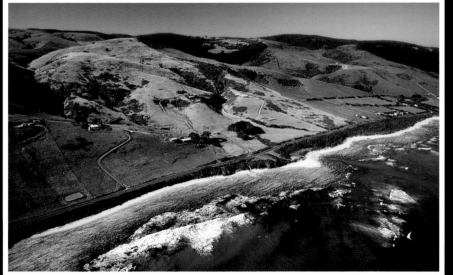

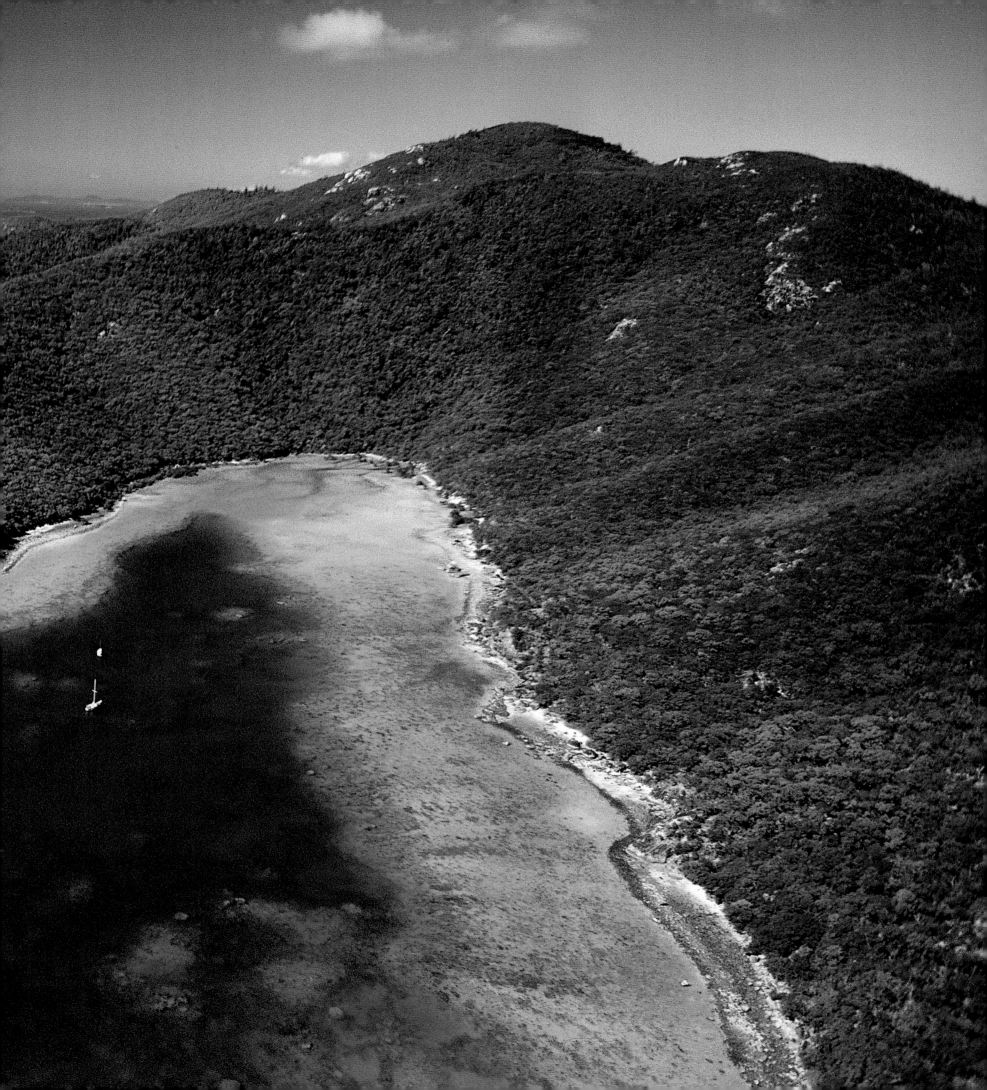

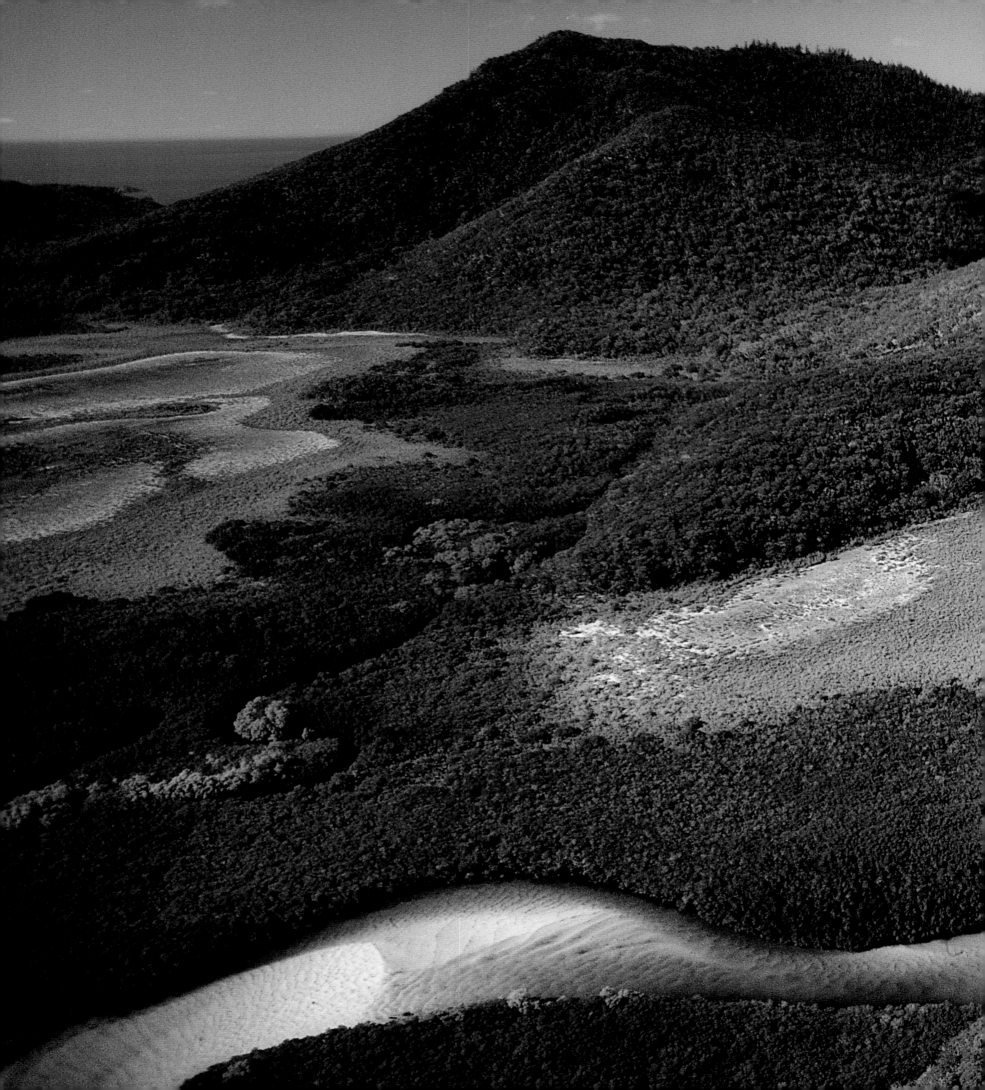

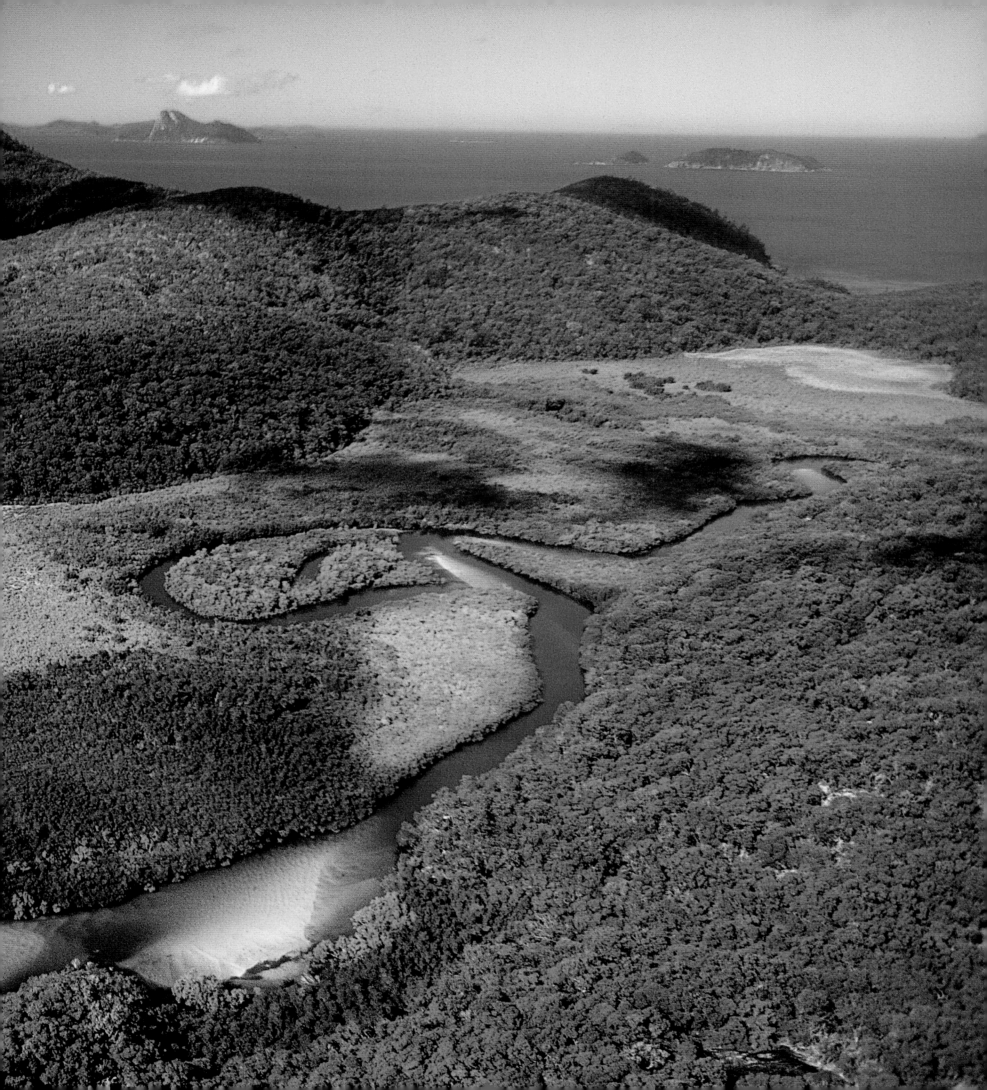

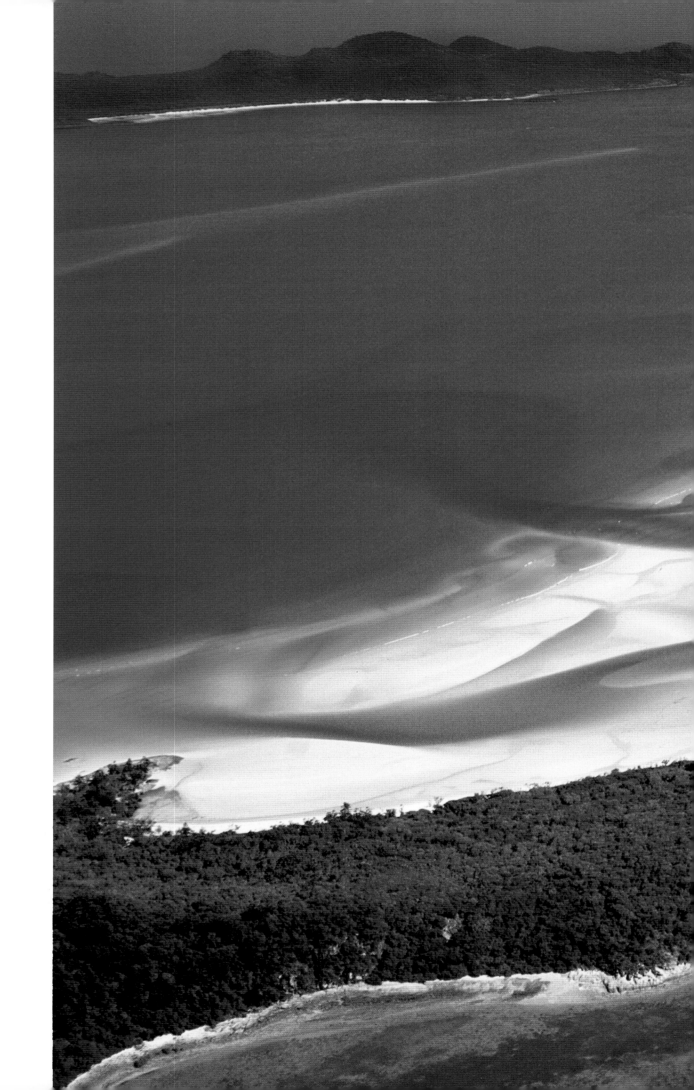

108-109 The velvety ramifications of Tongue Point, in the Whitsunday Islands, reach out into the sea patterned by currents and sandbanks.

110-111 Not far from Tongue Point is Whitehaven Beach, an almost four-mile stretch of dazzling white, powder-fine sand that is 98% silica.

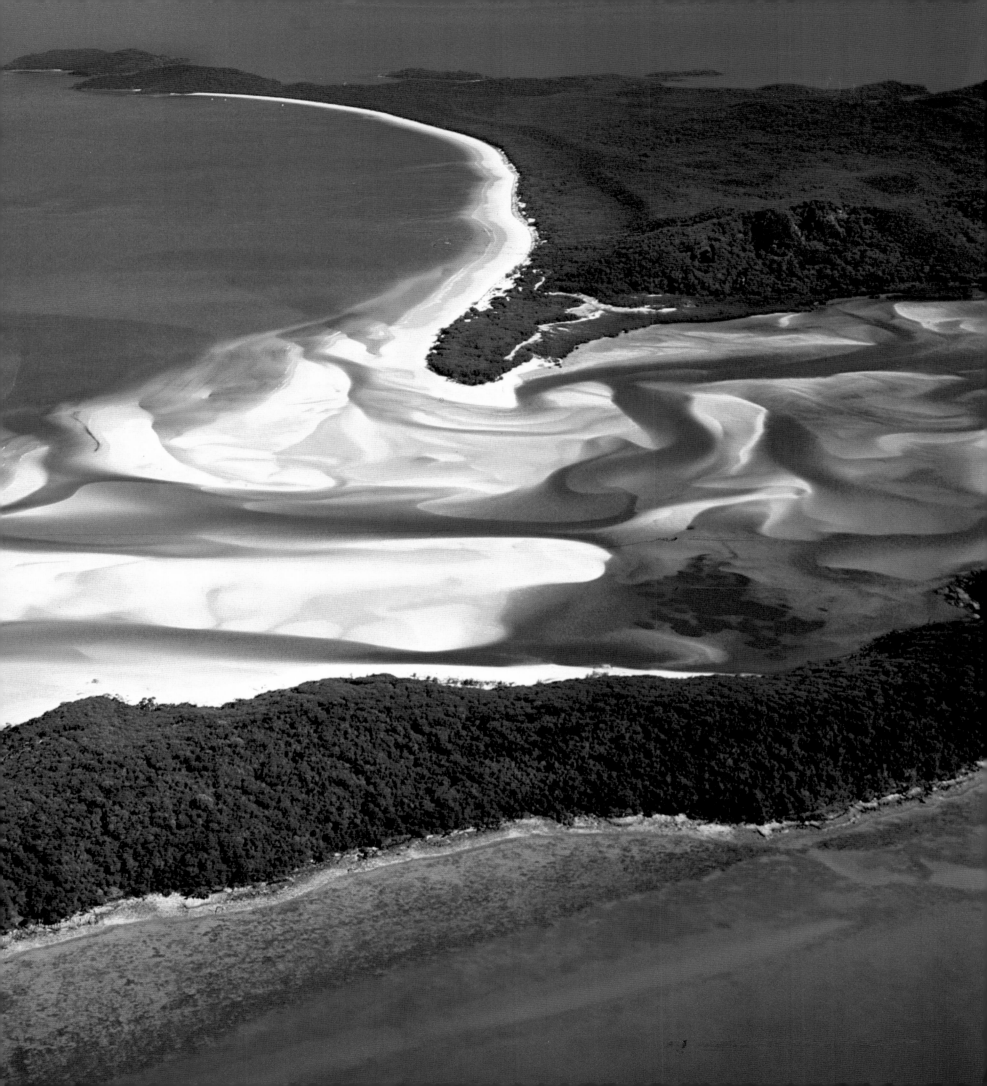

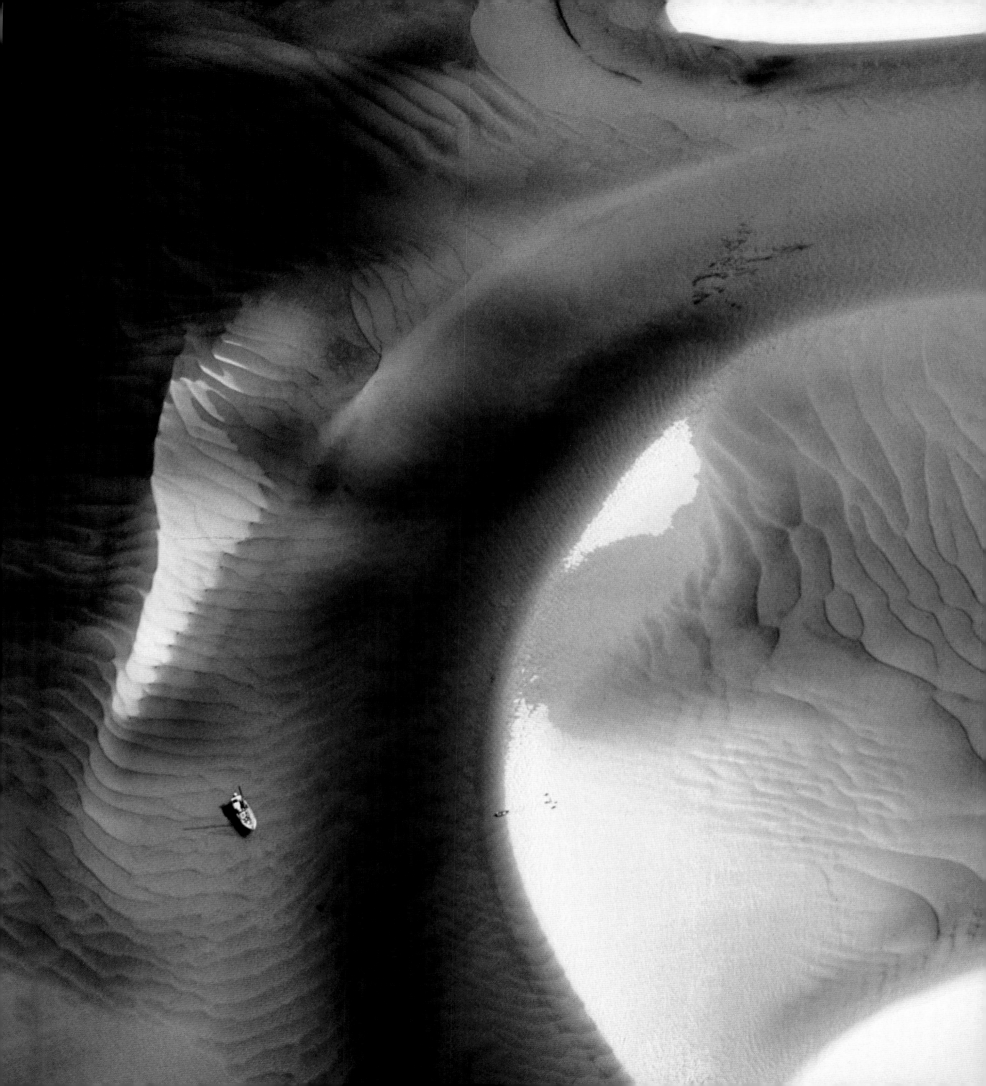

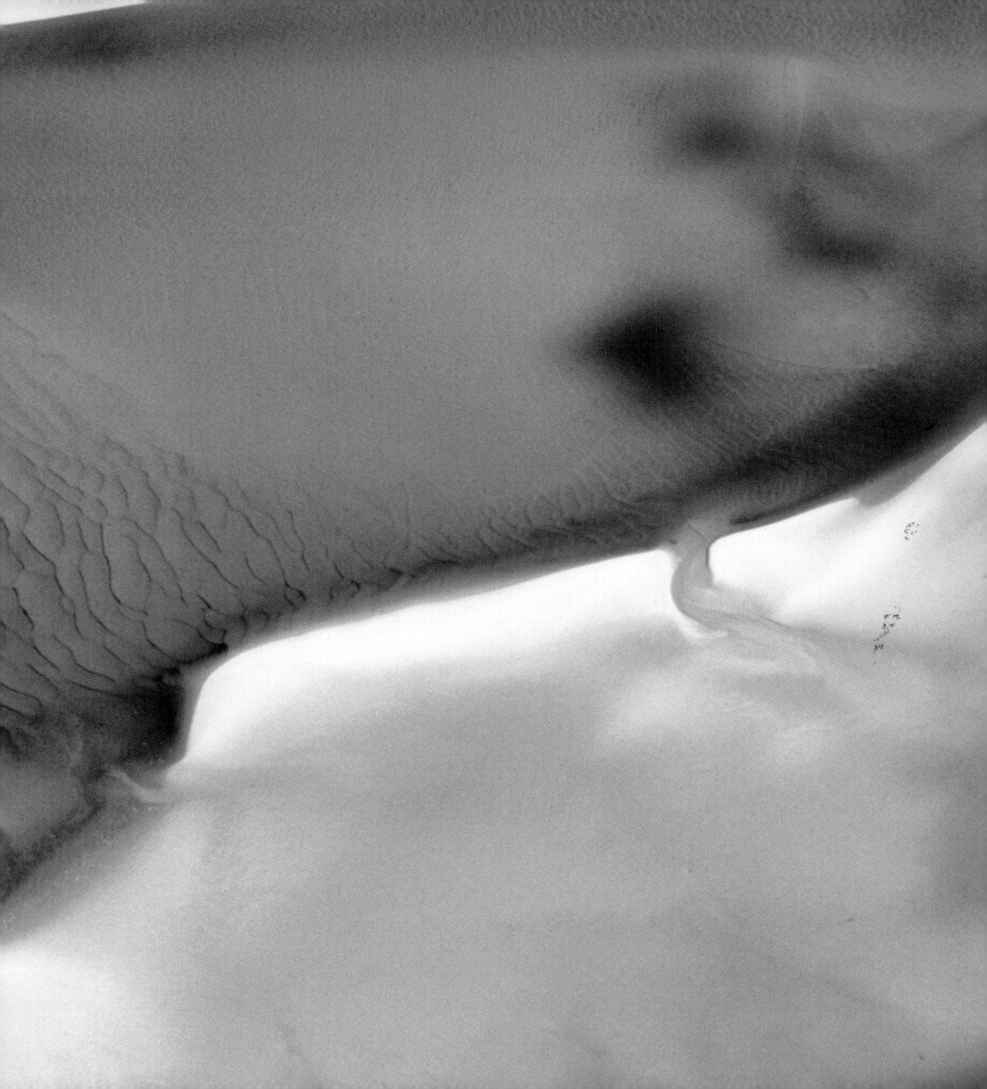

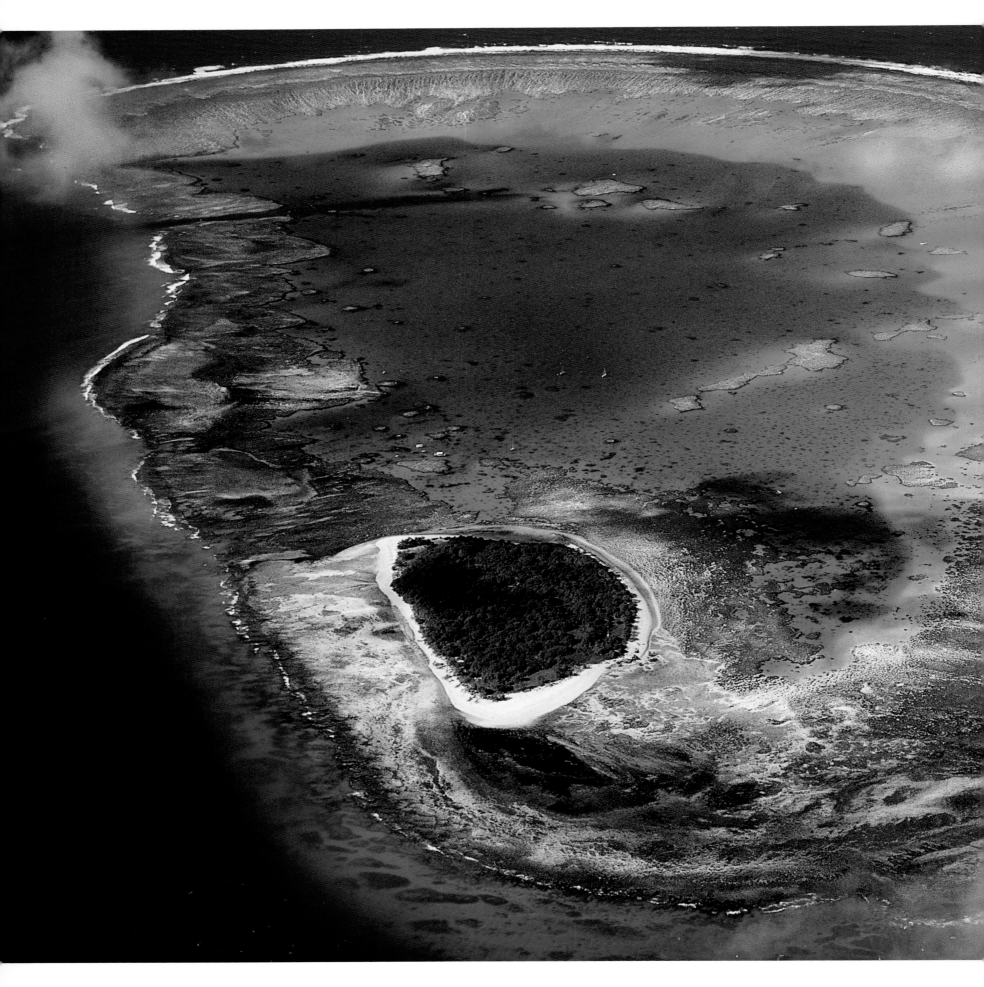

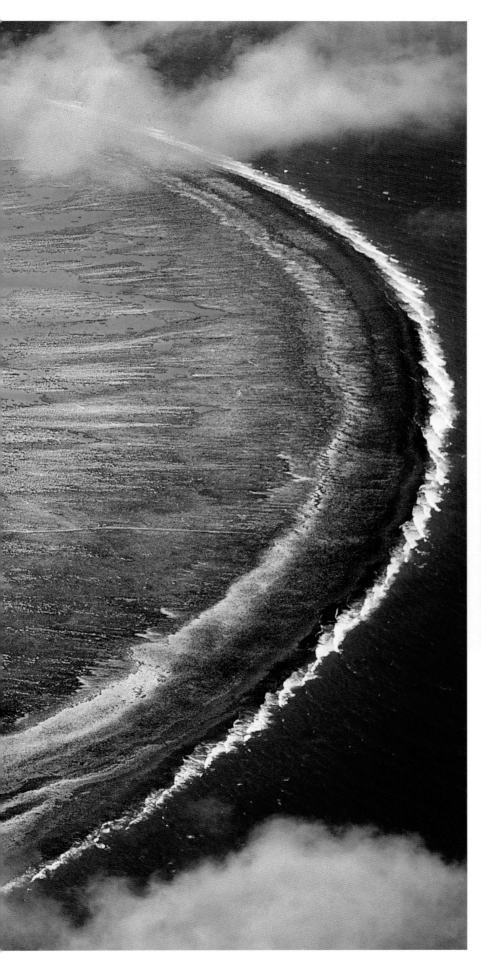

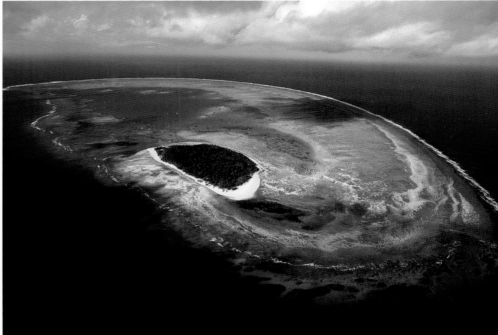

112-113 AND 113 Lady Musgrave Island, a lush green atoll ringed with sandy beaches, is surrounded by a swirl of silver and blue, forming a magnificent microcosm of land and coral.

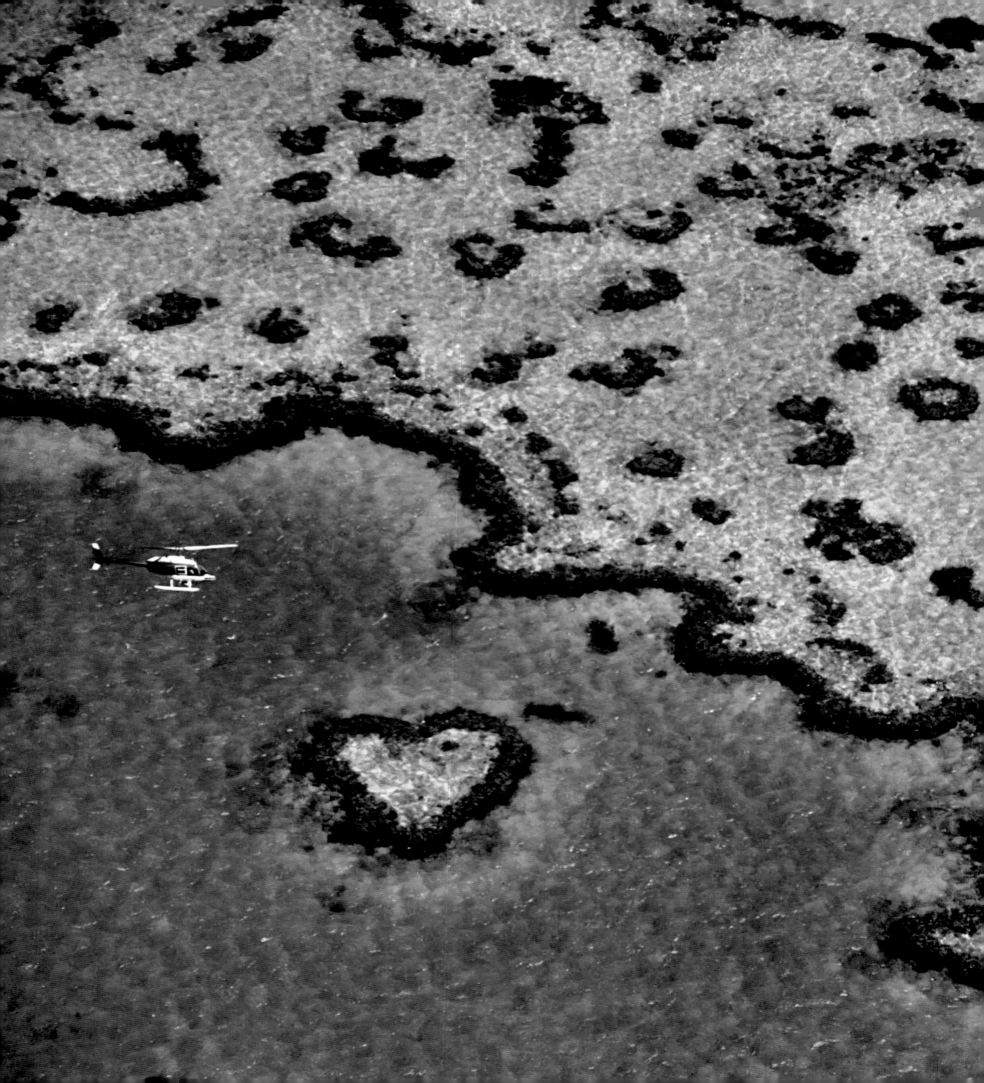

114-115 A helicopter flying over Hardy Reef, one of the most beautiful stretches of the Great Barrier Reef, which forms a lacy pattern of silver and blue dotted with the occasional heart-shaped atoll.

116-117 The full extent of the Great Barrier Reef can be appreciated only in a bird's-eye view, from a seaplane or small aircraft.

118-119 The coral paints the outline of the Great Barrier Reef, which stands like a wall between the wide blue sea and the pretty seaside resorts of Cairns and Townsville.

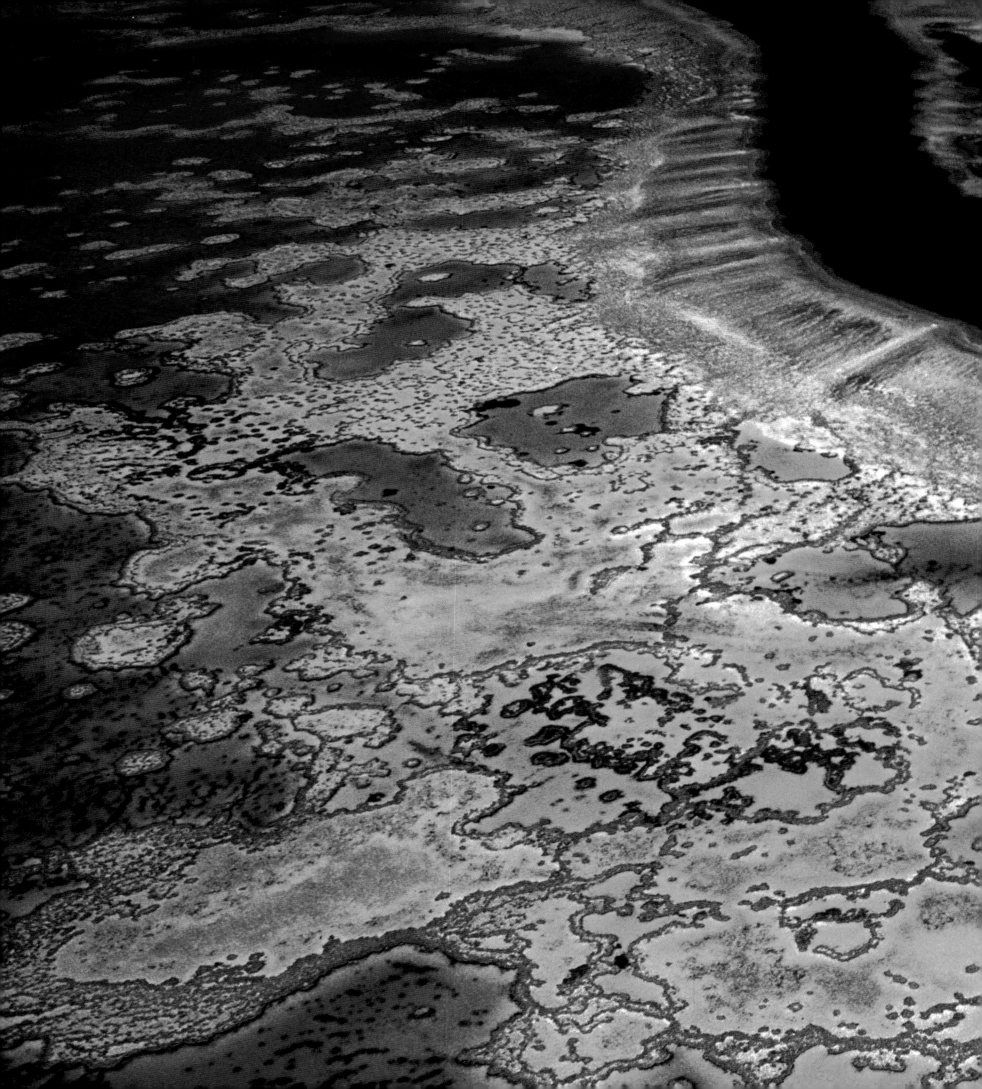

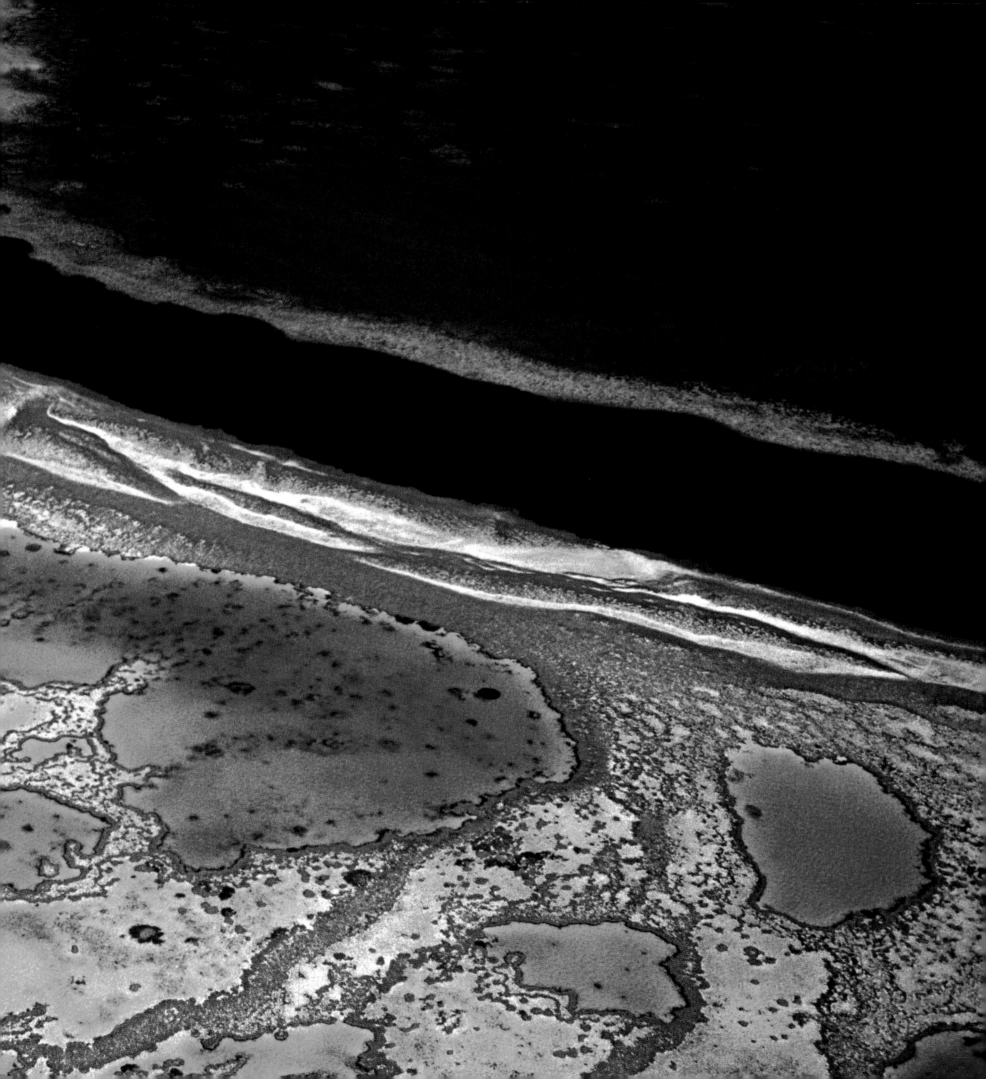

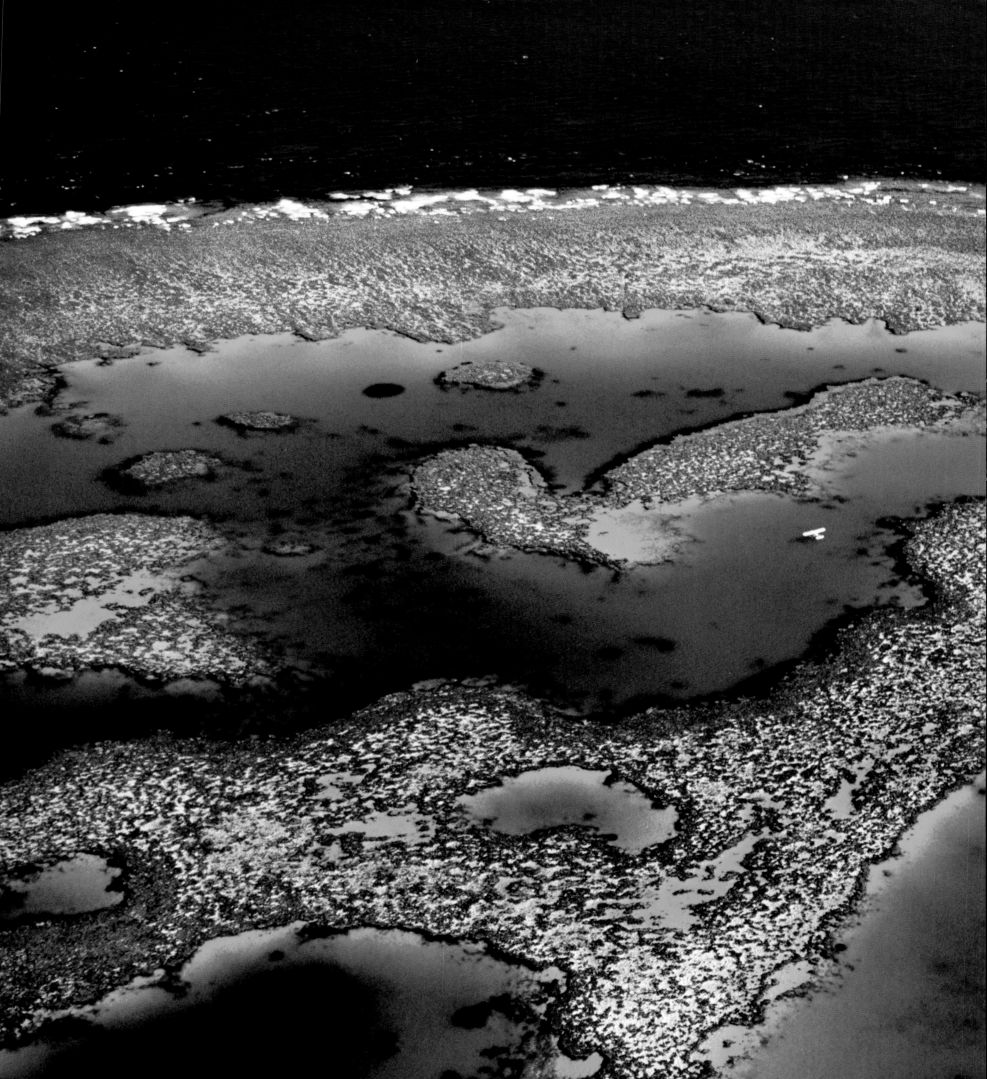

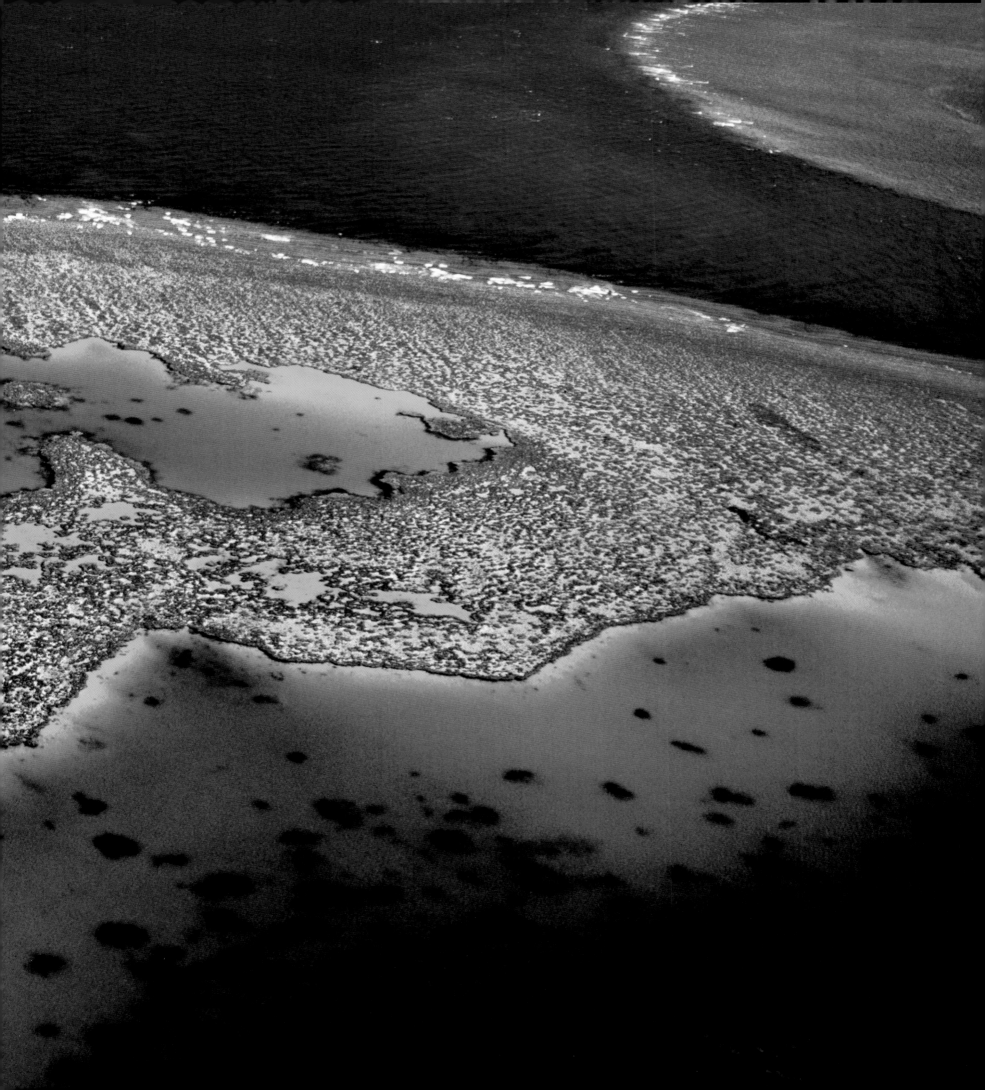

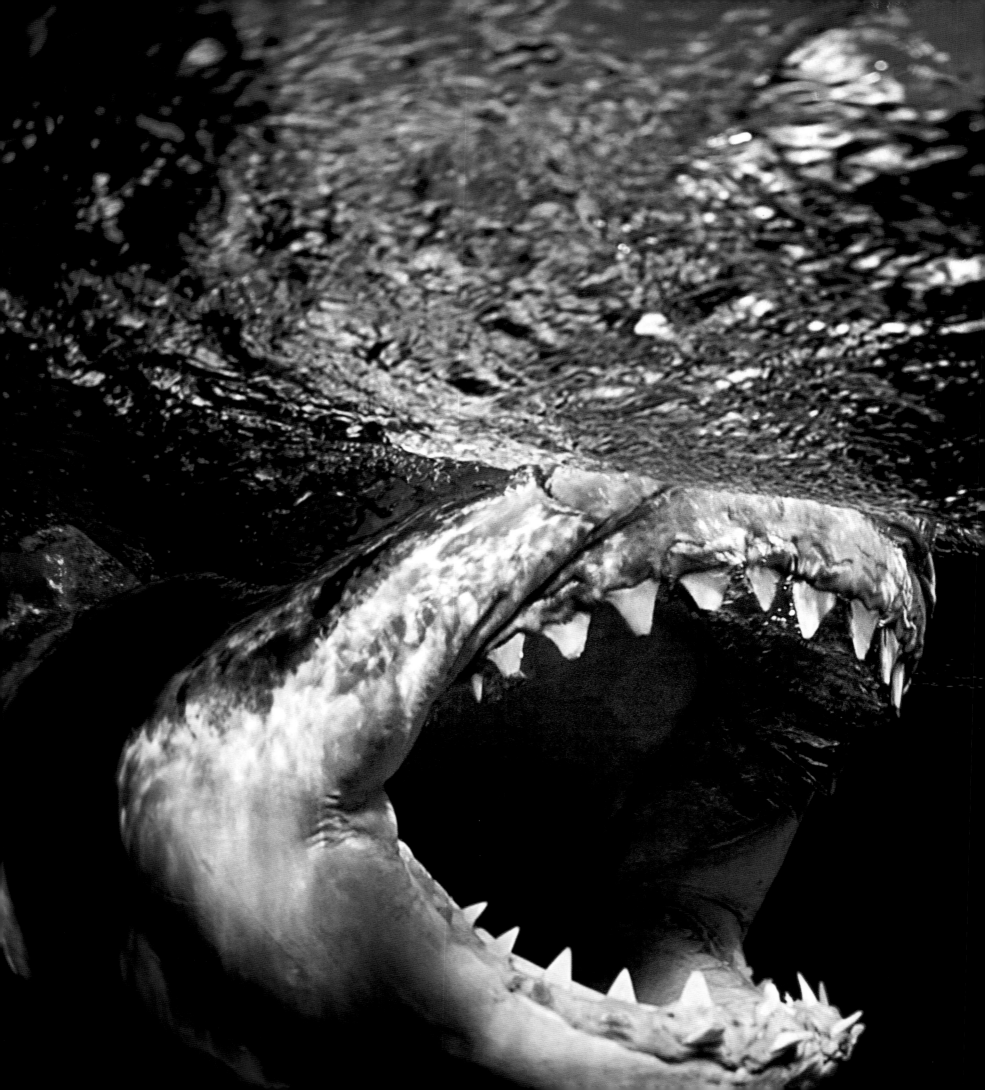

120-121 THIS HUGE AND MENACING
WHITE SHARK WAS PHOTOGRAPHED IN
THE WATERS OF NORTH NEPTUNE
ISLAND, OFF SOUTH AUSTRALIA.

MAGICAL NATURE | 121

122-123 A SCHOOL OF BARRACUDA
ACCOMPANIED BY A SOLITARY
CARANGID SWIM IN THE WATERS OF
THE GREAT BARRIER REEF.

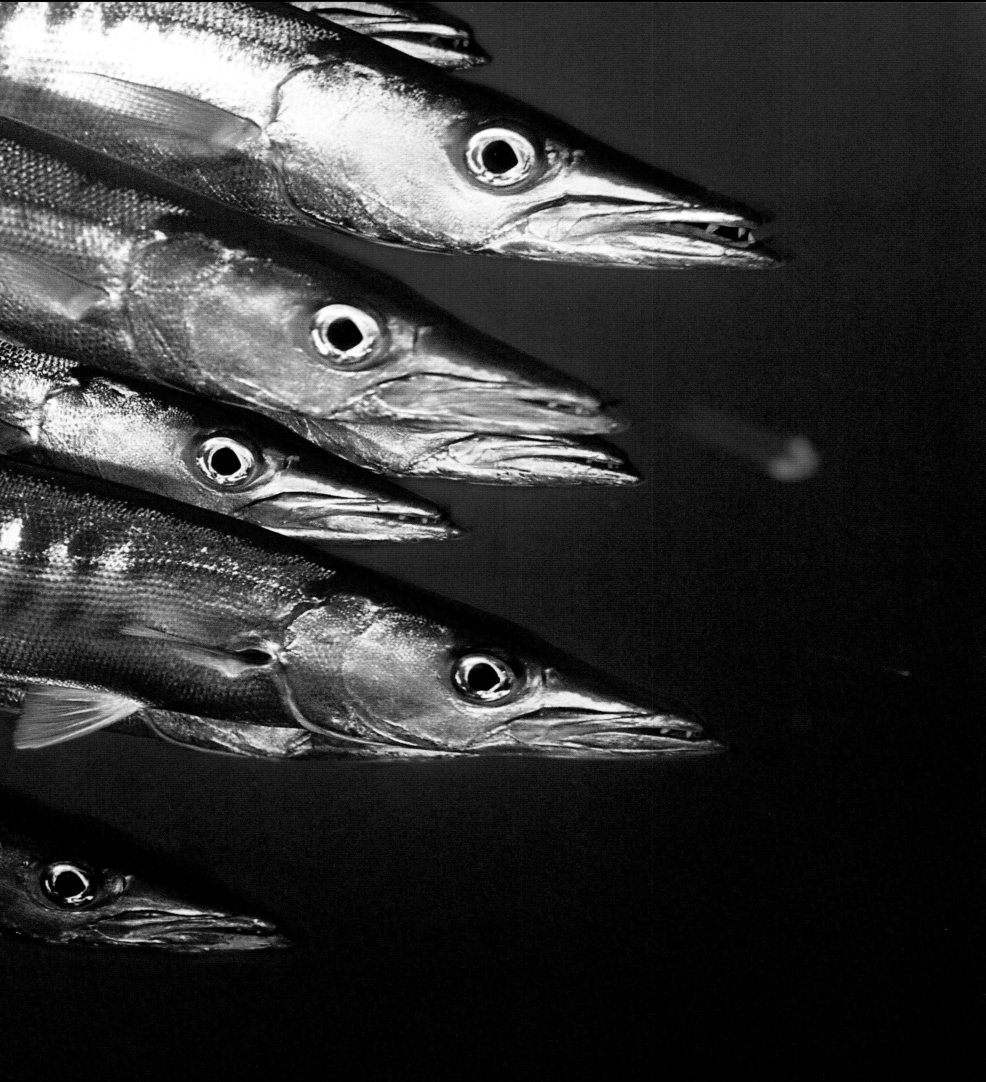

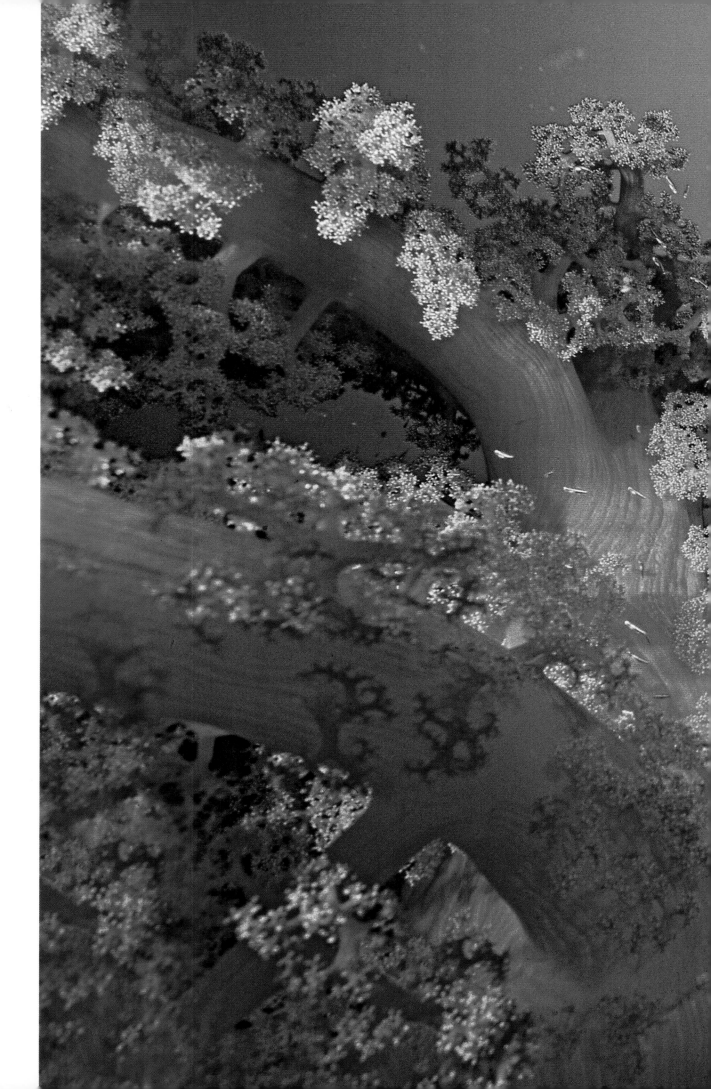

124-125 Gargantuan soft corals grow in the lagoon of the Flinders Reef, an atoll in the Coral Sea, off the Queensland coast.

126-127 The growth of benthic organisms, such as this splendid sea fan in the Flinders Reef, is aided by the narrow channels, where the water flows faster, transporting considerable quantities of plankton.

128 Two awe-inspiring green moray eels with menacing expressions peek out of their den at the sight of the diver in Jervis Bay, in New South Wales.

129 A bluntnose sixgill shark faces the photographer in the marine park of Governor Island, which lies off the Tasmanian town of Bicheno, before fleeing, startled by the sudden light.

130-131 The Australian giant cuttlefish can grow to lengths of over three feet. The photograph shows a close-up of one of its eyes. The color and intensity of its splendid white body seem to change intermittently.

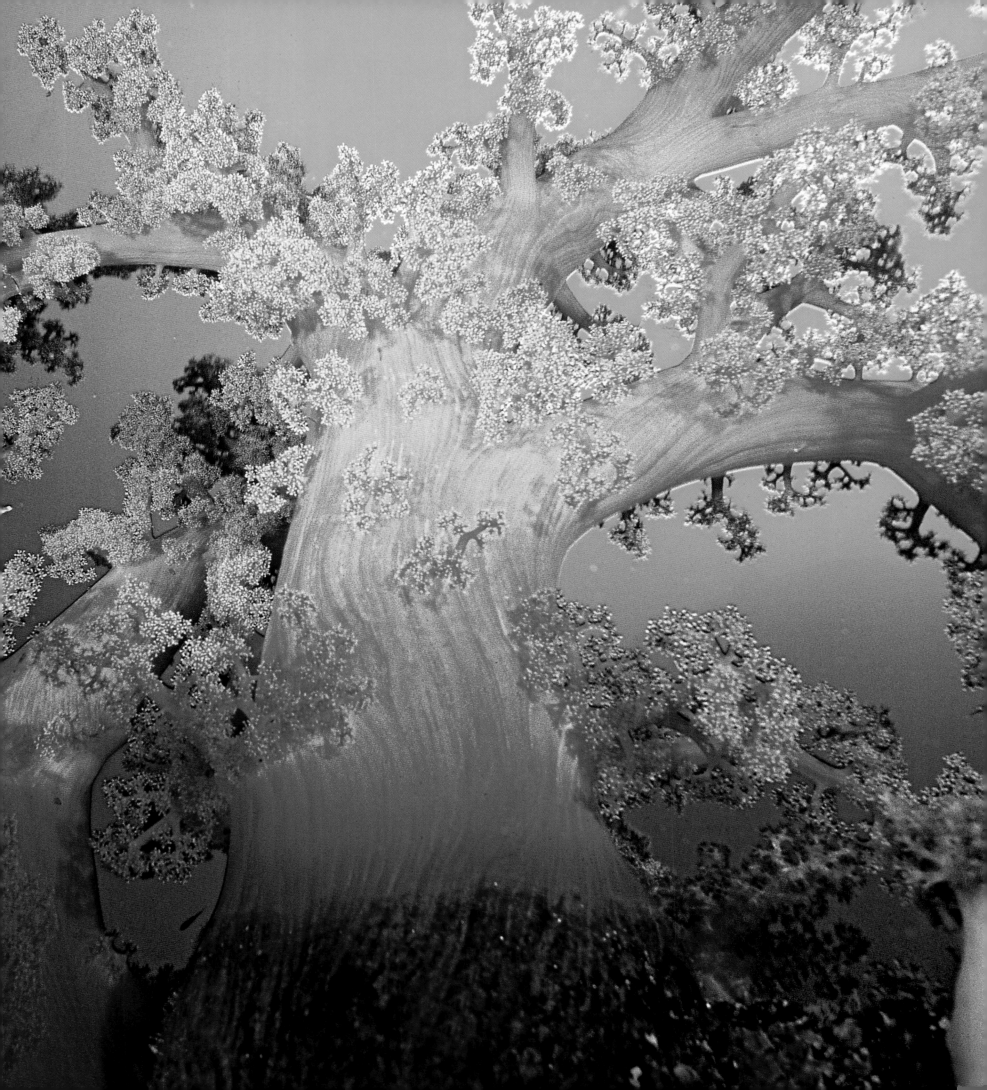

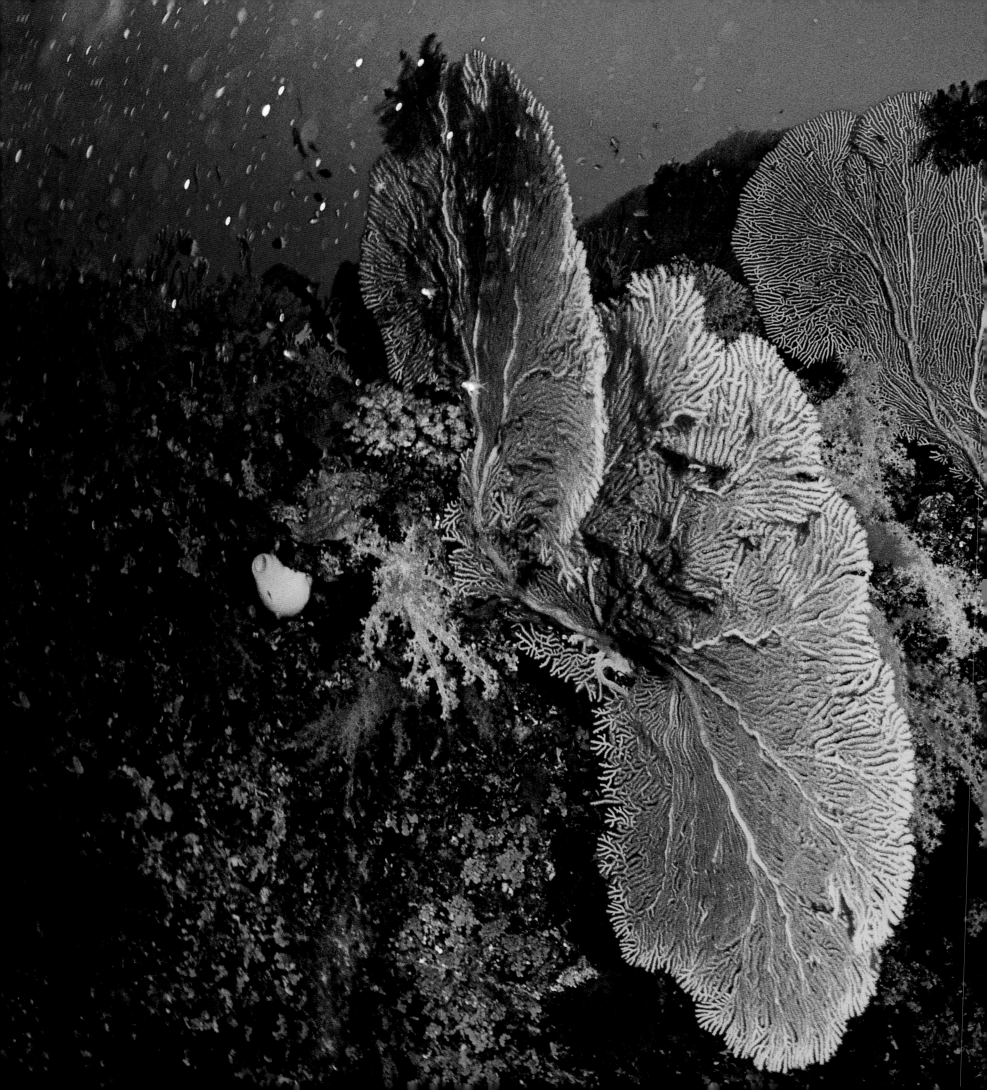

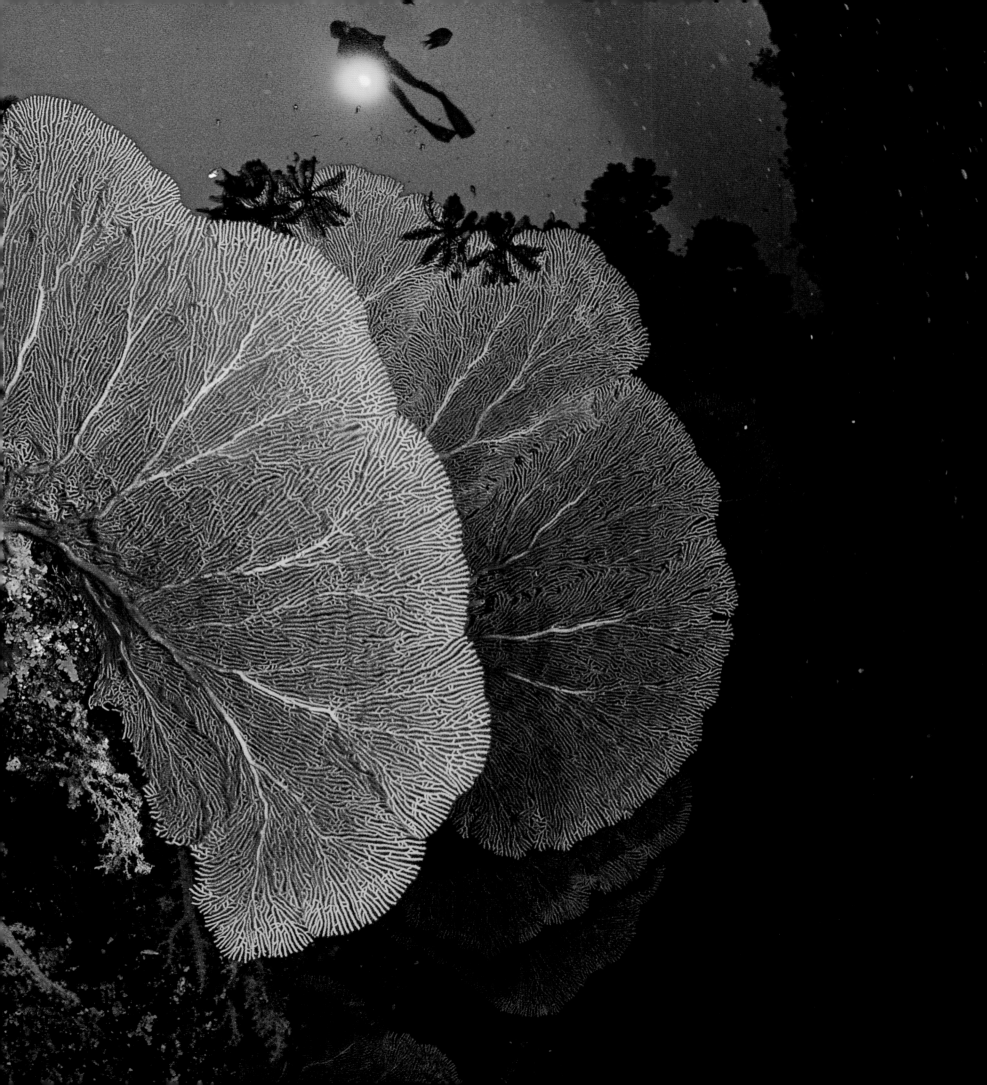

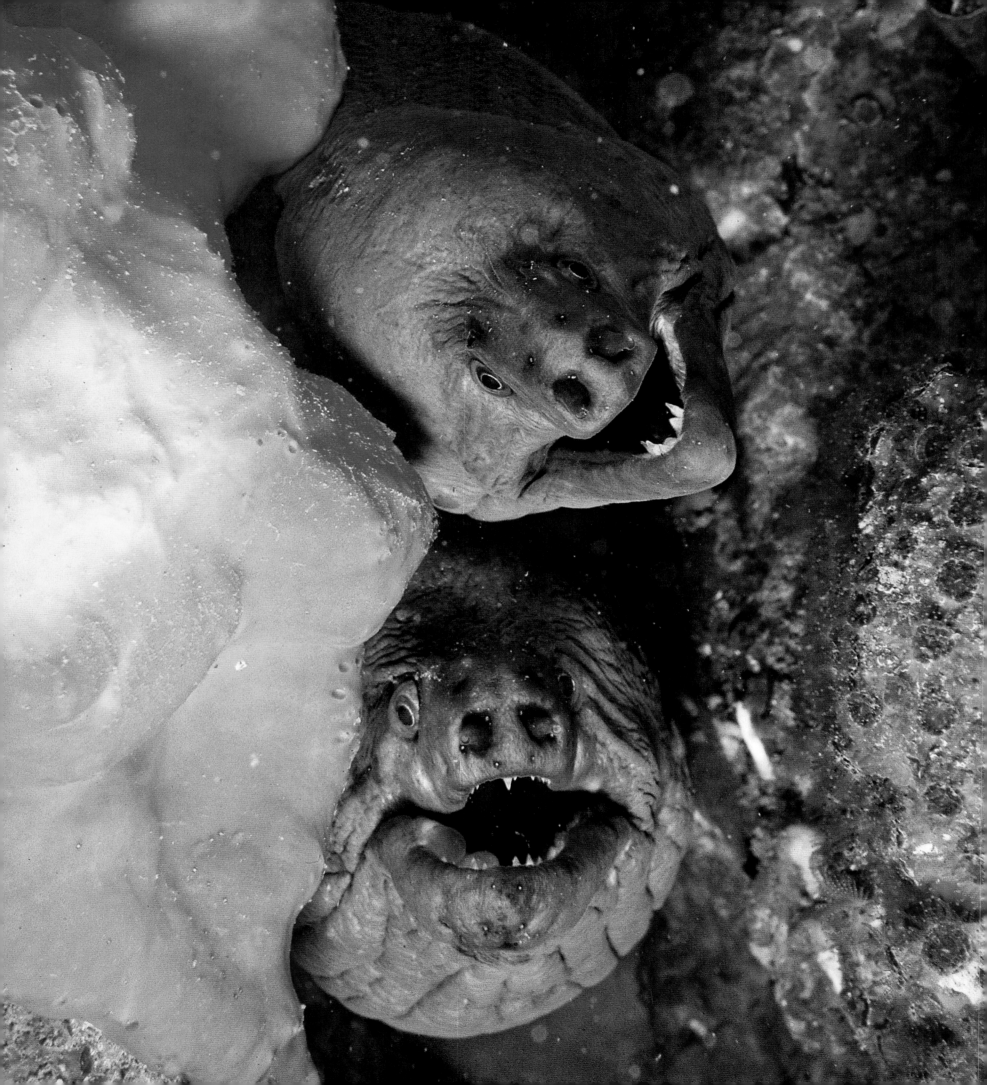

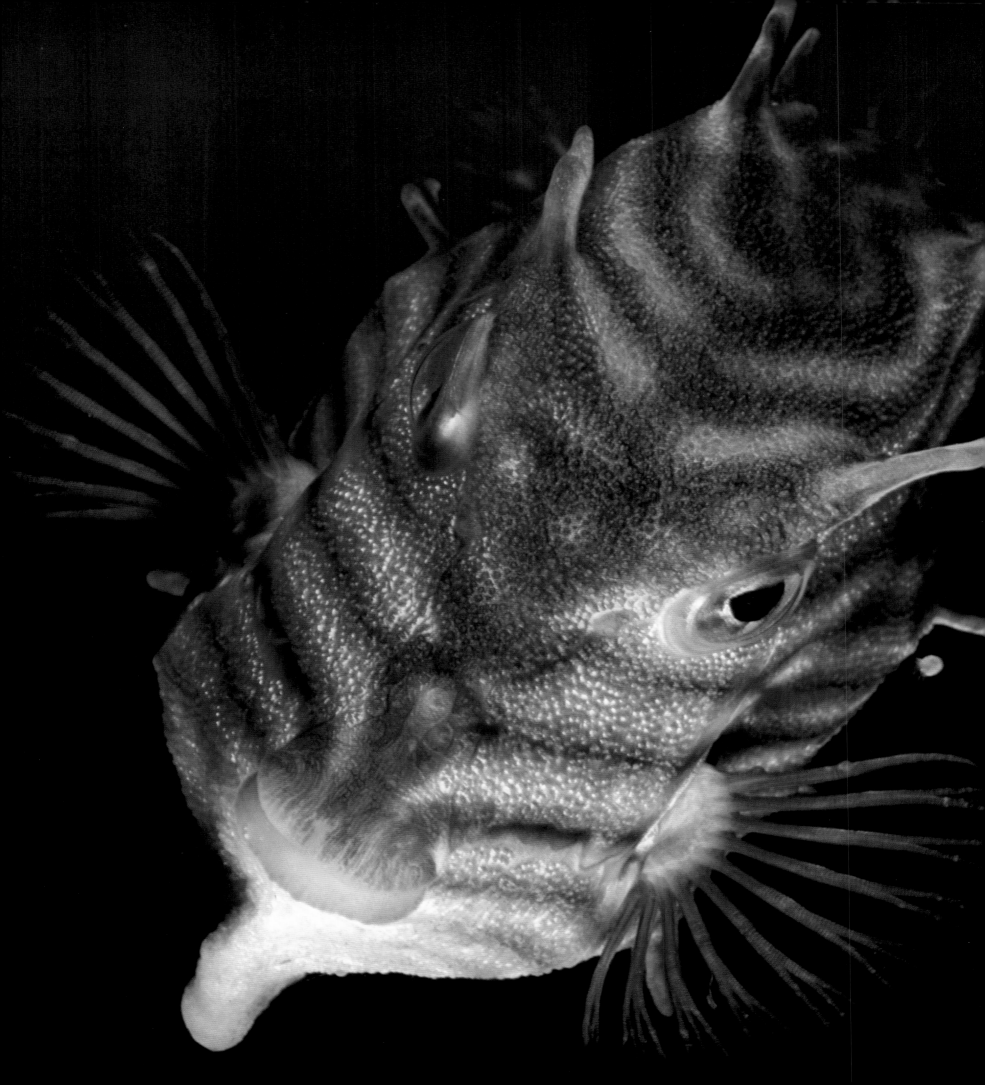

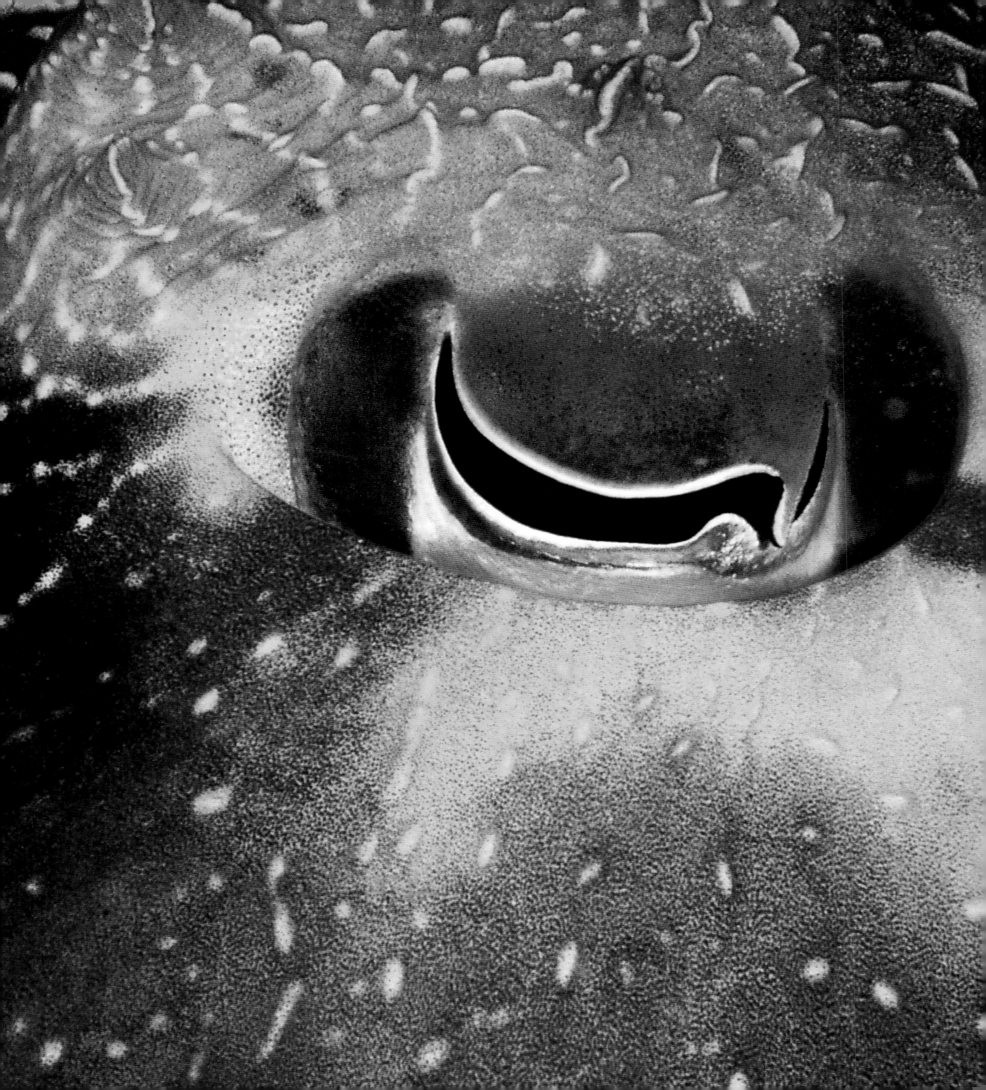

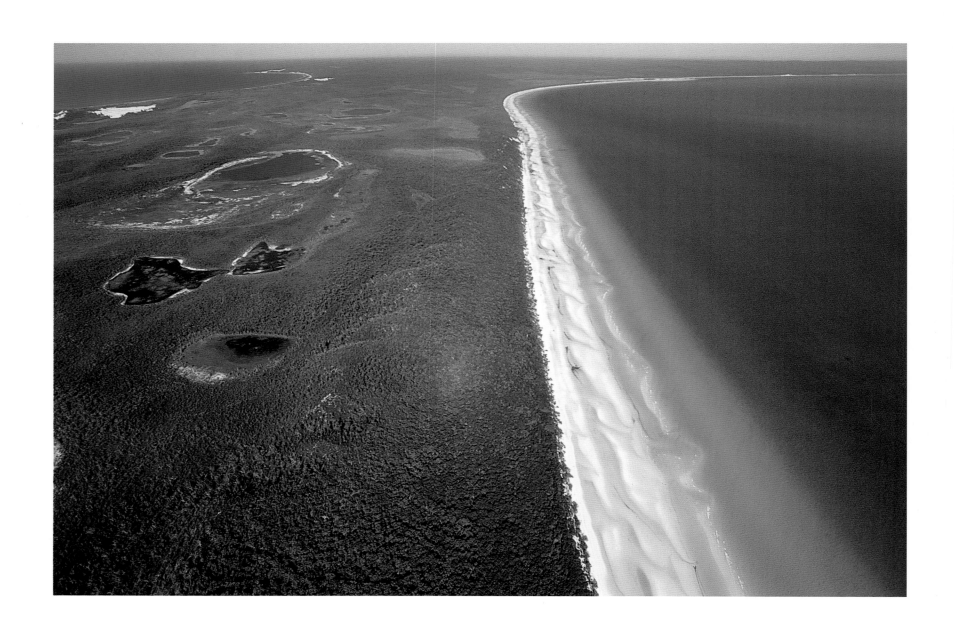

132 The forest grows right down to the beach in the West Lakes Sand Dunes area of the Great Sandy National Park on Fraser Island, off Queensland.

133 Only a tongue of dazzling white sand separates the forest from Maheno Beach, site of the Maheno Wreck, one of the numerous ships that have foundered on the Great Barrier Reef.

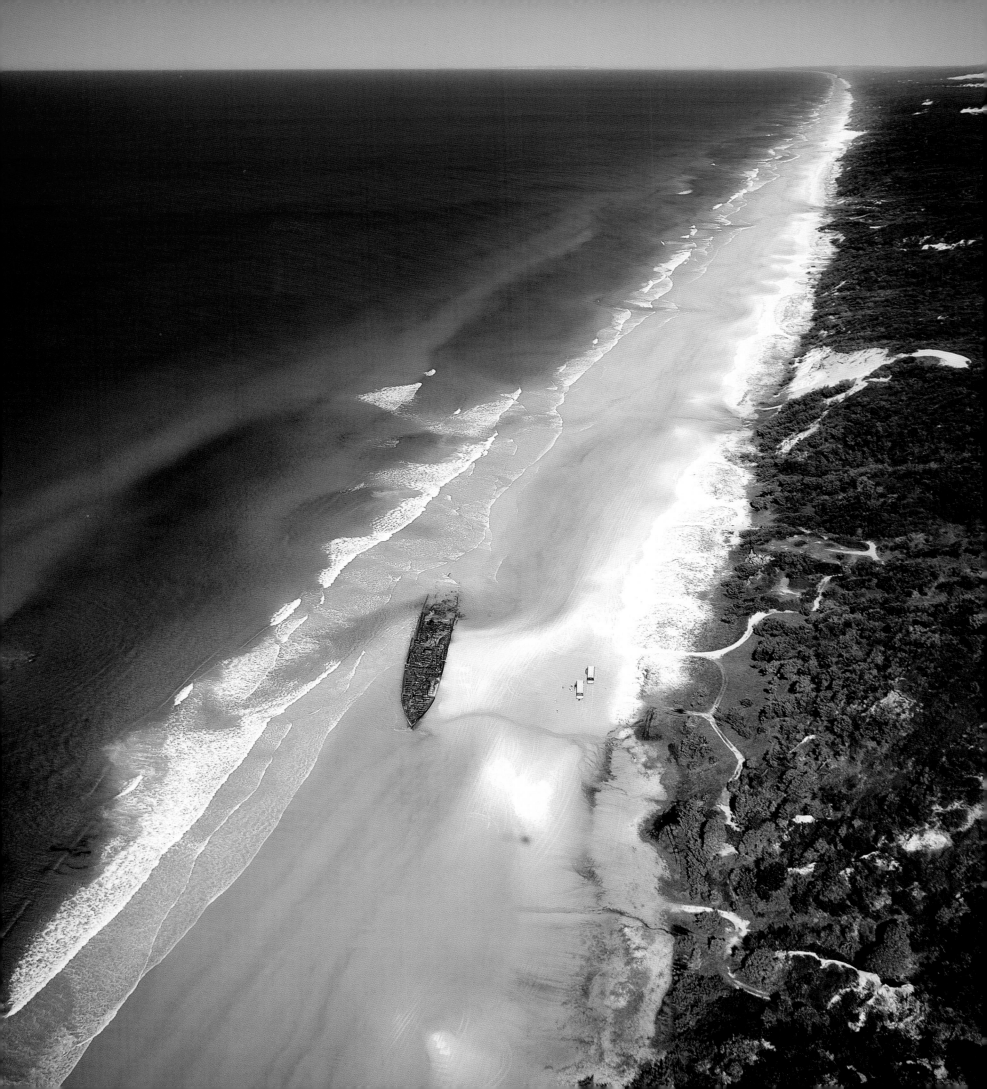

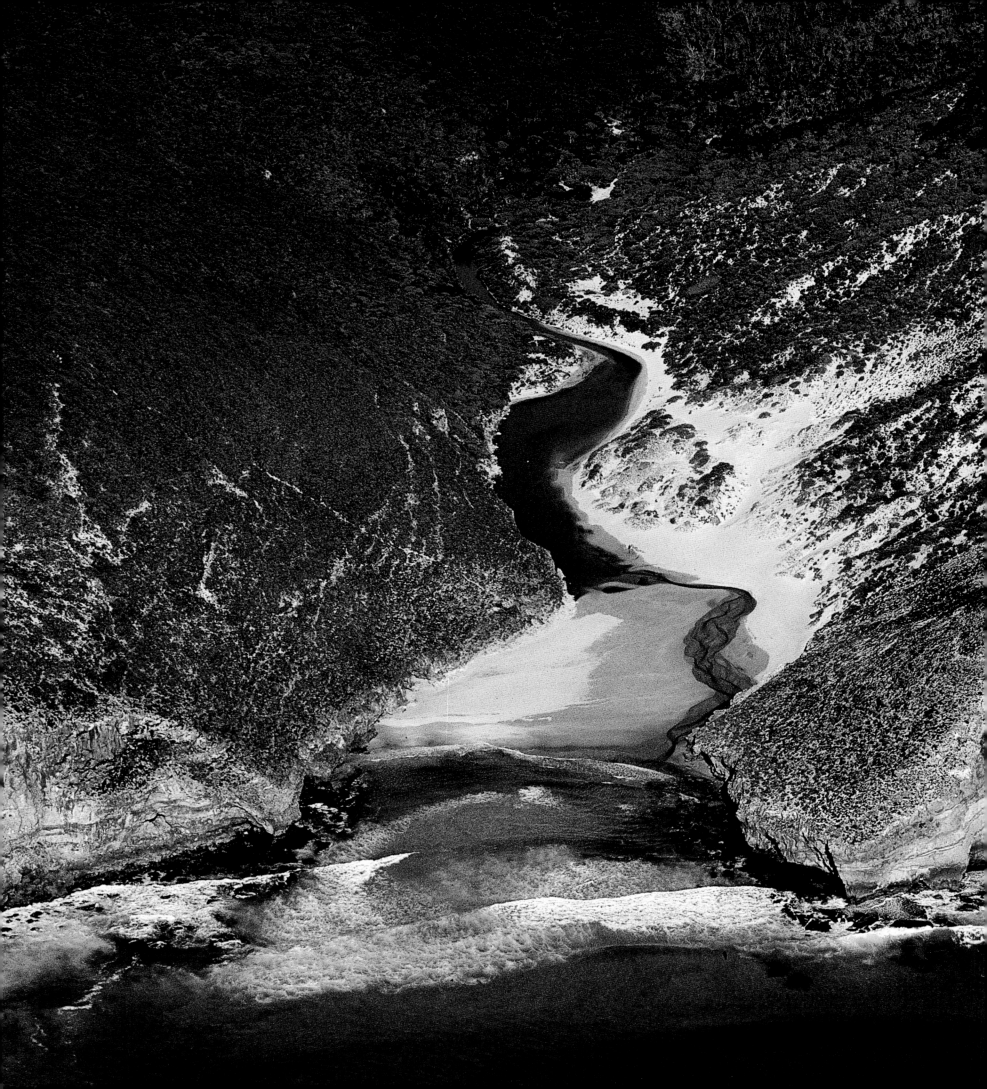

134–135 THE SEA LAPS THE COAST, CREATING AN INFINITE SUCCESSION OF BLUE, IN THE FLINDERS CHASE NATIONAL PARK ON KANGAROO ISLAND.

136–137 THE INCREDIBLE RED EXPANSE OF LAKE HILLER CUTS THROUGH THE TROPICAL RAINFOREST, AGAINST THE BACKDROP OF THE BEACH AND THE SEA.

138-139 Fingers of land stretch out like patches of color into the blue sea of Shark Bay, a splendid natural paradise.

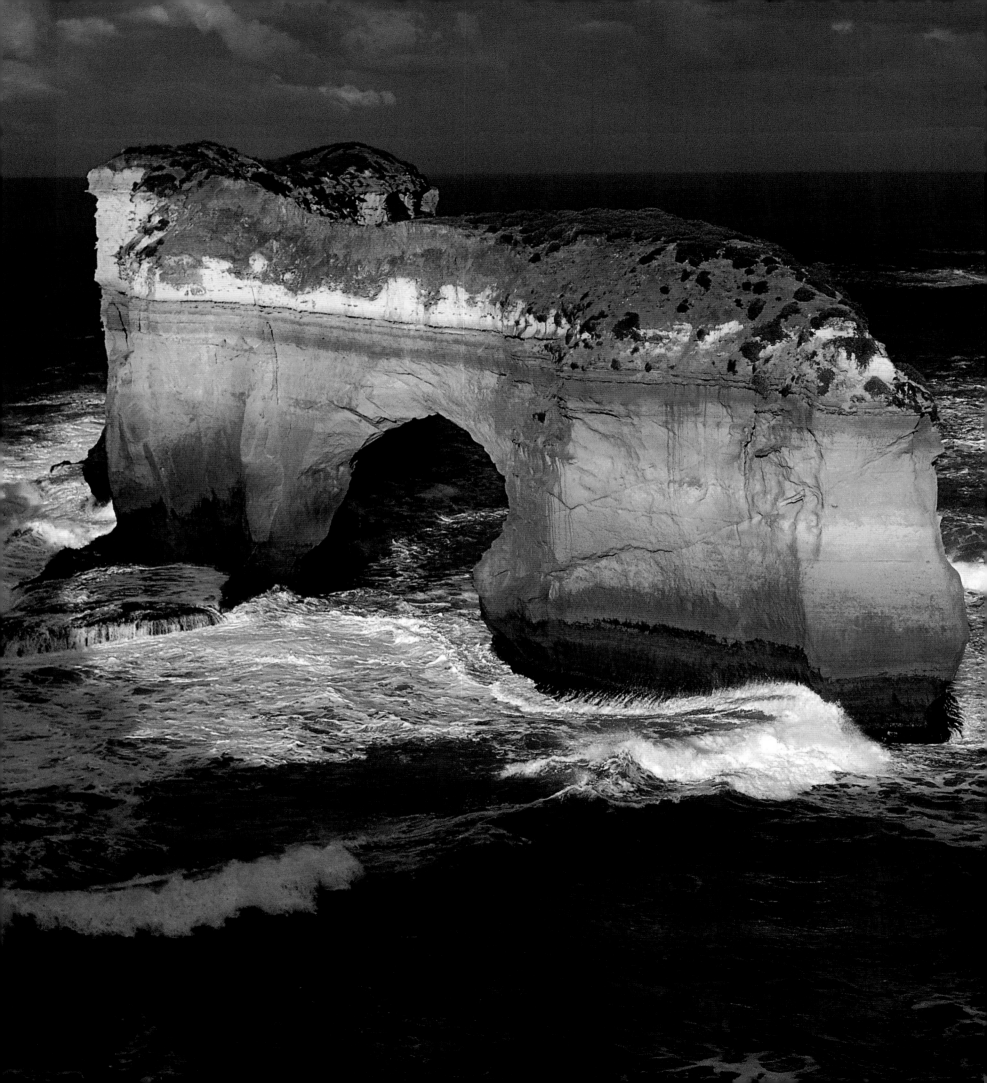

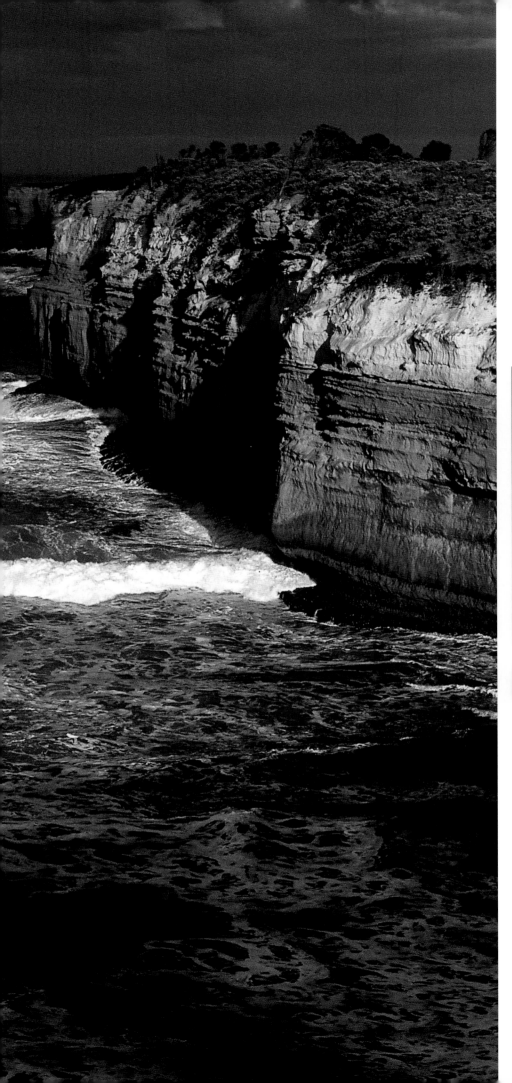

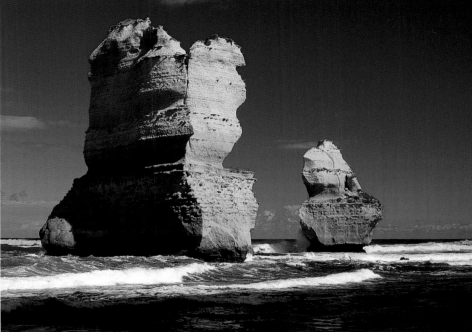

140-141 ALONG THE GREAT OCEAN ROAD, THE SEA HAS SCULPTED THE ROCK LIKE AN ARTIST, FORMING ANOTHER OF THE FABULOUS MYSTERIES OF AUSTRALIA.

141 TWO ROCK STACKS STAND GUARD LIKE SENTINELS AMID THE FOAMY WAVES, IN ONE OF THE SPECTACULAR PANORAMAS THAT CAN BE ENJOYED ALONG THE GREAT OCEAN ROAD.

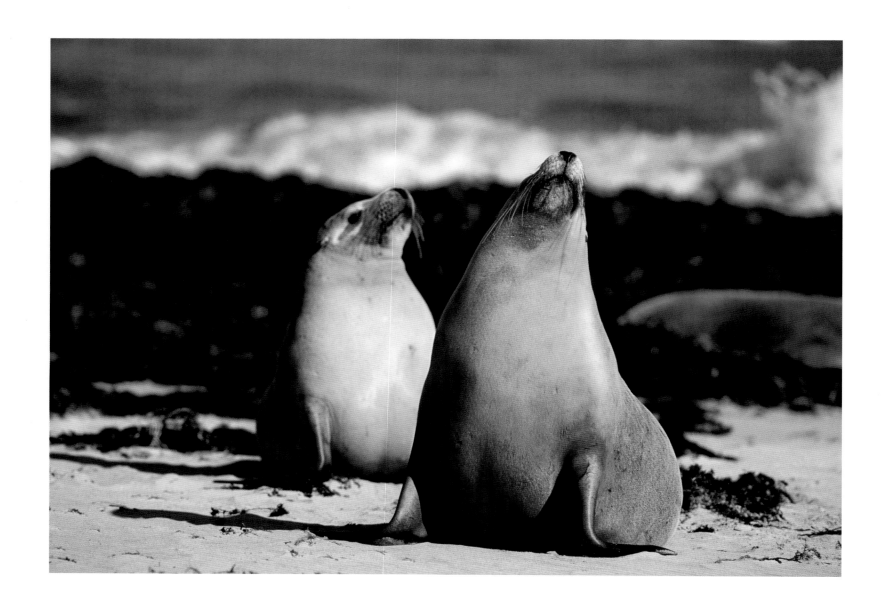

142 These two majestic sea lions lying on the beach almost seem to "roar" at the sky.

143 The Australian sea lion *(Neophoca cinerea)* is a very common species along the shores of Kangaroo Island. This one seems to be contemplating the rainbow.

144-145 Sea lions sleeping lazily on the warm sands of Seal Bay.

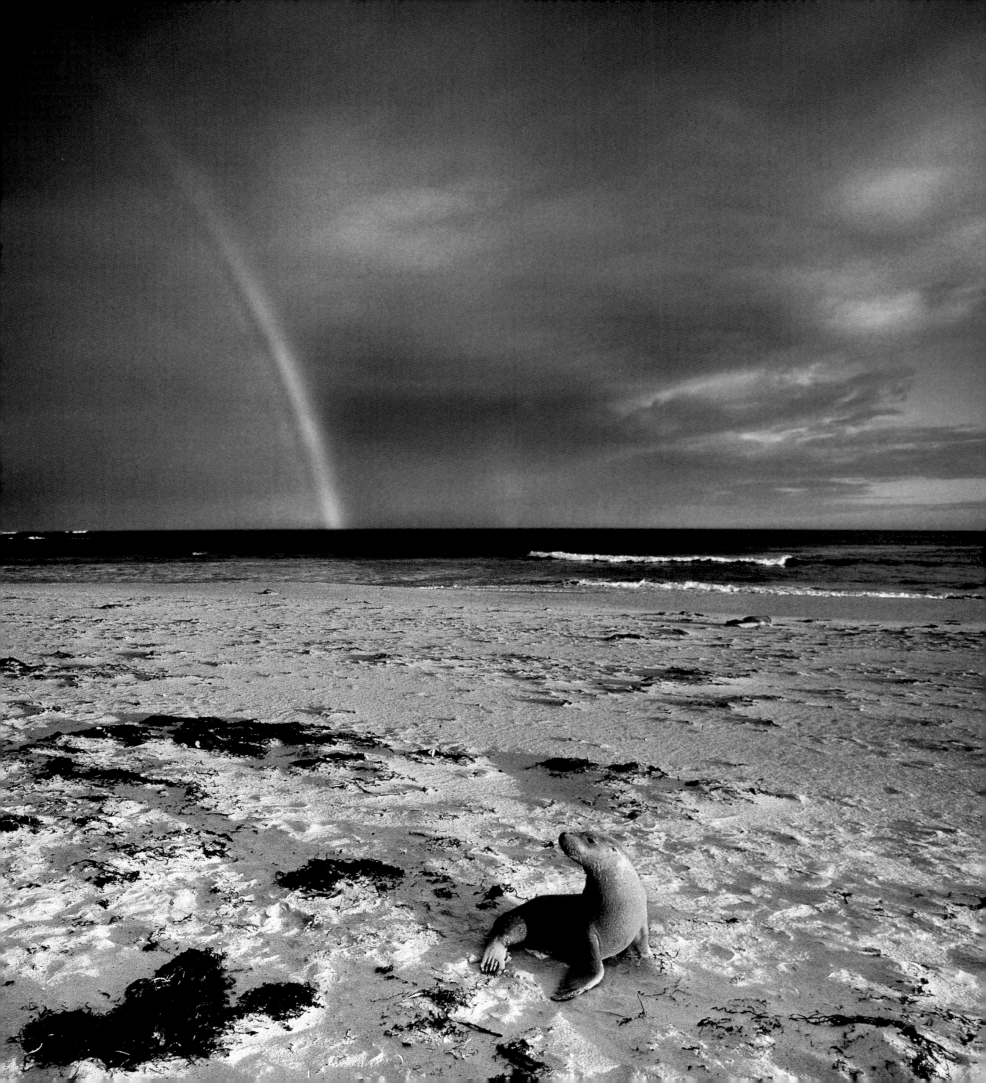

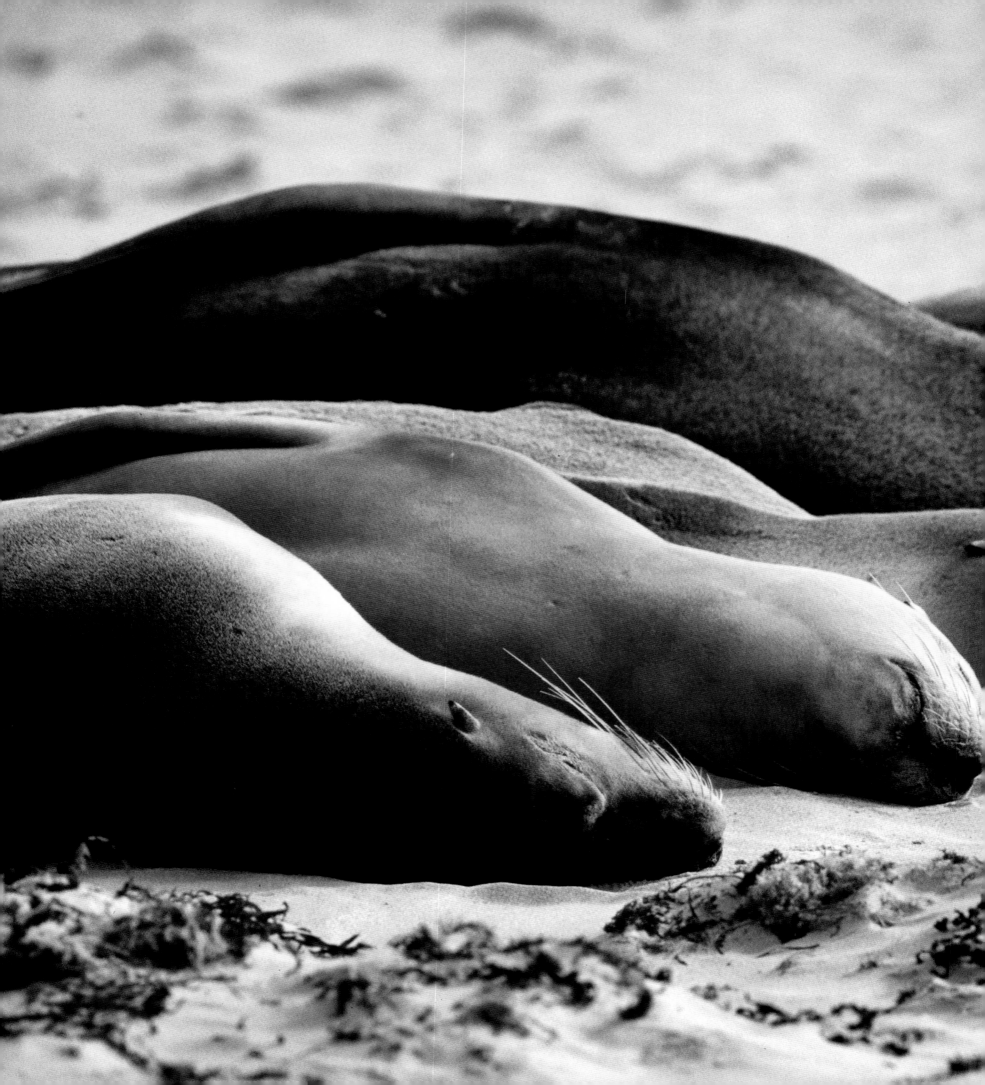

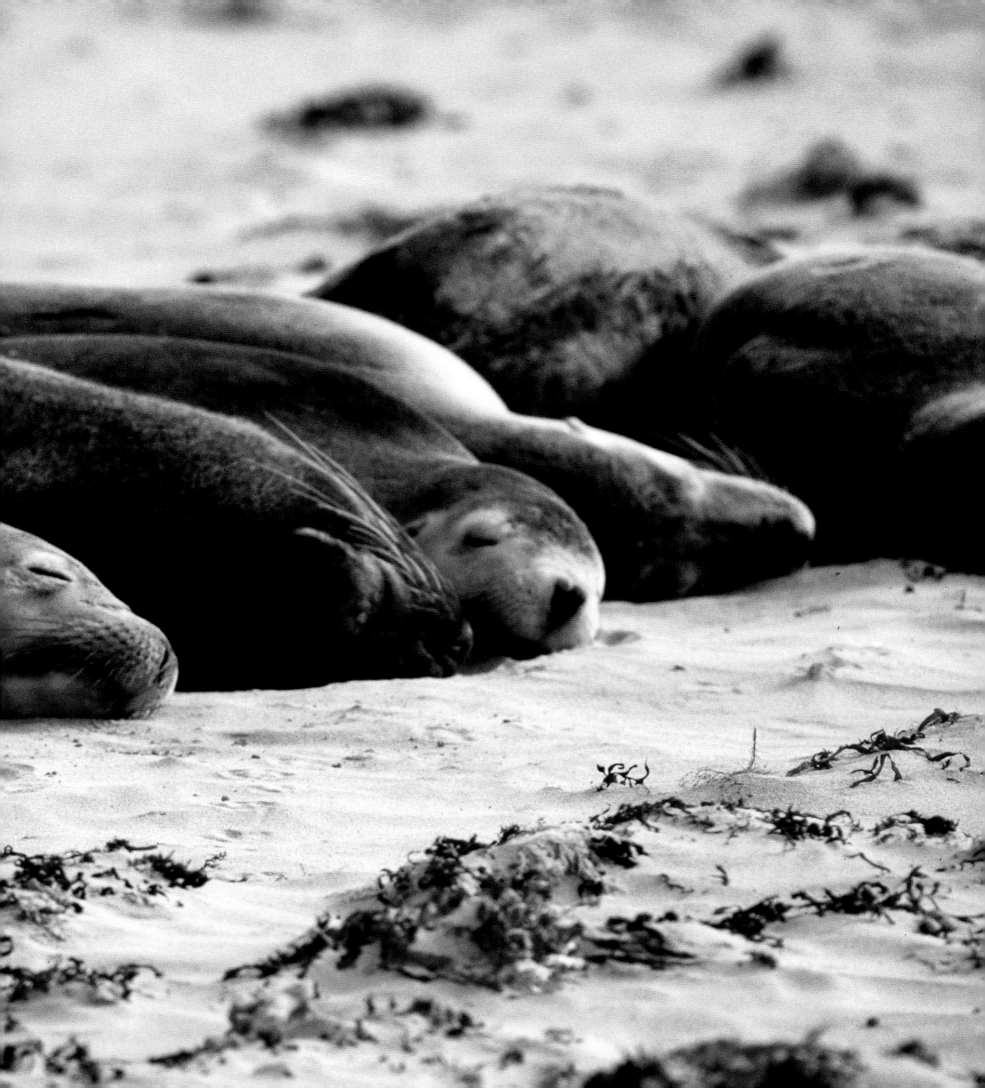

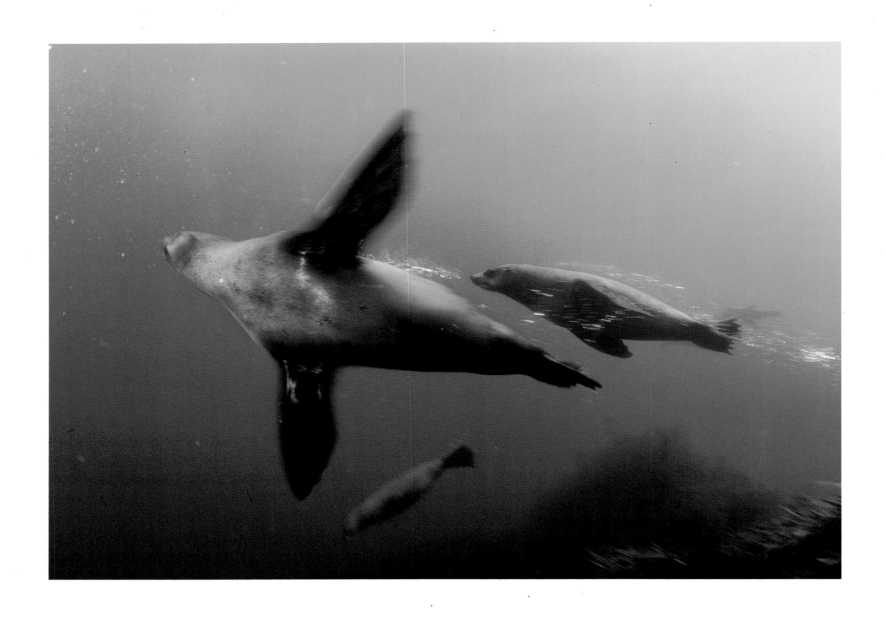

146 THREE SEA LIONS SWIM GRACEFULLY THROUGH THE OCEAN DEPTHS. THE MOVEMENTS OF
THESE MAMMALS ARE SO ELEGANT THAT THEY ALMOST APPEAR TO FLY.

147 SEA LIONS BELONG TO THE PINNIPEDIA SUBORDER OF MAMMALS, WHICH HAVE ADAPTED TO A
LIFE OF SWIMMING, AS TESTIFIED BY THEIR LIMBS THAT HAVE EVOLVED INTO FLIPPERS.

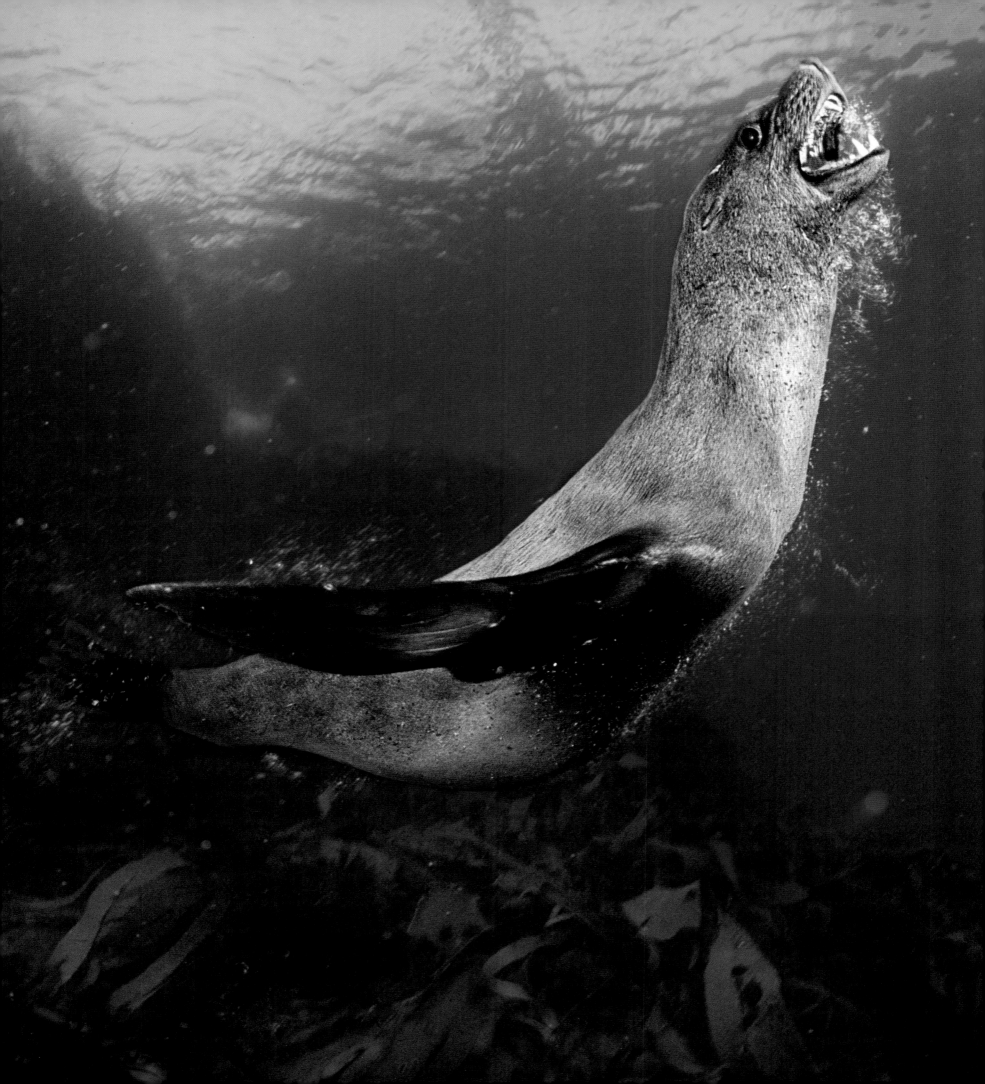

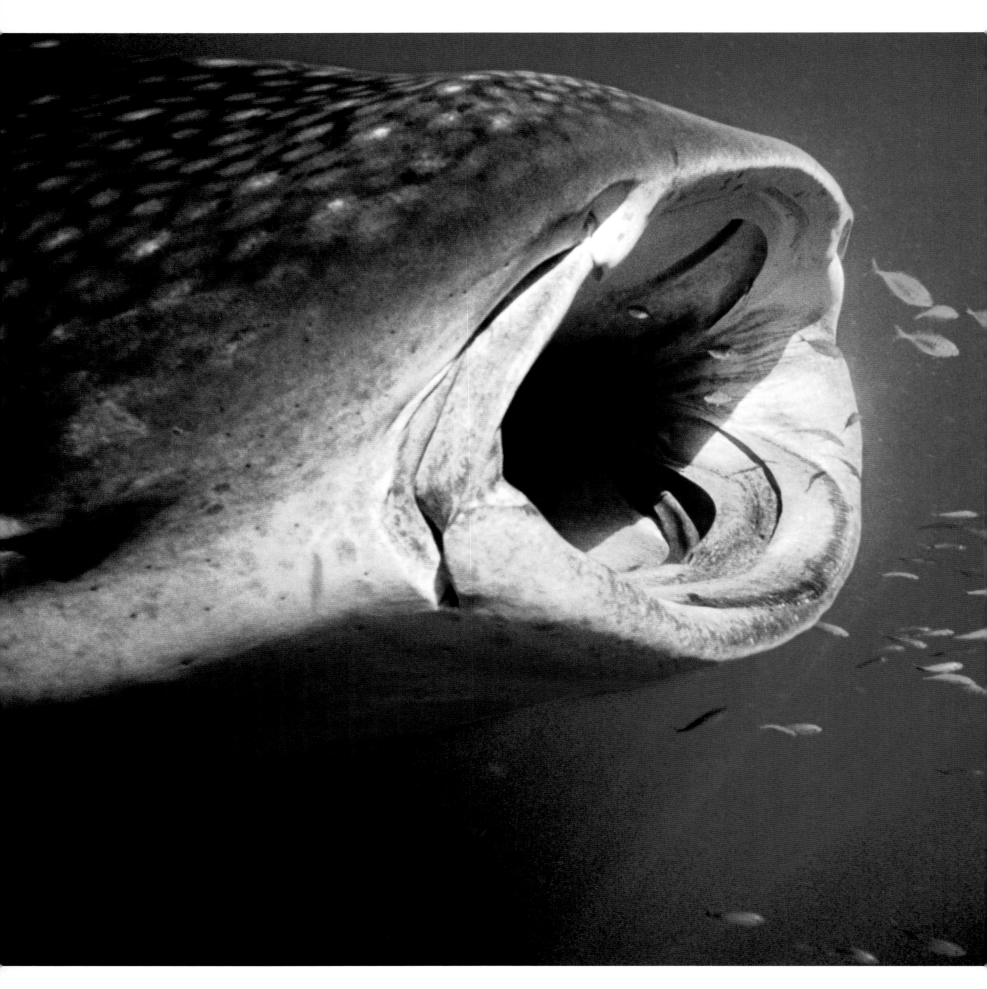

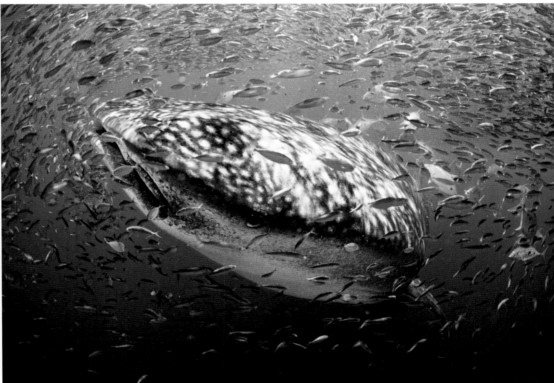

148-149 AND 149 The whale shark, the world's largest fish, swims in the Australian waters undisturbed, in search of the plankton on which it feeds.

150-151 A piked whale *(Balaenoptera acutorostrata)*, roams the blue depths of the Great Barrier Reef.

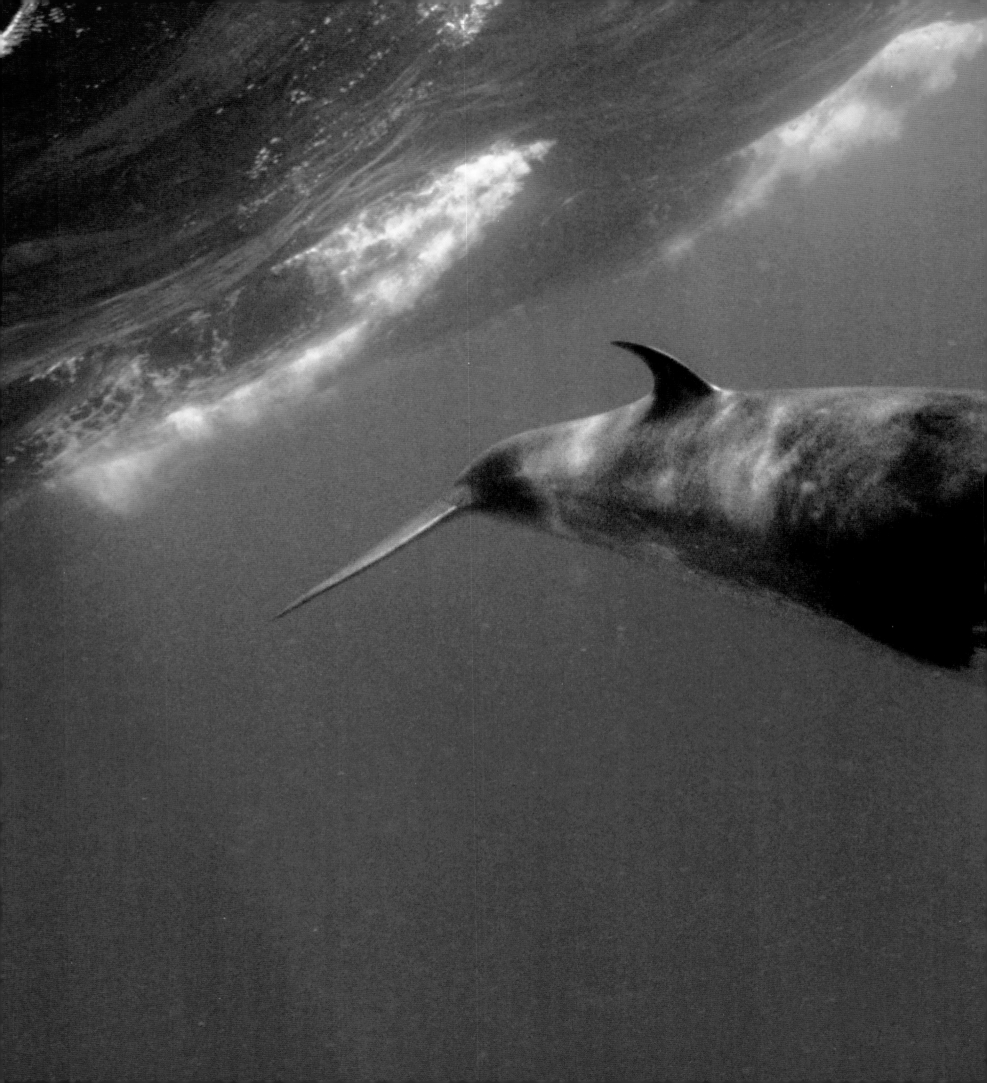

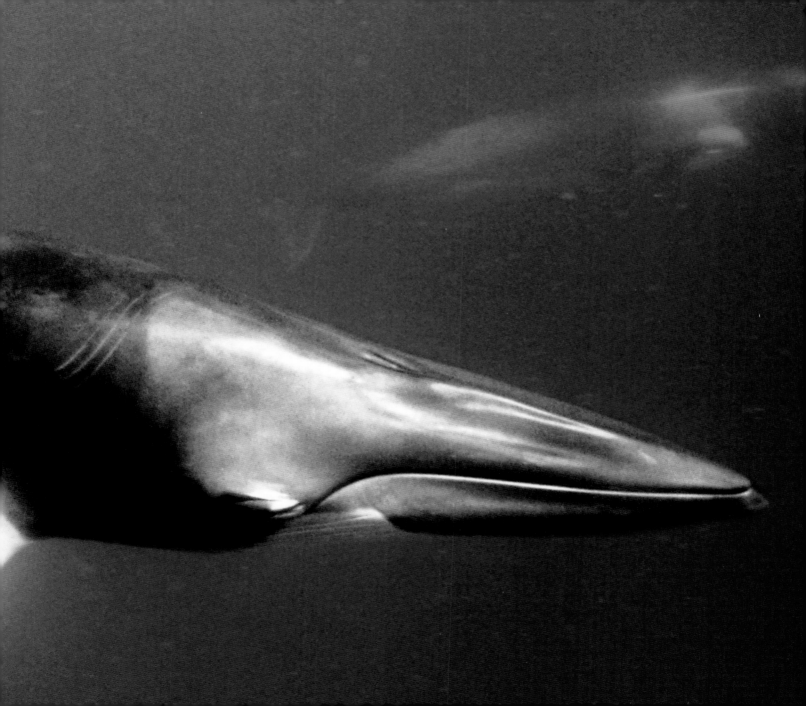

CITYSCENARIOS

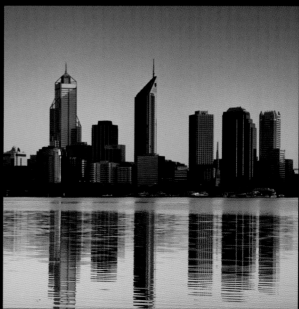

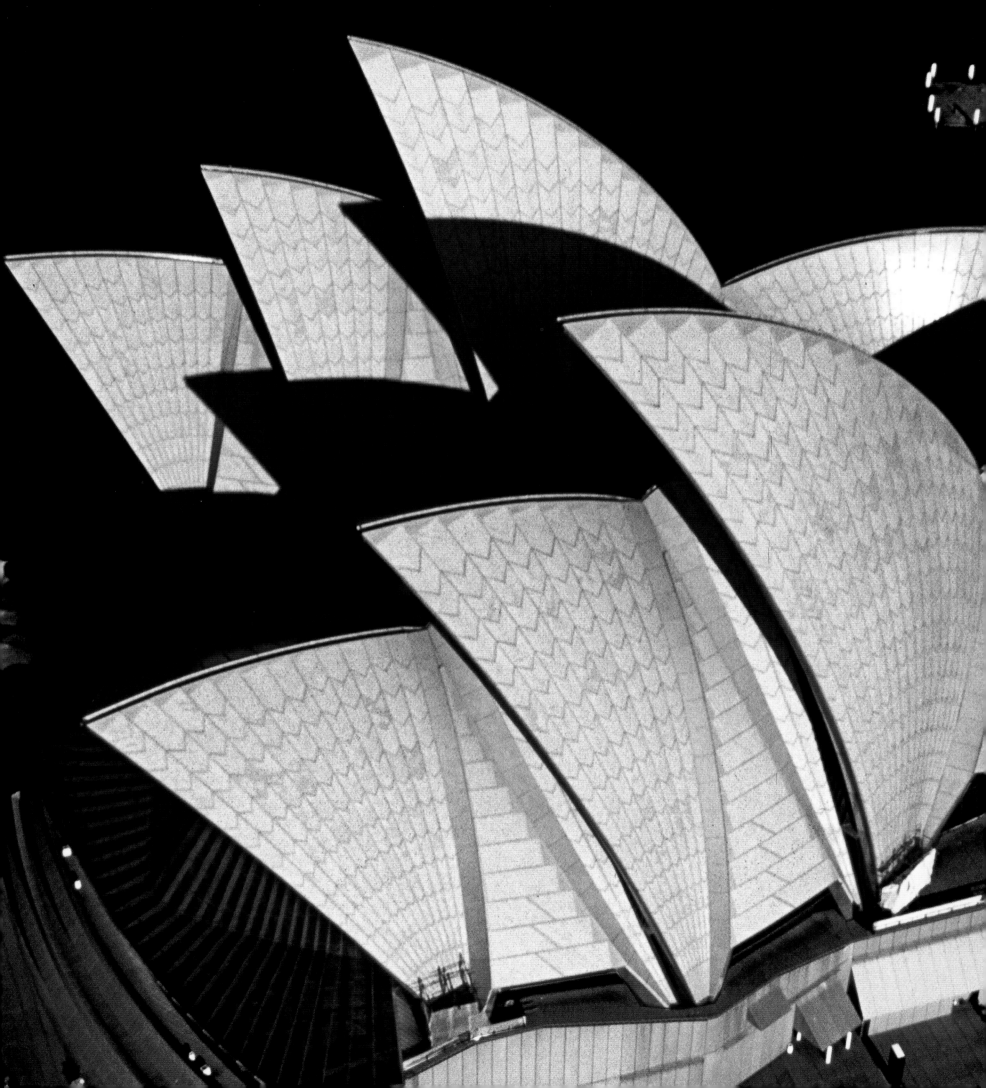

CITIES OF A THOUSAND LIGHTS AND COLORS

Australia's cities look out knowingly from coasts studded with Victorian townhouses; they dazzle with the lights of their skyscrapers, in the evening tinged with a thousand colors in the evening; they win hearts with their energy and their inhabitants' contagious activity. Like beautiful, perhaps slightly spoilt, yet always breathtaking women, they seduce at first glance, and it takes very little to fall hopelessly in love with them. Australian cities are brimming with vitality, lit by the sun that shines for most of the year and cheers their skylines with warm atmospheres that are pleasant to

 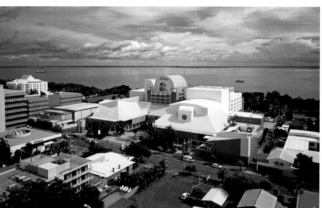

enjoy, perhaps sitting at a café overlooking the sea. They are charming, with their alternative districts, full of life and artists and streets dotted with Italian, Indian, Japanese, Chinese and Australian restaurants offering all the cuisines of the world. They are good-natured, characterized by their inhabitants' optimism and joie de vivre – a life of heedless pleasure to which it is all too easy to become accustomed.

The entire country is brimming with charming places, with their own distinctive personalities, starting with the little towns, such as lively Tamworth, in New South Wales, the Australian music capital, which is a triumph of guitars and country music. Or picturesque Kalgoorie, in Western Australia, which is perhaps the most evocative mining city with its many period buildings. Or the sporting surf cities, quieter on the Sunshine Coast and rowdier on the Gold Coast: a long stretch of beaches, hotels, motels and tall skyscrapers, dominated by Surfers Paradise, seething with nightclubs and casinos, stores, boutiques and theme parks, including spectacu-

lar Sea World. Or the welcoming little towns along the Murray, Australia's longest river, which is plied by steamboats and houseboats, and enveloped by the majestic red gum trees that grow on its banks. These atmospheric little towns are imbued with the spirit of adventure, like Euchuca, a picturesque old river port with a legendary quay dotted with restaurants and art galleries. Or the little towns of Tasmania, with their special atmosphere reminiscent of old England. The medium-sized cities also have a unique character: joyful Cairns, adventurous Darwin, wild Alice Springs, sunny Broome and foreign Hobart.

"Live, live and live again," could be the motto of pleasant Cairns, one of Queensland's best-loved tourist resorts, with a population of just over 100,000. It stretches languidly around a bay, surrounded by the deep green rainforest and lulled by the blue sea of the Great Barrier Reef. Toward the coast, sandbanks and mangroves announce a marsh inhabited by pelicans and other tropical birds. There is little to see apart from the Flecker Botanic Gardens, which are home to over 200 varieties of palm, and the Museum and Art Gallery. It is instead the atmosphere of the place that conquers visitors. The brightly colored colonial-style historic buildings shine in the dazzling light, while the sellers of crocodile skin and teeth, cowboy hats and other knick-knacks provide an exotic touch. A varied public meets in the cafés and restaurants, or in the huge swimming pool that faces the sea and Trinity Wharf.

Adventurous Darwin in the Northern Territory is surlier and its population only just reaches just 87,000. It is a tough city that has resisted 64 air raids and holds the record for lightning and storms. In 1974 Cyclone Tracy swept away all its wooden houses on stilts with their handsome verandas. They have been replaced by more solid brick buildings better able to withstand the elements. Apart from a few surviving buildings overlooking the Esplanade – such as Admiralty House, Lyon's Cottage and Government House – Darwin is now dotted with modern and rather anonymous apartment

blocks. Evasive and reluctant like a beautiful adventurer, the city does not reveal itself easily, but conquers with its truly unique "frontier" charm and Far West-style pubs.

Alice Springs, in the very heart of Australia, is another wild city. Dressed in a blanket of red dust, it suspiciously eyes new arrivals with the same elusive gaze that can be seen on the faces of the Aborigines sitting in the shade of the tall gum trees. The town is arranged around Todd Street, where its most interesting buildings are situated: the John Flynn Memorial Church, Adelaide House and the Museum of Central Australia. Today its population exceeds 28,000 (although its inhabitants once numbered just 200), but the desolate atmosphere of this town lying at the foot of the spectacular rocky walls of the Mac-Donnell Ranges has remained much the same. "The Alice," as Australians call it, still has a rather Spartan atmosphere, with picturesque saloons, where the tough men of the Outback meet, wearing cowboy hats and boots and drinking beer at the bar. The frontier spirit can also be found just outside town in the old stone Telegraph Station, which stands among hills of sand and rock dotted with rough vegetation, composed chiefly of gum trees and thorny bushes. It is here that the roots of wild Alice Springs lie, for the town was established in 1871 as a station on the telegraph line between Adelaide and Darwin. The settlement was founded near a spring in the bed of the Todd River, which is almost always dry and owes its name to Superintendent Charles Todd, while the town was named after his wife, Alice, and the springs.

Sunny Broome, isolated in the far corner of Western Australia, captivates visitors with its dazzling light, just like the pearls concealed in its waters. Sculpted between the sky and the red rocks of the shore, it stretches for miles and miles into the distance, following the path of the sun and kissed by the turquoise waters of the warm, fragrant and inviting Indian Ocean. It has the atmosphere of a charming old frontier port, brimming with legends and evocative sensations, with its picturesque wooden houses with verandas, Chinese-style architecture, luxuriant gardens and exotic palm-lined avenues and drives. The first to reach Broome were the adventurers without scruples who had been hit by "pearl fever" following the discovery of large quantities of the gemstones from 1880. Indeed the city soon became the world's pearl production capital; demand was high, mother-of-pearl was also used to make buttons. Chinese, Indonesians, Malaysians, Japanese and Asians mingled with the Aborigines and the odd white, defying the sea and the sharks, heedless of danger, as sadly and tragically testified by the pioneers' cemeteries. Today Broome has a population of 14,000 and a healthy tourist trade, and shimmers in the overwhelming and cosmopolitan turmoil of its throbbing heart: a handsome, slightly Westernized Chinatown, that still preserves a few traditional Chinese shops and historic pearl stores.

Finally, there are the large cities, which constantly compete with each other for leadership: beautiful Sydney, aristocratic Melbourne, bureaucratic Canberra, artistic Adelaide, youthful Brisbane, and Mediterranean Perth. And Hobart, the capital of Tasmania, which is smaller than the other main cities, but nonetheless very charming. However, regardless of size, all of Australia's towns and cities belong to the same phantasmagoric and many-sided kaleidoscope of lights and colors, which is almost impossible to resist.

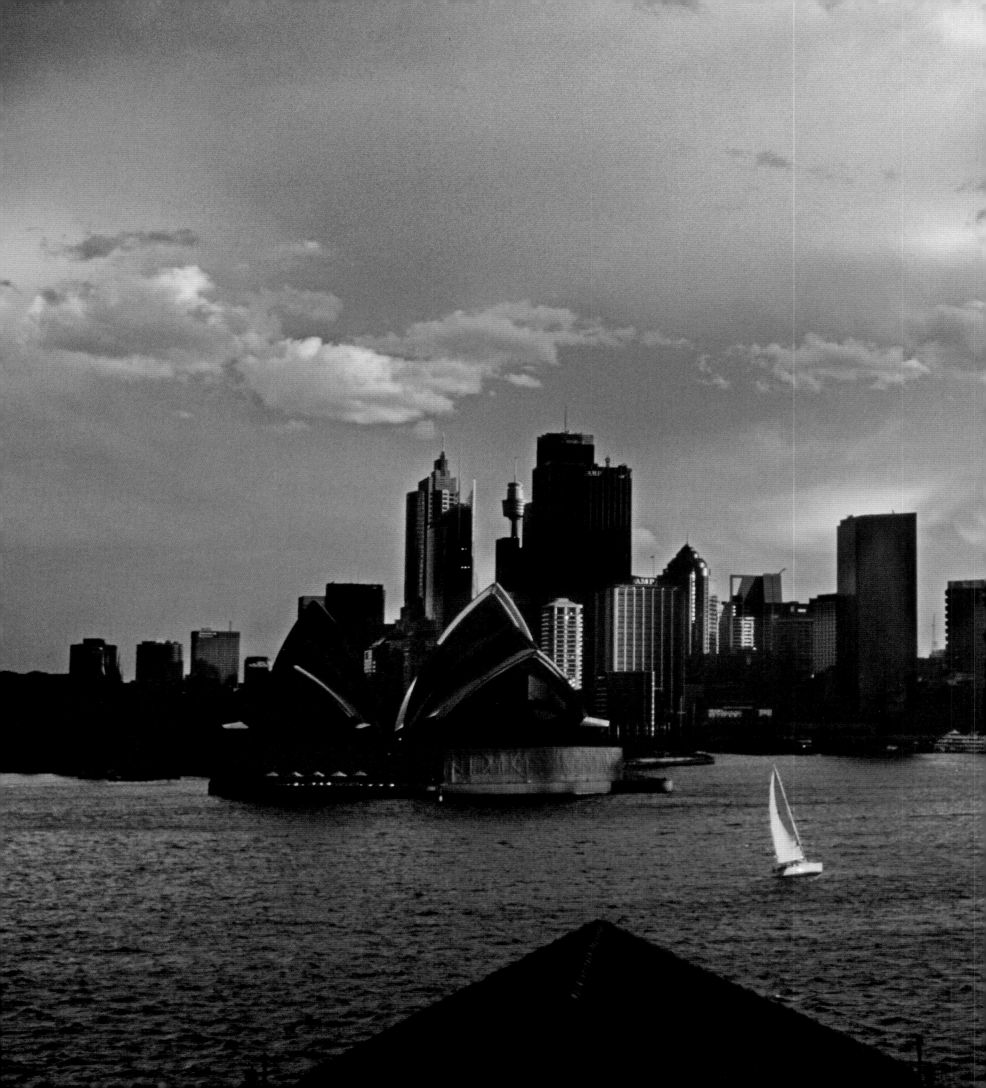

156 CHARMING SYDNEY UNFOLDS IN ALL ITS SPLENDOR FROM KIRRIBILLI.

157 TOP LEFT AND RIGHT THE TALL AMP TOWER AND THE SAILS OF THE OPERA HOUSE CAN BE MADE OUT IN THE PHOTOGRAPH ON THE LEFT, WHILE THAT ON THE RIGHT SHOWS THE COLONIAL FAÇADES OF THE HISTORIC BUILDINGS OF THE DISTRICT OF THE ROCKS.

157 BOTTOM THE MONORAIL SNAKES ITS WAY ABOVE THE STREETS OF THE CITY'S BUSINESS AND COMMERCIAL CENTER.

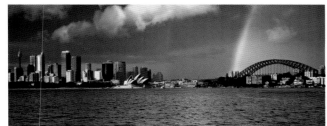

BEAUTIFUL
SYDNEY

Like a beautiful woman looking in the mirror in the morning, Sydney is reflected in the waters of Darling Harbour and rubs her eyes in the light of the rising sun that tinges the wings of the Opera House with hues of pink and violet. She contemplates herself for a moment from the top of the Harbour Bridge, when the first lights illuminate her skyline and the old houses of The Rocks. She powders her cheeks, light as the clouds that color the orange sky above the trees and bushes of the Domain. Then, with a slight sway of her hips, she turns on her heels and sets out happily toward the new day, while the sun traces the first shadows amid the coming and going of the ferries that bustle around Circular Quay. Sydney is well aware of her beauty, which combines the stunning blue water that stretches from her port into a thousand bays and inlets with the greenery and lush vegetation of her marvelous parks and tropical gardens. And she knows that she is slightly but delectably superficial, with that Californian-style way of life that beckons from Bondi Beach (pronounced Bond-eye).

It is easy to encounter magic in huge Sydney – which covers an area at least the size of Los Angeles, with a total population of 4 million people of 200 nationalities – that displays all her irresistible charm from both the sea and the sky. In order to become familiar with her, it is necessary to learn to know her various districts, which can be likened to the facets of the character of a great personality.

Framed beneath the metal skeleton of the Harbour Bridge, affectionately referred to as the "coat hanger" by locals, lies the city's historic district, known as The Rocks, which was once prowled by petty criminals and pickpockets. Tourists are the new "marauders" in the stretch of George Street that crosses one of the liveliest areas of the entire city, among splendidly restored historic buildings, cafés and pubs (including Sydney's oldest, The Hero of Waterloo), little shops of all kinds, art galleries and elegant boutiques. The atmosphere is truly electrifying: open-air restaurants and even a German-style beer garden, and people of all nationalities, who come and go and meet in the picturesque market, where books, paintings, antiques, soaps and perfumes mingle with jams, didgeridoos (musical instruments made from branches hollowed out by termites), boomerangs and odds and ends dating from all periods in a blaze of colors. The little houses of The Rocks look on knowingly, the keepers of tales of savage crimes and ghost stories (there's even a Ghost Tour that follows a path between these legendary spots in the evenings). The historic pubs

with live blues and jazz music are ideal for spending a few hours in front of a beer, perhaps chatting with a fellow customer. Beyond Cadman's Cottage, the oldest house in the city, a succession of buildings rises vertically, between stairs and steps, as far as the Observatory Hotel, a splendid colonial gem, and the park on Observatory Hill, which offers magnificent views of the Harbour Bridge. Its grassy lawns host impromptu parties and jam sessions toward sundown, or picnics in the warm and inviting light.

Descending towards the sea, you are stunned by the multicolor traffic of Circular Quay, which is animated by a great bustle of people thronging around the Art Nouveau façade of the Museum

splendid stage. Almost as though troubled by all the noise, the building seems ready to take to the sea with its white roofs shaped like wind-filled sails, which appear to change color with the light, just like the splendid rocks of the Outback.

When it was designed by the Danish architect Jorn Utzon in far-off 1959, the much-loved Opera House – the city's symbol – provoked great controversy, due to both its high cost and the design itself, which was truly innovative and original for the time. It is now one of the wonders of the world, as well as home to an institution that is a guiding light in the choice of ballets, operas and music and is capable of daring experimentations that have consecrated it as one

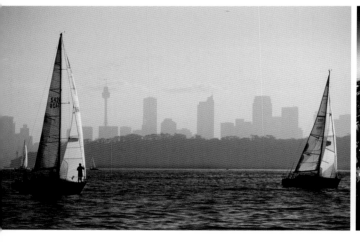

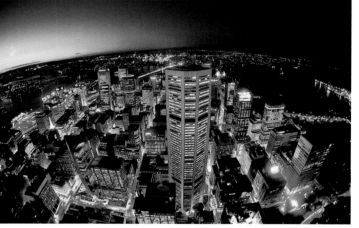

of the world's foremost important temples of art.

Behind its unmistakable profile, it is possible to glimpse the green of the Royal Botanic Gardens, where young men in white shirts and ties go to read the newspaper during their lunch breaks, girls in bikinis lie on blankets to sunbathe or read a book, and sports enthusiasts practice jog-

of Contemporary Art. Hordes of office workers and secretaries, jugglers and street artists, beggars and somewhat bedraggled Aborigines, didgeridoo players and commuters get on and off smoky ferries and disperse on the quay, mingling with a varied public composed of curious tourists craning their necks and speaking every language in the world, and a few hippies here and there. Suntanned youngsters almost seem to show themselves off, seated at the tables of the trendiest bars, which stretch down as far the magnificent Opera House: an authentic queen, set against this

ging. People walk between the trees that are home to nesting storks and the little lakes and ponds populated by ducks, pleasantly set among flowerbeds and clusters of eucalyptus trees and palms. They climb along paths that lead up the hills covered with lush vegetation in the park known as the Domain, until reaching a headland that dominates the entire bay. This is Mrs. Macquarie's Point, an incredibly romantic spot named after Elizabeth, the wife of the governor at the time in which the gardens were laid out in 1816. Swathed in the shady branches of fig trees, the colors of the sky and effects of the

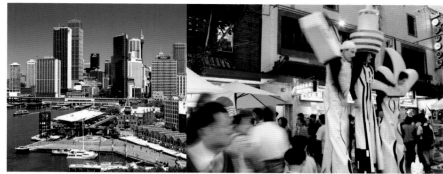

clouds at sunset, as the orange sun disappears below the horizon, setting the city ablaze, offer a truly moving experience. Exploring the park reveals important landmarks, such as Government House, an elegant Neo-Gothic building, the Art Gallery of New South Wales, with its ocher façade dating back to 1885 that is punctuated with a series of handsome columns, or imposing St. Mary's Cathedral, which overlooks another green paradise: Hyde Park.

Close to Hyde Park are the Mint, which once struck gold coins, the massive building of the Australian Museum (which houses a huge collection of natural history exhibits) and several evocative stone houses, which look as though they have appeared out of an improbable and distant past. These are the Hyde Park Barracks, which once housed the prisoners used for forced labor during a dark period of sunny Sydney's history, completely forgotten by the cheerful crowd that invades the park today. There are those who play chess or ride bicycles, while others sit on benches or the grass, framed by green tunnels of eucalyptus trees that flow towards the magnificent Anzac War Memorial and the powerful jets of water of the Archibald Fountain, embellished with mythological figures.

Behind these enormous green lungs beats the very heart of Sydney: the business center, a canyon of main streets and mountains of glass, but also luxury hotels (the record is held by the Shangri-La), flanking locales, cafés and restaurants, which are every bit as fashionable and trendy as those of New York. It is crossed by the monorail – the best and most enjoyable way to travel about the city center – that runs overhead, fast and sinuous as a snake. However, Sydney's heart must be won stage by stage. The easiest way of reaching it is via George Street and Elizabeth Street, the city's nerve centers. Sydney City Hall, an attractive and highly decorated Victorian building, is a meeting place frequented by all kinds of people, from small groups of demonstrators to idealists championing a particular cause. However, a little of its limelight is stolen by St. Andrew's Cathedral – built

in the same style – which is the country's oldest cathedral. The statue of Queen Victoria sternly observes passersby, almost as though it were the guardian of the imposing Queen Victoria Building, constructed in 1898 to house the fruit and vegetable market and extending over an entire block, in a triumph of sandstone, mosaics and colored glass, boutiques and cafés. The complex is dominated by the handsome Royal Clock, which hangs from the glass dome.

The city center is pervaded by a truly feverish and overwhelming rhythm. Pedestrians are swept from one street to another, amid the myriad of Victorian-style stores on Strand Avenue – a busy shopping center – as far as the gilded State Theatre or the solid State Parliament House. Office girls in cotton suits and bright lipstick holding cups of coffee and young men in white shirts and ties mingle with the more intellectual public around the great State Library of New South Wales. The city is dominated by the slender form of the Sydney Centrepoint Tower, the tall tower that offers one of the most breathtaking views of the metropolis. Opposite is Darling Harbour, a mosaic of lights and colors. Not far away, the monorail runs over futuristic Pyrmont Bridge. Then there is the National Maritime Museum with its stories of boats and the sea and a Soviet submarine anchored outside; the IMAX Theatre with its spectacular images; the immense and sprawling Star City hotel and casino, and the glass and steel Harbourside Festival Market Place with its infinite variety of shops. Finally, there is the blue world of Sydney Aquarium, where visitors can enjoy a close-up view of sharks and colored fish swimming through glass tunnels, as if they were immersed in the waters of the Great Barrier Reef, accompanied by the notes of classical music. Darling Harbour is not only Sydney's "safety valve" for tourists, but also for the city's inhabitants in the evenings, when they throng its locales and restaurants that offer music and tables stretching towards the sea and terraces on which people dance around minimalist bars. Sydney is a city in which you always have the impression of being at an open-air party.

A moment's peace can be found in the Chinese Garden – a walled green oasis with lotus-covered lakes and the brightly colored ornate forms of the Twin Pavilion. However, the tranquility soon disappears in Chinatown, with its bustling groceries and other little stores, where Asians hurry along laden down with bags and all kinds of objects in the shadow of Far Eastern-style architecture.

It is perhaps in the city's alternative districts that Sydney assumes an even more Bohemian air, with that atmosphere of melting pot and the artistic vein that give it such a beautiful soul. This triumph of colors and peoples culminates in the Mardi Gras carnival and the provocative Oxford Street parade, which also features the participation of transvestites, who form a substantial part of the city's gay community. Oxford Street is the street of the "Bohemian myth": a succession of bookstores, literary cafés, restaurants and takeaways offering food from all over the world, stores that are authentic little gems, strip joints, gay bars with music blaring out, and pubs (such as the characteristic Paddington Inn), where customers play billiards in a thoroughly English atmosphere. The air is heavy with aromas, ranging from India to China, which mingle with the perfumed incense of the New Age shops. The indefinable mix of Paddington Market is crowded with artists and craftsmen, with improvised stalls, as well as palmists and fortunetellers sitting in the dust in the shade of tall eucalyptus trees.

Paddington extends toward the city center, with charming little streets immersed in the peace and quiet and lined with colorful Victorian houses, flowering gardens and balconies framed with wrought iron (known as "Paddington lace"). The houses conceal craftsmen's workshops, the stores of Australian and New Zealand designers, elegant (and sometimes rather snobbish) art galleries, and delectable bars and cafés, many of which are Italian. Darlinghurst is another magnificent and even more alternative district, with splendid Victorian houses (some of which have been transformed into charming hotels, such as The Chelsea, inspired by a Tuscan villa with a few French touches), while Victoria Street and its fashionable cafés are frequented by artists, painters, intellectuals and yuppies. Kings Cross cannot be defined as a true district. It is more of a diverse tangle of red-light spots, sex shops, nightclubs and fast-food joints, which now have to compete with the arrival of the new boutiques and cafés gathered around the El Alamein fountain and Fitzroy Gardens, and with hotels such as the Regents Court, which is a favorite haunt of many actors. The elegant and fashionable streets of Elizabeth Bay – home to the splendid residence and museum of the same name – are lined with handsome mansions, inhabited by writers and journalists. Further on is Woolloomooloo, with its art festivals and bay thronged with yachts, lined with minimalist eateries and historic cafés, such as Harry's Café de Wheels, which has become a promising meeting place for artistic experimentations. Finally, Potts Point, the city's most picturesque hill, is home to a series of magnificent Georgian townhouses.

The number of fashionable districts grows each year: Surry Hills, still a destination of pilgrimage for many errant painters and artists; Newton, an extraordinary melting pot, with its trendy cafés and smoke-filled pubs offering excellent live music; Leichhardt, a sort of "Little Italy" with its own peculiar style; Glebe, a happy combination of bistros and welcoming eateries; and finally Balmain, with its Victorian pubs dotting the seafront.

Then there are the beaches, of which Sydney boasts at least 70: not bad at all for a large city! Lively Manly Beach occupies a stretch of sand that culminates in a magnificent rocky cliff, but the most glamorous of all is Bondi Beach, which is frequented by many local beauties. With its waves, ridden by fearless surfers, and soft white sand, dotted with splashes of color – beach towels, tanned lifeguards in trendy swimming costumes, sun umbrellas sprouting here and there like mushrooms, tattooed sports enthusiasts, muscular lifesavers and wide-shouldered surfers inseparable from their boards – Bondi is the symbol of the city's surf culture, its exuberant joie de vivre representing Sydney's most smiling face – a face that conquers at first glance.

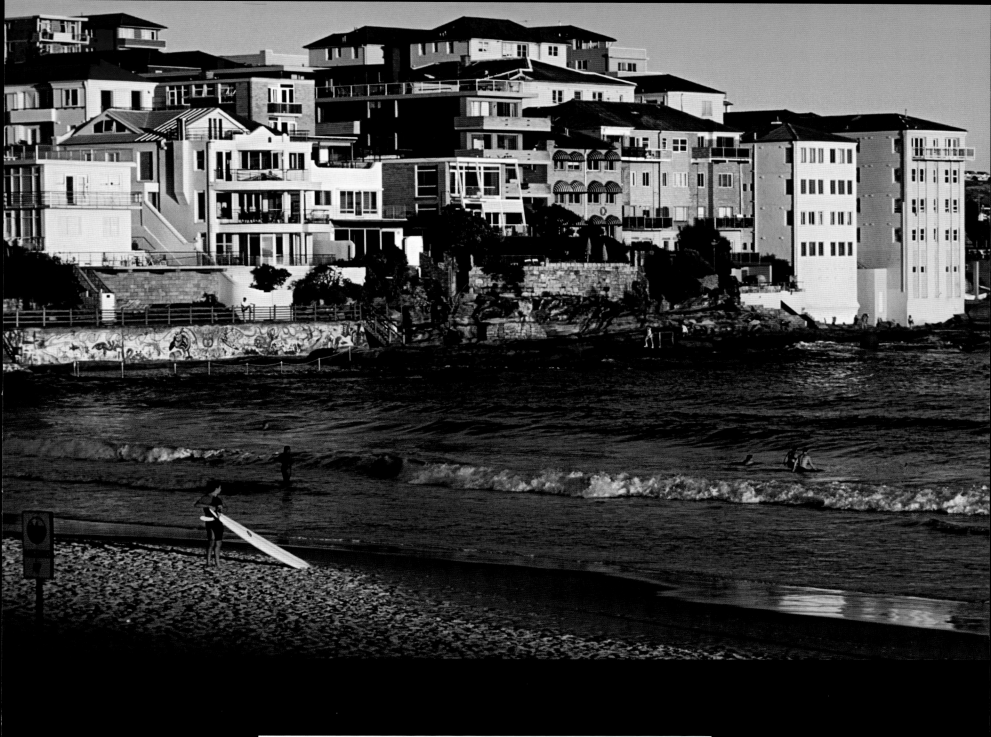

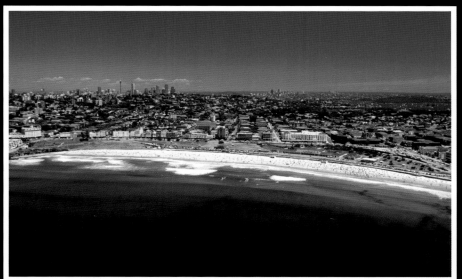

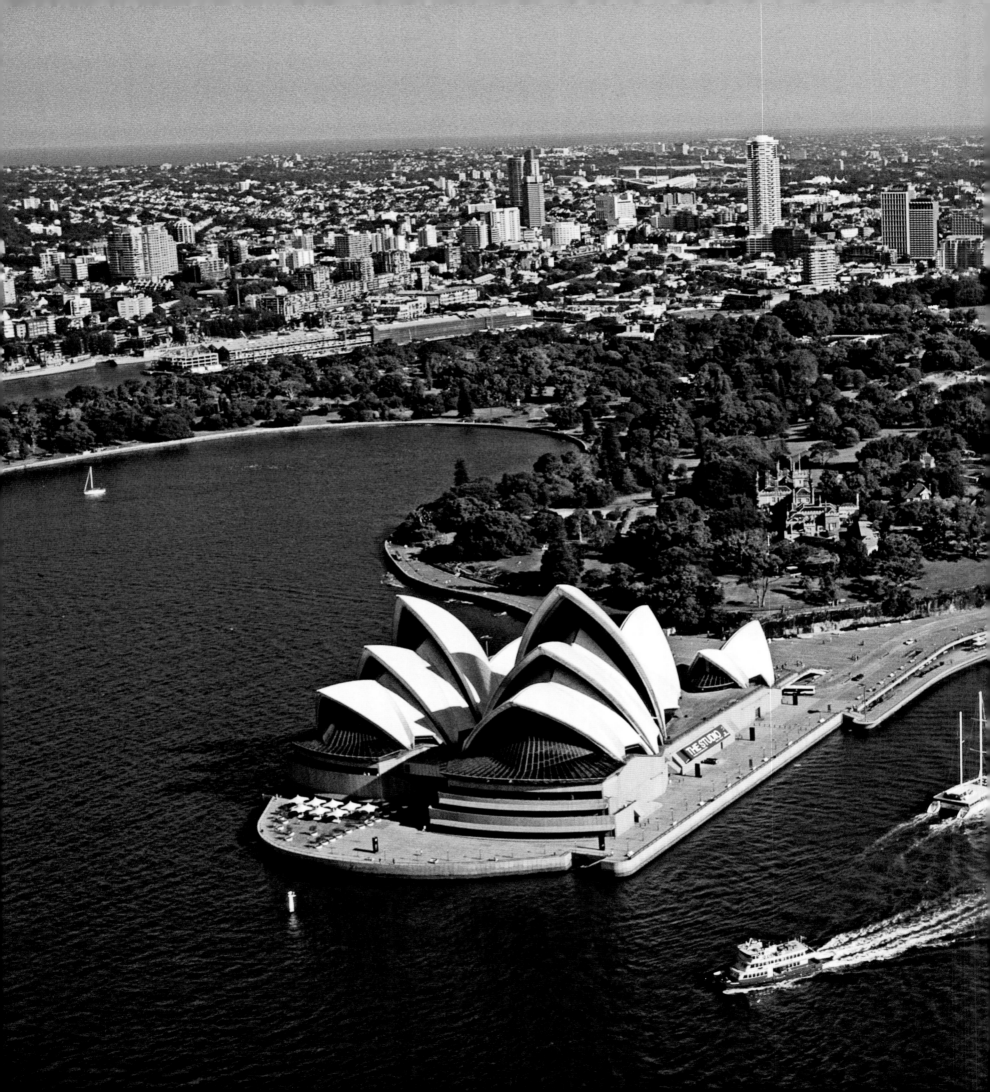

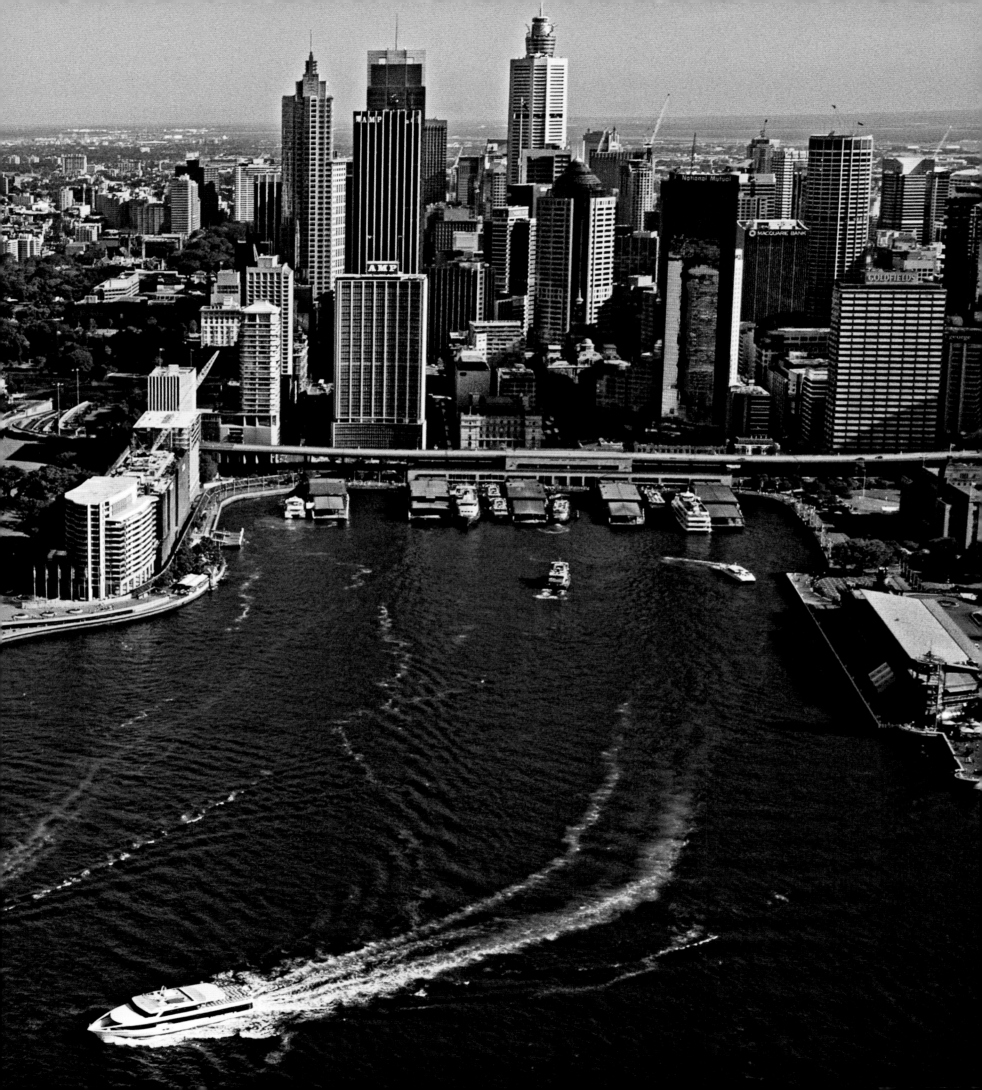

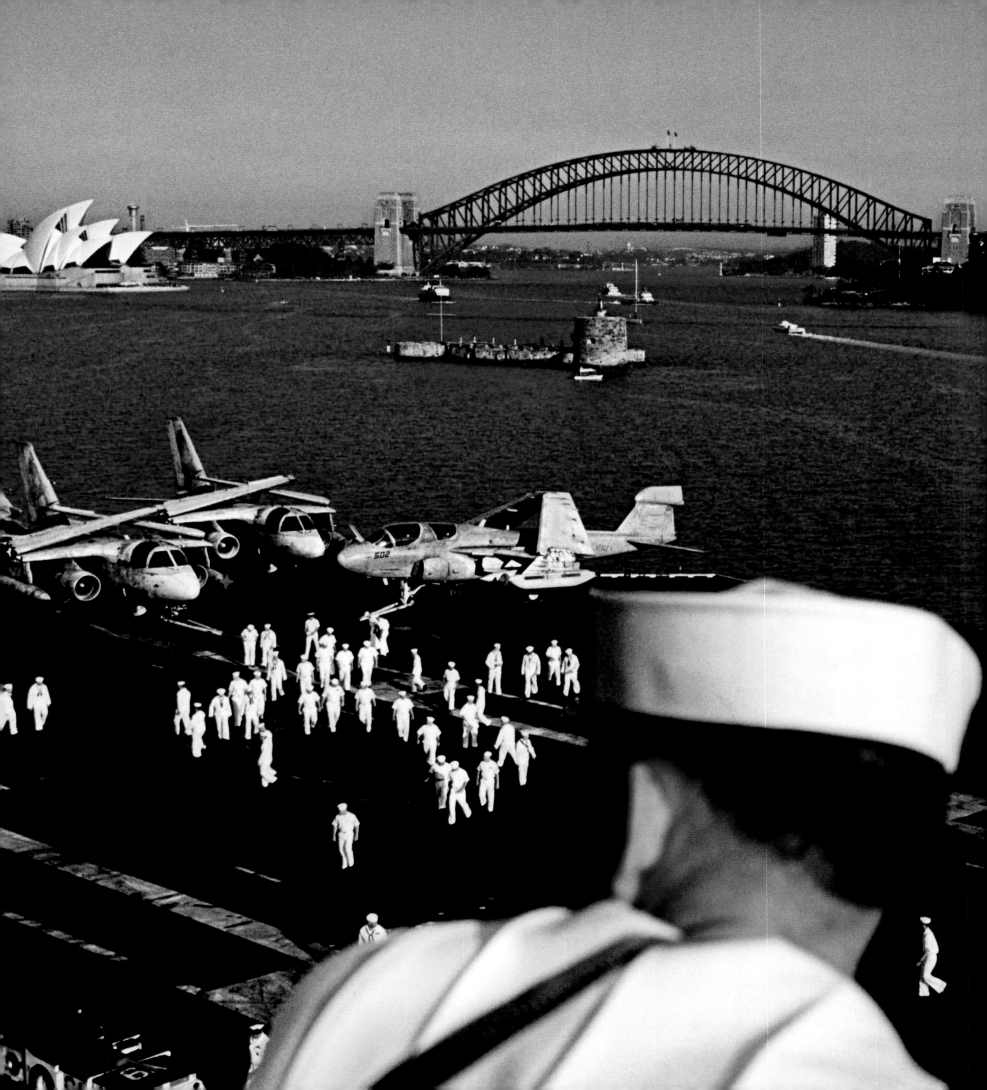

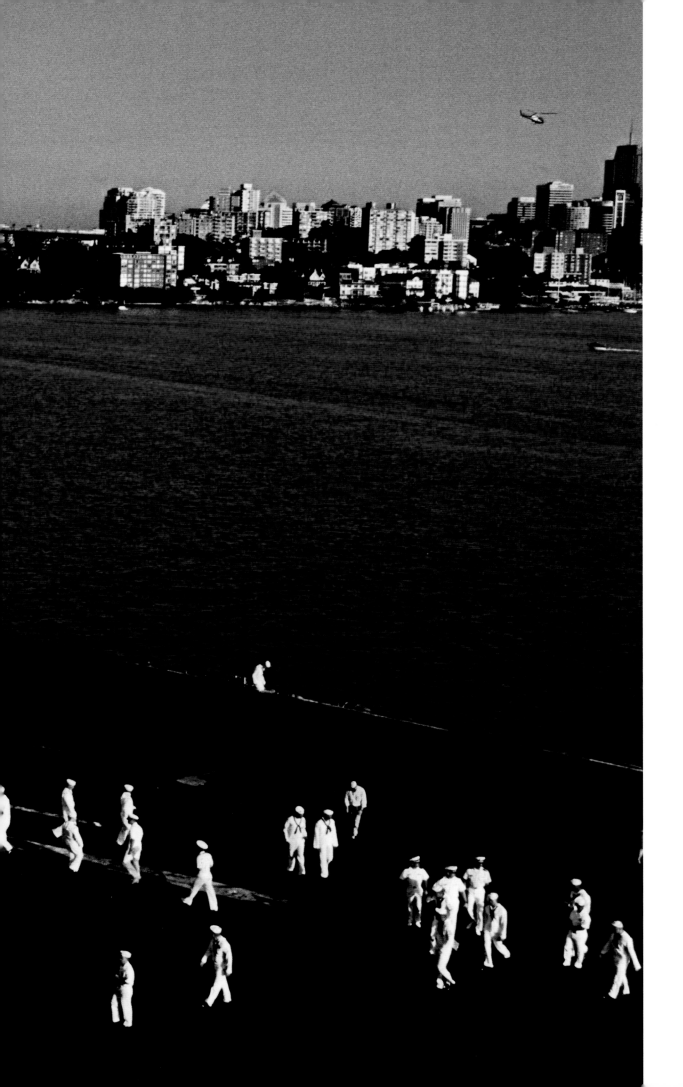

164-165 An aircraft carrier arriving in Sydney Harbour, which immediately reveals the city's full splendor, with the Opera House and the famous bridge.

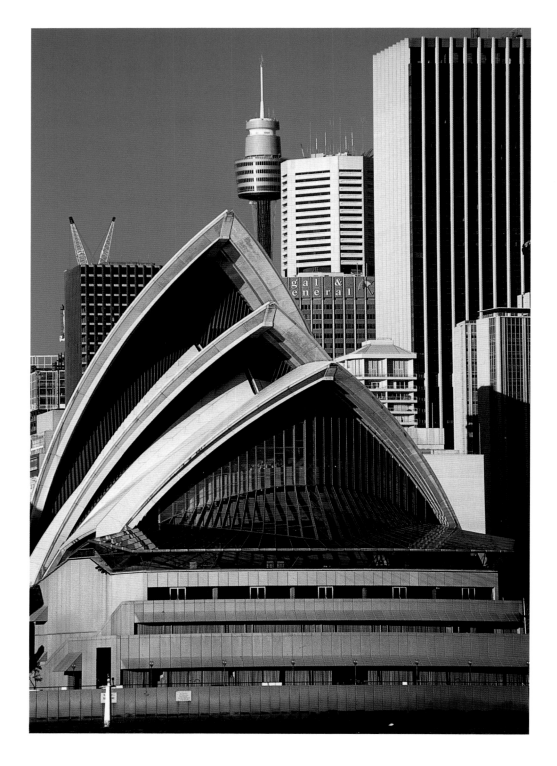

166 THE OPERA HOUSE'S SAILS ARE DOMINATED BY THE SYDNEY TOWER AND THE FINANCIAL DISTRICT'S SKYSCRAPERS.

167 CLIMBING HARBOUR BRIDGE IS AN INCREDIBLE EXPERIENCE, ONE THAT IS PARTICULARLY MOVING AT DUSK.

168 PAST AND PRESENT CONSTANTLY OVERLAP IN SYDNEY; BUILDINGS OF COMPLETELY DIFFERENT STYLES STAND NEXT TO ONE ANOTHER.

169 THE QUEEN VICTORIA BUILDING IS A HUGE MARKET BELONGING TO A VICTORIAN COMPLEX THAT WAS COMPLETED AT THE END OF THE 19TH CENTURY.

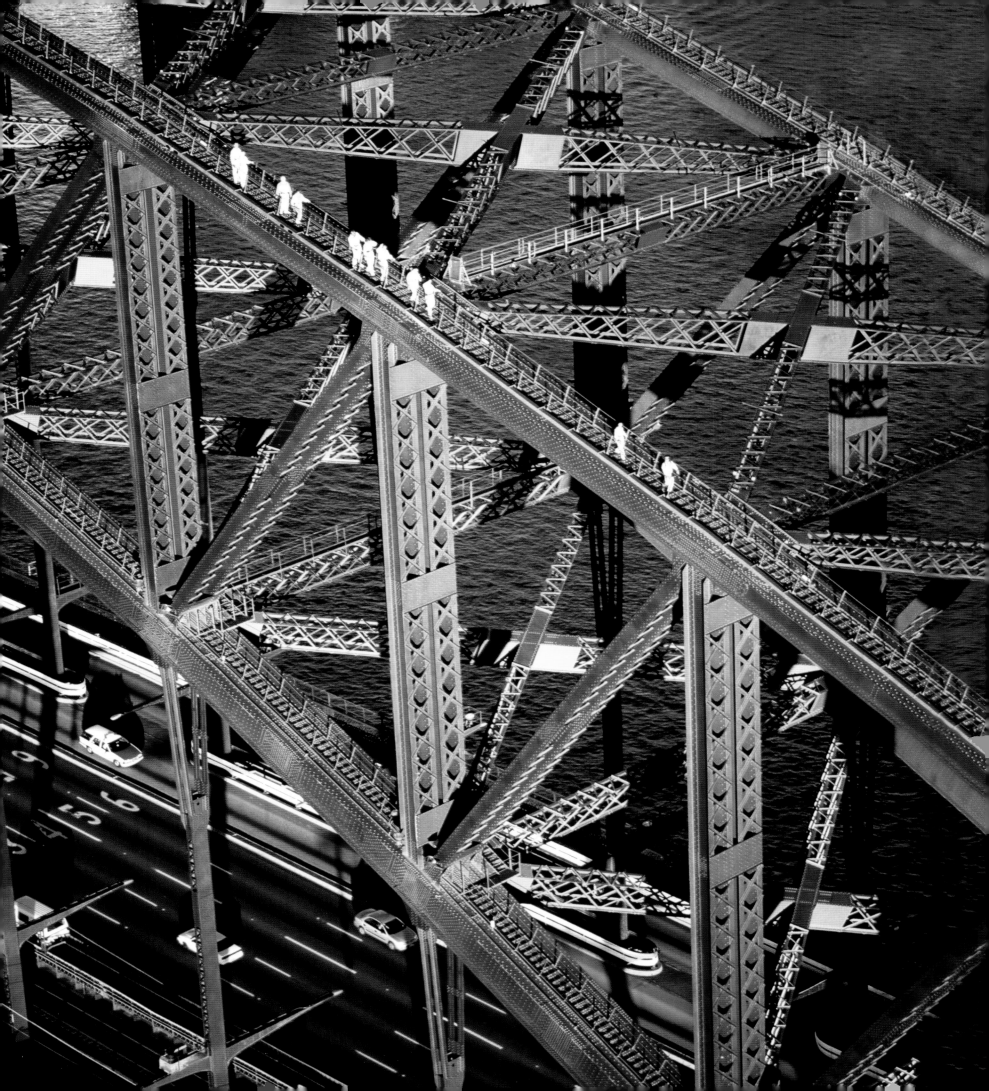

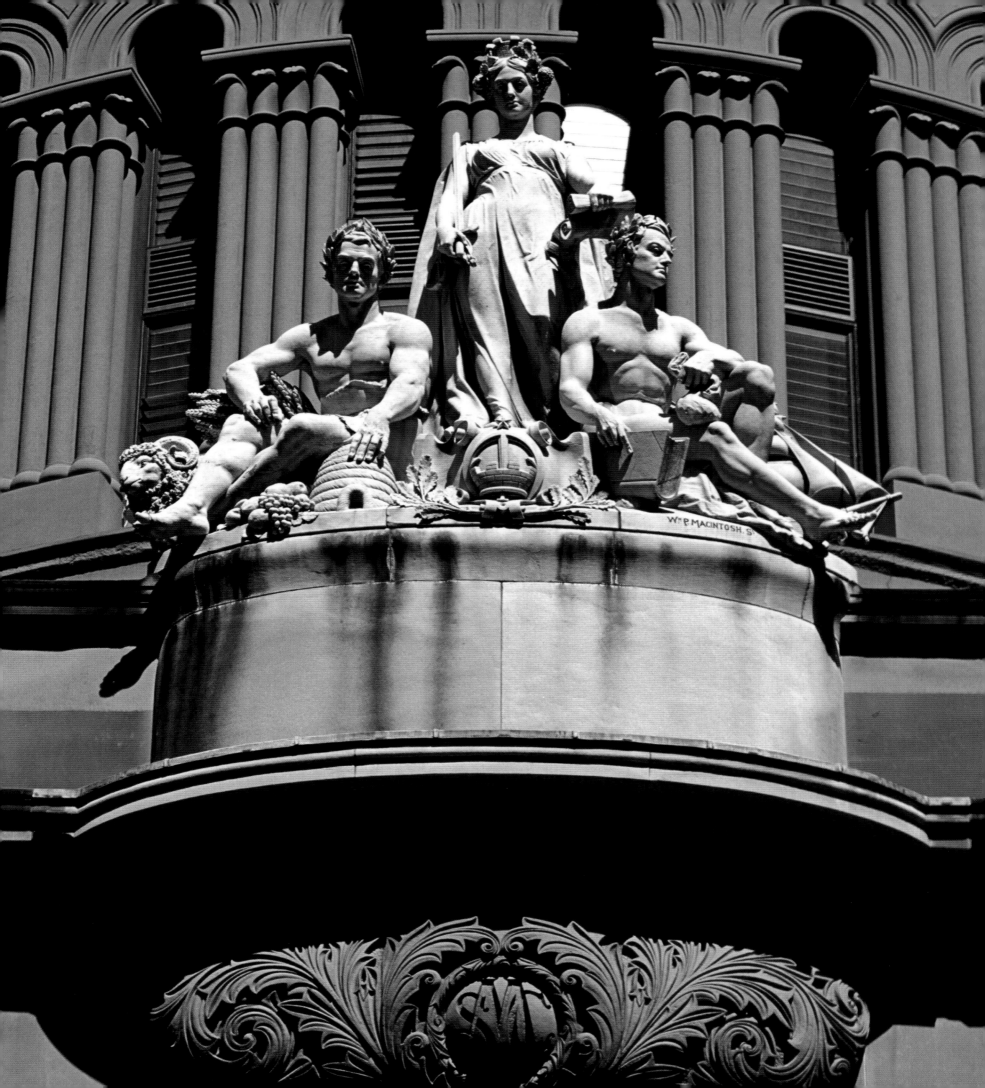

170-171 Certain areas of central Sydney are dotted with traditional English-style tearooms. The locals often frequent them during their lunch break, to grab a coffee or read the paper, or for the ritual of afternoon tea.

171 Students of one of the city's prestigious private schools during break time. Their conservative dress reveals the continuing British influence.

172-173 DARLING HARBOUR'S FUTURISTIC
ARCHITECTURE MAKE IT A GREAT AMUSEMENT PARK, A
FAVORITE WITH BOTH TOURISTS AND LOCALS, WHO
THRONG ITS CAFÉS AND TRENDY RESTAURANTS UNTIL THE
SMALL HOURS.

173 DARLING HARBOUR HAS A RATHER KITSCH
ATMOSPHERE AND IS FAMOUS FOR ITS AQUARIUM,
FAIRGROUND RIDES AND SPECTACULAR ATTRACTIONS THAT
APPEAL TO YOUNG AND OLD ALIKE.

174-175 A swim in the huge pool beneath the famous Iceberg restaurant at Bondi Beach is an unforgettable experience: when the sea is rough, it is flooded by the full force of the waves.

176-177 Sydney covers a huge area, amid canals, rivers, bays and inlets, dotted with little houses, spectacular villas and bohemian districts. The photo shows the Paramatta River with the suburb of Tennyson.

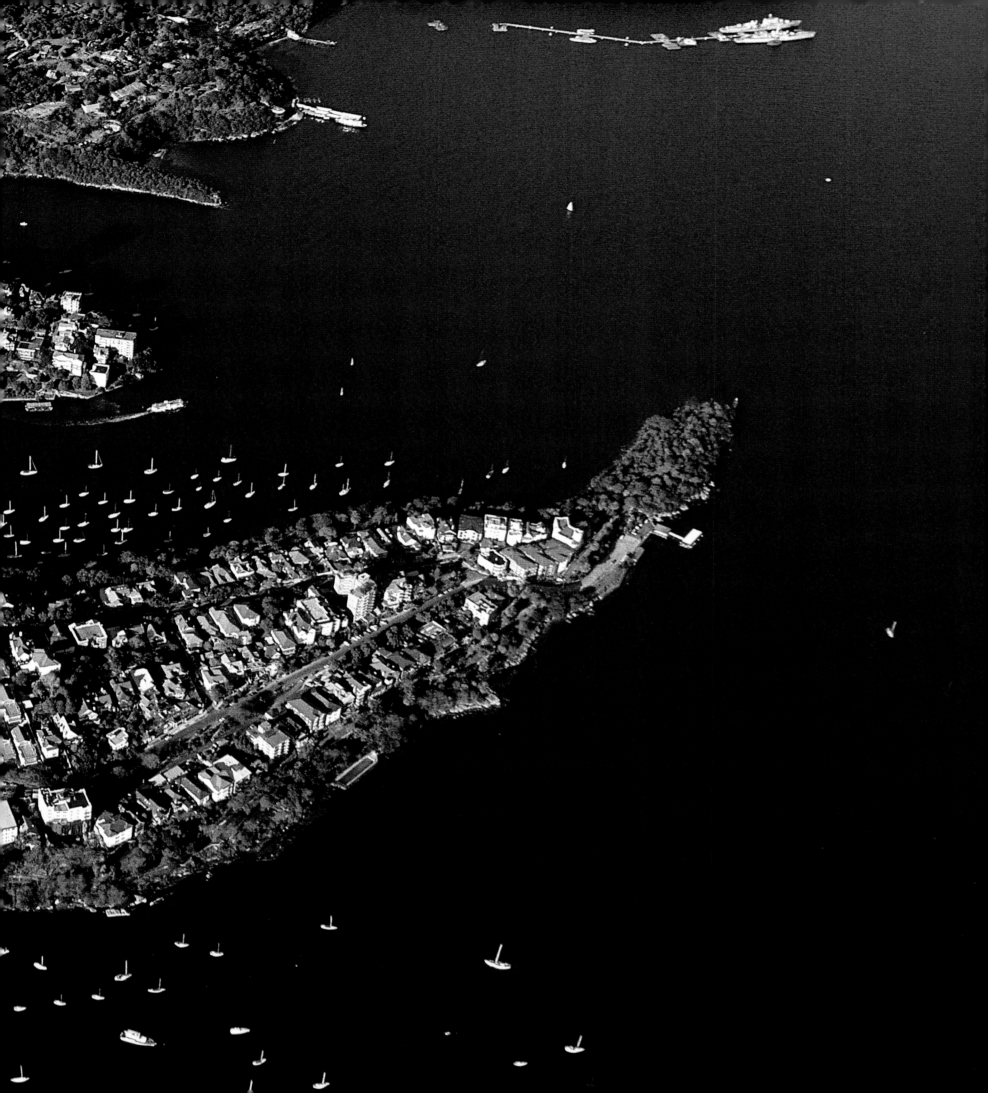

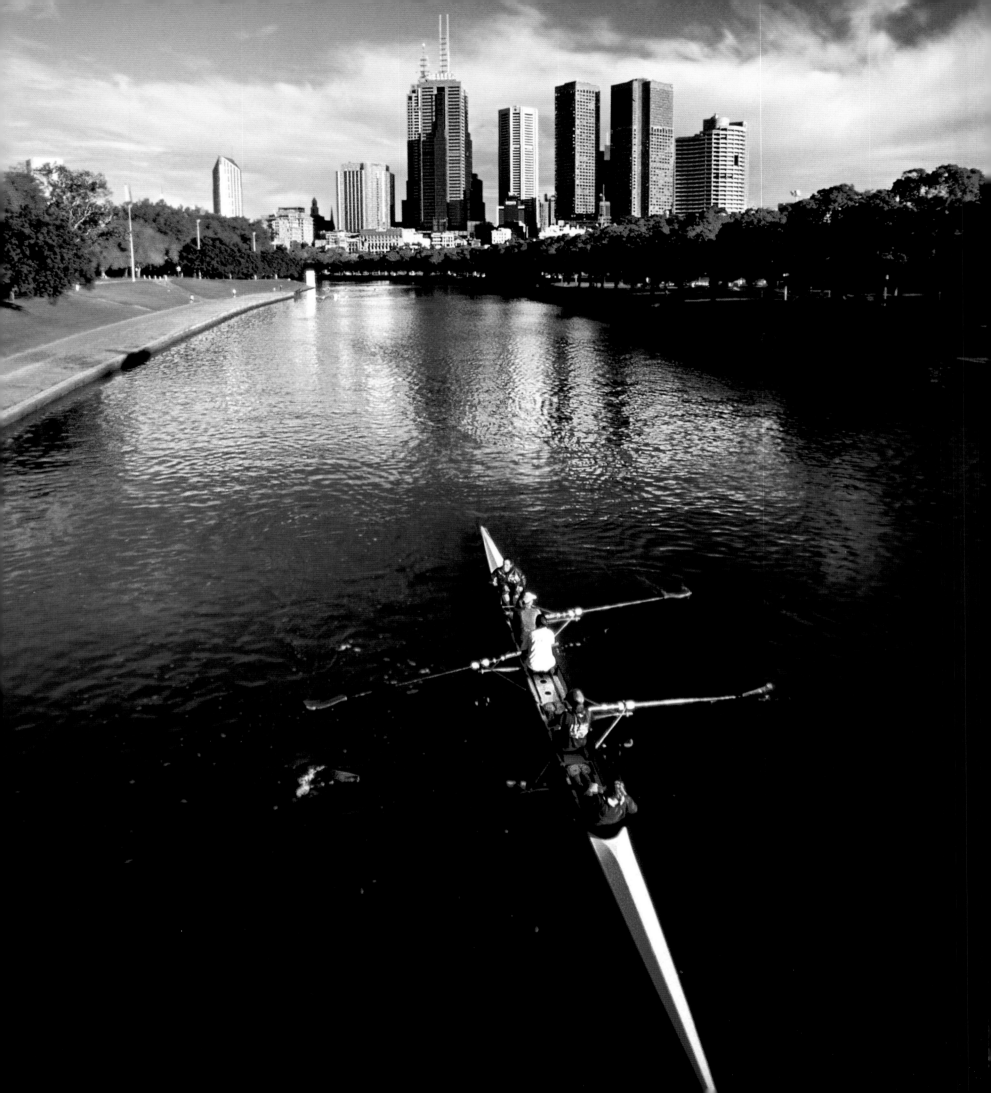

ARISTOCRATIC
MELBOURNE

Melbourne speaks straight to the heart, perhaps because it is the least typical of all the Australian cities. It is sporty, cosmopolitan, elegant and in constant competition with its arch-rival, Sydney, whom it eyes almost detachedly amid its colonial villas and imposing churches, tree-lined avenues and the chic trams that ply its streets. It is possible to perceive something unmistakable even in the slender contours of the skyscrapers – orderly arranged between the historic buildings that are home to offices and banks – which seem to soar skywards with an air of gentle conceit. Melbourne has an aristocratic spirit. The cultured, intellectual city considers itself the Australian capital of theater, music and the arts, posing as a European metropolis with that subtle Old World legacy that is revealed in the attention dedicated to certain "good family" social conventions, such as the importance attributed to frequenting a certain school. Even the air in this cultured and aristocratic city, which nonetheless conceals a thousand unexpected faces, is lighter and livelier, and at the same time enthralling.

Melbourne is a truly international city, with 3.4 million inhabitants who speak 170 different languages, which celebrates its ethnic groups in animated multicultural festivals, almost as if it were a collection of villages that combine to form a great metropolis. Its outdoor lifestyle, accompanied by the slow flow of the Yarra River – whose banks are frequented by joggers and its waters by canoeists and kayakers – makes it one of the most livable cities in the world, with bicycles racing along a complex network of cycle tracks, such as the Yarra Bike Path. Melbourne may not have Sydney's numerous beaches, but it is proud of its great parks, which it considers more chic: the Carlton Gardens with the Exhibition Building, the Alexandra Gardens, the Queen Victoria Gardens, the King's Domain and the Royal Botanic Gardens, where people picnic amid kangaroos and emus and enjoy live jazz music.

The city has class and style that ensures it never goes unnoticed. This is apparent in its in art exhibitions, held in prestigious 19th-century galleries with mosaic floors; in its society and cultural life; in its glittering casino (which – it is keen to point out – is larger than that of Sydney), and in its strings of elegant restaurants that pamper diners with dishes inspired by creative cuisine. However, Melbourne is also the colorful chaos of the district of St. Kilda – a melting pot of the Greek, Italian and Asian communities that enliven its delicatessens and bakeries. And it is also the playful spirit of the penguins that awkwardly parade, as straight as ninepins, on Phillip Island. Deep down, the veins of Melbourne pulsate with the same playful spirit as the other Australian cities, giving it a touch of life that makes its particular air of superiority even more intriguing.

Founded in 1835, when two Tasmanian entrepreneurs "stole" it from the Aborigines, in return for food and various trinkets, Melbourne became rich with the advent of the gold rush. However, today this fame has the flavor of a faded black-and-white postcard, which is especially evident in the business center, composed of a series of glass structures, large banks housed in period buildings, futuristic architecture, splendid churches, such as the imposing Neo-Gothic-style St. Paul's Cathedral, elegant Victorian sandstone façades, like

that of Flinders Street Station, neoclassical buildings such as the Parliament and Princess Theatre, and countless stores that culminate in Bourke Street and Collins Street, in the glittering Melbourne Central Mall. The Rialto Tower rises above it all, with its windows that change color with the light. The picturesque element once again dominates in the bustle of the famous Queen Victoria Market, which dates back to 1870. Fruit and vegetables, bread and cheese, sweetmeats and dried fruit, sausages and fish, and food products of every kind seem to beckon from the stalls, among the shouts of the sellers with foreign accents. It is always a joy to shop here.

Sauntering in a sort of urban walkabout, seeking fragments of history and memories of bygone times, the visitor comes across the historic Windsor Hotel, the last of Australia's grand hotels, where it is still possible to enjoy English tea and participate in so-called Murder Mystery Weekends – a British game, or rather legacy, in which a crime is staged and the guests seek the culprit. Another typical spot is the Young & Jackson Hotel, one of the city's oldest pubs that is better-known for *Chloe*, a full-sized nude painting that has become a much-loved symbol, than its beer. This historic heritage jars sharply with the "Melbourne of the arts and the future," the contemporary experimentations of the ACCA (Australian Centre for Contemporary Art), the futuristic spire of the Victoria Arts Centre and the almost space-like atmospheres of Federation Square (the new city "piazza") that is home to the National Gallery of Victoria, with its rich collection of Australian art, that now dedicates great attention to new forms of artistic experimentation. Indeed, gone are the days of the Heidelberg school (from the name of a town in the Yarra Valley) – a group of painters that represented the Australian landscape realistically for the first time, without classical or European contaminations.

The aristocratic soul of Melbourne, which maintains the closest links to the past, is instead reflected in the patrician homes of the "high quarters" of South Yarra and Toorak. These districts boasts a great display of colonial residences behind high gates, inhabited by billionaires who love the high life, cars, cricket and horses, shop among the art galleries and elegant boutiques of "Paris End" in Collins Street and often retreat to the elegant little coastal towns of the Mornington Peninsula.

In Melbourne even the bohemians have a less neglected air. Here the fashion is for chic intellectuals, who do not disdain the art venues of the center, but find the cosmopolitan charm of the suburbs more stimulating, preferring to wander among the cafés and bookshops of Fitzroy's Brunswick Street, the chaotic Vietnamese atmosphere of Richmond's Victoria Street, the Greek tavernas of Swan Street, which serve huge portions of moussaka and fish, the Italian restaurants and ice cream parlors of Carlton's Lygon Street and the delirious bustle of Chinatown. They live in the Art Nouveau houses and old luxury hotels of St. Kilda Bay, with its evocative Mediterranean views; they have breakfast in the bakeries and patisseries of Acland Street, then they immerse themselves in books, seated on the attractive promenade that catches the sea breeze that is the joy of windsurfers, among pretty girls roller-skating in bikinis.

Aristocratic Melbourne has a sporting heart, which never misses the opportunity for a bit of healthy exercise. It is the home of many professional Australian football teams and the venue of highly popular events, such as the Australian Open tennis tournament and the Formula One Grand Prix, as well as the Melbourne Cup, the country's most important horse race, which is a true national passion. While the whole of Australia holds its breath to learn the name of the winner, "racing fever" grips Melbourne: all of Australian high society mingles with the thoroughbreds, the elegant ladies moving as in a fashion show, sheltering themselves from the sun with hats bought for the occasion in Chapel Street, and the men in black suits and hats engaged in thrilling betting. The most aristocratic spectators eat caviar, washed down with champagne, while the others improvise lively picnics on the lawns with chicken sandwiches. The tension that precedes the start – when the horses prepare to set off at a gallop – or the brief instants in which they cut the finishing line affect everyone in a kind of class-less euphoria that is an invitation to indulge the pampered heart of splendid Melbourne.

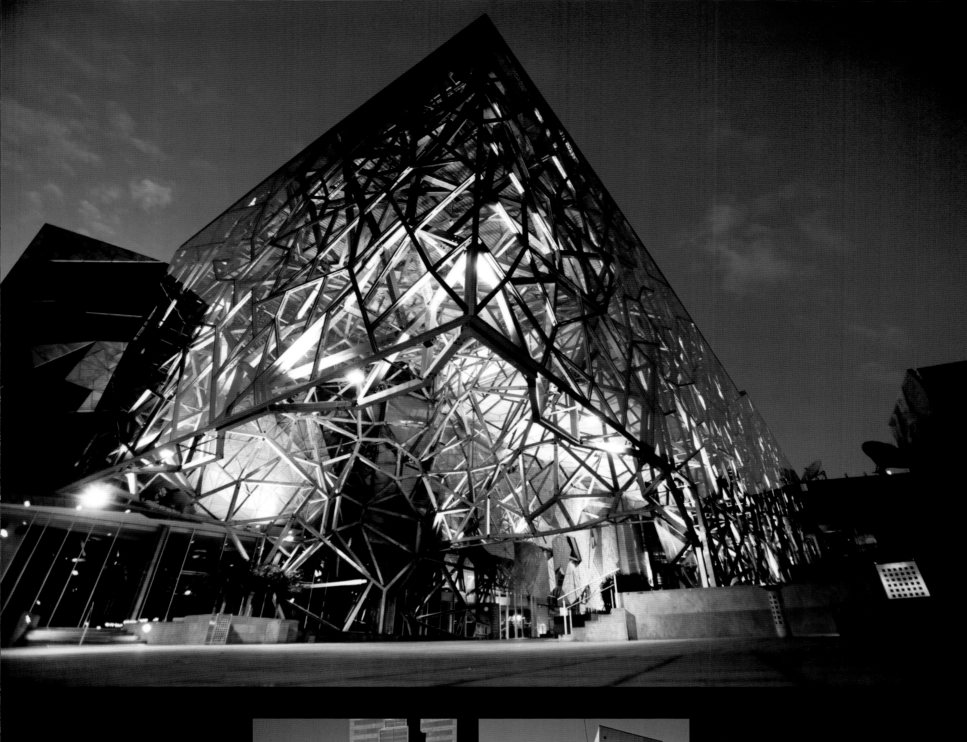

182 THE SOUTHGATE FOOT BRIDGE SPANS THE YARRA RIVER.

183 FLINDERS STREET STATION, WITH ITS UNMISTAKABLE COLORS, IS THE BUSIEST IN MELBOURNE AND WAS COMPLETED IN 1910.

184 ARISTOCRATIC MELBOURNE, LIKE MANY OTHER AUSTRALIAN CITIES, JUXTAPOSES PAST AND PRESENT. THE TRADITIONAL BUILDINGS OF THE ENGLISH COLONIAL PERIOD CONTRAST DRAMATICALLY WITH THE ULTRAMODERN SKYSCRAPERS.

185 PAST AND PRESENT IN COLLINS STREET. STRIKING ARCHITECTURAL CONTRASTS ARE COMMON IN THE CENTER OF MELBOURNE.

186-187 EDUCATION STILL PLAYS A FUNDAMENTAL ROLE IN MELBOURNE HIGH SOCIETY, WHICH IS VERY BRITISH IN THIS RESPECT.

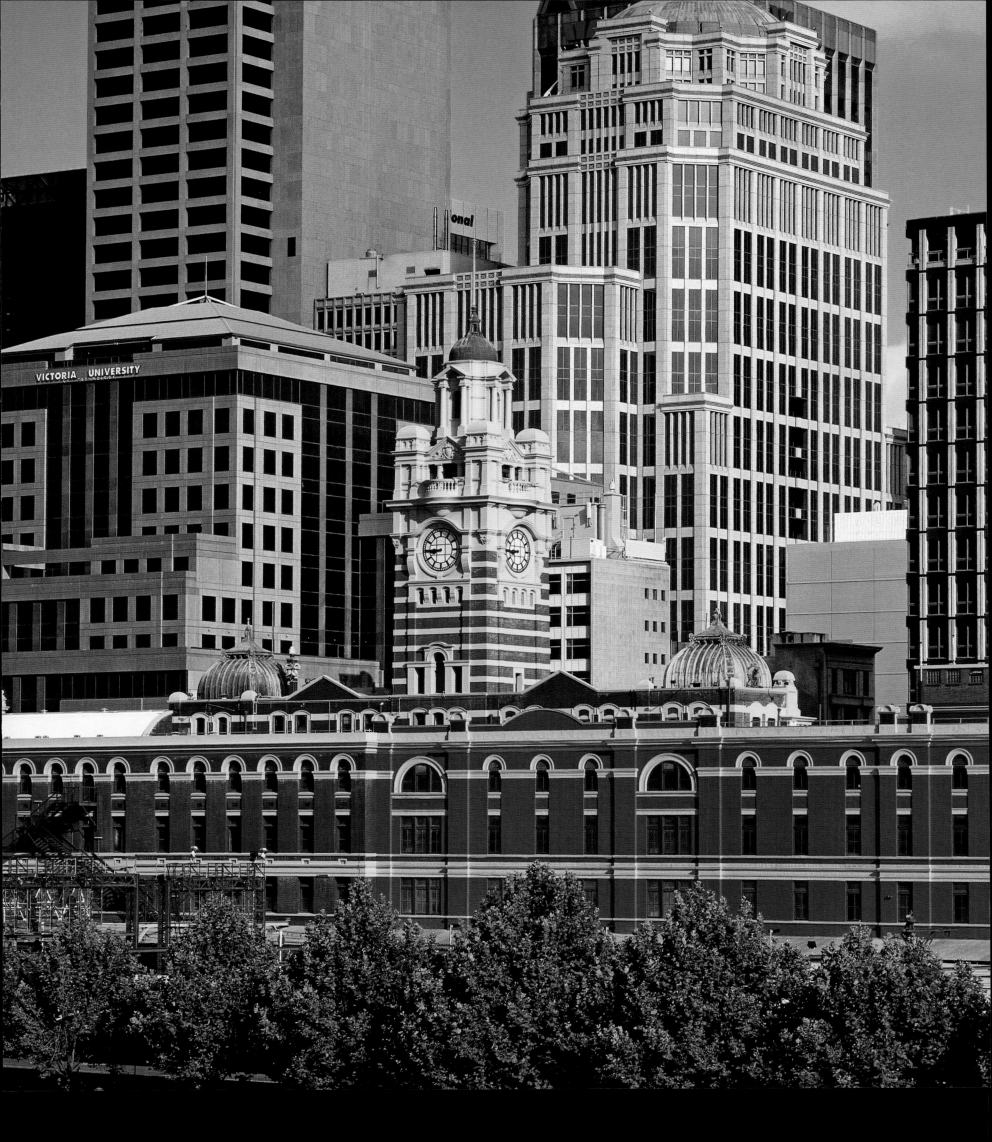

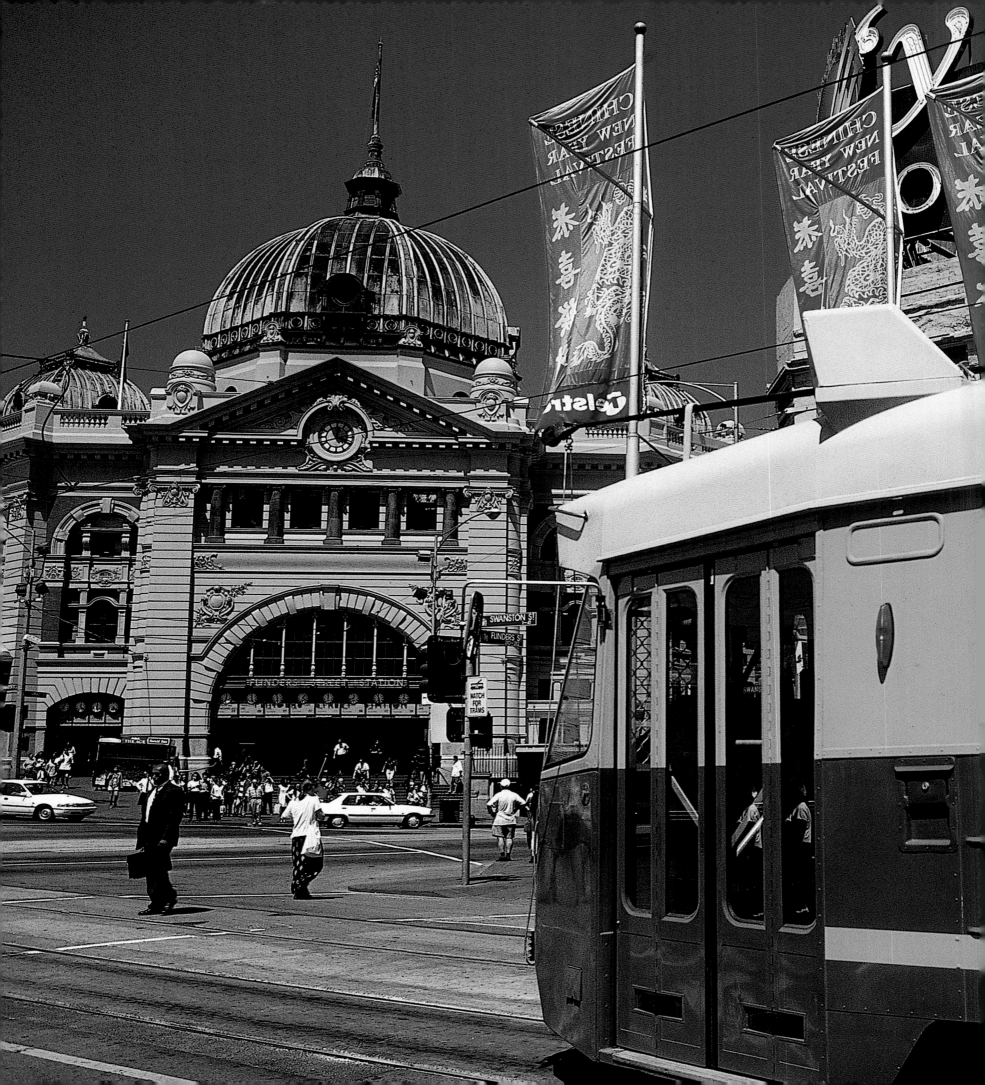

188-189 A TRAM IN THE CITY CENTER, NEAR FLINDERS STREET STATION. TRAMS ARE ONE OF MELBOURNE'S MOST POPULAR AND TYPICAL FORMS OF TRANSPORT.

190-191 The Princess Theatre is one of the most famous in Melbourne and is renowned for its musicals. The metropolis is proud of its culture and artistic tradition and is in fact considered Australia's most European city.

192 Since 1912 this charming amusement park has been one of St Kilda's most famous symbols. The park has maintained much of its appeal; its roller coaster has been declared a national monument.

193 For many Australians shopping is one of the main attractions of the city, which is renowned throughout the country for its stores. Seen here is the glass dome of the Melbourne Central shopping mall.

194-195 Night view of Melbourne: Flinders Street Station and St Paul's Cathedral can be seen in the foreground. Australia's most aristocratic city is also renowned for its lively nightlife.

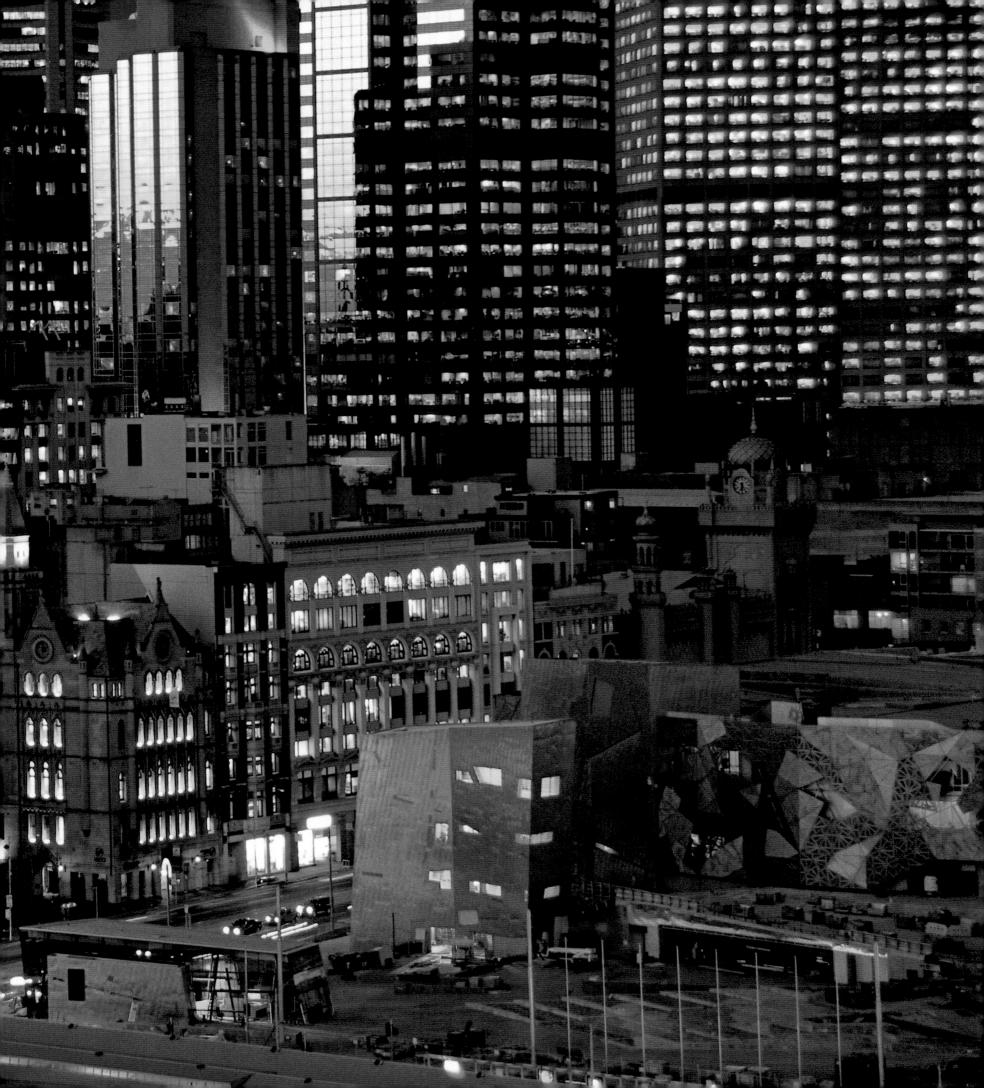

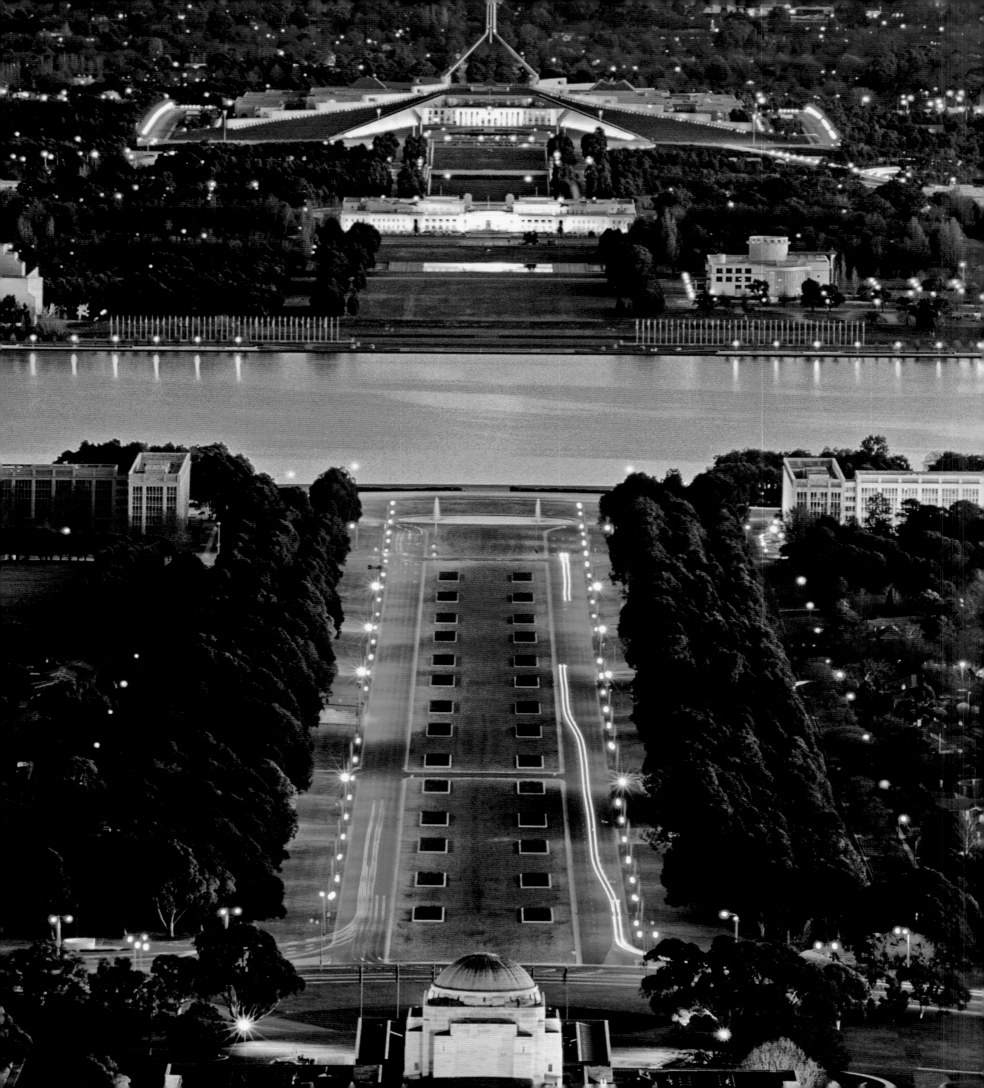

BUREAUCRATIC
CANBERRA

Canberra nestles in the greenery, amid government buildings, modern architecture and scientific centers, surrounded by parks, gardens and lakes that run right around its throbbing heart, the Parliament. Although the city is expressed in the heated political debates that it hosts and in the lively hum of the students who populate its universities, it actually loves tranquility and did not find the transformation from provincial town to metropolis an easy one. It has a population of 300,000 – mainly bureaucrats, office workers, diplomats, politicians and civil servants. The almost disbelieving winner of the fierce contest between Sydney and Melbourne for the title of Australian capital, today Canberra presents itself to the world in the guise carefully studied for it by the Chicagoan landscape architect Burley Griffin.

The city has a youthful, sporty and relaxed atmosphere, with a slight touch of elegance and wealth, which is reflected in a wide choice of restaurants and locales, the variety of stores of its Civic Centre and the ever-growing public that frequents the casino. At first glance, you seem to be in a huge, unbounded garden, a giant open space,

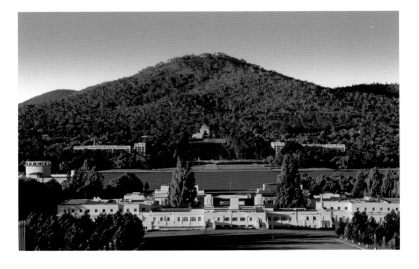

where it is rather difficult to orient yourself. It is necessary to climb Black Mountain in order to appreciate the layout of the city: from here it appears in all its splendor, with the green expanse of the Botanical Gardens, the high jet of water of the Captain Cook Memorial Water Jet and the charming lake furrowed by boats and canoes, whose banks teem with joggers, rollerbladers and cyclists.

Several important buildings rise above this tranquil landscape, such as the Parliament, which stands on Capital Hill. The billion-dollar complex features minimalist and futurist architecture, mosaics and marble stairs, columns reproducing eucalyptus forests and an original flagpole that surmounts the entire structure. The splendid National Gallery of Australia stands at its foot, housing the nation's largest collection of Australian and Aboriginal art. However, the most moving spot is the Australian War Memorial, a delightful blend of cloisters, pools and arcades, with an almost mystical evocative power. In order to love Canberra, it is necessary to accept the city for what it is: a magnificent garden that changes with the seasons, a green mermaid lost in the sea of the Australian bush.

198-199 The Australian Institute of Aboriginal and Torres Strait Islander Studies, housed in a futuristic building, traces the traditions and history of the Aborigines, from past to present.

199 The experimental Garden of Australian Dreams is situated in the outside area of the National Museum of Australia. It is located on a headland on the northern shore of Lake Burley Griffin.

200-201 The Australian War Memorial is a mystical and moving place. Anzac Day celebrations are held here on April 25th of each year.

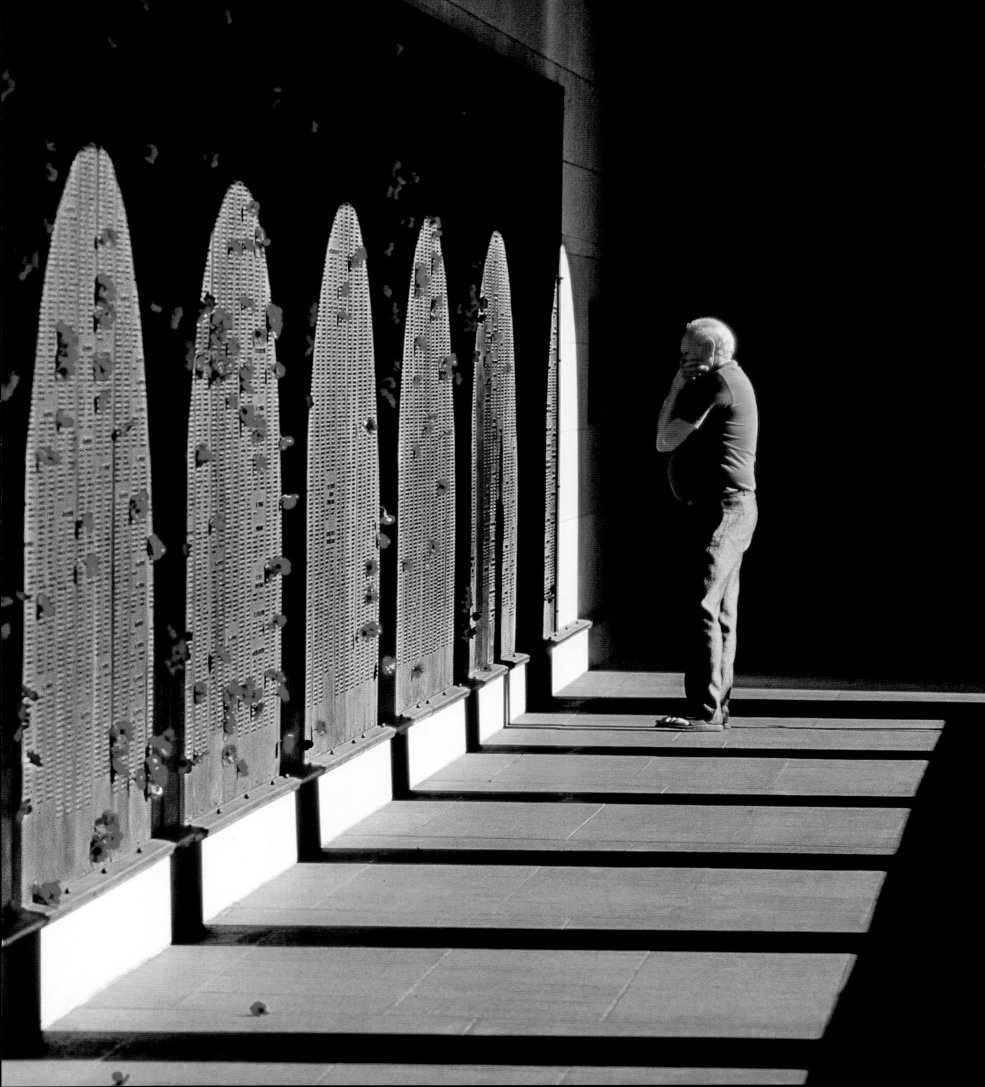

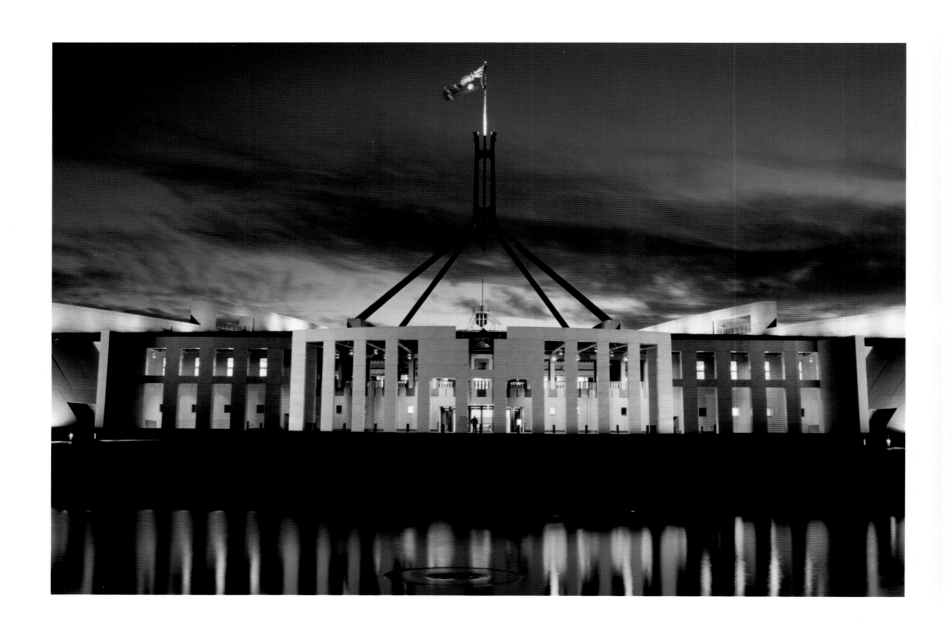

202 PARLIAMENT HOUSE IS ONE OF CANBERRA'S MAIN ATTRACTIONS. IT HOUSES PAINTINGS, SCULPTURES AND WORKS OF ART
AND OFFERS VISITORS THE OPPORTUNITY TO ATTEND ITS SESSIONS FREE OF CHARGE.

203 JOGGING AROUND LAKE BURLEY GRIFFIN EARLY IN THE MORNING CAN OFFER PLEASANT SURPRISES, SUCH AS THE MUFFLED
ATMOSPHERE CREATED BY THE MIST THAT ROLLS OFF THE LAKE AND ENVELOPS ITS SHORES, CONFUSING MEN AND OBJECTS.

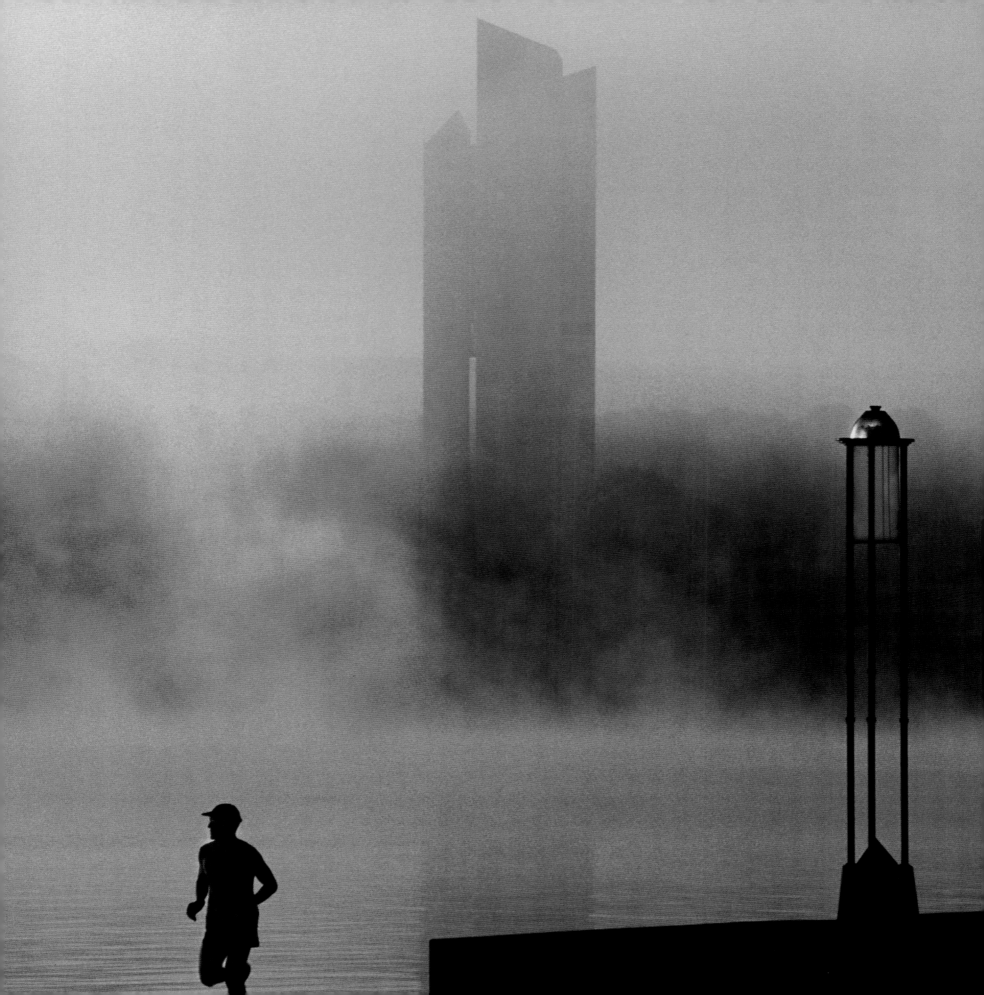

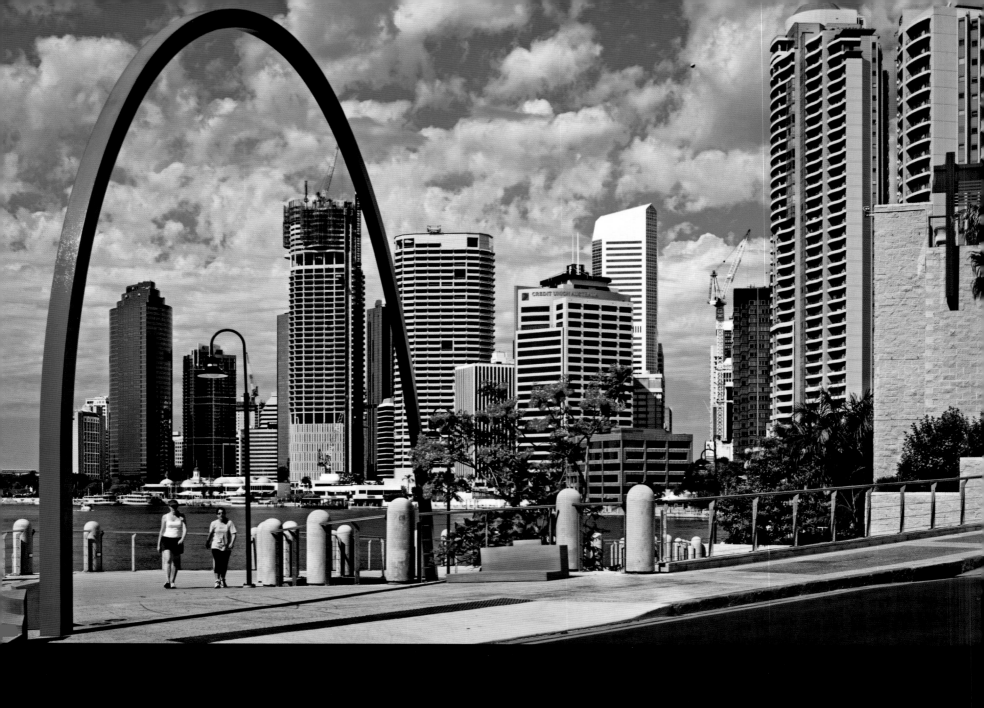
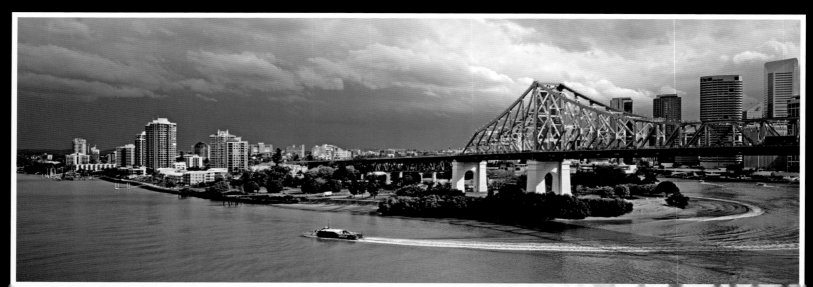

204 TOP THE MODERN SKYLINE OF BRISBANE OVERLOOKS THE RIVER OF THE SAME NAME.

204 BOTTOM THE BRISBANE RIVER IS SPANNED BY STORY BRIDGE.

205 TOP LEFT AND RIGHT BRISBANE IS DOMINATED BY MODERN BUILDINGS, LEFT; CITY HALL, RIGHT, GLITTERS IN THE NIGHT.

205 BOTTOM THE CLASSICAL-STYLE NALDHAM HOUSE IS HOME TO THE POLO CLUB.

YOUTHFUL
BRISBANE

Sunny, peaceful Brisbane nestles between the loops and numerous bridges of the river of the same name. Despite its substantial population (1.6 million people), the city has a rather provincial atmosphere. Indeed the main charm of beautiful Brisbane is its simple, unpretentious and easygoing manner. The city happily and lightheartedly smiles as its inhabitants go about their pleasant lives and youngsters cycle or rollerblade along its cycle tracks.

Brisbane is a multifaceted microcosm of glass and stone, water and greenery, art and leisure. The city is adorned with brightly colored streets and Victorian architecture, such as the atmospheric pedestrian area formed by Elizabeth Street, George Street and Queen Street where musicians perform among huge flower planters, youngsters stroll around the stores in shorts and flip-flops and office workers snatch a quick sandwich. It is surrounded by historic buildings – such as Queensland's vaguely Italianate Parliament House and the Conrad Treasure Casino, or the Italianate City Hall – that contrast with the glass office blocks that line the lively riverside. The lush parks, Brisbane City Botanic Gardens and Mount Coot-tha Botanic Gardens (that are also home to the Planetarium) offer an enchanting landscape of bougainvillea and

roses, palms and bamboo thickets, rainforests and Japanese gardens.

Brisbane shows its seductive and lively side in its cafés, bookstores and restaurants housed in charming little buildings with wrought-iron trim, in the bustling alternative quarters, such as Fortitude Valley, which is home to a little Chinatown and lively nightlife, and in the high-profile new districts, such as New Farm, whose exclusive locales are frequented by actors and models.

The city's sunny nature can be seen in the South Bank Parkland leisure and entertainment complex that stands on the opposite bank of the river to the business center where work and study are concentrated. It is also expressed among the tanned youngsters in bathing suits on the artificial beach, the Italian bars, live music and rollerblade virtuosos. Finally, there is no lack of cultural attractions, for Brisbane is home to some of the state's most interesting museums, including the Queensland Maritime Museum and Art Gallery, the Performing Arts Complex and the National Library. There is also the Gondwana Wildlife Sanctuary, which houses tropical birds, friendly koalas, opossums and menacing crocodiles, which even manage to be likeable here! It is this diverse combination of elements that has generated Brisbane's joie de vivre.

206-207 Brisbane's riverside is dotted with colonial buildings, set like precious gems between towering skyscrapers, threatened by the encroachment of modernity.

208-209 GOODWIN PEDESTRIAN BRIDGE'S INNOVATIVE ARCHITECTURE CONTRIBUTES TO BRISBANE'S MODERN AIR. IT ALSO VERY POPULAR WITH CYCLISTS AND ROLLERBLADERS.

210 The towers of St Stephen's Church, with their warm hues of brick and stone, provide the backdrop for the aseptic surface of a skyscraper that soars toward the sky, creating an apparently contrasting effect of sacred and profane.

210-211 From Story Bridge the view sweeps toward the commercial buildings that are reflected in the waters of the river.

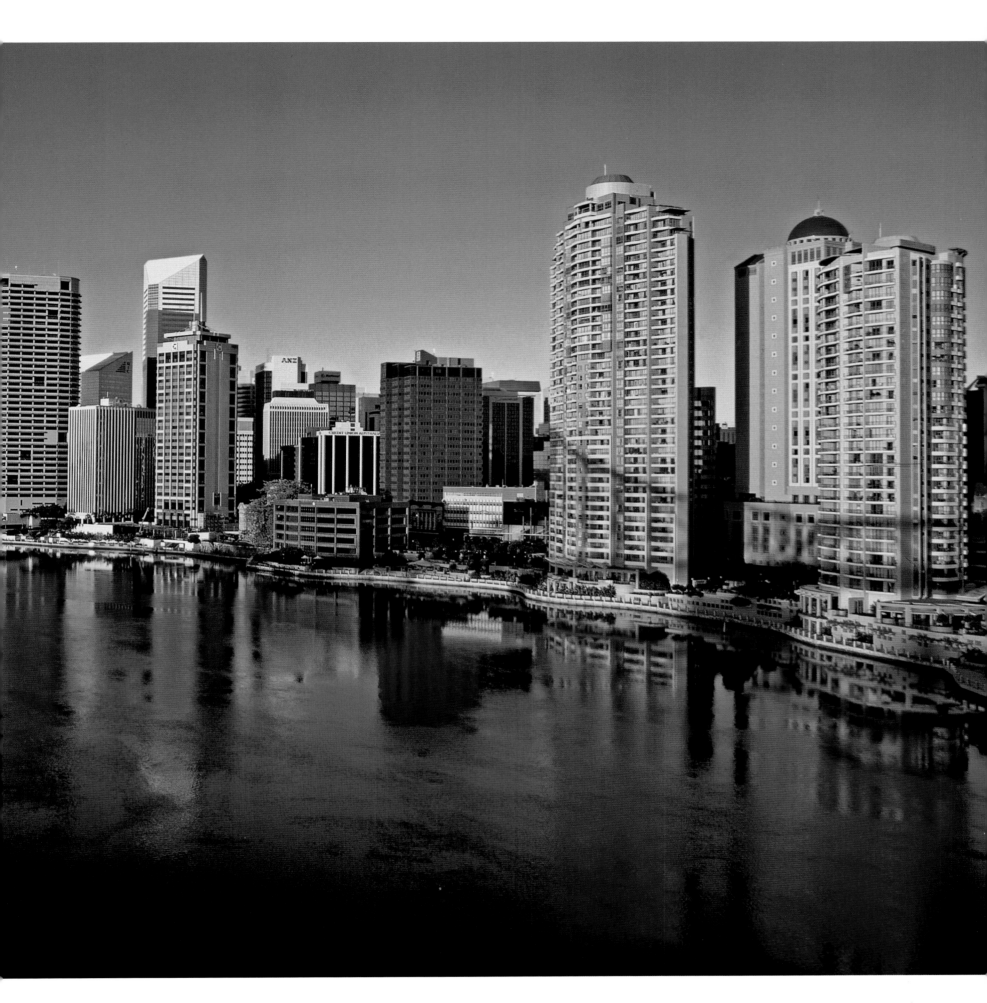

212 THE RIVERSIDE CENTRE, BRISBANE'S BUSINESS DISTRICT, IS A MICROCOSM OF SKYSCRAPERS, PUBLIC BUILDINGS, OFFICES AND RESTAURANTS.

212-213 KANGAROO POINT, ON THE BANK OPPOSITE THE RIVERSIDE CENTRE, IS A FAVORITE OUTDOOR AREA FOR CYCLISTS, ROLLERBLADERS AND JOGGERS. IT IS ALSO POSSIBLE TO HIRE CANOES ON THE RIVER.

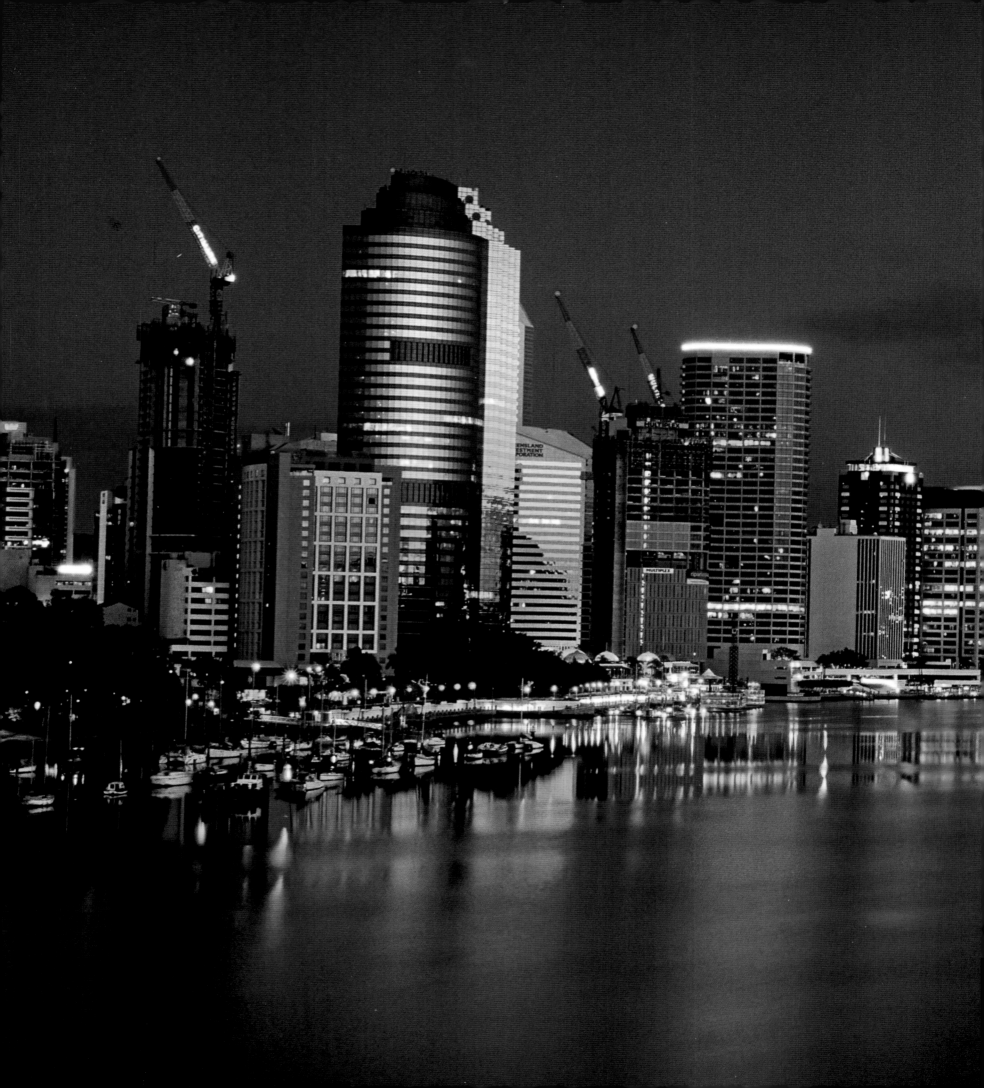

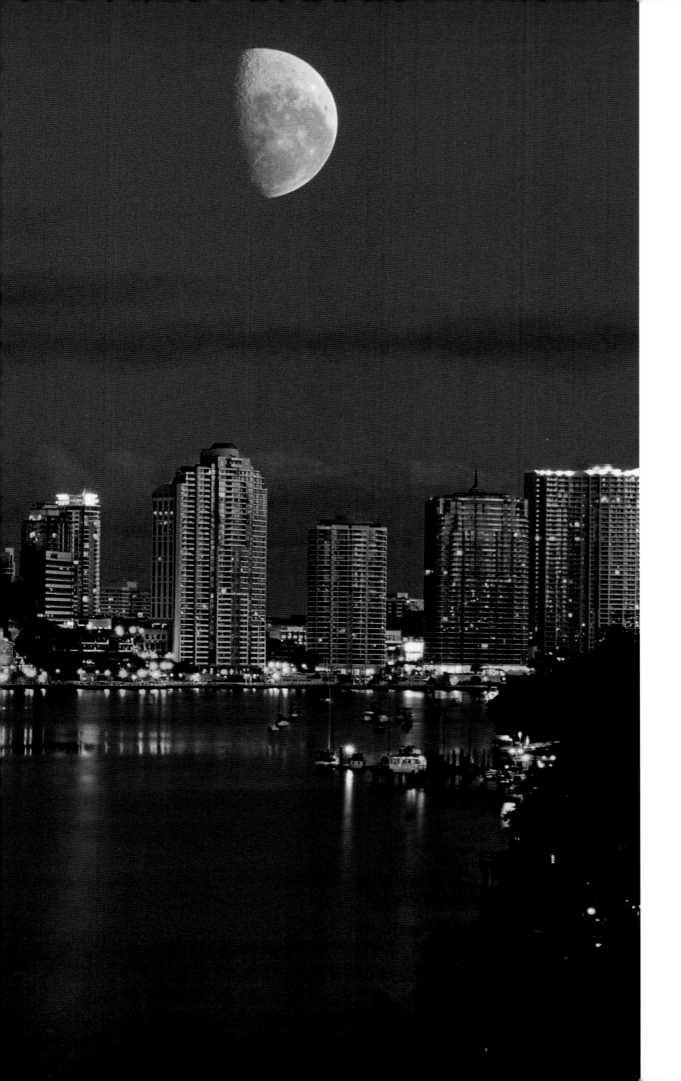

214–215 "Brissie," as Brisbane is called, sleeps in the shadow of its skyline, bathed in the moonlight. The silent Brisbane River reflects the city lights.

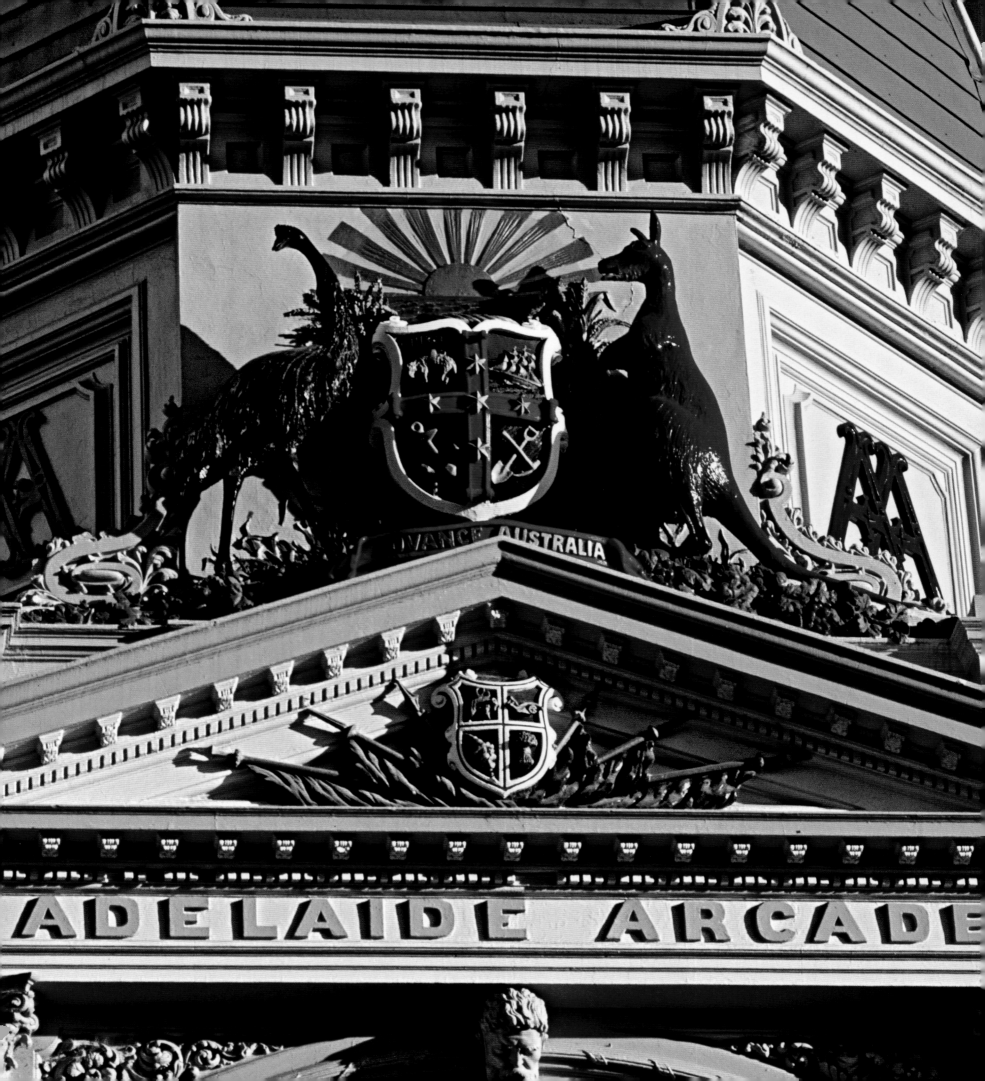

ADVANCE AUSTRALIA

ADELAIDE ARCADE

216 Historic Adelaide Arcade is situated in Rundle Street, one of the city's favorite shopping and art districts.

217 LEFT AND RIGHT The world-famous Festival Theater Playhouse (left), overlooking the Torrens River, is part of the great Adelaide Festival Centre; Adelaide Plaza (right) is an extravaganza of modern art and architecture.

CULTURED
ADELAIDE

Adelaide is the utopian city, as demonstrated by its idealistic and dreamy gaze that looks toward a future brimming with promise and is reflected in "Light's Vision," the panorama that unfolds from the top of Montefiore Hill and takes its name from Colonel William Light. Light decided to build the city here, on slightly rising ground, despite his superiors, who had wished it to be sited at the mouth of the Murray River. History proved Light's choice to be the right one and his statue, which now stands atop the hill, seems to contemplate his creation, set between the Mount Lofty Ranges and the sea. Adelaide was born out of a dream, a beautiful and radiant city with old stone buildings, cloaked in the green of the parks crossed by the Torrens River.

The city was built on a simple grid plan, its charming contradictions only developing later. Today it counts over a million inhabitants and is a mosaic of villages that live peacefully alongside. It has a very respectable, British-style countenance and it is no coincidence that it is known as "the city of churches." However, its heart is inhabited by the free spirit of the artists, who enjoy "sketching" its skyline with highly provocative plastic installations. Adelaide was founded in the shadow of Sydney and Melbourne and was the first to establish an arts festival – the Adelaide Festival of Arts – which is animated by a spirit of experimentation that is effectively encapsulated in several public buildings. The Lion Arts Centre, which hosts the two-yearly Adelaide Fringe Festival is a sparkling kaleidoscope of art galleries, exhibition spaces, cinemas, theaters, bars and design stores. The Adelaide Festival Centre is a miniature version of the Sydney Opera House, but with even better acoustics; it is home to the country's largest theater, along with two smaller ones, and boasts a magnificent auditorium. The Adelaide Festival of Arts is held there every two years, but the center is a constant hive of activity, with a great coming and going of musicians, students and actors from the leading theater companies, forming a creative buzz of minds at work. These minds gladly meet in the streets around Rundle Street, the artists' quarter. The same minds also enjoy the sun at Glenelg Beach, which also has a very bohemian atmosphere. Adelaide's artistic soul has always been torn between past and present and between the two parts of the city, divided by the river. The larger one comprises the business center and North Terrace, lined with museums and colonial-style buildings, while the smaller one is more aristocratic and known as North Adelaide. The Establishment resides on the northern bank, almost as though offended by the hubbub, immersed in the cool gardens of villas and old cottages. The area boasts tree-lined avenues and Pennington Gardens, the spires of St. Peter's Cathedral, the locales of O'Connell Street and Melbourne Street, and the green expanse of the Adelaide Cricket Ground. The other bank is home to the pulsating streets that unfold from Victoria Square, with the old sandstone railway station that also houses the elegant Adelaide Casino, the pie carts (selling pie floaters, a local specialty), the marble columns of Parliament House, the South Australian Museum, the Art Gallery and the Migration Museum. Other attractions include the Botanical Gardens and the zoo, Ayers House, the shops around Rundle Mall enlivened by street artists, the bars and red-light spots of Hundley Street, and the riverside of Elder Park, where the "Popeyes" – the city's characteristic tour boats – are moored. The city culminates in the carnival of colors of the restaurants of Gourger Street and Central Market, where exotic fruit, fish and meat, cheese and countless pies form artistic compositions.

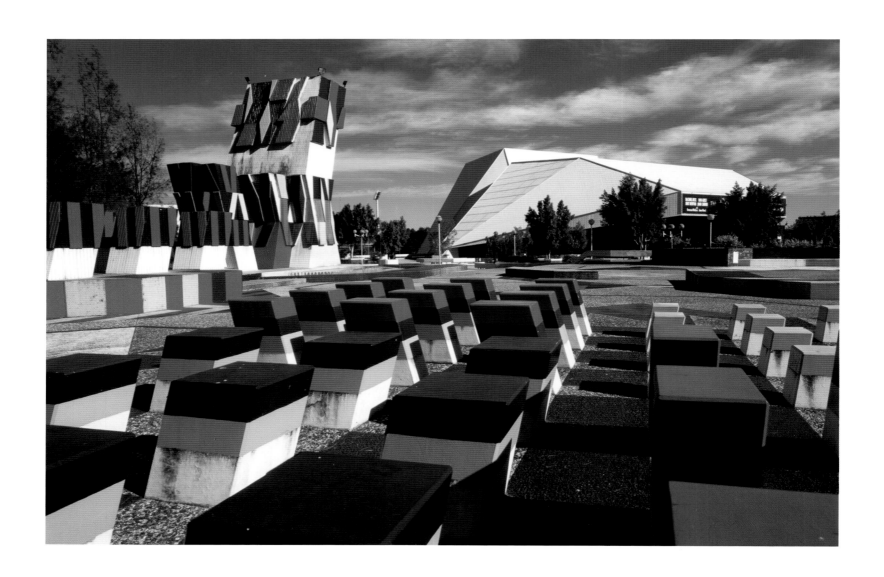

218 THE FAMOUS AND VERY COLORFUL HAJEK SCULPTURE GARDEN,
WITH THE ADELAIDE FESTIVAL CENTRE – ALSO A FAVORITE LOCAL PICNIC SPOT –
IN THE BACKGROUND.

219 ART DOES NOT MISS THE OPPORTUNITY TO SHOW ITS FACE HERE AND THERE IN
ADELAIDE. THE FESTIVAL CENTRE, FOR EXAMPLE, IS PERVADED BY AN ATMOSPHERE
OF GREAT CREATIVITY, AS TESTIFIED BY THIS DETAIL OF A COLORFUL MURAL.

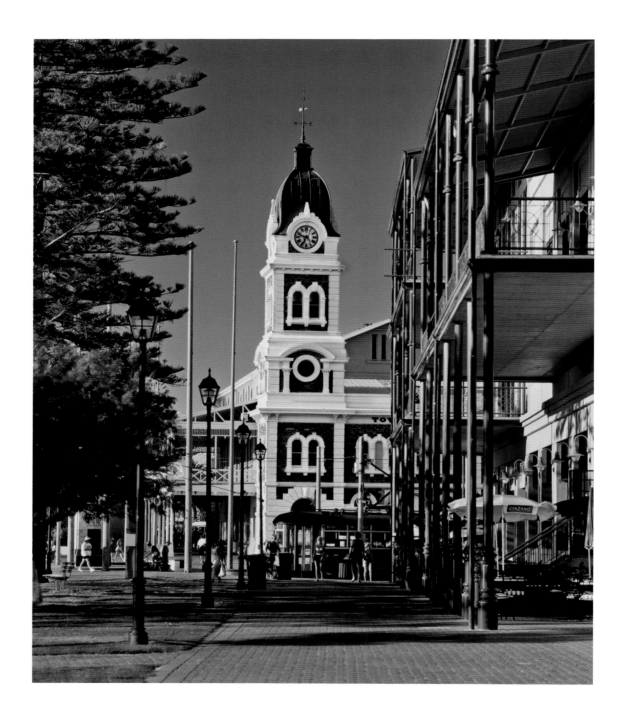

220 GLENELG TOWN HALL BOASTS A FINE CLOCK TOWER AND A CHARACTERISTIC VERANDA.

221 KING WILLIAM STREET IS HOME TO THE STATUE OF CHARLES C. KINGSTON, THE FIRST PRIME MINISTER OF SOUTH AUSTRALIA.

222 RUNDLE MALL IS THE CITY'S LARGEST SHOPPING CENTER. THE PHOTO SHOWS THREE OF ITS FOUR FAMOUS PIGS (TRUFFLES, HORATIO, OLIVER AND AUGUSTA).

223 SOME OF ADELAIDE'S MOST RECENT BUILDINGS REFLECTED IN THE WATERS OF THE TORRENS RIVER.

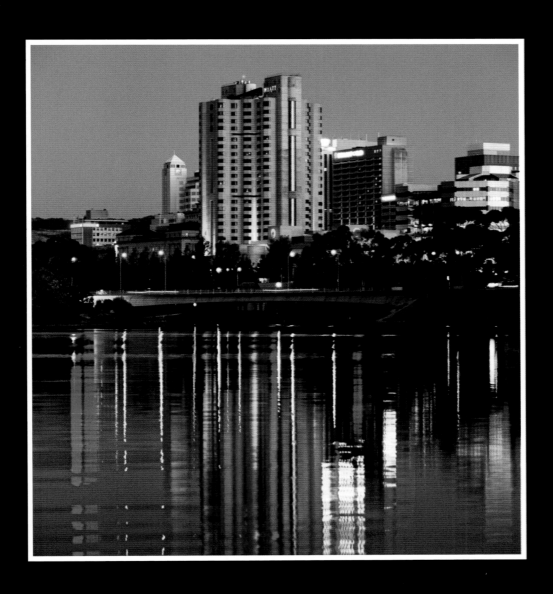

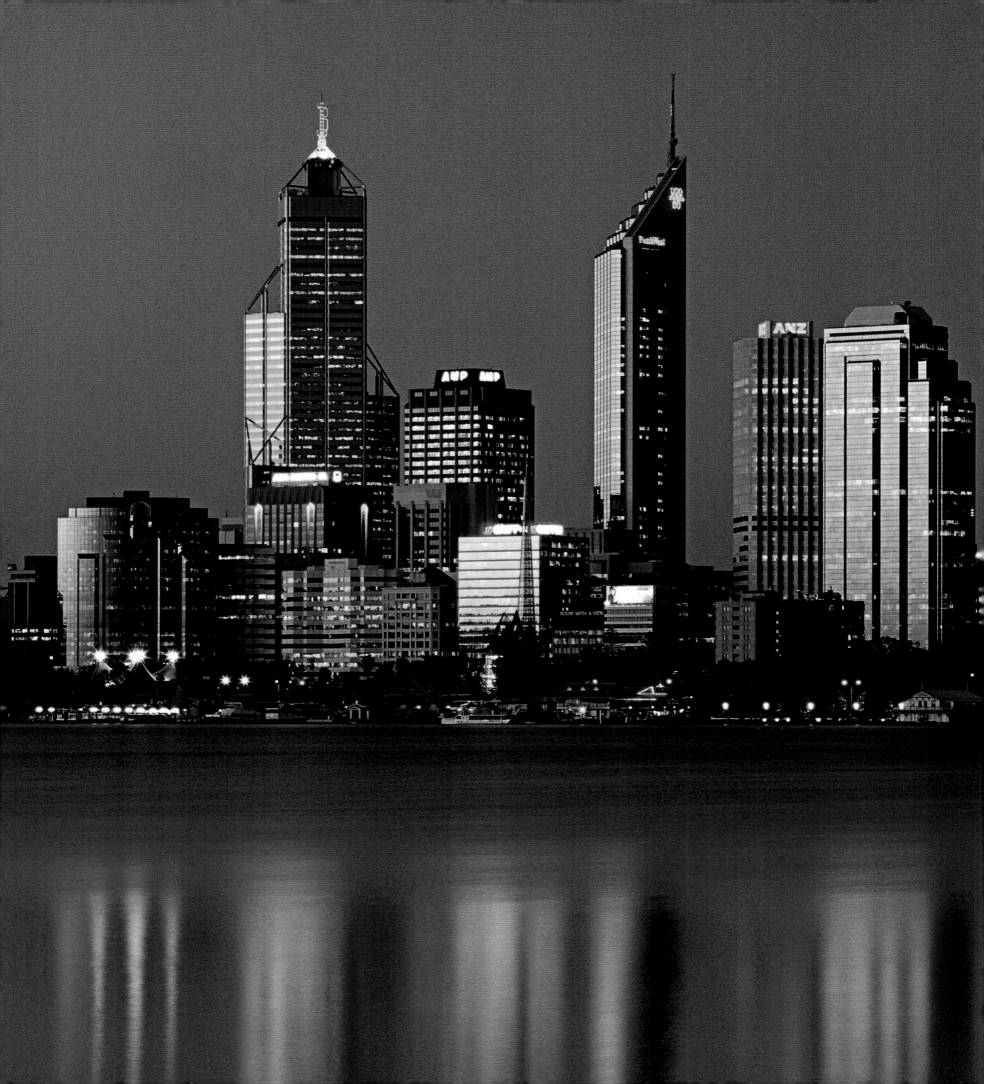

224 THE PERTH SKYLINE REFLECTED IN THE WATERS OF THE
SWAN RIVER AT SUNSET.

225 FROM LEFT TO RIGHT THE SWAN BELLS ARE 18 DIFFERENTLY PITCHED
BELLS, HOUSED IN A MODERN GLASS AND STEEL TOWER; A VIEW OF PERTH'S PORT ON
THE SWAN RIVER; THE HISTORIC BUILDINGS OF CENTRAL PERTH.

MEDITERRANEAN
PERTH

Breathtakingly beautiful Perth, with its 1.3 million inhabitants, enjoys a life of heedless pleasure, nestling around the greenery of its huge Kings Park, which resembles a piece of land snatched from the bush, and the waters of the generous Swan River. This wide watercourse is even frequented by the odd curious dolphin and winds its way lazily, widening into small inlets and bays or melancholy little ports overlooked by villas and castles. The city is caressed by beaches of soft white sand that contrast with the deep turquoise waters of the Indian Ocean and the waves ridden by surfers, and is ringed by strikingly beautiful coasts and islands. Sun-kissed almost all year round, and blessed with a marvelous climate and a warm light that makes its fiery sunsets truly unforgettable, Perth has a Mediterranean spirit, perhaps enhanced by the presence of many Italians, who have opened gourmet food shops, restaurants and pizzerias, ice cream parlors, patisseries and bakeries in the city. The vitality of its inhabitants and the Mediterranean, or in any case European, style of its architecture make it one of the country's most attractive tourist destinations, boasting fine restaurants that are authentic gourmet islands offering multiethnic cuisine and fresh fish dishes washed down with noble wines. Perth, with its independent spirit, is not bothered by its fame as the world's remotest city, but has made it an integral part of its lifestyle, characterized by vast spaces – here everyone, or almost everyone, has a house with garden, many featuring a swimming pool. The business district is a futuristic complex of skyscrapers and blocks housing the headquarters of mining and oil companies or banks, which alternate with enchanting parks and lawns, characteristic churches, like St. George's Cathedral and St. Mary's Cathedral, elegant historic buildings, such as the Perth Mint (which is still active

today), Parliament House, Town Hall, the Supreme Court Buildings and Government House. The latter is a precious gem set in enchanting silent gardens with roses, palms and green fronds, where time seems to hesitate and almost stand still. The city is given an intellectual touch by its museums – the Western Australian Museum and the Art Gallery – and theaters and an important institute of contemporary art, which promotes the experimental work of new artists, including Aboriginal ones. However, the heart of city life is to be found among the bistros and locales of the lively Northbridge district, which faces the skyscrapers of the business center, amid the cricket fields, entertainment spots and futuristic sail-like architecture of its Burswood Resort & Casino. Perth breathes to the rhythm of its cycle tracks, which run through Kings Park, in the lush atmosphere of its marvelous Botanical Gardens, where flocks of birds and the inebriating perfume of flowers accompany visitors. Each evening toward sunset people meet on the grassy lawn overlooking the high, orange-streaked skyline of the business center for a picnic or game of football, volleyball or cricket or simply to await nightfall while chatting and greeting the arrival of the moon with music.

Perth's sunny and relaxed character is also apparent in the small coastal city of Fremantle, which can be reached by ferry along the river; a colonial oasis enlivened by the large presence of students, who frequent its handsome university. The town's elegant buildings are framed by long arcades with art and antique galleries and markets, historic pubs and evocative cafés, where you can sip a cappuccino or enjoy a glass of papaya juice. The city is also home to Fremantle Market, a favorite weekend destination and authentic bazaar of sounds, colors and sensations, is pervaded by an almost Mediterranean atmosphere.

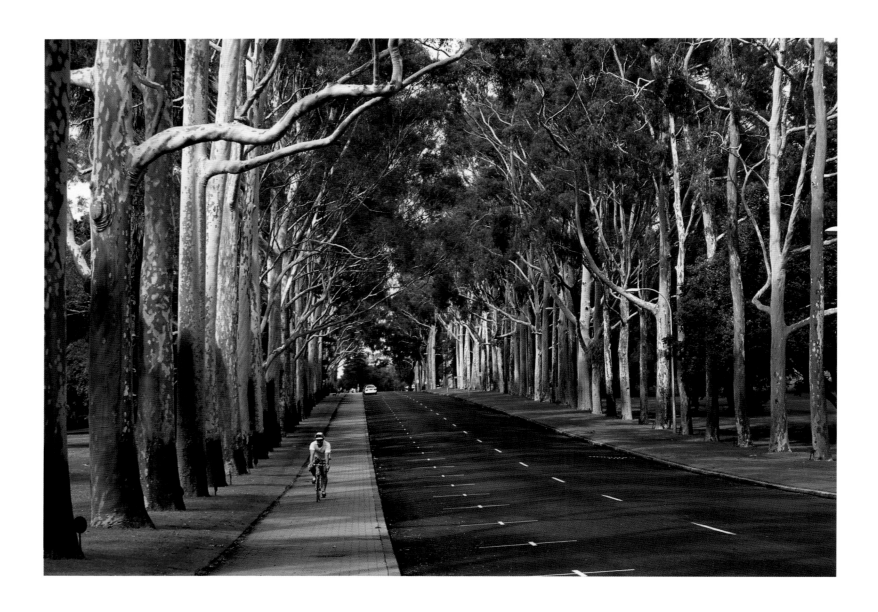

226 Sport is important to the inhabitants of Perth. Shown here is the Avenue of Gum Trees, named for the eucalyptus trees that line it. A fine cycle track runs alongside it.

227 Huge Kings Park is famous for the Western Australian Botanic Garden, which occupies 42 acres of its area and is home to 1,700 endemic species.

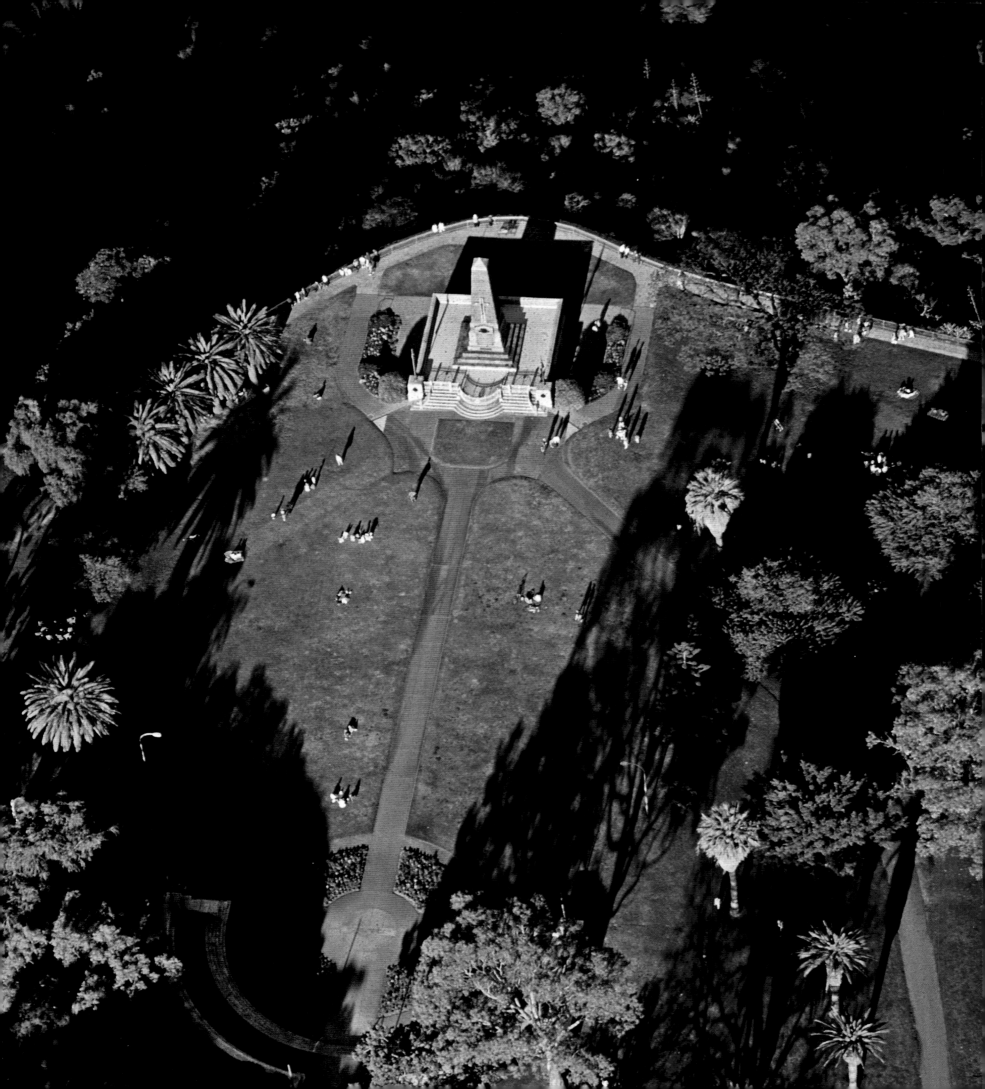

228 AND 229 THE HANDSOME CITY HALL CLOCK TOWER, BUILT IN 1870, IS REFLECTED IN THE GLASS AND STEEL FAÇADE OF A SKYSCRAPER.

230 GEORGE'S TERRACE IS ONE OF THE BUSIEST AREAS IN PERTH'S FINANCIAL CENTER.

231 THE DNA TOWER IS A TALL METAL STAIRCASE THAT STANDS IN KINGS PARK, THE CITY'S FAVORITE PUBLIC GARDENS.

232-233 A STREET ARTIST LEANING AGAINST A WALL IN THE CITY CENTER. PERTH, THE MOST "MEDITERRANEAN" CITY IN AUSTRALIA, IS FAMOUS FOR ITS RELAXED ATMOSPHERE AND IS MUCH LOVED BY ALTERNATIVE ARTISTS.

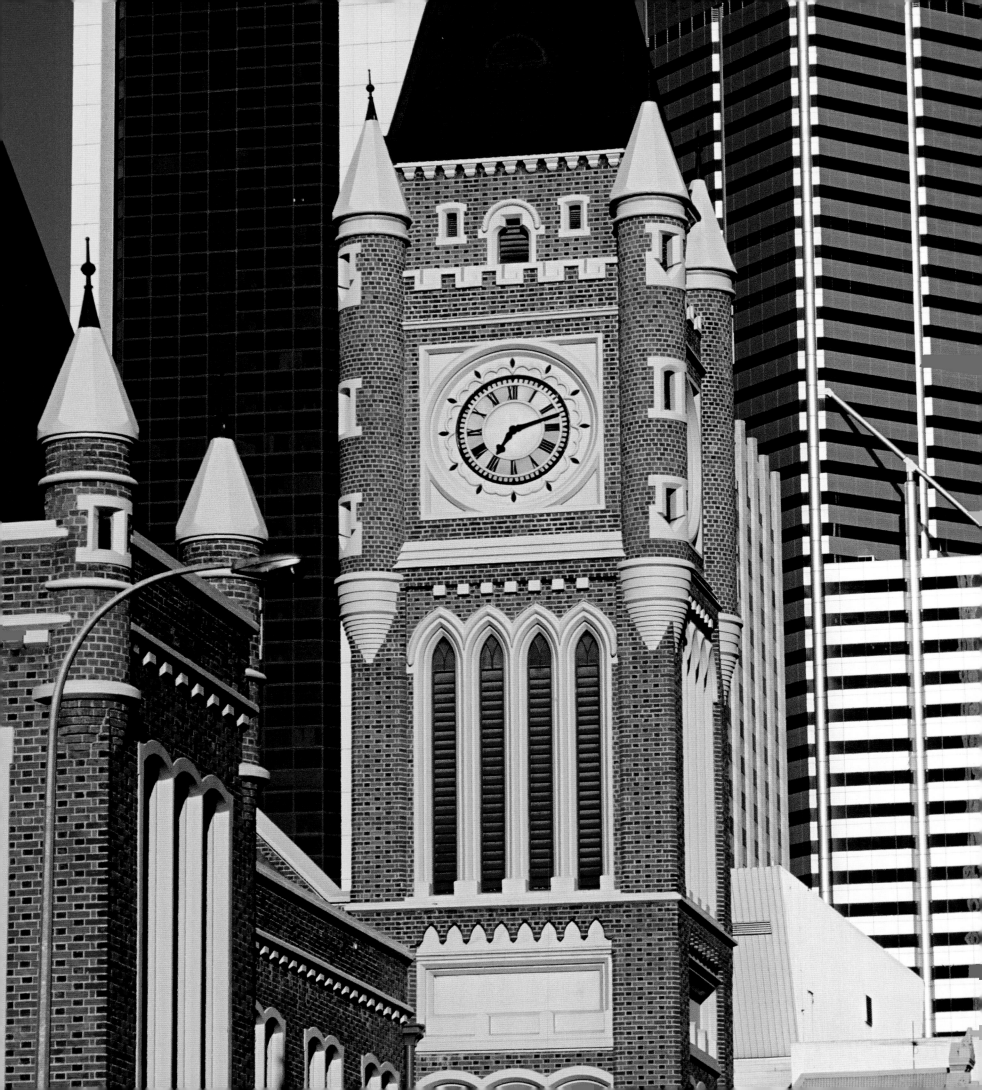

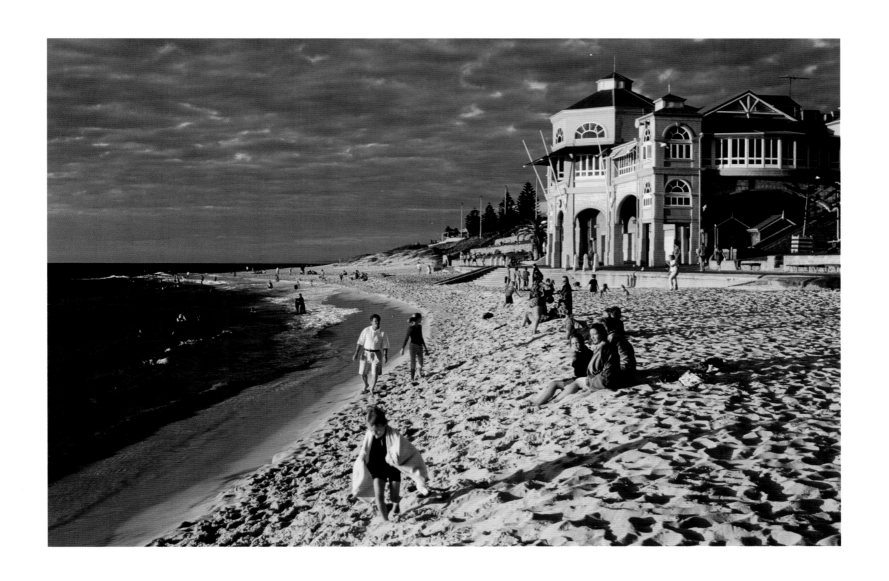

234 A STORE BECKONS CUSTOMERS WITH AN ENORMOUS GAPING SHARK'S MOUTH. ALTHOUGH RARE, SHARK ATTACKS DO OCCUR ALONG THE BEAUTIFUL BEACHES FRINGING THE INDIAN OCEAN AROUND PERTH.

235 COTTLESLOE BEACH IS ONE OF THE CITY'S MOST PICTURESQUE BEACHES AND ALSO ONE OF THE SAFEST FOR BATHING. ITS COLONIAL-STYLE TEA HOUSE ALSO BOASTS AN EXCELLENT RESTAURANT.

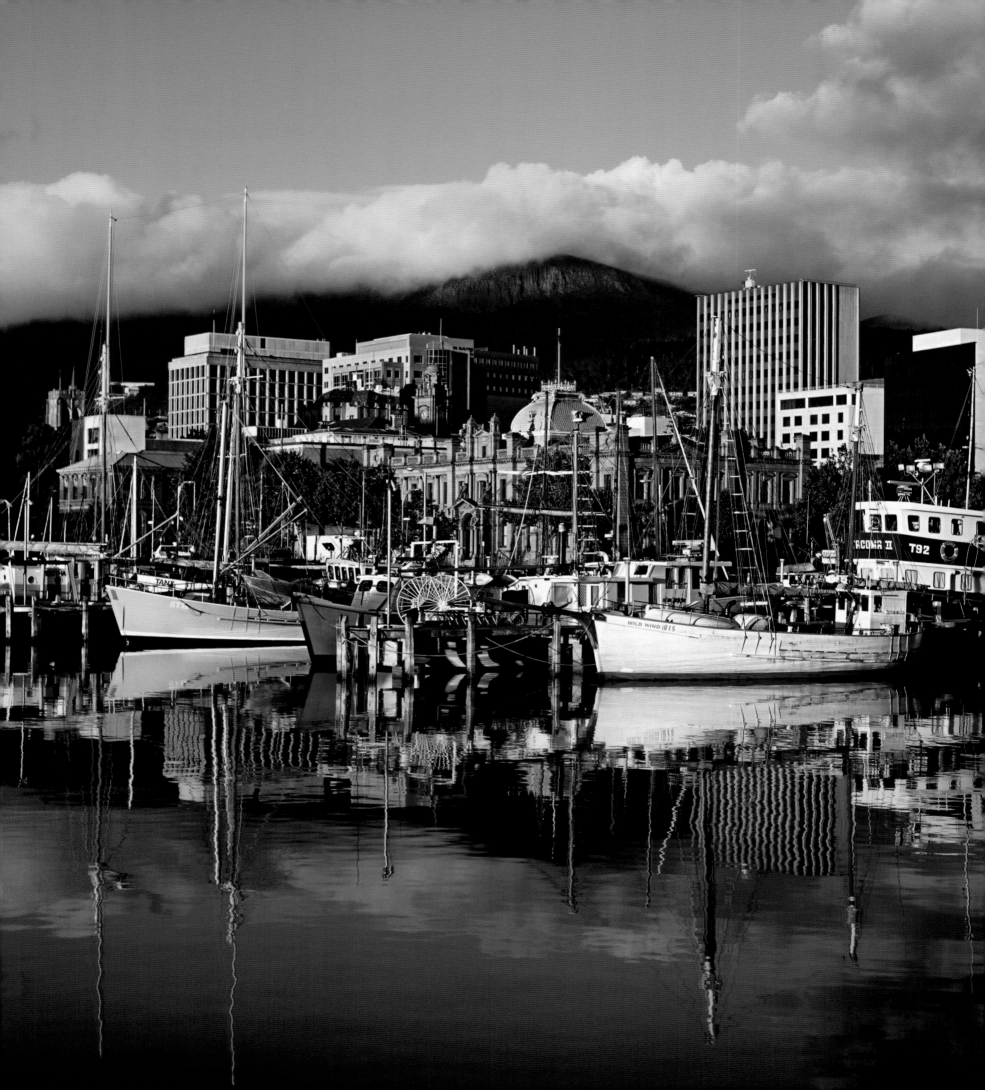

FOREIGN
HOBART

All Tasmania's pretty little towns have a very un-Australian feel, with their English village calm and very European air of cleanliness and tidiness. Hobart in particular has the allure of a beautiful foreigner, with an intense spirit, great colonial charm, forward-looking liveliness and the wild power of a breathtaking natural setting. All these elements meet and merge in a wondrous miracle, giving the city – the second oldest in Australia after Sydney – unique traits.

Hobart nestles on the slopes of Mount Wellington, a disturbing shadow whose peak is often covered in snow, like a queen sitting on her throne, stretching languidly along the banks of the Derwent River, which winds its sleepy way through the city. The elegant and refined city is crowned by the façades of its 19th-century wooden buildings painted in pastel colors. It clusters around Elizabeth Street, slipping lightly away towards the port, piers, wharves and old warehouses, which have been completely renovated and converted into an burst of restaurants and pubs, boating stores, anchored barges selling fish and chips and gourmet paradises specialized in seafood. The most important museums, such as the Tasmanian Museum & Art Gallery and the Maritime Museum, are housed in splendid Georgian residences, while the superb Theatre Royal – the oldest theatre in

Australia – is a true gem, with a thoroughly English interior.

Although whaling, which once attracted sailors seeking their fortunes, ceased long ago, the city has retained a certain legendary aura. This atmosphere lives on in the lively Saturday market held in Salamanca Place (where it is possible to find absolutely everything), framed by old sandstone warehouses that are now home to art galleries, cafés and locales, and stores selling all manner of wares from fruit and vegetables to antiques. However, it is above all among the streets, small stone churches, historic cottages and red-roofed workers' houses of the Battery Point district that the images and faces of the characters that populated the legendary whale hunts (that still smile out of a few old black-and-white photographs) can be found. Indeed it would some as no surprise to meet a whaler straight out of the pages of *Moby Dick* here!

As Christmas approaches, Hobart assumes a vaguely snobbish air as it hosts the Sydney-Hobart regatta and the city fills with a multitude of trendy and varied spectators: boat and sailing enthusiasts, often with foreign accents, and beautiful tanned girls with sunglasses who look as though they have stepped straight out of a fashion magazine. This exclusive public tinges the city with elegant and European hues, giving it an even more foreign appearance.

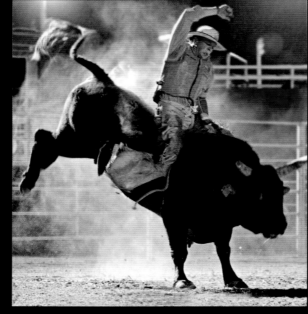

A MULTIETHNIC WORLD

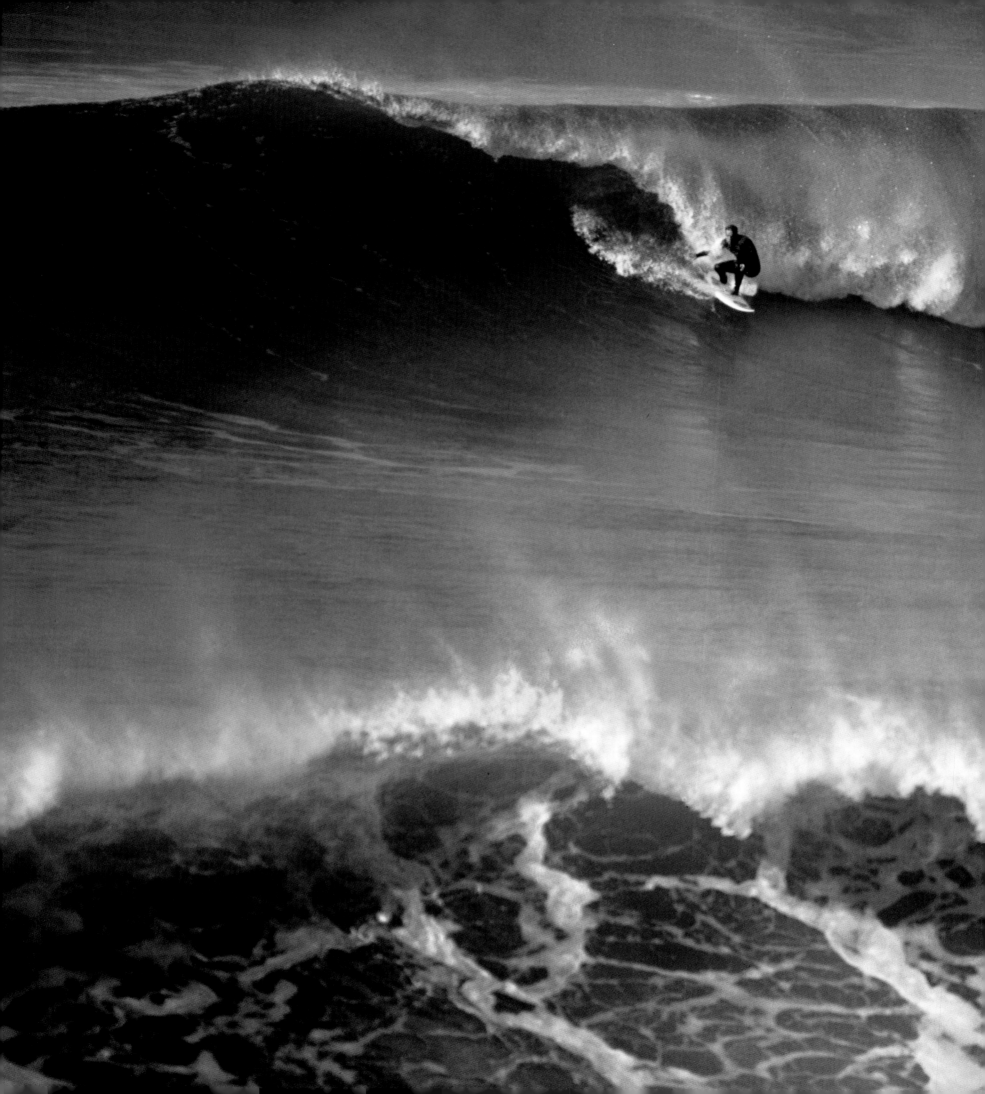

A YOUNG PEOPLE

The spirit of adventure dwells in the hearts of all Australians. Whether they live in the shadow of a skyscraper, ride the waves on a surfboard, or follow flocks of sheep in the endless and desolate Outback, their eyes are lit by the flame of passion, their soul vibrates with the specter of restlessness and their veins throb with the insatiable thirst for new discoveries that brought their ancestors to this unknown land. Most early settlers were criminals, banished forever from their homeland, but also pirates, adventurers and explorers arrived, united by the same craving for new and exciting experiences.

Australia is a melting pot of faces, peoples and different cultures and traditions – both Asian and European. Sunburned faces as red as the earth, tanned faces as brown as the mountains, pale faces as white as the fine sand and dark faces as black as a cavern: faces like landscapes, which conserve the memory of distant lands. Blue, green, hazel and brown eyes, brimming with old memories and shadows of never-known worlds.

Australia is a multiethnic world of colors, a mix of people from 200 different countries who speak countless different tongues, united under a single flag and sharing the same everyday language: English. It is a world full of colors, passions and perfumes, with a cuisine accompanied by the finest wines that is the result of the blend of cultures, combining Asian and Mediterranean traditions. It is a world that testifies to the prodigy of a multiethnic, free, tolerant and pacific community characterized by considerable wealth and one of the lowest crime rates in the world.

Of course, there are many contrasts, but these are minimal if compared to the rest of the planet. They are mainly associated with the problem of the integration of the Aborigines, the original inhabitants of the country, who were marginalized and discriminated against for almost a century and a half following the arrival of the white man, only obtaining full Australian citizenship and their own flag in 1967.

The country is inhabited by over 19 million people, distributed over an immense area. Indeed, Australia has a population density of 6.5 people per square mile, which is ridiculously low in comparison to the United States (73.0) or Great Britain (630.9). Some 90 percent of the entire population lives in cities, chiefly concentrated along the "Boomerang Coast," between Adelaide and Cairns, and along the southwestern coastal strip of Western Australia.

However, the cities are also creative workshops – churning out films, opera, music, painting, dance, theater, art and new trends – and a breeding ground for great talents. Nicole Kidman and Cate Blanchett, Russell Crowe and Mel Gibson, Paul Hogan (the legendary *Crocodile Dundee*) and the film director Peter Weir are all Australian.

"Aussies" are outgoing and relaxed people, who love sport and the outdoor life, or at least that is the impression that they give to visiting tourists, although of course the actual situation is far more complex than it may appear at first sight. The different styles are nonetheless united by the same way of life and an identical philosophy: people don't live to work but work to live.

The typical Australian lives in a red-brick house with a garden and dedicates his weekends to his family, friends and sport: horseracing, soccer, Australian football, rugby or, better still, cricket. Alternatively he may spend his time in the *bush*, the local "countryside," whose natural beauty rivals that of a finely groomed park. For Australians the relationship with the sea and its immense spaces is fundamental, but the Outback, with its desolate expanses, is also one of the characteristic aspects of the country's true identity.

Australia wins hearts because it represents Utopia. It is the people's last frontier, with its endless and unspoiled landscapes and ideal cities projected towards the future; it is an America of the new millennium, where the "Australian dream" is still reality. It is the country of myth, in which it is possible to commence a new life, from scratch. It is a dream that instills the desire to leave everything and move to the Antipodes, just as the people who inhabit this marvelous country have done.

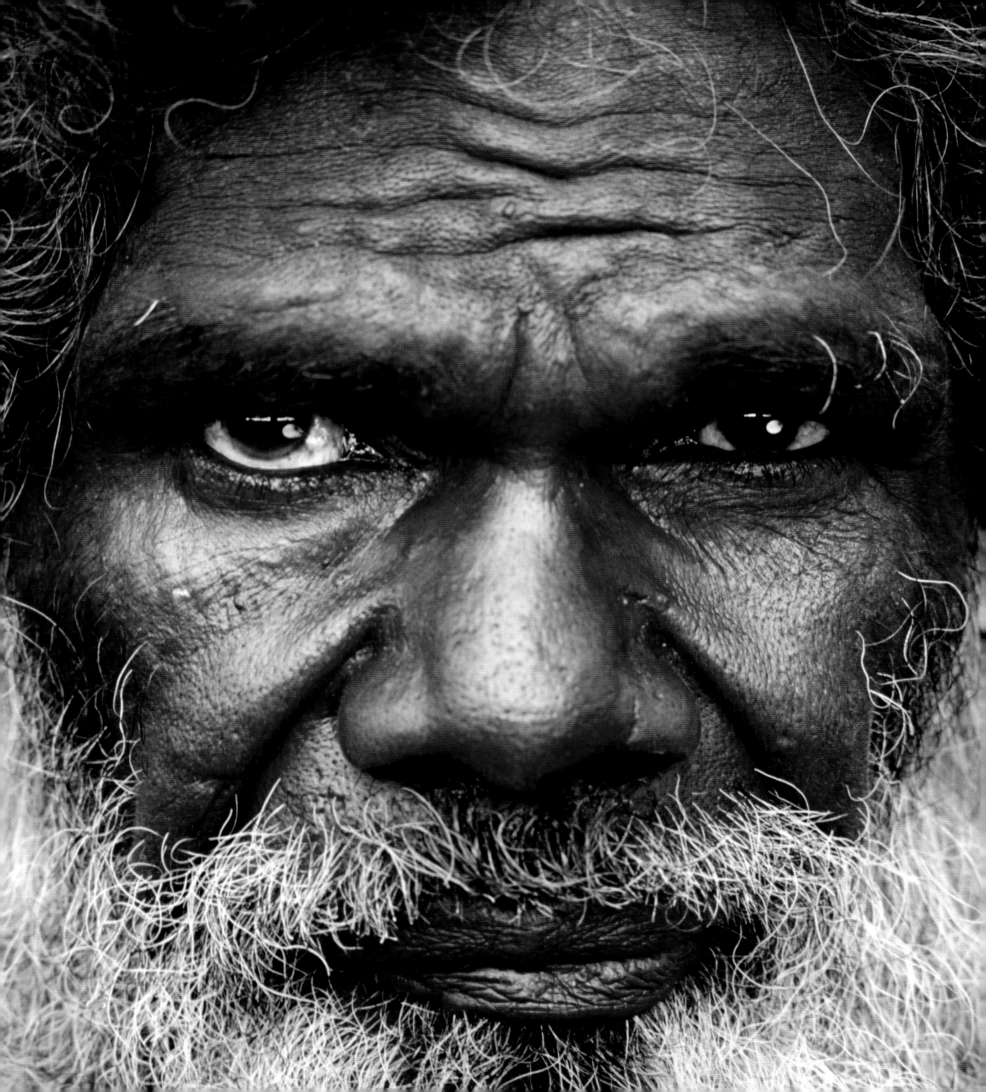

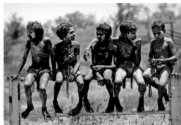

244 A PORTRAIT OF AN ABORIGINAL MAN. FOR ABORIGINES, ESPECIALLY ELDERLY ONES, CUSTOM DECREES THAT THEY NEVER LOOK A PERSON STRAIGHT IN THE EYES.

245 FROM LEFT TO RIGHT AN ABORIGINAL WOMAN WITH PAINTED FACE; ABORIGINAL MEN PERFORMING A DANCE; ABORIGINAL CHILDREN WITH THEIR FACES AND BODIES PAINTED IN THE TRADITIONAL MANNER.

THE SPIRIT
OF THE ABORIGINES

Australia has a deep soul, rooted in blood: the spirit of the Aborigines. The Aborigines have inhabited this continent for over 40,000 years and boast the oldest living culture in the world. Today they represent just two per cent of the entire population and live mainly in the center and north. However, their presence pervades the whole of Australia, invisibly reaching out to the most remote corners of the great metropolises and the hearts of the most fearless stockbreeders. There are even those who believe that the future of the Earth is recounted in the memory of the Aborigines.

"… During the Dreamtime the ancestral spirits came up out of the Earth and down from the Sky to walk on the Land. They shaped its rocks, rivers, mountains, forests and deserts; they also created all the people, animals and plants that were to live in the country and laid down the patterns their lives were to follow. When they had completed their work, the Ancestors returned to the Land. They became springs, mountains, bays. . . ." These words were used by Bruce Chatwin, whose peregrinations also brought him into contact with this culture, whose creation myth he describes in the book entitled *The Songlines*. The natives believe that the Earth was created long ago – during the *Tjukurpa*, the Time of Creation – by the ancestral spirits, supernatural creatures that possessed both animal and human characteristics. They emerged from the Earth, where they had lain sleeping, and started to travel, covering their traces with the Songlines, trails of words and musical notes that still help those who know them to orient themselves like a map. The spirits created the mountains, valleys, rivers, sand dunes, waterholes and animals – from kangaroos and emus to honey ants and man – by naming them and singing them, leaving on Earth the energy that the Abo-

rigines now perceive in their sacred places. However, *Tjukurpa* is much more than this. It enables the Aborigines to know the world and the laws of human behavior, to relate to animals, and even to prepare certain types of food. It is the knowledge handed down through the generations, the past, present and future. It is the spirit of the Aborigines, or what remains of it following the invasion of the white man, to which the natives reacted by opposing the enemy guns with their spears. However, the various tribes never managed to form a truly united front, perhaps because of their wide dispersion over the territory, and the presence of at least 400 different languages. In the end, the guns vanquished the spears and the Aborigines were relegated to remote areas. Cultures over 40,000 years old crumbled. Some Aborigines learned to ride horses and work on the sheep and cattle stations, others became trackers – guides who helped explorers to cross the desert – while others still went into hiding in the most impenetrable areas of the Outback. Today the spirit of the Aborigines is represented by approximately 400,000 individuals, part of whom form a maladjusted urban population that inhabits the fringes of the cities, while the remainder are scattered around northern Queensland, the islands dotting the stretch of sea between the Cape York Peninsula and Papua New Guinea, the Northern Territory and the Top End. It is embodied in the communities that live happily in remote spots, proud of the strength of their traditions, prolific artists and musicians and faithful guardians of myths and dreams. Examples are the tribes that inhabit the forest of Arnhem Land, the Cobourg Peninsula, on the edges of the Top End, and the Melville and Bathurst Islands, which are home to the Tiwi. The Aborigines are a people apart, characterized by a fascinating culture that takes the mem-

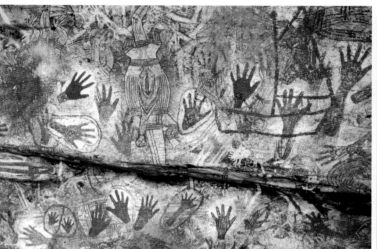

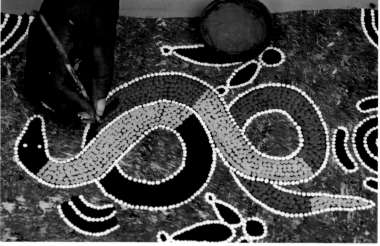

ory back in time and is manifested in *pukumani* poles – carved and painted funerary poles. A journey among these people leads to the quest for the spirits. The eyes of the spirit of the Aborigines lie in art, which is expressed in the form of simple handprints, prehistoric kangaroos, wombats the size of rhinoceroses, scenes of hunters slaying kangaroos with boomerangs, fantastic Rainbow Serpents, mythological figures with the heads of men and bodies of animals, and x-ray-like skeleton figures, whose bones and internal organs are depicted. This art is described in rock drawings. Some of these are "sacred-secret," concealed in hidden places inhabited by creatures so dangerous that they cannot be approached by those unaware of local customs. It is manifested in dotted paintings that recount the stories of the Dream and is partially derived from "ground drawing," a fundamental aspect of Aboriginal songs and dances. Talented new artists contribute to revealing this rich art to the world, generating a sort of "Aboriginal boom," which ranges from the works of art displayed in the galleries of the great cities – paintings on canvas or bark and wooden sculptures – to craft shop souvenirs, boomerangs, batik and brightly colored didgeridoos. Art acts as a link between one world and another, a role that it has always possessed in this culture, of which it continues to play a fundamental part. It is a mirror of human vicissitudes, a means of paying tribute to the land, of transmitting the stories of creation and the feats of the spirits to other generations. It is a medium between past and present, the supernatural world and earthly life, Man and Earth. The ears of the spirit of the Abo-

rigines lie in music, in the rhythmic and hypnotic laments of the didgeridoo – the instrument made from a branch hollowed out by termites that is used during ceremonies and, according to legend, by men to win the hearts of women. Ceremonial Aboriginal music is a strong sensorial experience. It penetrates the soul with its deep sounds produced by beating the ground with hunting sticks and hitting boomerangs together to the rhythm of hands and feet. And then there is dance, which recalls the stories of the Dream and the ancestral spirits, in which music, song and art mingle. It is like living in a dream – an experience that provokes extreme sensations. On the one hand there is vibrant passion, a yearning sense of belonging, and on the other inner instability, capable of shaking the spirit, and fading the contours of time. It is capable of generating fear, establishing contact with a world that in many respects remains incomprehensible. The voice of the spirit of the Aborigines lies in the stories of the Dream. The Dream as a complex concept of Aboriginal spirituality, where – alongside the evocation of the Time of Creation – there is also the recognition of the spiritual energies that continue to live around man and the ancestral spirits that return to manifest themselves. The Dream that is simultaneously tradition and law, myth and legend. The Dream that determines life and traces the world, where the Aborigines manage to expand their mind over time and space and transmit their thought over enormous distances to communicate in a sort of magic telepathy without frontiers – a contagious telepathy.

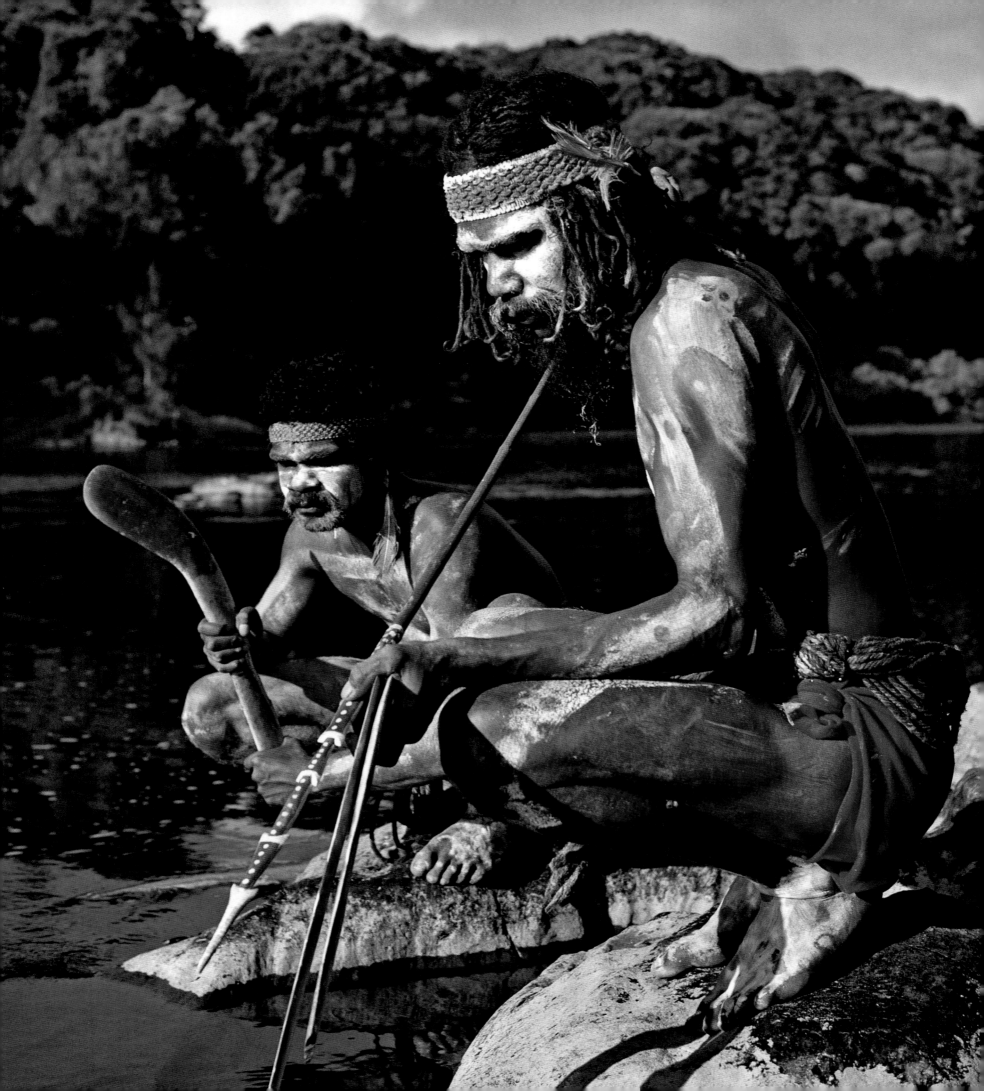

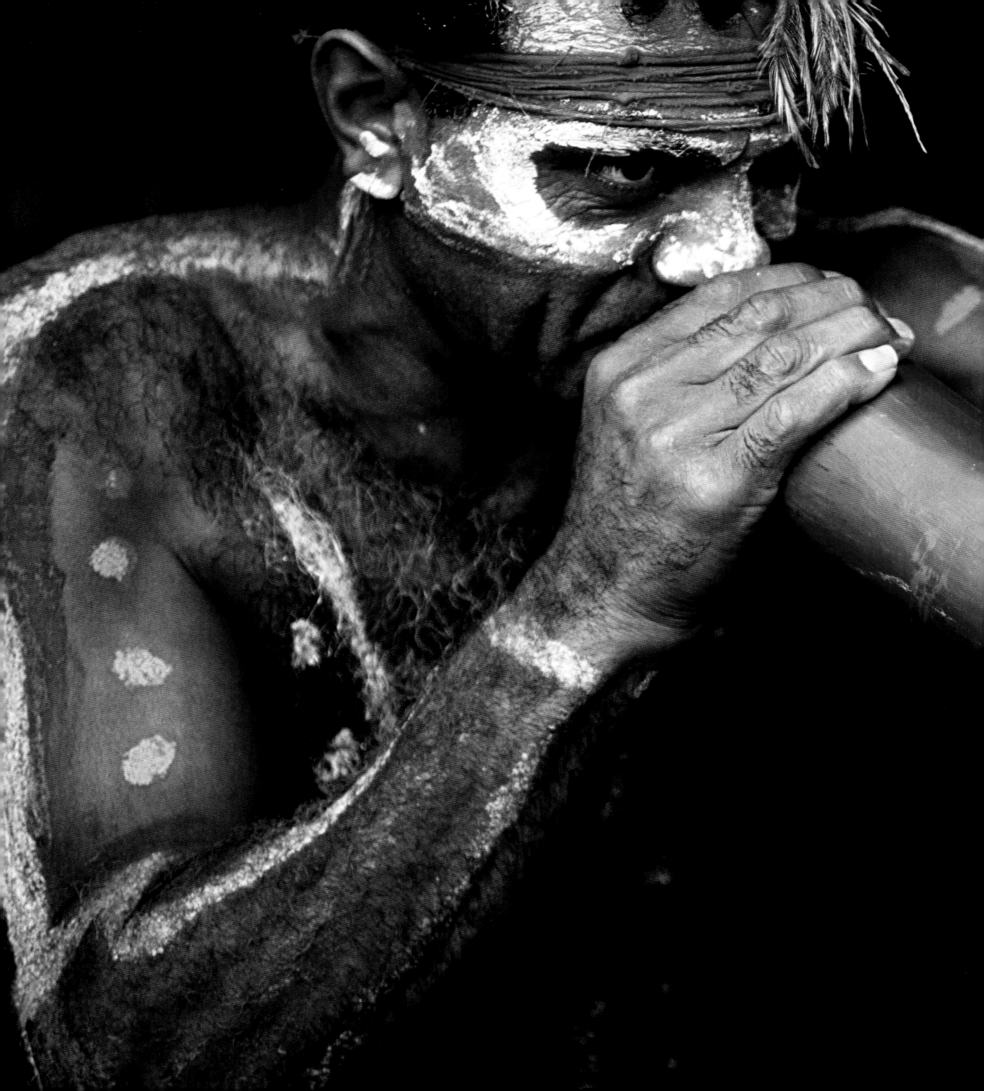

248-249 An Aborigine playing the didgeridoo. According to tradition, this instrument is reserved for men only.

250 A Tiwi Aborigine coloring his face and body for a ceremony in Arnhem Land.

251 A Yolngu Aborigine having his face painted during the Garma Festival of Traditional Culture.

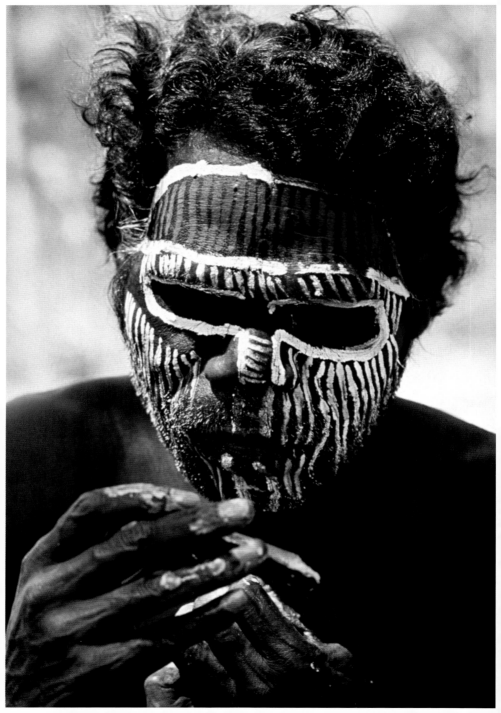

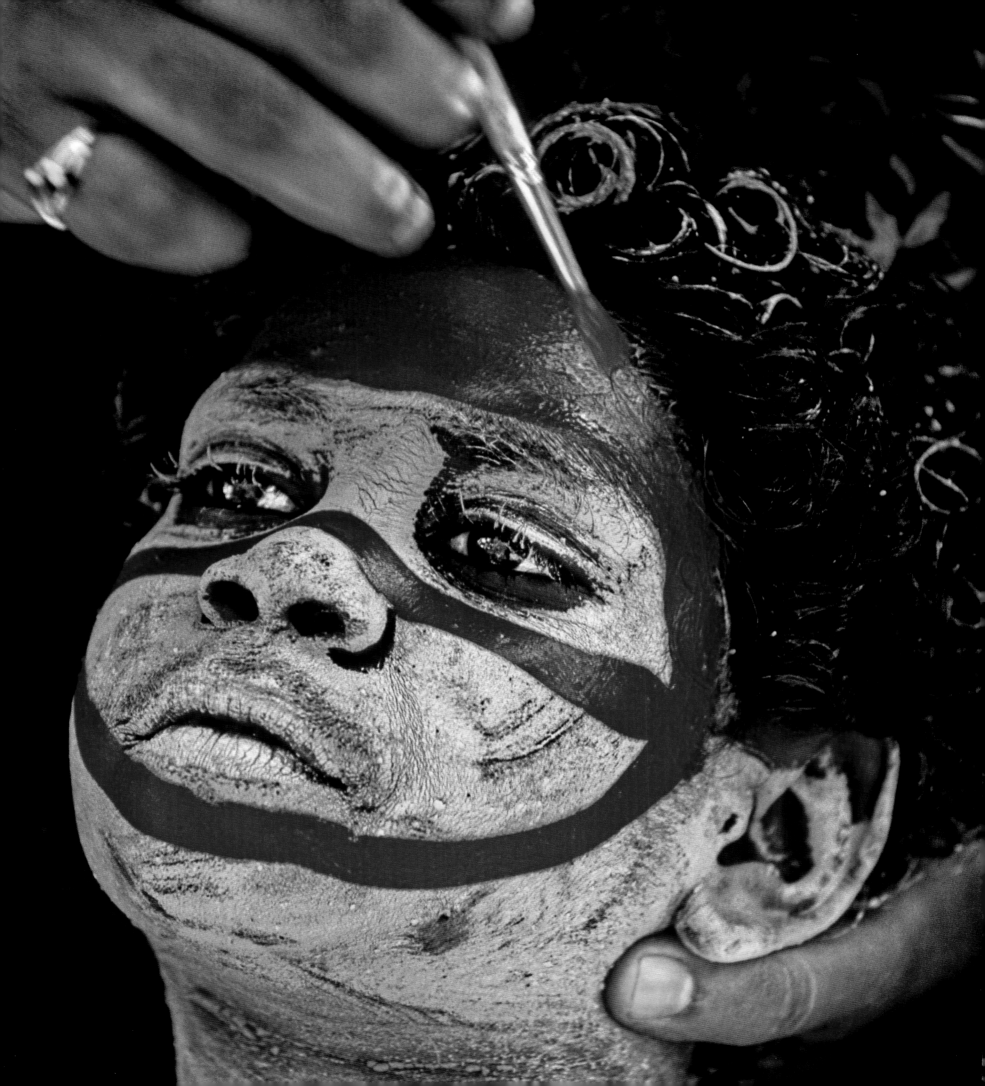

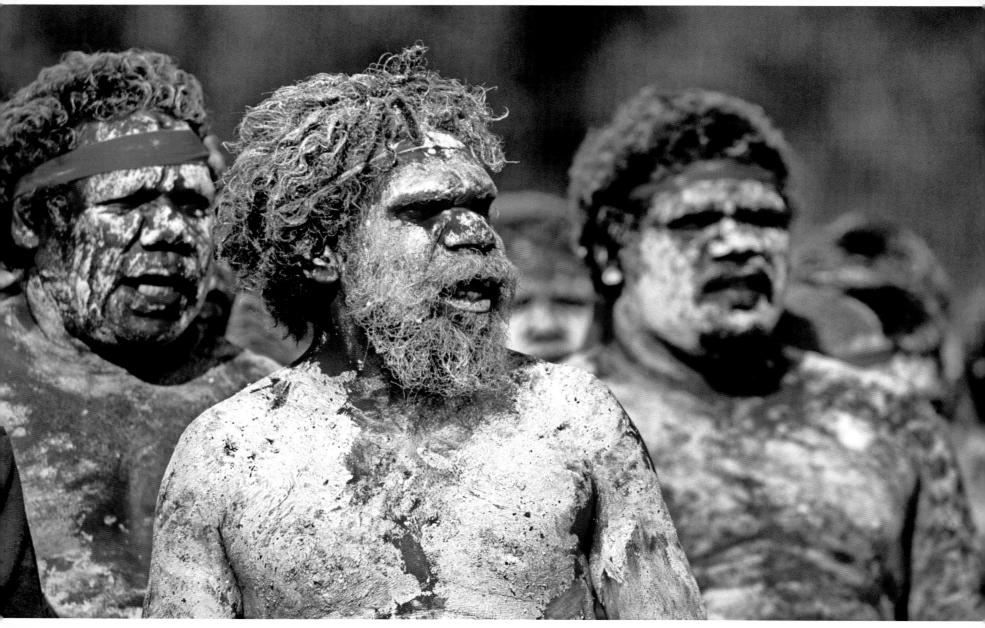

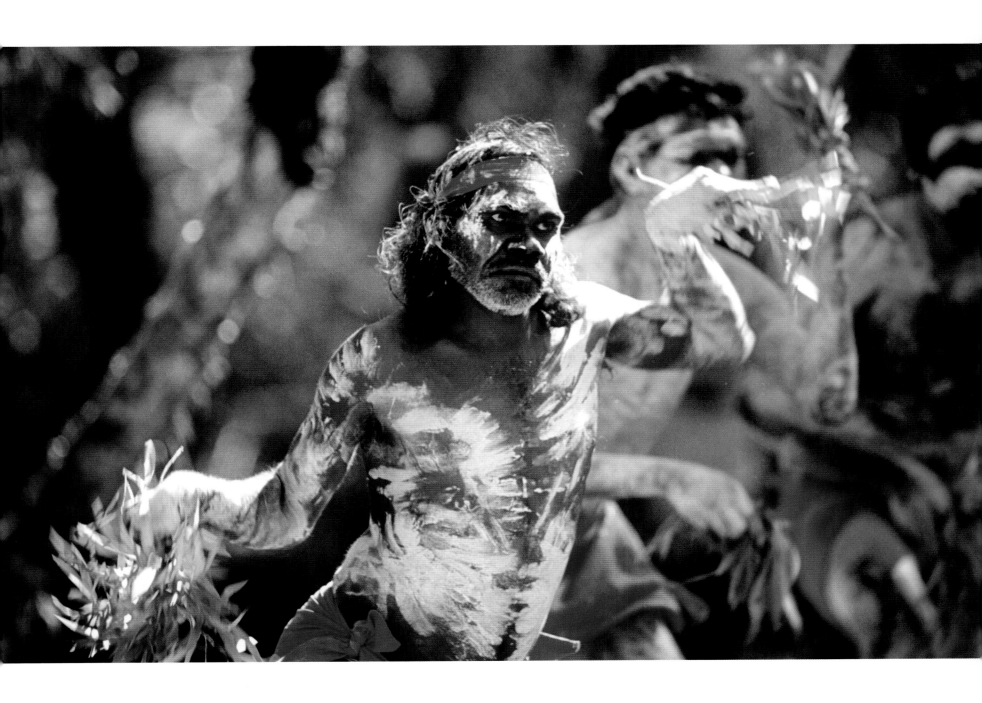

252 A group of Aborigines in Arnhem Land performing an ancient ritual dance, their bodies painted with white clay or *GUPUNG*.

253 An Aborigine dancing during a ceremony in Nitmiluk National Park near Katherine.

254 AND 254-255 A group of Aboriginal men, youths and children dancing in a trance-like state in southeastern Arnhem Land.

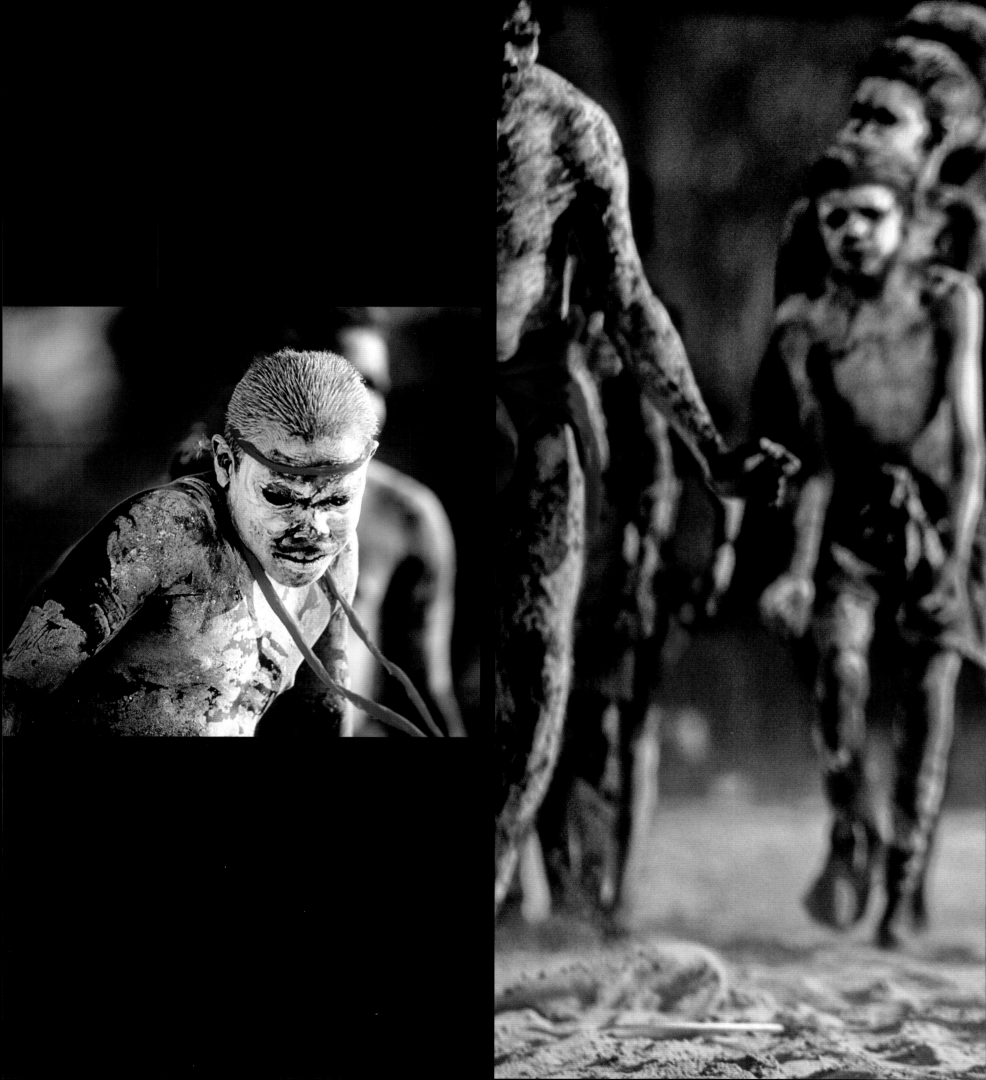

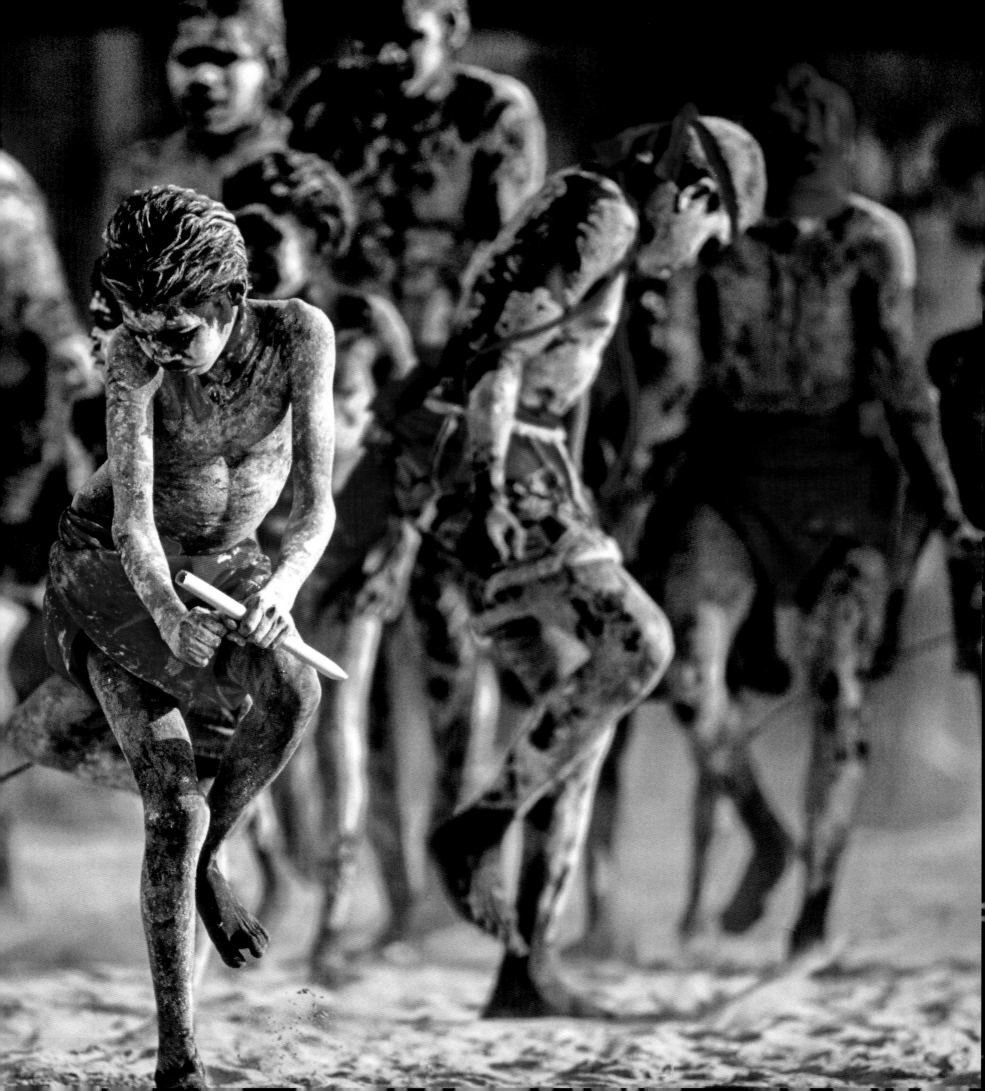

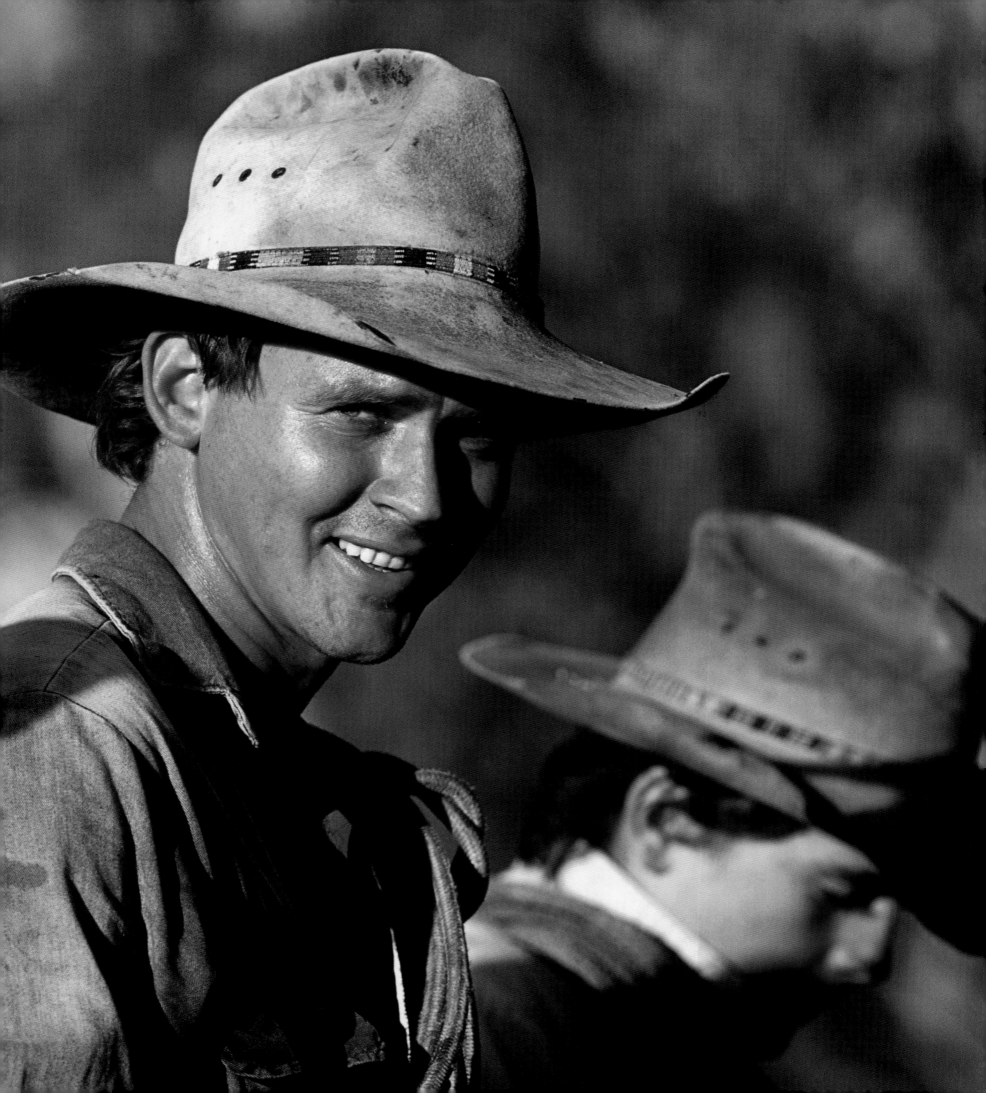

256 A "stockman," as Australian cowboys are known, wearing the typical Akubra hat on the New Pixie Station.

257 FROM LEFT TO RIGHT A stockman riding a bull at the Kununurra Rodeo; the dirty, dusty face of a miner; the harvest in the Australian vineyards.

NEW
PIONEERS

The culture of Australia is one of adventure, which triumphs in the crocodile farms of Queensland or Kakadu National Park, whose guides prefer untamed nature to civilization. It is the culture of those – swagmen or myth seekers – who go "walkabout," an adventurous roaming without an apparent purpose, like the journeys upon which the Aborigines embark to communicate with the spirits: a voyage of self-discovery. It is also the culture of the Outback and the huge cattle and sheep stations that are located hours of flying time from the first signs of civilization.

The Outback is the world of the livestock breeders who face fires, drought, and floods. It is the realm of the sheepshearers who are able to shear over 150 animals a day and the undisputed domain of the stockmen, who challenge furious bulls and horses. These are men who work from dawn to dusk and lead a hard and rough life. The last true pioneers, they are united by an intense camaraderie. During the sheep-shearing period, they get together with their entire families and closest friends for boisterous festivities, with children playing amidst bales of wool, sometimes featuring impromptu contests. This same spirit unites the stockmen, who sleep by the fire beneath a blanket of stars: a sense of freedom that they would not exchange for anything in the world.

In total contrast, there is the culture of wine, embodied by the owners of the elegant wineries of the Hunter Valley, Barrossa Valley and Margaret River, a magnificent region of Western Australia, where the green vineyards contrast with the blue of the Indian Ocean, beaches crowded with surfers and karri forests. Australia's wines are among the best in the world – white, red or rosé, sweet or dry, sparkling and prestigious labels. The largest estates often also flank winemaking with the production of authentic gourmet specialties, such as cheese, smoked meats, pickles, jams, candies and chocolate: a multicolored universe of temptations for refined palates.

Australia also has a culture of the land, that of the most reckless pioneers: the gold, silver, platinum and uranium miners – unrefined people of few words. Men who really do resemble ants in the earth, among the conical heaps of clay that dot the apocalyptic landscape around Coober Pedy (a curious name that is the result of the mispronunciation of the Aboriginal words Kupa Piti, meaning "white men in a hole"). In this area the heat is so fierce as to force many of the inhabitants to seek refuge below ground in hand-dug caves, often transformed into elegant homes. This is the land of opals, the magical, highly-prized and valuable stones; enchanting thin layers of silicon that refract the light like a prism flashing gleams of blue and white, culminating in a fiery red sparkle.

Finally, Australia is also a land of heroes, men who risk their lives to save those of others, such as the Flying Doctors, for example, who spend more time in the air than on the ground, always desperately seeking people lost in the desert, fallen into gorges, bitten by poisonous snakes, or victims of serious accidents.

258-259 A STOCKMAN LEADING HIS ANIMALS TO THE SUMMER PASTURES IN THE INTERIOR OF THE COUNTRY.

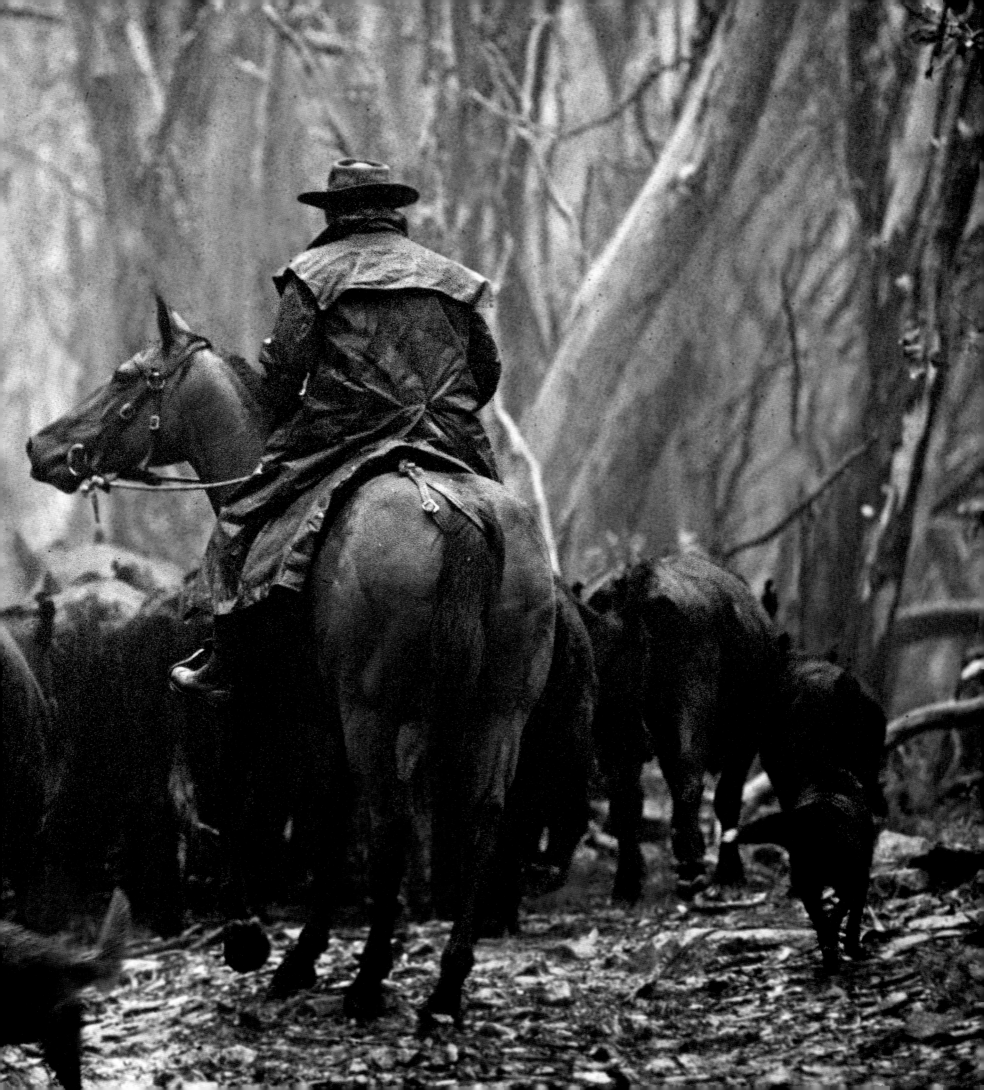

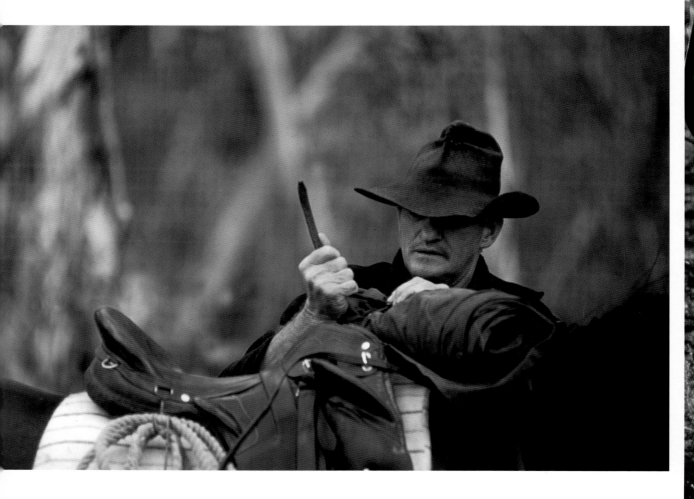

260 A STOCKMAN SADDLING HIS HORSE.

260-261 PACIFIC COWBOYS ARRANGING THEIR SADDLES ON A FENCE
FOLLOWING A HARD DAY'S WORK.

262-263 A GROUP OF PACIFIC COWBOYS CHECK THEIR STATION,
ACCOMPANIED BY THEIR FAITHFUL AND HIGHLY SKILLED SHEEPDOGS.

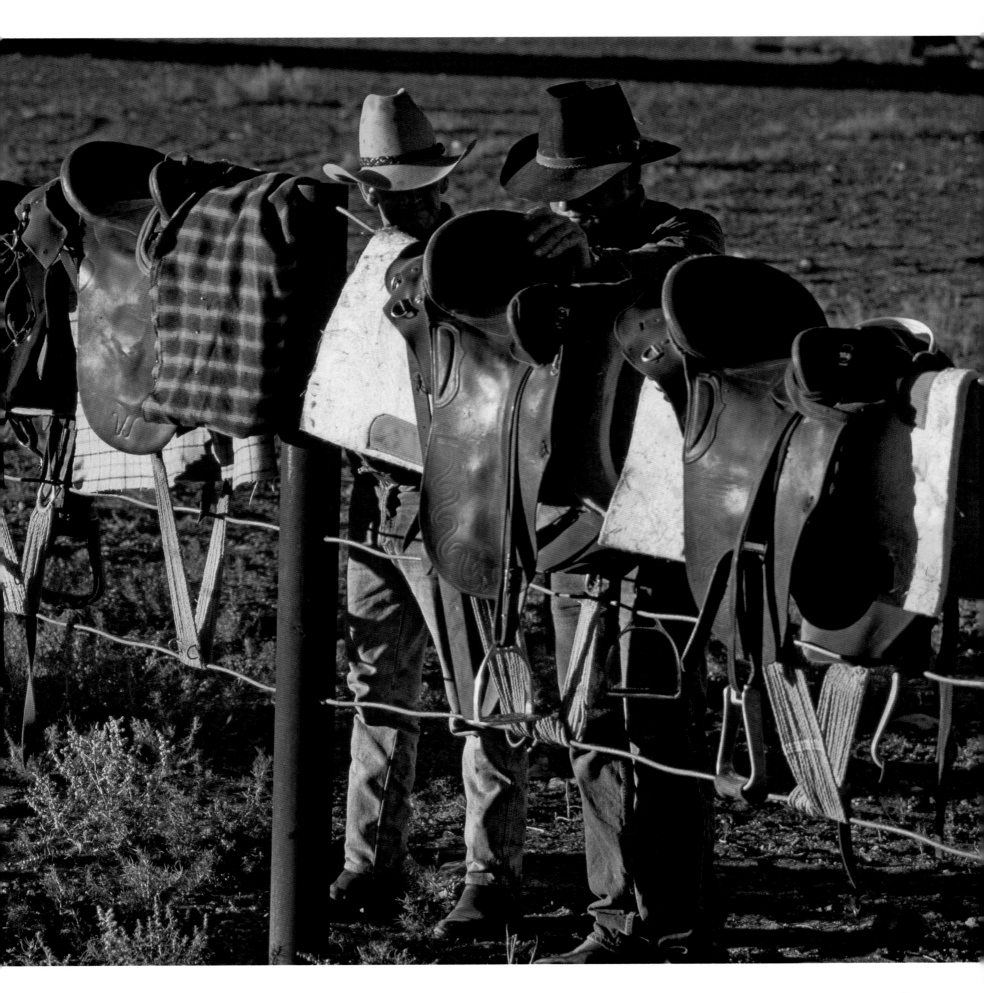

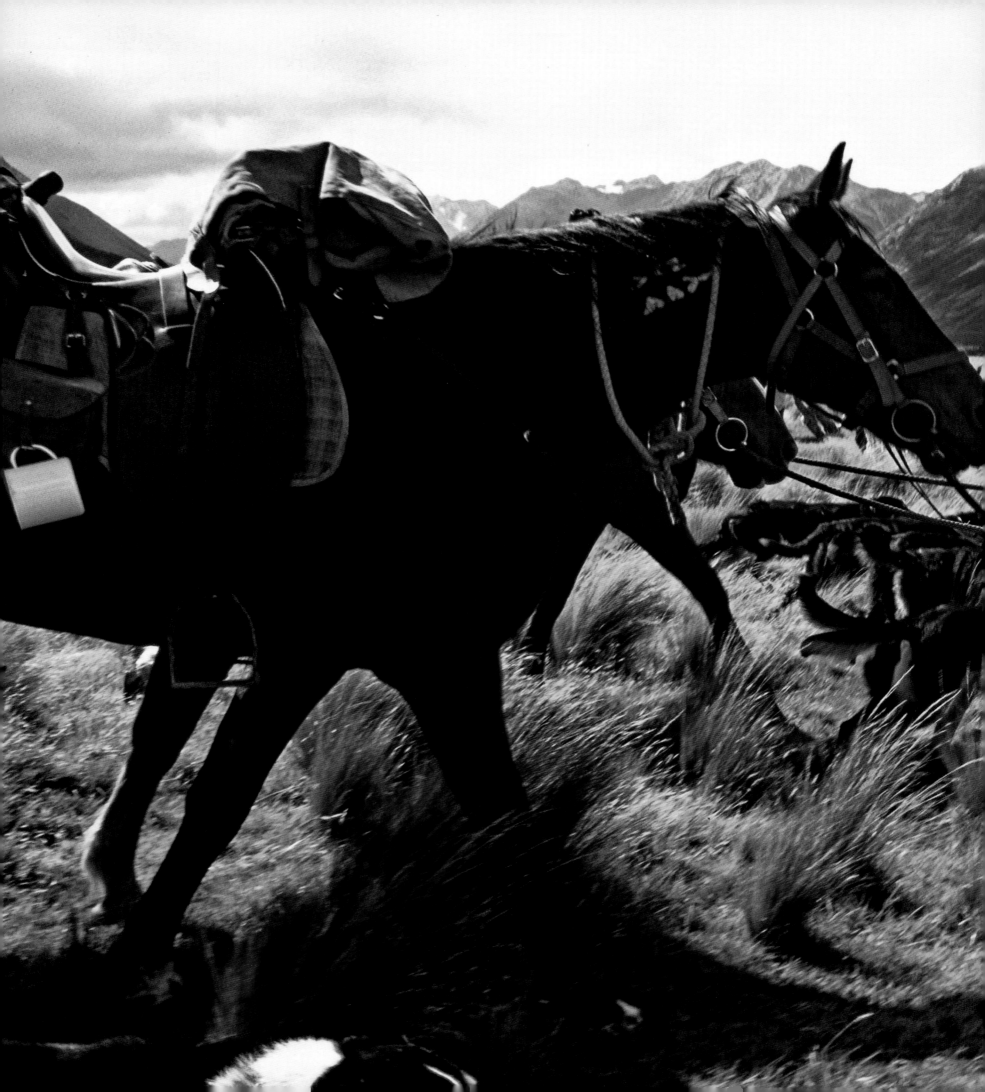

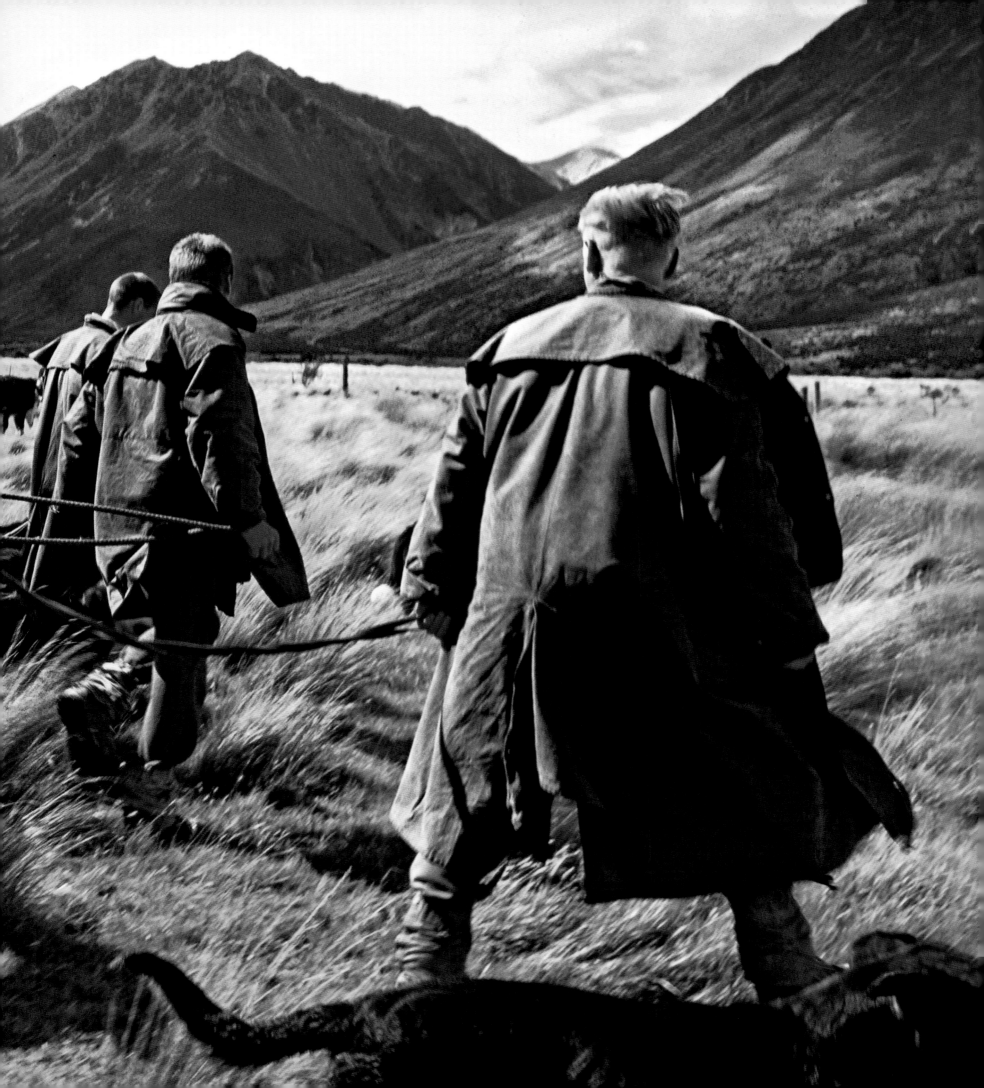

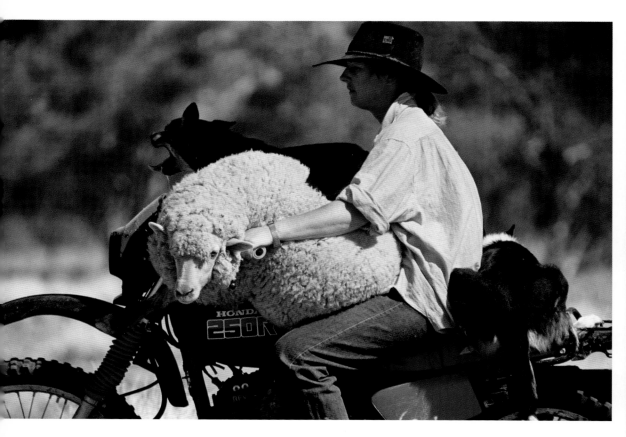

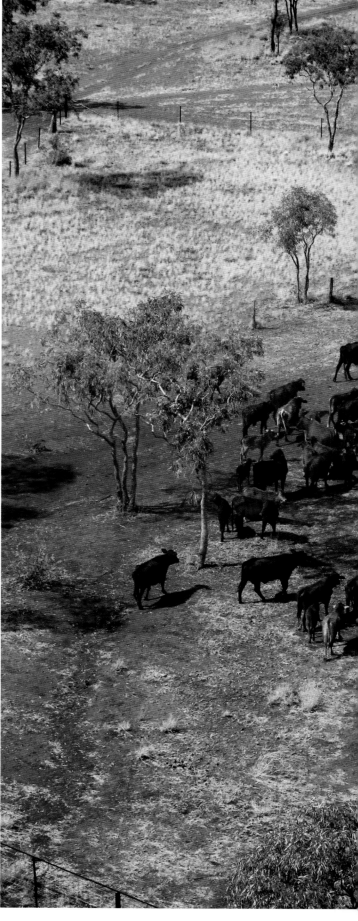

264 A COWGIRL AND HER DOG RETRIEVE A SHEEP THAT HAD STRAYED FROM ITS FLOCK
ON THE DAGWORTH STATION.

264-265 AUSTRALIAN STOCK STATIONS CAN BE ALMOST AS LARGE AS A EUROPEAN
COUNTRY; CONSEQUENTLY SOME BREEDERS USE HELICOPTERS TO CHECK THEIR ANIMALS.

266 A COWBOY RETRIEVING A LOST CALF.

267 AN ABORIGINAL STOCK GIRL. MANY ABORIGINES HAVE ADAPTED THEMSELVES
TO WORKING ON STATIONS, BECOMING EXPERT.

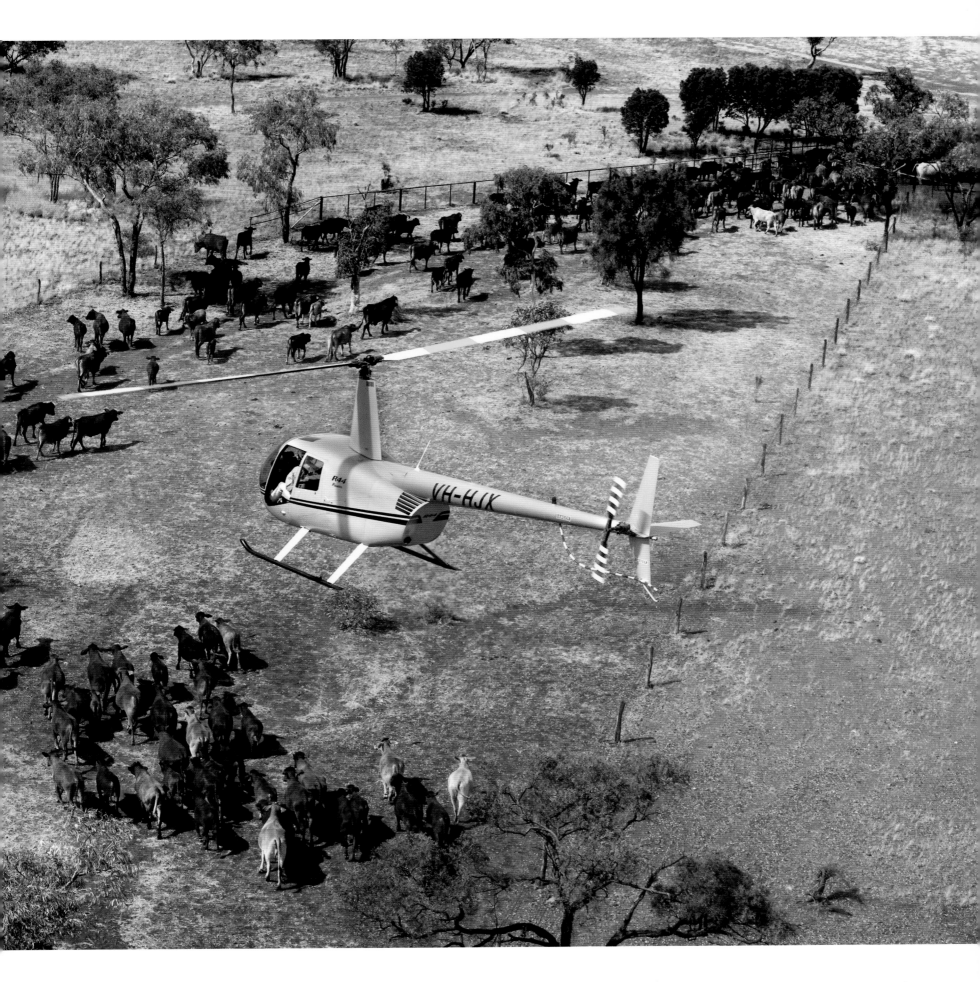

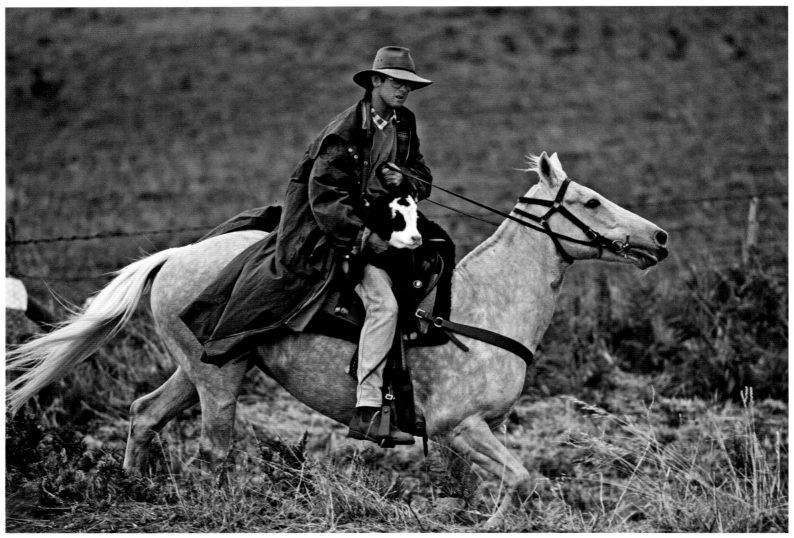

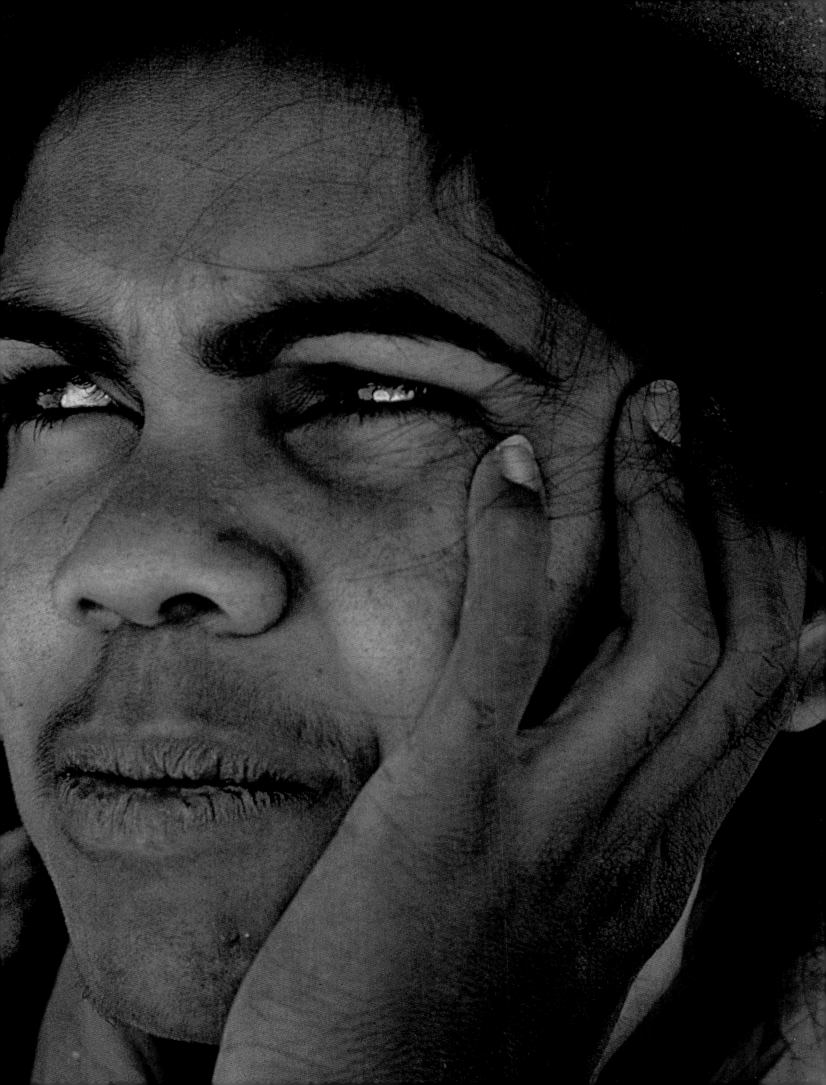

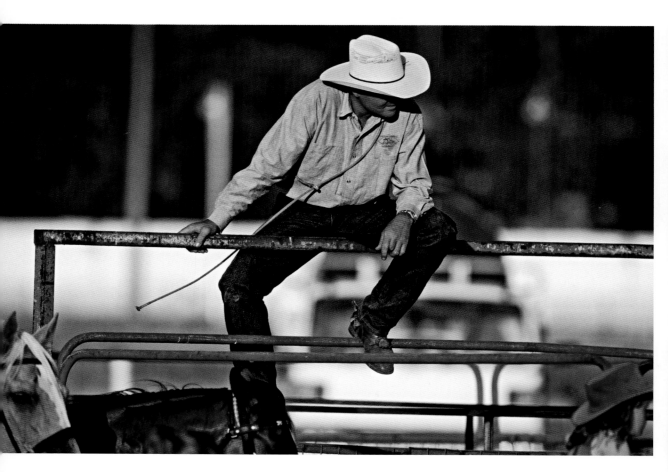

268 A STOCKMAN CHECKS A HERD OF HORSES.

268-269 A HUGE HERD OF LIVESTOCK ON A STATION IN THE NORTHERN AUSTRALIAN OUTBACK.

270-271 BREEDERS AND BROKERS WATCH THE SALE OF LIVESTOCK ON A STATION ABOUT TO CLOSE DOWN. LIFE IN THE OUTBACK IS VERY HARD, DUE TO FIRES, INVASIONS OF WILD ANIMALS, FLOODS AND SO ON, AND NOT ALL BREEDERS MANAGE TO KEEP AFLOAT.

272-273 A FLOCK OF SHEEP MONITORED BY A MOTORIZED SHEPHERD, WHO HAS REPLACED THE TRADITIONAL CROOK WITH A MOTORBIKE, FOR THE HUGE SPACES CALL FOR MORE MODERN TOOLS.

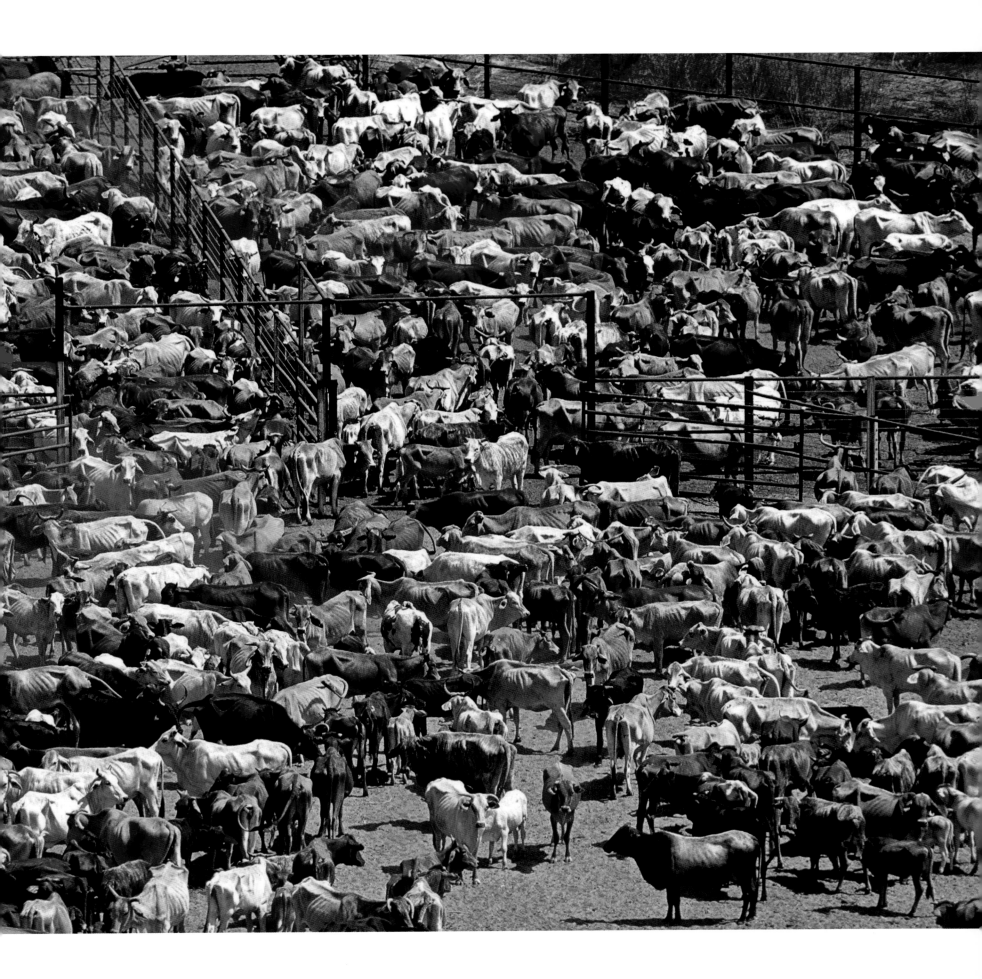

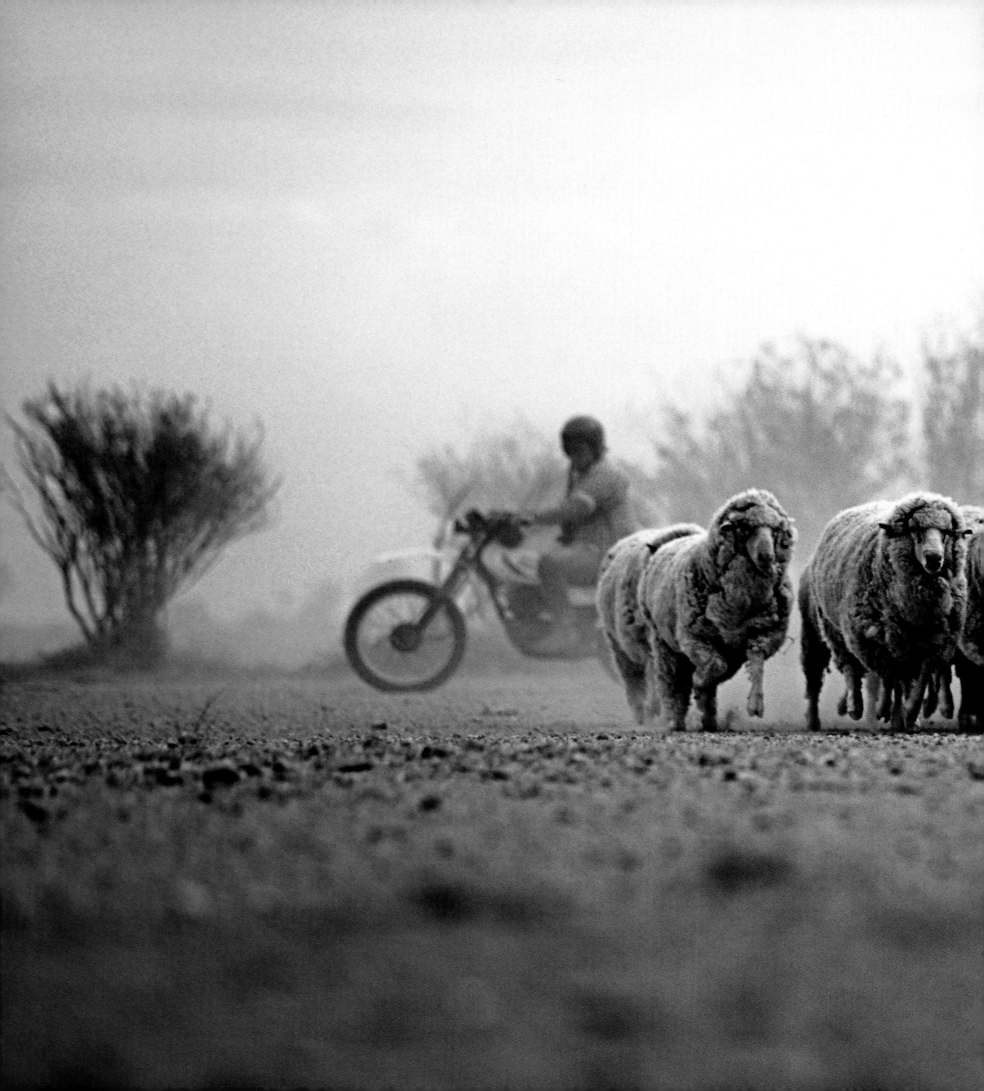

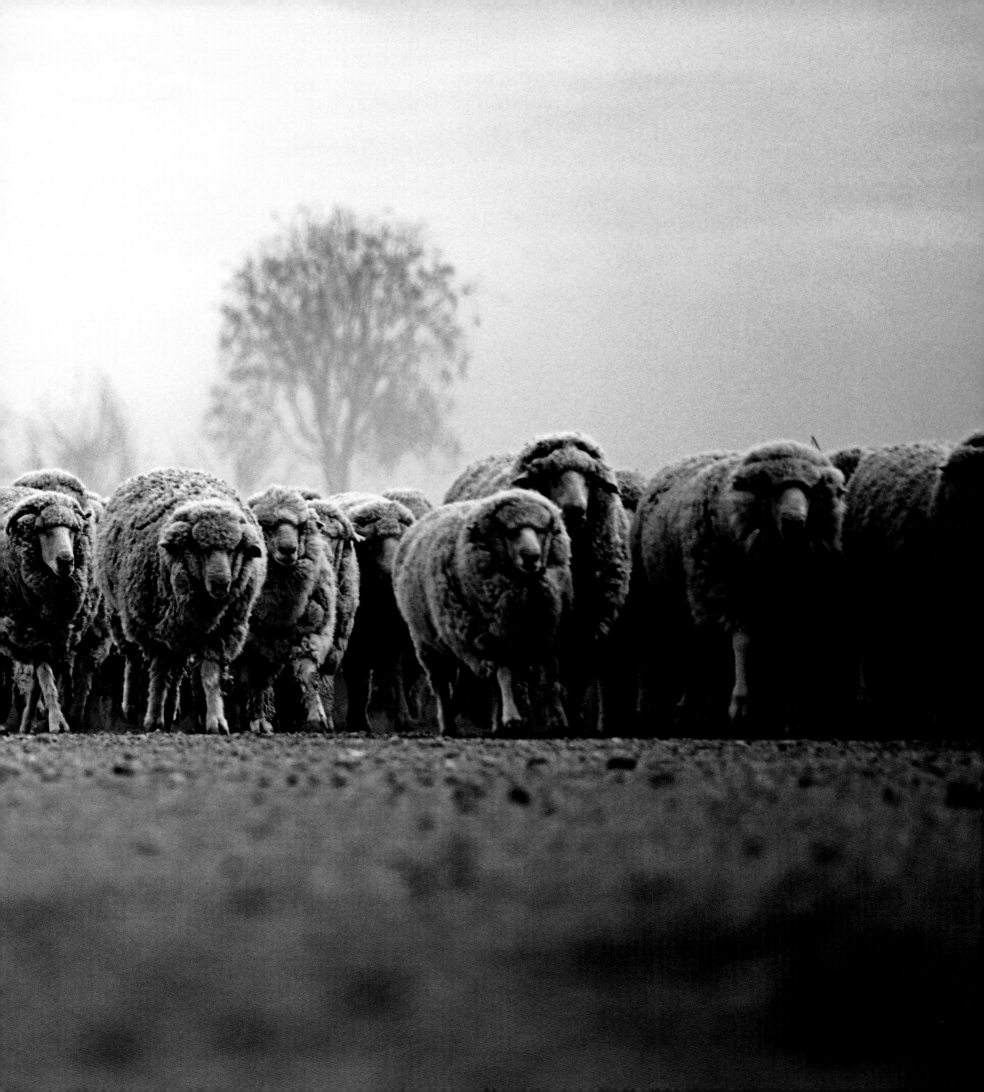

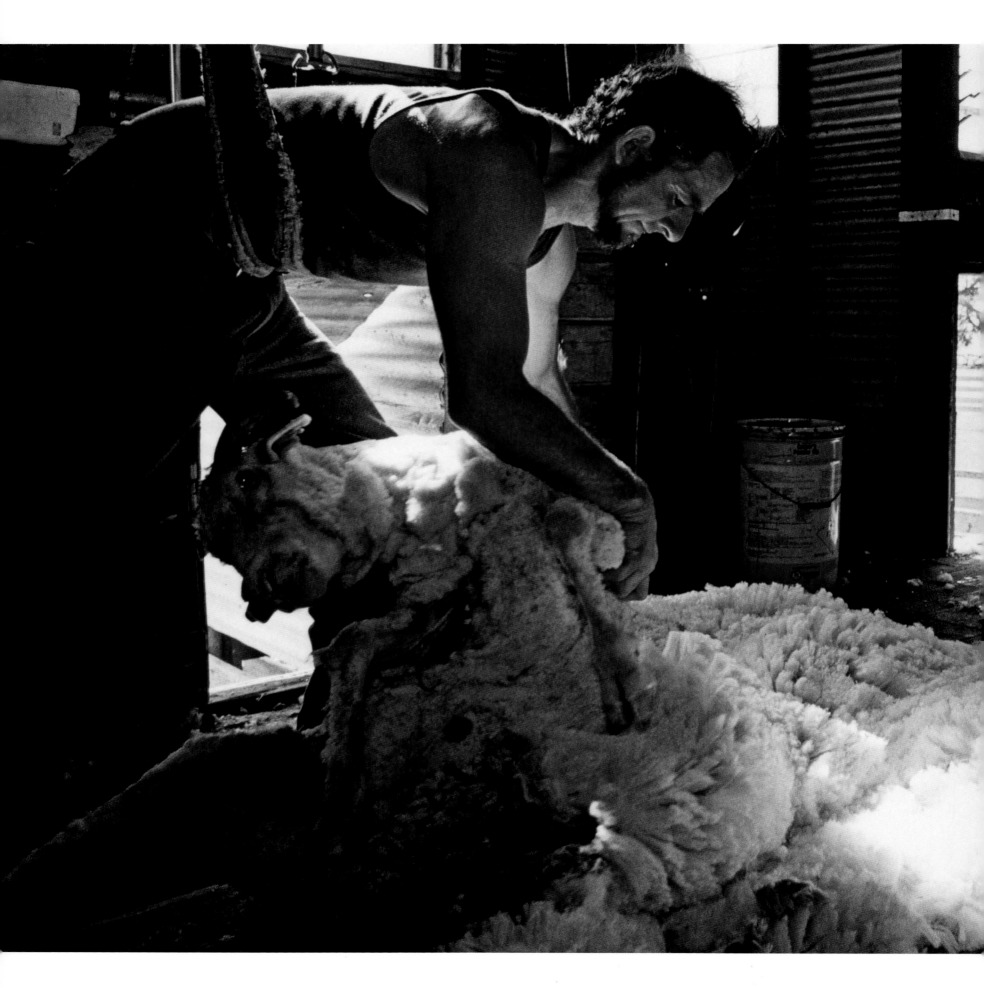

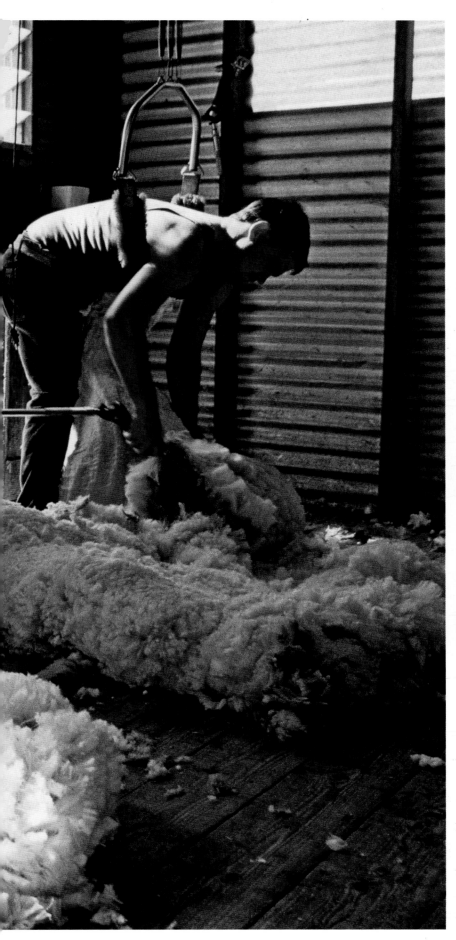

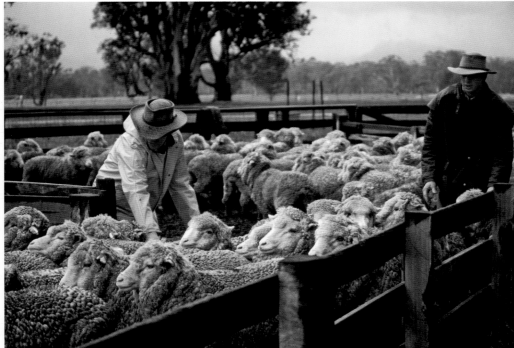

274-275 A SHEEPSHEARER HAS COMPLETELY SHORN THE ANIMAL.
THIS IS PERHAPS ONE OF THE TOUGHEST JOBS, ALTHOUGH THERE ARE
EXPERTS WHO HAVE MADE IT INTO AN AUTHENTIC PROFESSION
AND PARTICIPATE IN VARIOUS CONTESTS. SOME HAVE EVEN ACHIEVED
THE FAME OF MINOR STARS.

275 SHEEP ARE CHECKED AND INSPECTED PRIOR TO SELECTION
FOR SHEARING.

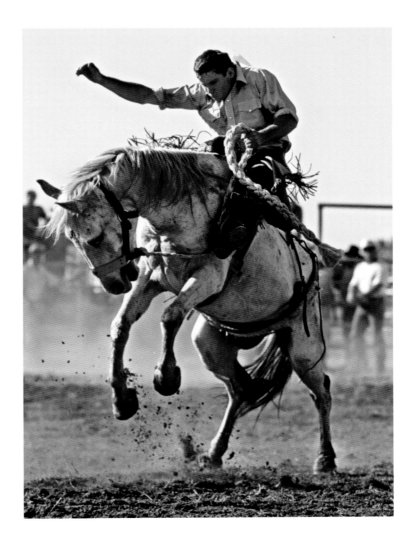

276-277 SKILLED STOCKMEN SUBDUE AN UNRULY BULL ON A RANCH IN THE NORTHERN TERRITORY.

277 A YOUTH TRYING TO BREAK A WILD HORSE DURING THE QUALIFICATIONS FOR THE PROFESSION OF STANDMAN HELD AT THE ADELAIDE RIVER RODEO.

278 A LITTLE BOY WITH HARD HAT RIDING A SHEEP.

278-279 A SMALL BOY GRASPING THE FLEECE OF A SHEEP TO KEEP HIMSELF
FIRMLY ON ITS BACK AT THE KATHERINE SHOW. CHILDREN LEARN TO RIDE
SHEEP FIRST OF ALL, PROGRESSING TO BULLS AND WILD COLTS AS THEY GROW.

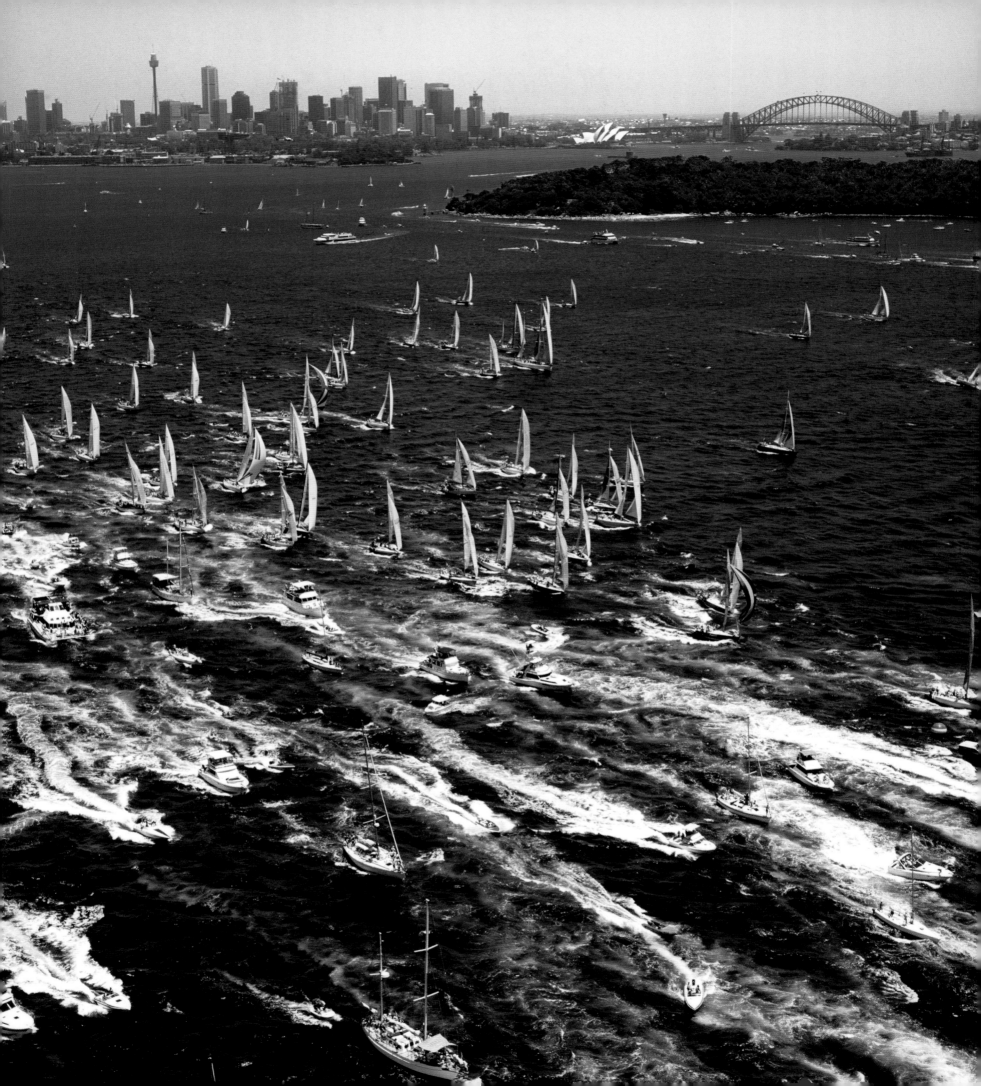

THE SEA
AND ITS PEOPLE

Australia's rapport with the oceans that surround it is reflected by its surf culture, populated by kids who sleep in pickup trucks on the edge of the beach, in order to ride the rollers at dawn – free spirits dedicated to the lifelong quest for the Big One – and white-collar workers impatient to swap their paperwork for a surfboard. Surfing is more than a sport: it is a lifestyle, which combines sun, sea, wind, nature and destiny, and which forms a winning combination with the Australian character. A great love of freedom is necessary to understand the spirit of surfing to the full and the Australians – true rebels at heart – who just love danger, dedicating themselves body and soul to this discipline, which they consider a sort of great adventure towards the unknown.

Courage is required to swim fearlessly against walls of water as high as a mountain, to risk one's life for the sake of a single moment and to proceed despite sharks, currents and howling winds. And indeed, Australians have plenty of courage. It is necessary to know the flavor of life to enjoy playing with the waves, let oneself be rocked by gentle bodysurfing, and capture that moment of infinite completeness in which one manages to stand up on the board, hair caressed by the wind. It is a moment of wild and vibrant freedom. There are those who manage to reconcile it with their job, contenting themselves with surfing in their free time, while others have made it a profession, like Queenland's "iron men," who meet for competitions and grueling training sessions at the numerous surfing events that enliven the calendar of the Gold Coast. There are those who pursue this moment for their whole lives, coast after coast, beach after beach, sea after sea, but with a gypsy soul, tormented by the flames of the challenge, reinvigorated by the fire of passion, in pursuit of an ever bigger wave, in an encounter between man and the sea that so closely recalls Australia's rebel soul. It is a soul that still struggles to remain authentic and remember its origins, despite progress and the passage of time.

It is the same spirit that drives the fishermen far from the coast and Australian city

dwellers to climb onto a sailboard or boat. Sailing is one of the most popular sports, but above all an opportunity for leisure: people take to the sea for a simple tour around the bay, an impromptu party with friends at sundown, a romantic candlelit dinner or to discover new areas, amid the fury of the waves and the horizon. Boats are also used as a base for exploring the sea floor, either snorkeling or scuba diving.

This spirit brings out a competitive drive whenever people see a boat cutting through the water during a regatta. There are countless sailing competitions, and also historical re-enactments with old

 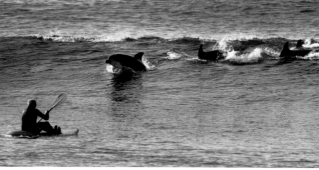

sailing ships, echoing a distant past. Then there is the collective fever triggered by the America's Cup, with its highly technological boats and professional skippers, who can be likened to true stars, for even when the competition is held far away overseas, it catalyzes the attention of Australian television viewers, who are capable of highly contagious attacks of sports madness. The same enthusiasm is displayed by oarsmen, who rhythmic rowing seems to wish to scale the surge of a stormy sea.

The competitive spirit fuels the desire to swim, expressed in the irrepressible drive to build handsome Olympic-size swimming pools everywhere, on the edge of a park framed by Sydney Har-

bour Bridge, or on the rocky shore of the coast, a stone's throw from the ocean, like at Bondi Beach, where the water of the swimming pool that merges with that of the sea, whose stormy waves invade it. The love for this sport is embodied in emblematic venues, such as the Sydney Aquatic Centre, which hosted the swimming races during the 2000 Olympic Games. It is the perseverance that drives swimmers to complete resistance races, their arms "consuming" wide stretches of untamed sea, launching a new kind of swimming, freestyle in the ocean. Indeed, swimming is Australia's most popular sport and is even practiced in the sea, despite the mortal danger posed during certain periods of the year by giant jellyfish and saltwater crocodiles, with their predilection for haunting estuaries.

The same spirit animates beach life, attracting myriads of people onto the sand, to bask in the sun, play volleyball, meet in the fashionable bars or engage in sport. It is a spirit infusing those who choose the beach as an alternative to city life, moving to one of the many enchanting seaside towns with a permanent holiday atmosphere, where life proceeds at a slow, almost Jamaican pace. In all, it is a lifestyle that not only appears to have definitively forgotten the city, but the rest of the planet as well.

This world also has its own heroes: the bronzed, muscular surf lifesavers and lifesavers who jog on the beach at dawn in their swimming costumes and caps, or train hard on the beach, in readiness for the great challenge in which they risk their lives among the ocean waves to save those of others, heedless of the currents and breakers, undaunted in the face of destiny, which has always governed the land of Australia.

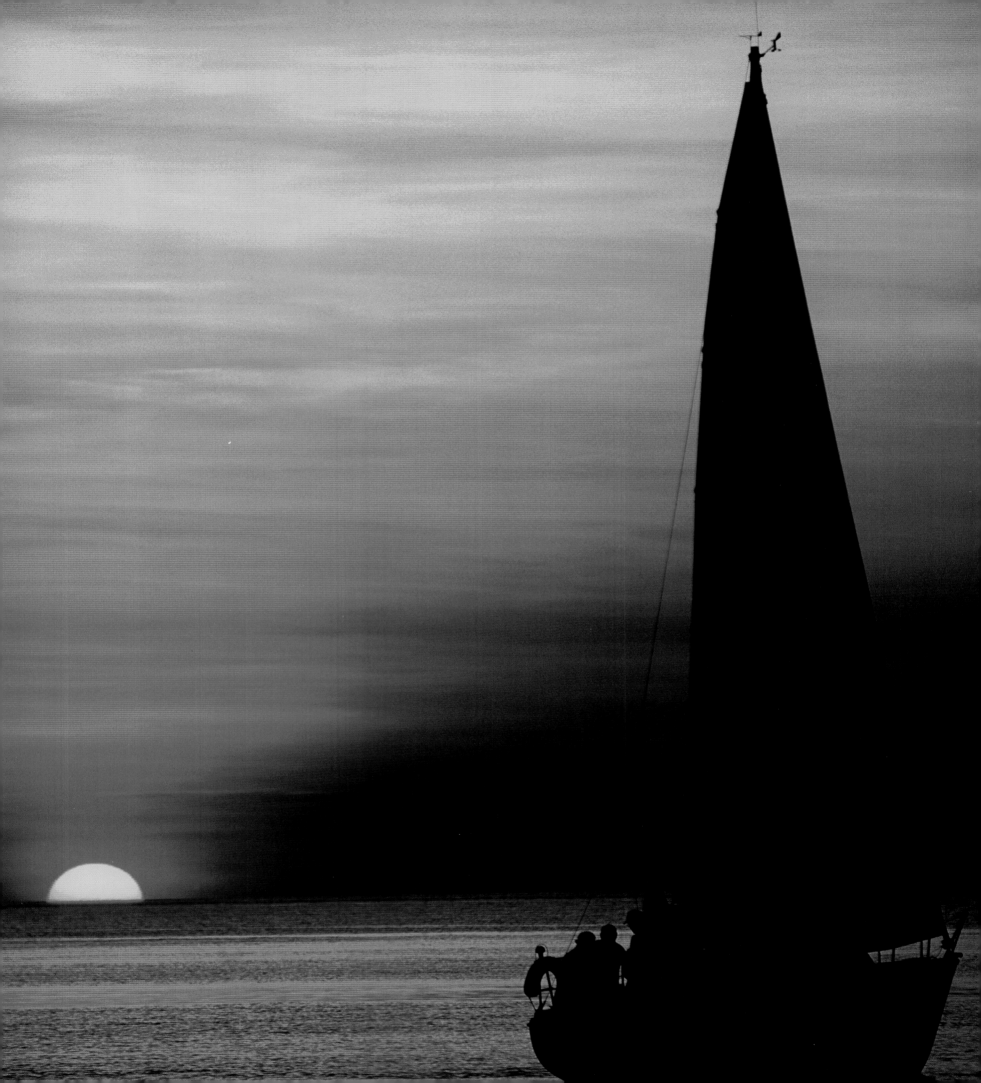

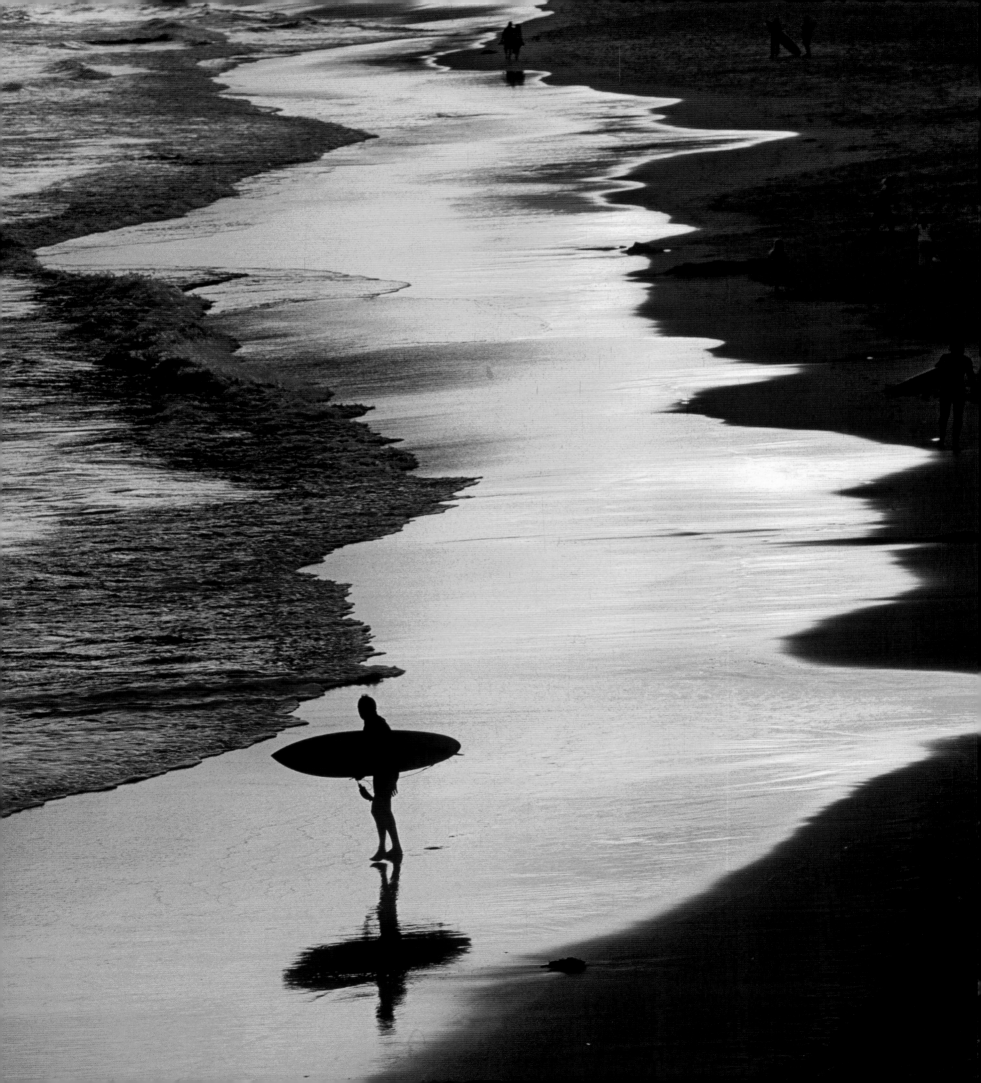

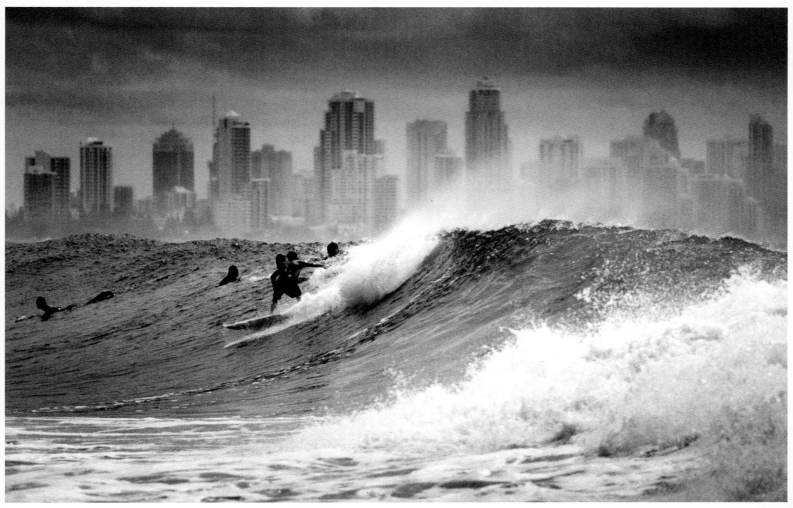

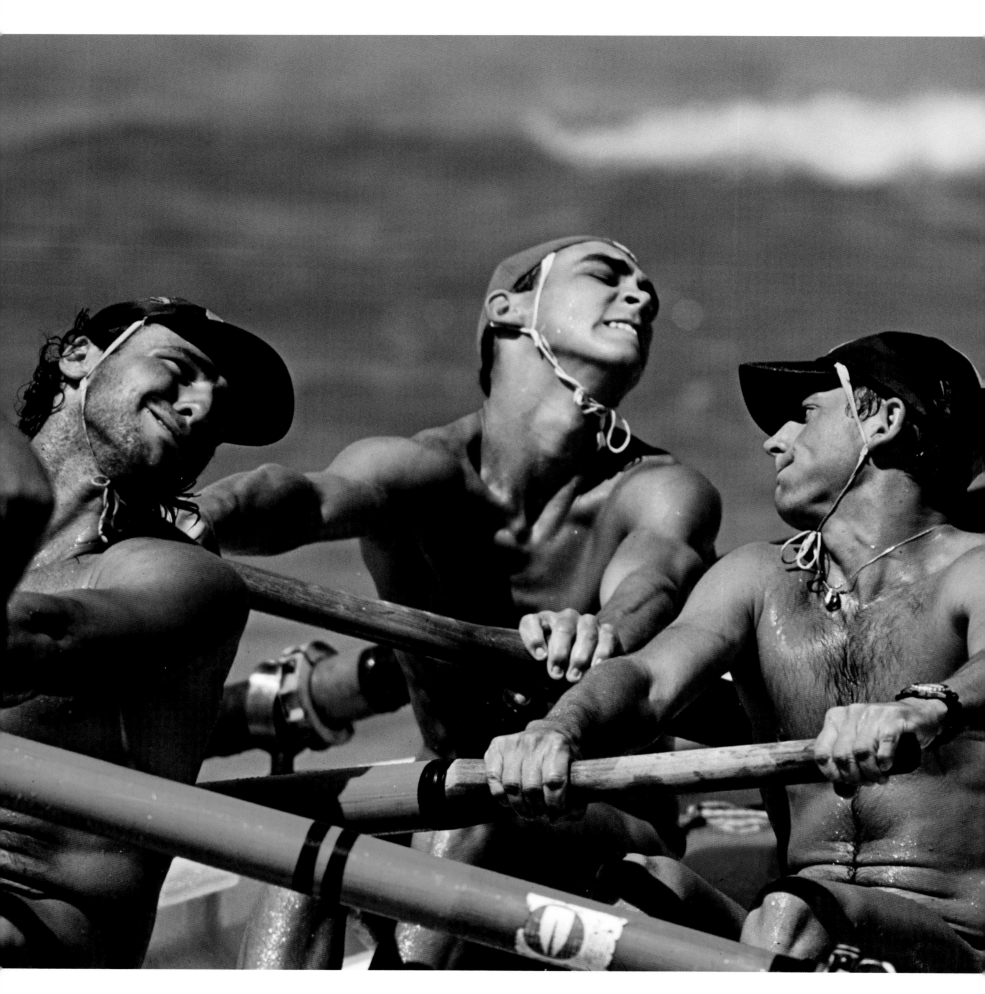

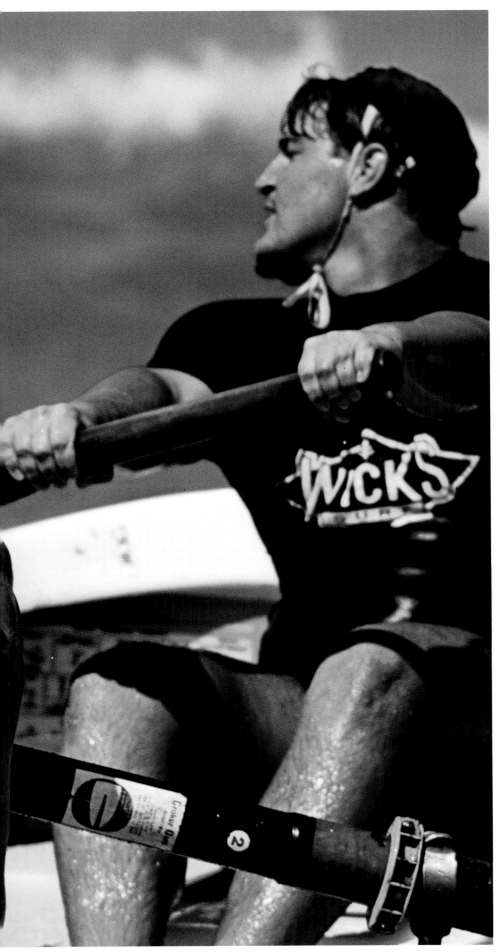

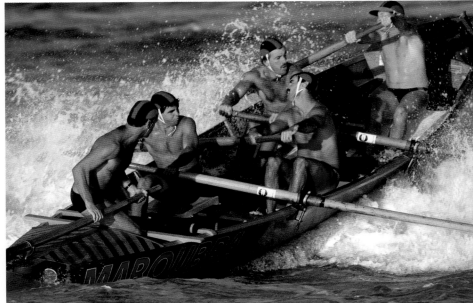

286-287 A team of lifesavers trying to win the Surferboat Race. The numerous lifesaving associations often organize competitions to measure the physical and sporting capacities of their men. These are always great events.

287 Lifesavers rowing their boat through the waves at Bondi Beach.

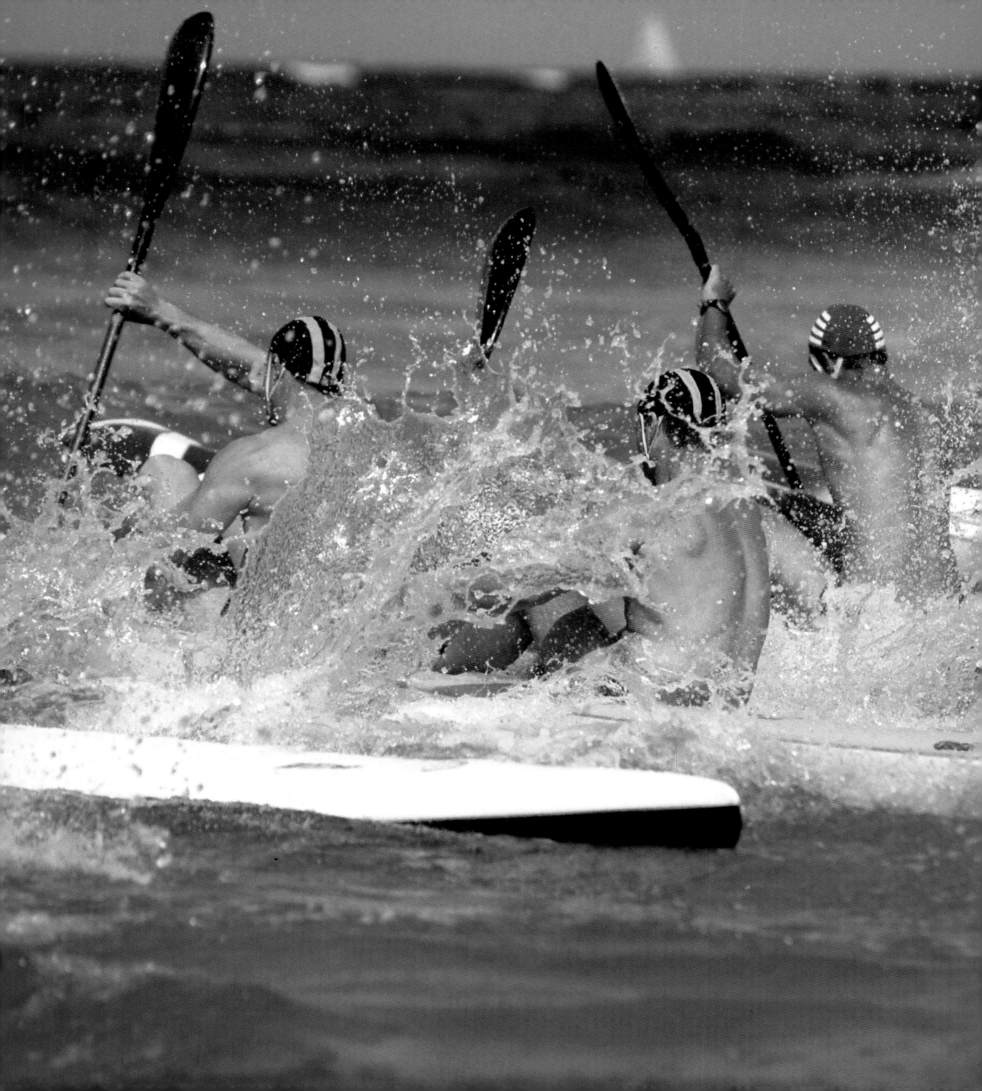

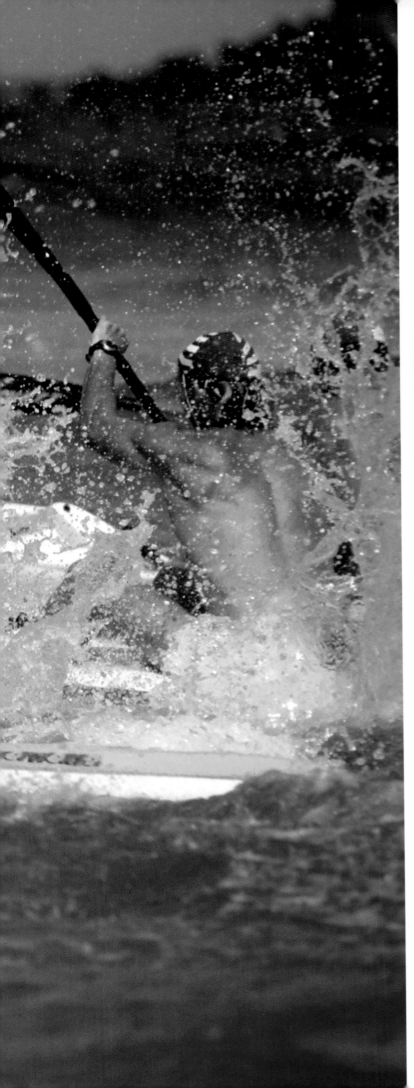

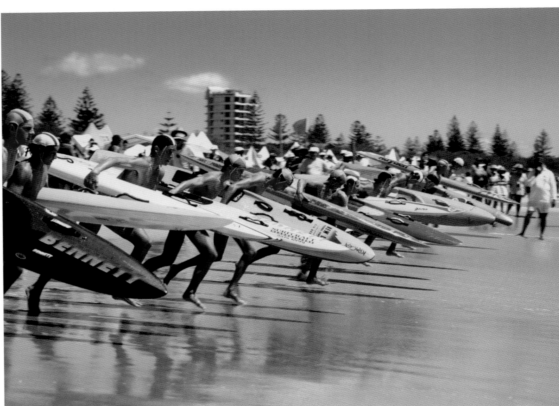

288-289 Ironmen challenge each other on their surfboards in one of the contests of the densely-packed Gold Coast season.

289 The ironmen of the Surf Carnival are ready for the competition at Kirra Beach on the Gold Coast.

290-291 A WINDSURFER PERFORMS
EXTRAORDINARY ACROBATIC FEATS ON
THE CREST OF A BLUE OCEAN WAVE.

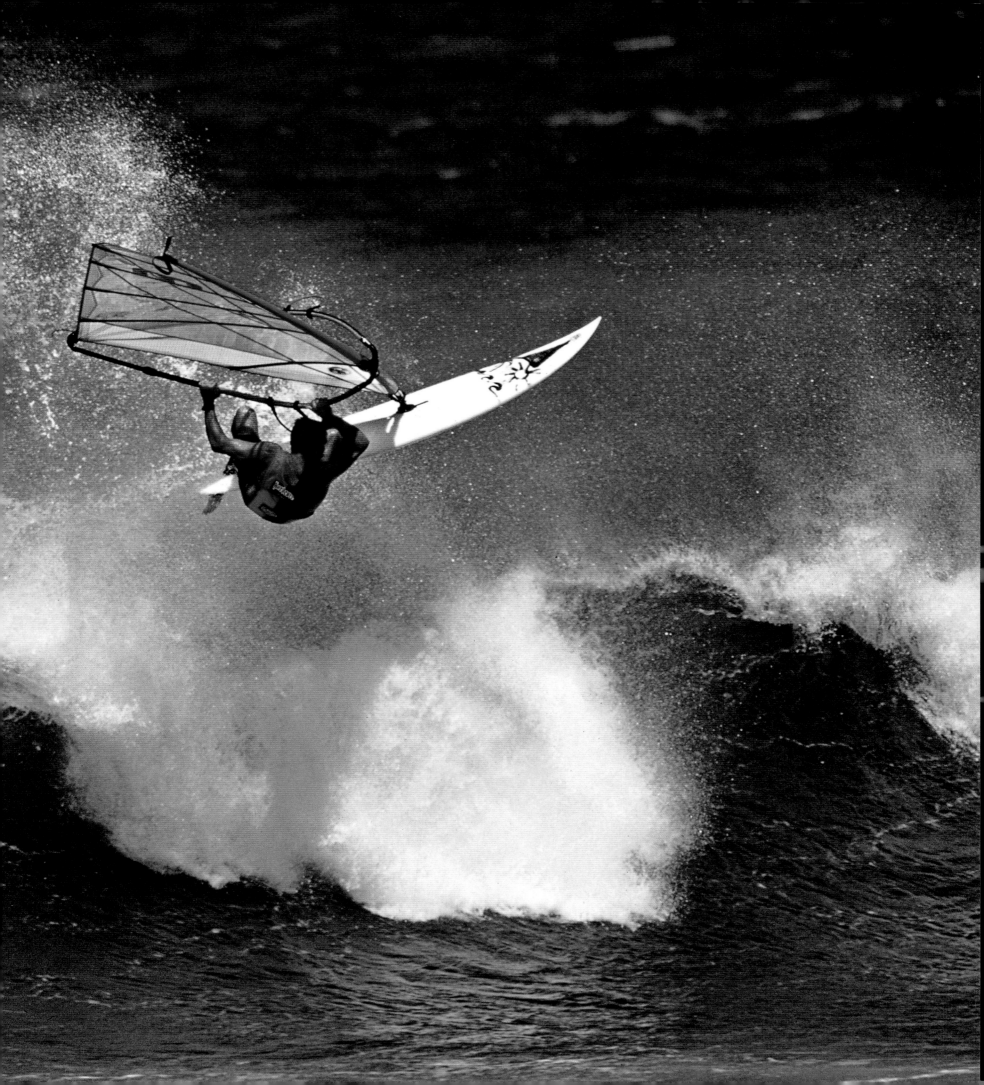

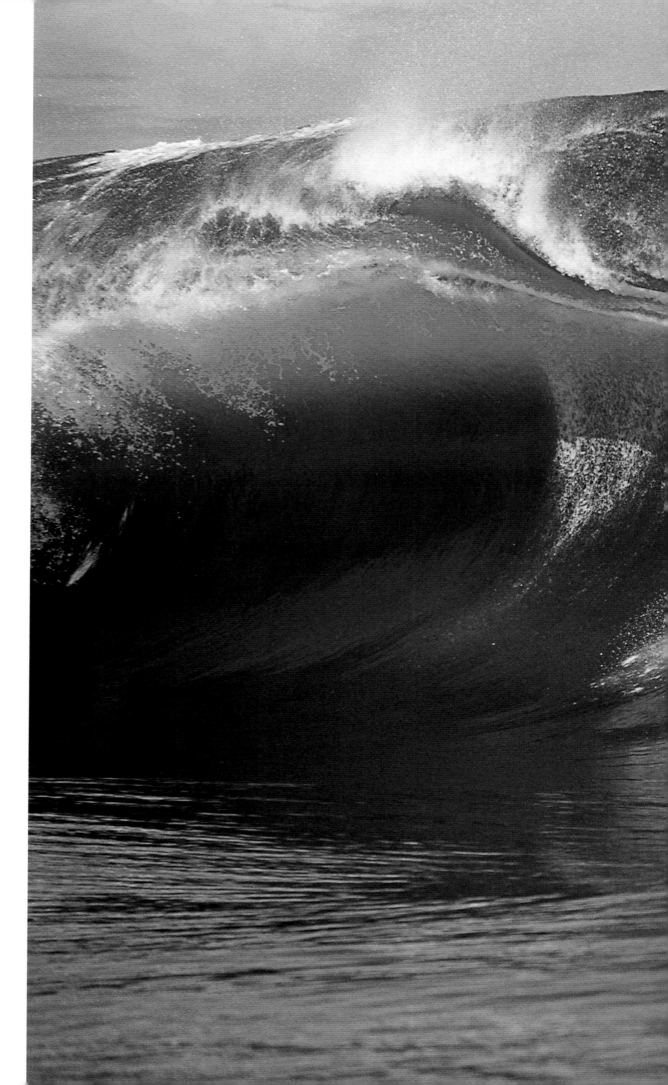

292-293 Surfing is a passion shared by many young Australians; they fearlessly ride the breakers, heedless of the dangers of sharks and strong currents.

294-295 This Queensland surfer seems to be imprisoned by the wave that breaks directly above him.

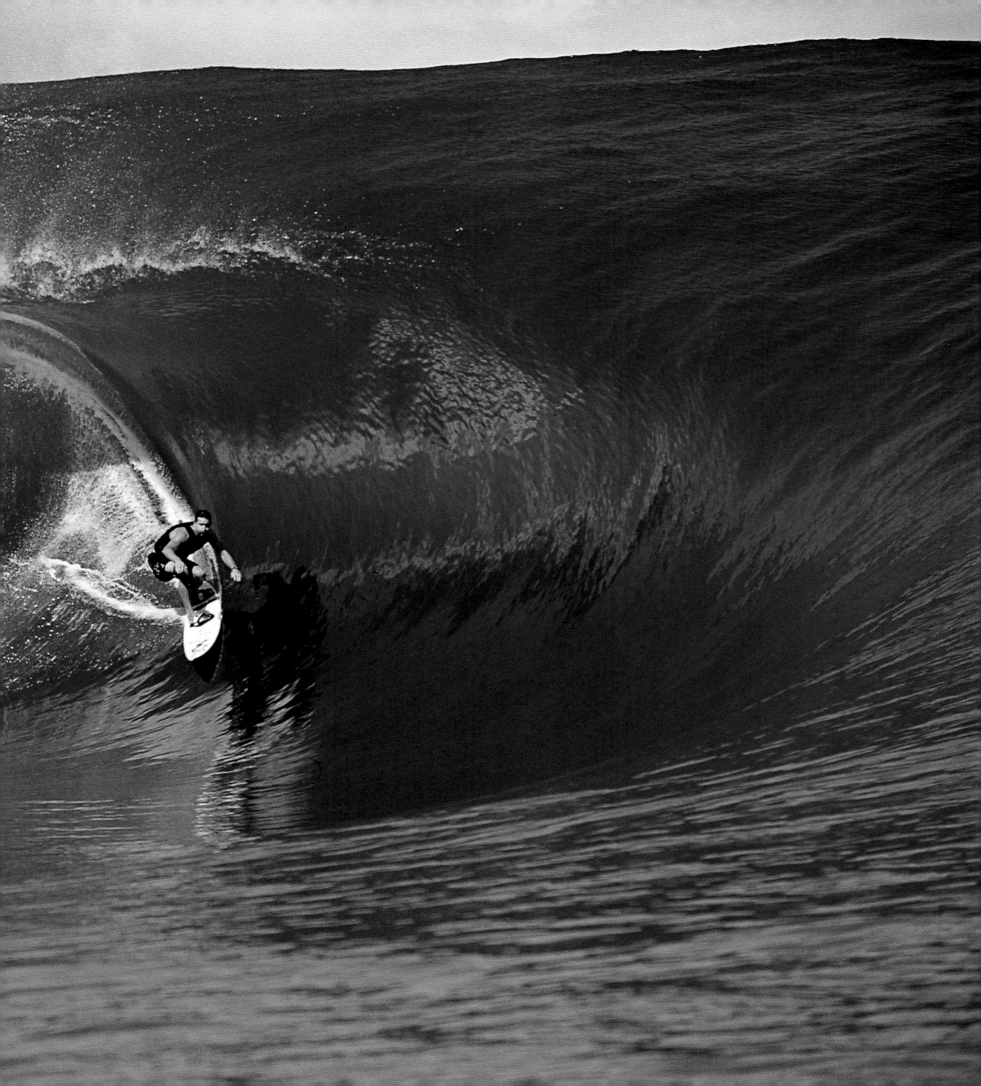

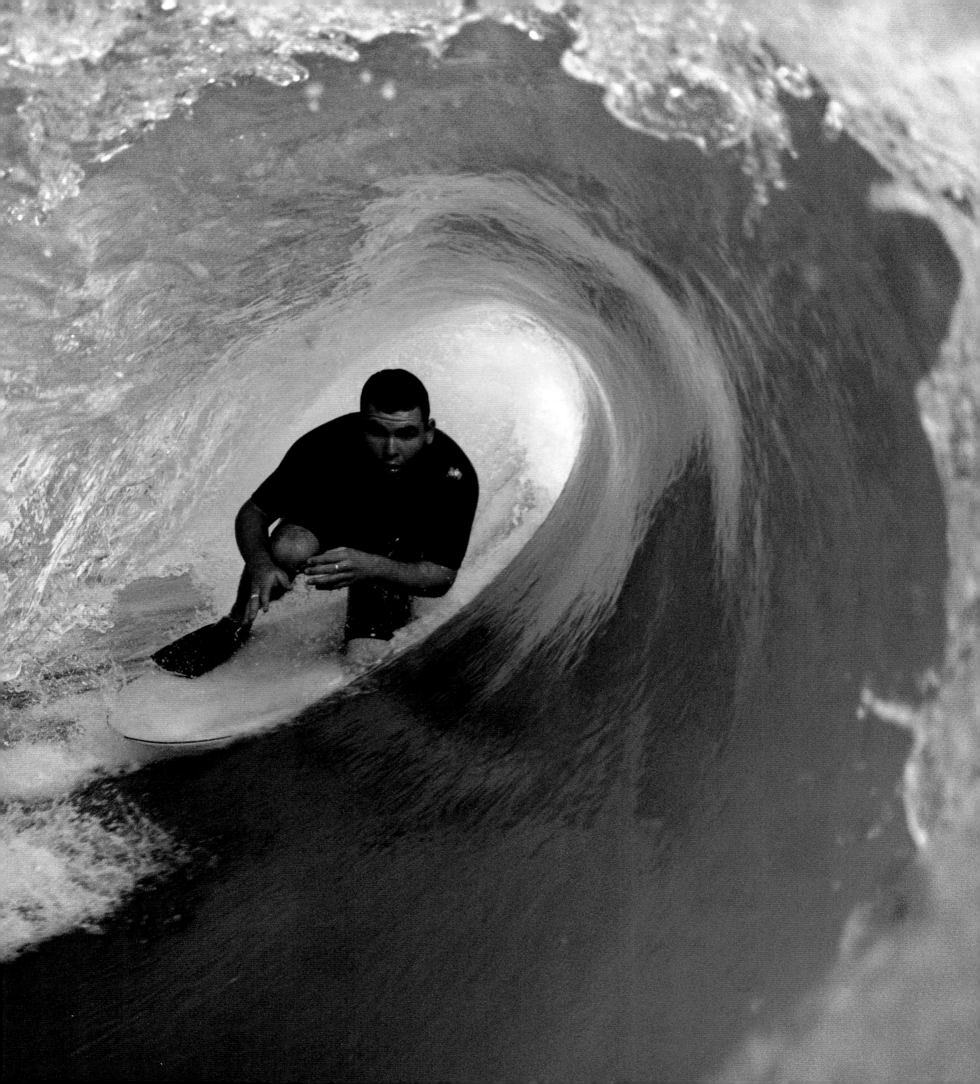

INDEX

PHOTOGRAPHIC CREDITS

Theo Allofs/Corbis/Contrasto: pagg. 9 a destra , 60-61, 86, 86-87

Alice Alston/Auscape: pagg. 46-47

Auscape: pagg. 222, 260, 264-265, 272-273

Auscape International/Ardea: pag. 101 al centro

Australian Picture Library: pagg. 238-239

Australian War Memorial/The Art Archive; pag. 33 in basso

John Banagan/Lonely Planet Images: pagg. 74 a sinistra, 216

Ross Barnett/Lonely Planet Images: pagg. 152 in alto a destra, 205 in alto a destra

Marcello Bertinetti/Archivio White Star: pagg. 176-177

Yann Arthus-Bertrand/Corbis/Contrasto: pagg. 36 in basso a sinistra, 38, 39 a sinistra, 48-49, 66, 66-67, 70-71, 110-111, 114-115, 116-117, 118-119, 153

Bettmann/Corbis/Contrasto: pag. 35 a sinistra

Bialobrzeski/laif/Contrasto: pag. 159 al centro

Nicholas Birks/Auscape: pagg. 68-69

The Bridgeman Art Library/Archivio Alinari: pagg. 21, 26, 28, 30 in basso

British Library: pag. 25 a sinistra

Will Burgess/Reuters/Contrasto: pag. 282 a destra

Alain Buu/Gamma/Contrasto: pag. 157 in basso

Claver Carroll/Agefotostock/Marka: pag. 240 in basso a sinistra

L. Clarke/Corbis/Contrasto: pag. 155 a sinistra

Sara-Jane Cleland/Lonely Planet Images: pag. 154 a sinistra

Matthieu Colin/Hemisphers Images: pagg. 169, 170-171

Collection: Ballarat Fine Art Gallery: pag. 29 in alto

Juliet Coombe/Lonely Planet Images: pag. 182

Corbis/Contrasto: pagg. 32 in basso, 33 in alto a destra, 34 in basso a sinistra

Guido Cozzi/Atlantide Photo Travel: pagg. 230, 234, 281 in alto al centro

David Curl/Lonely Planet Images: pagg. 45 a sinistra, 96-97

Giovanni Dagli Orti/The Art Archive: pag. 34 in basso a destra

Stefan Damm/Sime/Sie: pag. 217 a sinistra

Isabelle De La Moureyre/Corbis Sygma/Contrasto: pagg. 260-261, 262-263

Krzysztof Dydynski/Lonely Planet Images: pagg. 58-59

Double's/ICP: pag. 290-291

Greg Elms/Lonely Planet Images: pag. 157 in alto a destra

Emmler/laif/Contrasto: pagg. 159 a destra, 172-173, 173, 288-289

Patrick Fagot/Nhpa: pag. 143

John Fairhall/Auscape: pag. 77

Jean-Paul Ferrero/Ardea: pagg. 14-15, 16-17, 45 a destra, 73 al centro, 75 a destra, 90-91, 91, 92-93, 98, 99 a sinistra, 100 a destra, 101 a sinistra, 104-105, 106-107, 132, 133, 134-135, 136-137, 138-139

Jean-Paul Ferrero/Auscape: pagg. 40, 41 al centro, 41 a destra, 50-51, 84, 167

Franco Figari: pagg. 140-141, 141

Lincoln Fowler/Tourism Australia: pag. 289

Stephen Frink/Corbis/Contrasto: pagg. 120-121

Free Agents Limited/Corbis/Contrasto: pag. 247

Bertrand Gardel/Hemisphers Images: pag. 9 a sinistra

Garma Festival David Hancock/Ardea: pag. 251

Manfred Gottschalk/Lonely Planet Images: pag. 218

Robert Gravey/Corbis/Contrasto: pagg. 227, 231

David Gray/Reuters/Contrasto: pag. 240 in alto a sinistra

Brett Gregory/Auscape: pagg. 73 a destra, 161 in basso

Christopher Groenhout/Lonely Planet Images: pagg. 56-57, 64-65, 196, 198-199, 204 in basso

David Hancock/Ardea: pagg. 276-277

David Hancock/Anzenberger/Contrasto: pagg. 240 in basso a destra, 245 al centro, 245 a destra, 246 a sinistra, 252, 253, 254, 254-255, 268-269, 277, 278, 278-279

Dennis Harding/Auscape: pag. 81

Hartz/laif/Contrasto: pagg. 2-3

Martin Harvey/Agefotostock/Marka: pagg. 62

John Hay/Lonely Planet Images: pagg. 9 al centro, 221

Heeb/Agefotostock/Marka: pagg. 212-213

Christian Heeb/Hemisphers Images: pagg. 152 in alto a sinistra, 181 in basso a destra, 193, 202, 205 in basso, 206-207, 217 a destra, 268

Heeb/laif/Contrasto: pagg. 197 in alto a sinistra, 197 in alto a destra, 214-215, 241, 284

Jon Hicks/Corbis/Contrasto: pagg. 204 in alto, 205 in alto a sinistra, 208-209

Hoa-qui/Grazia Neri: pag. 43 in alto

Johanna Huber/Sime/Sie: pag. 45 al centro, 155 a destra

Hervé Hughes/Hemisphers Images: pag. 103 in alto

Hulton-Deutsch Collection/Corbis/Contrasto: pagg. 32 in alto, 33 in alto a sinistra, 34 in alto

Richard I' Anson/Lonely Planet Images: pagg. 36 in basso a destra, 72, 73 a sinistra, 74 al centro, 154 a destra, 183, 220

Mitsuaki Iwago/Minden Pictures/Grazia Neri: pag. 52

Mark A. Johnson/Corbis/Contrasto: pagg. 294-295

Dennis Jones/Lonely Planet Images: pag. 203

Kreuels/laif/Contrasto: pag. 282 a sinistra, 285

Frans Lanting/Minden Pictures/Grazia Neri: pag. 244

Mark Laricchia/Corbis/Contrasto: pagg. 54-55

Jean-Marc La Roque/Ardea: pagg. 74 a destra, 103 in basso

Jean-Marc La Roque/Auscape: pagg. 157 in alto a sinistra, 258-259

La Trobe Pictures collection, State Library of Victoria: pages 30 top, 31 bottom

Wayne Lawler/Auscape: pag. 85

Geoffrey Lea/Auscape: pag 237 in alto a sinistra

R. Ian Lloyd/Masterfile/Sie: pagg. 39 a destra, 181 in alto, 194-195, 223

James Marshall/Corbis/Contrasto: pagg. 162-163

R. Martina/Agefotostock/Marka: pag. 229

Mary Evans Picture Library: pagg. 20 in basso a sinistra, 29 in basso

Diana Mayfield/Lonely Planet Images: pagg. 155 al centro, 219

Daniele Mattioli/Anzenberger/Contrasto: pagg. 161 in alto, 188-189, 225 a destra, 281 in basso

Tim McKenna: pagg. 292-293

Ted Mead/Woodfall Wild Images: pagg. 78-79

Chris Mellor/Lonely Planet Images: pagg. 178, 185, 210, 210-211

David Messent/Auscape: pag. 235

Steven David Miller/Auscape: pag. 257 a sinistra

Marco Moretti: pagg. 108-109

Reg Morrison/Auscape: pag. 80

Multhaupt/laif/Contrasto: pag. 192

Amos Nachoum/Corbis/Contrasto: pagg. 148-149

National Library of Australia: pagg. 20 in alto a destra, 22 in alto a sinistra, 23 in basso a sinistra e a destra, 25 a destra, 27 in alto

National Library of Australia/The Art Archive: pag. 27 in basso

Stefano Nicolini: pagg. 88-89, 174-175

Richard T. Nowitz/Corbis/Contrasto: pag. 181 in bassoa sinistra

Panstock/Agefotostock/Marka: pag. 228

Vincenzo Paolillo: pagg. 146, 147

D. Parer & E. Parer-Cook/Ardea: pagg. 8, 99 al centro, 100 a sinistra, 112-113, 113

Trent Parke/Magnum Photos/Contrasto: pagg. 156, 164-165

Photoservice Electa/Akg: pag. 20 in basso a destra, 35 a destra

Massimo Pignatelli/Sime/Sie: pag. 43 in basso

Angela Prati: pag. 11

Nick Rains; Cordaiy Photo Library Ltd./Corbis/Contrasto: pag. 280

Nicolas Reynard/Hemisphers images: pag. 1

Roberto Rinaldi: pagg. 18-19, 36 in alto a sinistra, 101 a destra, 124-125, 126-127, 128, 129, 130-131

Roberto Rinaldi/Sime/Sie: pag. 99 a destra

Royalty-free/Corbis/Contrasto: pagg. 36 in alto a destra, 257 in centro

Chris Sattlberger/Anzenberger/Contrasto: pag. 264

Seapics.com: pagg. 122-123, 150-151

Douglas David Seifert/Ardea: pag. 149

Gerard Sioen/Anzenberger/Contrasto: pag. 287

Paul A. Souders/Corbis/Contrasto: pagg. 82-83, 142, 144-145, 152 in basso a sinistra, 158 a sinistra, 197 in basso, 200-201, 225 al centro, 226, 232-233, 237 al centro, 237 a destra, 237 in basso, 242, 248-249, 257 a destra, 266, 281 in alto a destra, 286-287

Stapleton Collection/Corbis/Contrasto: pag. 22 in alto a destra, 22 in basso, 23 in alto

D. Stock/Magnum Photos/Contrasto: pag. 53

Dallas Stribley/Lonely Planet Images: pag. 179 a sinistra

SuperStock/Agefotostock/Marka: pagg. 63, 212

Lloyd Sutton/Masterfile/Sie: pagg. 6-7

The Art Archive: pagg. 20 in alto a sinistra, 24-25, 31 in alto

Tom Van Sant/Corbis/Contrasto: pagg. 12-13

Oliver Strewe/Lonely Planet Images: pag. 41 a sinistra, 256

Valerie Taylor/Ardea: pagg. 75 a sinistra, 94-95

Nico Tondini/Agefotostock/ Marka: pag. 300

Tourism Australia: pag. 240 in alto destra

Penny Tweedie/Corbis/Contrasto: pagg. 245 a sinistra, 250, 266-267

Giulio Veggi/Archivio White Star: pagg. 158 a destra, 166, 168, 184, 186-187, 190-191

Steve Vidler/Sime/Sie: pagg. 159 a sinistra, 236, 246 a destra

Wayne Walton/Lonely Planet Images: pag. 199, 225 a sinistra

Patrick Ward/Corbis/Contrasto: pagg. 44 a sinistra, 171

Phill Weymouth/Lonely Planet Images: pagg. 270-271, 283

S. Wilby & C. Ciantar/Auscape: pag. 44 a destra

Adam Wilson/Tourism Australia: pag. 281 in alto a sinistra

Jeremy Woodhouse/Masterfile/Sie: pagg. 152 in basso a destra, 179 a destra, 224

Michael S. Yamashita/Corbis/Contrasto: pagg. 274-275, 275

Gunter Ziesler: pagg. 4-5

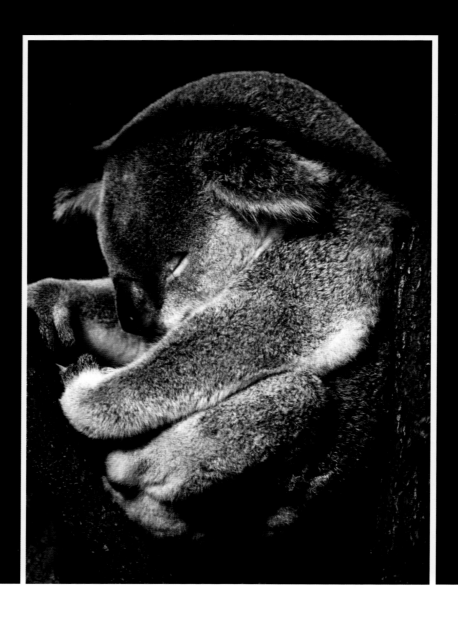

300 A BABY KOALA SLEEPING ON A TREE BRANCH. AUSTRALIA'S HUGE POPULATION
OF THESE ENGAGING ANIMALS IS SERIOUSLY DAMAGING THE NATION'S EUCALYPTUS
TREES, WHOSE LEAVES ARE THE KOALAS' FAVORITE FOOD.